UTOPIA & REALITY
MODERNITY IN SWEDEN 1900-1960

PUBLISHED FOR THE
BARD GRADUATE CENTER FOR STUDIES IN THE
DECORATIVE ARTS, DESIGN, AND CULTURE, NEW YORK
BY YALE UNIVERSITY PRESS
NEW HAVEN AND LONDON

UTOPIA AND REALITY – MODERNITY IN SWEDEN 1900–1960
Bard Graduate Center for Studies in the Decorative Arts,
Design, and Culture, New York
March 14 – June 16, 2002

Exhibition Curators Cecilia Widenheim, Moderna Museet, Stockholm
 Eva Rudberg, Swedish Museum of Architecture, Stockholm

Exhibition Committee Art, Graphic and Industrial Design:
 Cilla Robach, Nationalmuseum, with Marie-Louise Bowallius and Gustaf Rosell
 Photography: Leif Wigh, Moderna Museet
 Drawings and Graphic Design: Ragnar von Holten, Moderna Museet

BARD GRADUATE CENTER
Director of Exhibitions Nina Stritzler-Levine
Curator of Exhibitions Olga Vallé Tetkowski

CATALOGUE
Editor Cecilia Widenheim
Illustration Editor Jenny Håkansson Hedberg
Designer Martin Farran-Lee
Co-ordinators Elizabeth Haitto Connah, Jenny Håkansson Hedberg (Swedish edition)
 Sally Salvesen (English edition)
Translators Henning Koch
 Sylvester Mazzarella
 David McDuff

First published in Swedish by Moderna Museet, Stockholm, and Norstedts, 2000,
in conjunction with the exhibition 'Utopi och Verklighet – Svensk Modernism 1900–1960'
held at Moderna Museet, Stockholm, October 7, 2000 – January 14, 2001

English edition published 2002 by Yale University Press, New Haven and London
in association with the Bard Graduate Center for Studies in the Decorative Arts, Design, and Culture, New York

Swedish edition © Moderna Museet, Swedish Museum of Architecture, BUS/2000, Artists, Authors,
Photographers
Translations © Bard Graduate Center for Studies in the Decorative Arts, Design, and Culture, New York

Library of Congress Cataloguing-in-Publication Data

Utopia and reality: Modernity in Sweden 1900–1960 / edited by Cecilia Widenheim
 p. cm.
"Bard Graduate Center for Studies in the Decorative Arts, Design, and Culture,
New York March 14 – June 16, 2002 exhibition curators, Cecilia Widenheim,
Moderna Museet, Stockholm, Eva Rudberg, Arkitekturmuseet, Stockholm"

Includes bibliographical references and index

ISBN 0-300-09359-4

1. Modernism (Art)–Sweden–Exhibitions. 2. Art, Swedish–20th
century–Exhibitions. 3. Arts, Swedish–20th century–Exhibitions.
I. Widenheim, Cecilia. II. Rudberg, Eva.

N7088.5.M6 U88 2002
709'.485'0747471--dc21 2001007129

CONTENTS

Ingrid Helleberg, Härnösand; Malmö Konstmuseum, Malmö; Moderna Museet, Stockholm; Nationalmuseum, Stockholm; Norrköpings Konstmuseum, Norrköping; Olle and Rut Eksell, Stockholm; Orrefors Kosta Boda AB, Orrefors; Per Ekströmmuseet, Mörbylånga; Rörstrands Museum, Lidköping; SKF Sverige AB, Göteborg; Skövde Konstmuseum, Skövde; Stockholms Universitets Konstsamlingar; Agnes Hellners samling, Stockholm; Sven and Anna-Lisa Nilsson; Jerker Ekström Vaggeryd; Svenska Filminstitutet, Stockholm; Syskonen Derkert, Lidingö; Telemuseum, Stockholm; Thomas Lindblad, Solna; Torbjörn Lenskog, Kungsör; Uppsala Universitetsbibliotek, Uppsala; Wigerdals värld, Stockholm. The exhibition at the Bard Graduate Center gallery was designed by Henrik Widenheim, who admirably succeeded in this task.

John Nicoll, managing director of Yale University Press in London enthusiastically offered to publish the English-language translation of the catalogue. I would like to thank the many contributors to the catalogue including Sverker Sörlin, Peter Cornell, Per Hedström, Jeff Werner, Shulamith Behr, Sven-Olov Wallenstein, Gertrud Sandqvist, Eva Eriksson, Eva Rudberg, Björn Linn, Cilla Robach, Gustaf Rosell, Marie-Louise Bowallius, Leif Wigh, Niclas Östlind, Bo Florin, Henrik Orrje and Sören Engblom. I appreciate the fine work of Sally Salvesen, who edited the translated manuscripts and directed the publication of the catalogue. I would also like to thank Martin Farran-Lee who permitted us to adapt his original design to the translated version of the catalogue.

At the Bard Graduate Center Olga Vallé Tetkowski served as the project coordinator in New York and Ron Labaco worked closely with her in this effort. Linda Stubbs organized the transport and assembly of the exhibition with professionalism. Han Vu provided extensive support in the production of the media components of the exhibition. Susan Loftin, assisted by Ian Sullivan, organized the installation crew and coordinated the installation in our gallery.

Many other individuals at the Bard Graduate Center provided assistance and contributed to the success of this project. Susan Wall and Tara d'Andrea conducted the fundraising effort. Tim Mulligan assisted by David Tucker initiated the press campaign. The exhibition was enhanced by a marvelous selection of public programs originated by Lisa Podos and coordinated by her able staff including Sonia Gallant, Jill Gustafson, Leslie Klingner, and Jennie McCahey. Lorraine Bacalles, assisted by Dianora Watson, attended to many details related to finance and administration. In my office I want to thank Sandra Fell for her help with this project. Jason Petty and Edina Deme oversee the daily running of the gallery and offer assistance to visitors. John Donovan manages the building operations with skill and professionalism; Chandler Small and the dedicated group of Bard Graduate Center guards provide the necessary security for the gallery. Finally I wish to express my gratitude to the entire staff and faculty of the Bard Graduate Center for their fine work and support.

Susan Weber Soros

Director, Bard Graduate Center

January 2002

FOREWORD

We tend to distinguish the world in terms of contrasts: between modern and traditional, hot and cold, primitive and civilized, between utopia and reality. And every utopia has its nightmare, every reality its dream...

Distinctions or conflicts of this kind only become clear from certain perspectives. It has been generally accepted that culture is essential to the development of society, and as a result it has come to be classified according to society's ideological systems. Hence the basis of the battle over opinion, meaning and power that was a notable feature of Europe in the first half of the twentieth century.

The pursuit of new impulses and the struggle to be accepted as part of the modern movement in Europe at the beginning of the twentieth century reflect a sometimes naive faith in progress and development. By the end of the nineteenth century World Exhibitions had grown into enormous manifestations at which each nation showed off its technological, social and not least its artistic innovations. New times called for new ideologies, new social structures and new technology, and there was a demand for new consumer goods and new lifestyles, while at the same time new artistic expressions of modernity took shape. For the artistic avant-garde of this flourishing Modernism renewal and accelerated development – sometimes speeded up to the point of revolt – became the obvious way to engage with the new age. The academic tradition's established system of values was called in question and the *Salon des Refusés* became the first setting for the series of rebellious Modernist infractions of the rules or 'isms' which were to characterize the art world during the first half of the twentieth century. Many Scandinavian artists went to mainland Europe, in search of the hallmarks of the new age in Paris and Berlin, the art metropolises. Others stayed at home to depict what happened when the provinces came in contact with the modern city and international culture.

This book and the exhibition of the same title examine Modernism's often self-contradictory complexity within Swedish art, photography, film, design and architecture from the turn of the century to the 1950s. Since Modernism frequently still affects the way we see the world, it makes sense to bring together the various fields of artistic endeavor and explore how Modernism expressed itself through them. But we shall find a divided picture. The way in which Modernism has been interpreted in recent times in relation to concepts like modernity and modernization has inevitably made it an instrument for looking back from the present. But we can also extrapolate various interpretations and attitudes by highlighting the differing starting-points and the assumptions of different professional groups.

Modernism has many faces. It can include a tendency to abstraction as well as a sometimes political documentary vein; it can long for pure form and expression and also for a comprehensive overview beyond the separate disciplines. It oscillates between an optimistic attitude to progress and a stinging criticism of the very idea of modernity. Looked at one way, Primitivism and a provincial tendency are reactions against Modernism, but looked at another way they are part of the same complex story.

Swedish Modernism has international roots, but it also has local features. Out in Europe – not least in countries to the east of what used to be the Iron Curtain – one finds today firmly established local forms of Modernism, in which the 'center' is modified by its relationship with what is often tellingly described as Europe's outskirts or 'periphery.' Is there also a 'typical Swedish' form of Modernism?

The only profitable way to look at Modernism as a heritage of ideas in Sweden is to take account of the views of both prophets and deniers, and try to relate international impulses to regional traits. If we are to understand how twentieth-century art has been described and for what reason and by whom, we need a sort of double perspective: we must consider not only the tension between tradition and artistic renewal, but also the tension between past perspectives and present perspectives. It is also essential to ask ourselves to what extent Modernism may be described as a way of liberating art or as a project for developing instructive culture and whether it has been effective in creating order.

Naturally a comprehensive analysis is necessary if we are to discover whether there is any such thing as a specifically Swedish form of Modernism. *Utopia and Reality* aims to provide a background for contemporary debate on the aesthetic and ideological legacy of Modernism in Sweden. We shall attempt to cast light on various aspects of Modernism – from the aesthetic avant-garde to practical social projects – by juxtaposing more or less visionary forms of expression not only with architectural reality and objects intended for practical everyday use, but also with graphic form and photography.

Modernism in architecture and design is part of the Swedish welfare state, 'the people's home.' The Functionalists had the welfare society – that everyday utopia – in mind in their projects. This was controversial even within the Social Democratic movement, since many people interpreted lack of ornament as a sign of poverty rather than of freedom and modernity. Both international influences and national characteristics can be found in Swedish Modernist architecture just as they can in the architecture of other countries. In Sweden architecture came to be distinguished by the democratic principle that everyone had an equal right to a decent environment, which encouraged a stylistic tendency towards the understated, restrained, provincial and 'average.' In other countries with different power-structures exclusive, original, poetic or monumental aspects of Modernism came to dominate.

Organization and planning; rational, sober and functional design; architecture – all these have their place in this story and their roots in the widespread belief in progress and development characteristic of interwar and postwar Sweden. They form part of a continuing legacy from Modernism and the modern movement which still determines the way Sweden is viewed by the rest of the world. Many contemporary artists identify reluctantly with this heritage though with nostalgia, as well as skepticism and irony.

Naturally the story doesn't end in 1960. It is still going on today, but around 1960 there was a considerable change in scale and temperature; this has already been thoroughly studied in other exhibitions and writings. The present book concentrates not only on the universal artwork of the period in question, but also on high Modernism as a central part of its general history, with glances at neighboring areas such as music and film.

Utopia and Reality is an interdisciplinary project which aims at presenting a nuanced picture of Modernism. Our purpose is to examine what emerges at the point where the various art forms meet – natural enough now that in Stockholm Moderna Museet and the Museum of Architecture share the same building. We would like to thank the Nationalmuseum of Sweden which has not only put a large number of items at our disposal but also made expert contributions to the exhibition in matters of form and design. We would also like to express our sincere gratitude to the Bard Graduate Center for providing an opportunity to show the exhibtion to an international audience in New York.

David Elliott
Director, Moderna Museet
July 2000

Bitte Nygren
Director, Swedish Museum of
Architecture

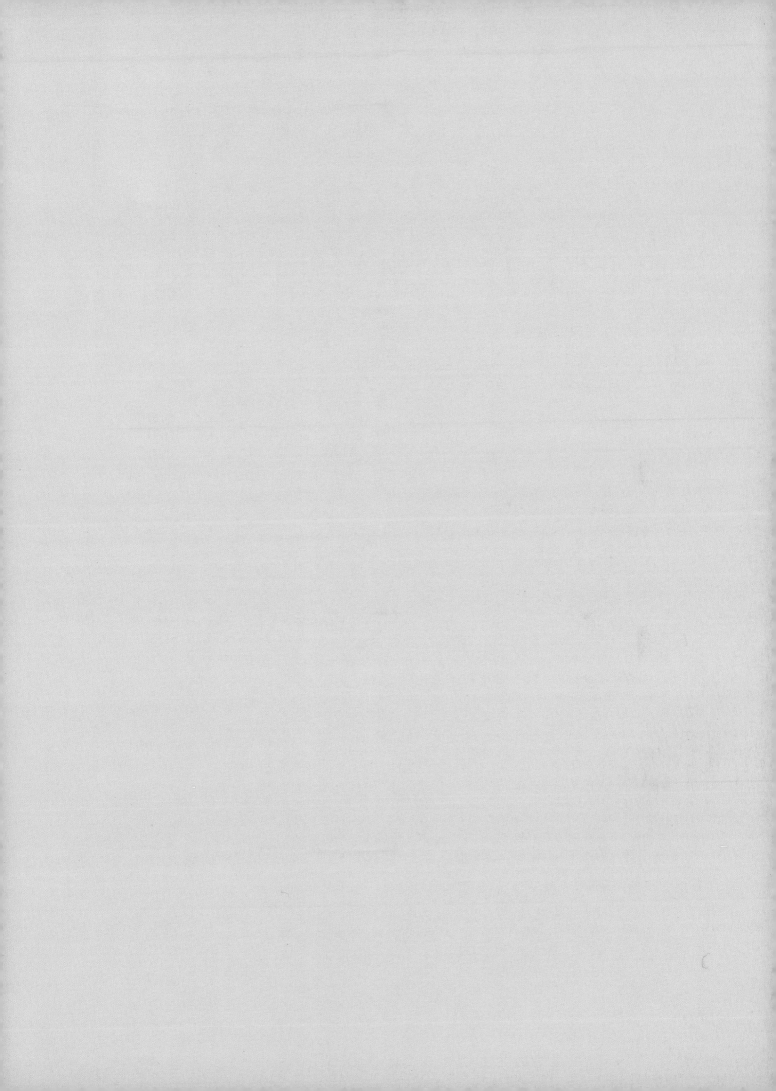

SVERKER SÖRLIN

PROPHETS AND DENIERS

The Idea of Modernity in Swedish Tradition

In the days before Modernism had become a movement, or had even begun to interpret itself as 'modern,' Friedrich Nietzsche published his book about the uses and drawbacks of history, *Vom Nützen und Nachteil der Historie für das Leben*. The year was 1874. Nietzsche drew a fundamental distinction between memory and existence. A person who lacks the ability to forget the past risks losing both the ability to act and the ability to experience joy and satisfaction. Memory is an enslaving *yoke*. What is characteristic of man, however, Nietzsche says, is his ability, in his brightest and happiest moments, to be completely unconscious of the past, to experience the world 'a-historically.'

It is hard to imagine a more modernistic assertion: the complete elimination of what has been, where all that exists is a pure and unsullied now. On the other hand, without history we should not be human beings, but cattle. We cannot erase history. What we need to do instead, suggested Nietzsche, is to make history serve life, the present. To act, to show courage and go-ahead spirit.

It may be apt to recall these words at a period when history has fallen on hard times. It is being forgotten and marginalized, as in the school timetable, or turned into a best-selling entertainment industry, or – perhaps the most alarming and, alas, persistent tendency – converted into a gallery of clichés that is supposed to function as an *ersatz* replacement for the functioning and practical everyday environment that people have a right to desire, but by no means always attain. During the latter decades of the twentieth century retrospection and nostalgia, history as packaging in the form of picturesque quarters and the fashionable remolding of harbor and factory districts, became an increasingly common way of making money out of urbanization and the human need for a tolerable environment.

In a way that was probably unforeseen, the postmodern currents of the late twentieth century came to form an ideological support for this spatial remolding. The homage paid to the fragment and the dismantling of the large narratives had their spatial counterpart in the

lack of an integrated and conceptual vision of urban construction, and perhaps also of social construction. During the 1980s an increasingly articulate and wide-ranging critique of the welfare state arose in Sweden, and by the end of the century the 'Swedish model' had in all important respects slid away out of time, become the past, without anything else that was livable and tangible taking its place. We were living after something familiar, but before what? The critique of the legacy of Modernism has, however, had its day. Perhaps in the future its high point will be considered to have been the competition that was held in the final year of the century to dismantle the symbolic heart of the functional and democratic social vision associated with Modernism, the urban center of Stockholm's city, Sergels Torg, an idea conceived exactly fifty years earlier.

It was the demise not only of a social model, but also of an aesthetic, of an attitude towards politics, history and national destiny. It is too soon to assess the consequences, though there is already a sense that the era we are entering is characterized less by national destinies and more by global interweavings and other shared links in regions, cities, professional and social groupings. From an age like the present, in which borders are crossed in encounters between the local and the much larger, the Öresund Bridge linking Sweden and Denmark has every chance of rising as a statement reaching far into the future; or at any rate as a gesture, the expression of a dream.

It is a long time now since the birth of that era of Modernism and social construction, so long that we are able to create for ourselves a picture of what happened, and of what life was like during the first sixty years of this century: between the time at the turn of the nineteenth and twentieth centuries when the era of the opening of the railways was not yet over, and the mid-century period that saw the conception and creation of Sergels Torg and the Hötorg high-rise blocks. It is a story of utopian dreams and belief in the future, but also one that involves a critique of modernity.

That critique did not follow any simple political lines. Classical critics of modernity existed on right and left, in south and north, among men and women, in all social classes, even though certain patterns may also be found there. Those on the side of modernization were most often people involved in business, usually together with the working class and its representatives. Among the skeptics were those who had their roots, and their livelihoods, in an agrarian society. To them, change was a threat.

Art, design and architecture also occupied this field of tension between modernity and tradition. The strides were enormous: from Jugendstil through Functionalism to the kind of experimental Modernism that was associated with the avant-garde poetry of the 1940s. The picture is complicated by the fact that those who took up cudgels for material modernization, of roads, factories, hospitals, schools and welfare, were by no means always those who walked the narrow ways of aesthetics. One man who managed to die just before the dawning of the new century, but who represented some of its most modernistic ideals – a faith in science and the bold exploitation of natural forces – also expressed his contempt for art that was non-representational. His name was Salomon August Andrée, the Icarus of the machine age, who in 1897 in vain tried to fly his balloon across the Arctic Sea; the balloon crashed and the crew of three perished, Andrée included. The men of the new age often lacked aesthetic foresight, and they frequently made mistakes. The art of the era took shape to the accompaniment of the constant noise of war and disaster, some of the worst in the history of mankind. We began to fly in earnest, and artists engaged with an aerial perspective. But we still flew too high.

The critique existed in the reality of the age. Only later, perhaps, has it become most clear, now that we can see the consequences: Minerva's owl flies at dusk. One image has been formulated by the author Jan Myrdal in his autobiographical book *Childhood* (1982). It is around 1930. Jan, son of the radical formists Alva and Gunnar Myrdal, is only a few years old. He is up early in the morning, he is alone. Through the large windows a pale light falls in across the shadows of the empty floor. He knows that he can go sliding across the floor, but ought not to. On the cold floor there are some chairs. They are also cold. And he

remembers once being scolded for peeing on them. The chairs had been designed by the architect Sven Markelius, a leading modernist architect.

The scene invoked by this memory may seem unusual, but perhaps it reflects the problematic aspect of the functionalist version of Modernism, which became something of an official Swedish design doctrine and an instrument of social planning. This was not, of course, something that Markelius invented, but it is possible that in his work Functionalism acquired a more semi-official aspect than it did in that of many other Swedish architects, partly because of his friendship with the Myrdals, and the many public commissions he was given.

What we need to explain, therefore, is how it came about that Sweden acquired a Sven Markelius, that Modernism grew so strong in there, not merely as artistic avant-gardism, but as a social project. We must also ask ourselves if it has stood alone, or if it has been called into question.

MODERNITY AND CRITICISM

What do we mean when we speak of modernity? The very word 'modern' presupposes an antithesis, something old and classical out of which the modern was able to grow. The term was established in this sense in the Renaissance. Words like 'modernization' and 'modernity' came later, but were fully established during the eighteenth century. The concepts were particularly applied to the style and appearance of dress and buildings. In 1748 Horace Walpole wrote that 'the rest of the house is all modernized.' At this time 'modern' was also a thoroughly negative concept. Not until the nineteenth century did the connotations became more positive. 'Gunpowder and printing tended to modernize the world,' wrote William M. Thackeray.

Even as a concept, modernity is apt to give rise to clashes of opinion. That is what happened in Sweden during the course of the nineteenth century. Even early figures, such as the Geatish poets or C.J.L. Almqvist's 'Porridge-Eaters' Society,' or Carl Anton Wetter-bergh with his village utopias, were capable of nursing a desire for some form of retro-spective and self-sufficient model of society.

Some of the participants in this early debate about modernity were very articulate. Their critique could not target the industrial urban monsters and traffic congestion that would only come into being later, but it could deal with issues like self-determination and popular power. And it could deal with the perils of commerce. Carl Adolph Agardh, the bishop and botanist, was, for example, critical of the foreign timber companies which, during the nineteenth century, began to buy up the Swedish forests. 'The viewing of estates as commodities' was the driving force in the expansion of the forests, he maintained. Instead, the people should be allowed to manage their own assets. In Agardh's warnings about 'cosmopolitan' theories and in his plea for a good and omniscient state authority one can recognize the post-romantic conservative. This is important, as an ideological dimension of precisely this kind is often concealed in attitudes towards modernization and modernity.

This was a dimension that appeared in a number of debates and major social issues at the turn of the nineteenth and twentieth century: the social question, the temperance question, the suffrage question, the woman question. The lines of conflict were not always clear-cut, but one way or another modernization was there as an underlying element. Typical of the differences of opinion was the debate about industrial development in Norrland in the far north of Sweden. In this debate, often called 'the Norrland question,' there was a faction that reached back to precisely the arguments that Agardh had raised half a century earlier. The forests were a national capital asset that should be put to steady use for local needs. On the other side stood the opinion of market liberals, mainly supported by the timber industry. To introduce legislation concerning the purchase of forest lands would be to impede something the advocates of this position liked to call 'the law of development.' Just as had happened in the USA, Britain and Germany, and as was now happening in the colonies, natural resources must be put to beneficial use. There was

no turning back. This was how this fate-bound creed of modernity was expressed in 1911 by one of the industrialists' foremost spokesmen, the founder of the Swedish Confederation of Industry, the forestry company Modo's managing director Frans Kempe:

> Were Norrland a part of the United States, one would have reason to suppose that within a short space of time its mines would be known and worked, its waterfalls tamed, mighty industries would have blossomed, the population would have increased many fold, and the land would be criss-crossed by railways…

The interesting thing about this creed of modernity, with its affirmation of development, is that it was by no means confined to industrialists. The labor movement also embraced it, and if one is to try to understand why the Social Democrats and capitalism worked so well together, in spite of everything, one cannot ignore this basic community of values with regard to the direction of society's development. We find practically every Social Democrat ideologist sharing this attitude during the party's first decades. The critics – especially the radical ones – also paid attention to it. August Strindberg heaped abuse on the social democratic leader Hjalmar Branting and his 'industrial-collective-capital-society.'

THE PROPHET OF MODERNITY

The person who expressed the attitude more openly than anyone else was, however, not a politician but a writer and intellectual, Ludvig Nordström, one of the most devoted proponents of modernity in Sweden, with a great interest in aesthetics and architecture, and a far-reaching spokesman for the critique of ornamental aesthetics. It is no accident that it was he who, in imitation of Le Corbusier, enthusiastically pleaded for the demolition of Stockholm's Old Town.

For Lubbe, as he was called, collaboration was the basis of society. The division of labor in the modern world made people dependent on one another. In an agrarian economy people had been able to keep themselves to themselves, but now they had to unite. When Lubbe himself described the progress that was being made, he usually did so in concrete terms. He moved around Sweden on one reporting trip after another. It was a period when the Swedish Tourist Board was promoting churches and mountain pastures as travel destinations. But Lubbe's gaze was drawn to harbors and railways, power stations and pulp mills. He spoke of how 'Americanization and the machine spirit have been accepted as a fact.' Among the fishermen of the Gulf of Bothnia, who a few years earlier had been parsimonious and unwilling to adopt new technology, co-operatives now thrived, and the ladies drove around 'in automobile veils.' Lubbe hated sunsets and false colors; he often sounded like this:

> Grey! That is the modern color *par excellence*. And there are two things in the modern world we, who are living now, have grown up in that have concentrated our minds more powerfully than anything else: railway bridges and warships, and these two things are therefore also the most beautiful that a modern eye can see.

It is not easy to analyze what was Social Democratic about this. It involves the as-yet unresearched relationship between intellectuals and practical politics. What we can say is that Lubbe himself for many years carried a party card.

In fact, he created an entire philosophy of history from his Social Democratic preaching of modernity. The process of development had passed from the Christian state, through the aristocracy and the bourgeois state to the 'people's state,' history's highest stage. He put this subject into writing in a short article written in 1915, 'The Need For A New Swedish Patriotism,' originally a speech delivered to the Leksand Workers' Commune. The people's state was to be led by Social Democrats, whose proud historic task was to make Sweden a world leader, characterized by peaceful progress and social tranquillity.

THE HYGIENIC REVOLUTION

Lubbe was also interested in hygiene. *Dirty Sweden*, the 1938 radio documentary that marked the climax of his campaign, spotlighted lingering vestiges of squalor in a kind of journalistic

autopsy of a dying agrarian Sweden. Lubbe's guides were provincial doctors, who, like engineers, were precisely the sort of heroic experts that Swedish social construction required. Sanitation and better housing were recommended. The models existed in the new industrial localities: a mining town like Kiruna, the villa communities of the Bothnian coast. There modernity was to be found.

But Lubbe was not the only prophet of hygiene; an entire health movement developed, led by radical intellectuals and doctors. 'Foträta' shoes, 'reform clothing' and well-aired housing became the measure of progress. The movement's roots go back to the enlightenment tradition; scientific reason was to conquer an unhealthy popular mentality. Reason was reinforced by reading, and it is hardly an accident that there are so many examples of combined bathhouses and libraries in Sweden, as well as joint bathhouses and community centers.

This was not, however, the only sort of hygiene. The entire nation could be improved. Hjalmar Branting himself took part, in the proposal of the 1920s for the establishment of an Institute of Racial Hygiene, one of the directors of which was Gunnar Dahlberg, a friend of Alva and Gunnar Myrdal. Their pamphlet *Crisis In The Population Question* (1934) contained a plea for racial hygiene. Modern society increased the 'demands for quality' on human beings, they wrote. And they continued:

> The top priority is, of course, the radical elimination of individuals who are in a high degree unfit to live, and this can be achieved by means of sterilization…
>
> In this way it should be possible to root out all kinds of physical and psychological inferiority in the population, including mental deficiency and mental illness, physical diseases and poor character disposition.

This faith in technology, experts and, in general, the possibility of intervening in people's lives with the aid of a cold and dispassionate reason can nowadays seem both naive and frightening. Sterilization, birth control and other attempts to manage those who are 'unfit to live' represent the shadow side of the welfare and social state. How could this have come to pass? Nothing should be swept under the carpet; new research has shown that this manifestation of modernity took place openly, and the doctors and politicians involved were perfectly aware of what they were doing. There was a blind faith in modernity that in retrospect looks cynical and heartless. At the same time, one should not forget that this was an era when technological development had not yet experienced any great setbacks, even though the signs had begun to be dimly visible: the poison gases of the First World War came from the same laboratories that produced life-promoting fertilizers. But environmental pollution was not yet an expression in common use, and atomic bombs were unknown, while genetic manipulation was usually confined to innocent experiments with cereal types and fruit flies. In the 1930s the cruelties of Nazism had not been completely carried through and were not directly linked to a faith in modernity, though this also existed in Germany. Many people saw the promise of the techniques and instruments of modernity, but not their drawbacks.

In spite of the signs of trouble on the horizon – clear in retrospect – it was easy to be enthusiastic. In 1932, in an article in the radical cultural journal *Spektrum*, Gunnar Myrdal expressed the opinion that traditional ideologies were passé. The new ideology was classless and universal, and its name was 'prophylactic social politics.' It was best practiced by experts.

> This new social political ideology contains within it strong radical and to a certain extent revolutionary possibilities. It is intellectual and coolly rationalistic, whereas the old one, which still rules, was rather sentimental…It is to a large extent free of the brakes placed on ideas by liberalism…it is 'objective'. Its romanticism is that of the engineer.

With the architect Uno Åhrén he wrote: 'Put an architect to work on the housing question, his political hue is not so important. An economist, and we solve the unemployment problem. International economic planning is not a slogan but a scientific conclusion. The rationality of science stands, in short, on the side of the functionalists.'

Social Democracy was not the only movement that nursed this faith in enlightenment.

It was, however, a faith that found it easy to put down roots there. It aimed, after all, to change the wretched and dirty society that hid the good life behind tuberculosis germs and dusty orders of merit.

THE RATIONALIZATION DEBATE

The affirmation of technology and industry could not, of course, take place in a vacuum. It was obvious that there were harmful features in the factory system. This was not perhaps so noticeable while factories were still characterized by the loving and detailed routines of handcraft. It was, however, soon apparent, particularly in America, that it was possible to rationalize work by means of time and motion studies, conveyor belts and Frederick Taylor's 'scientific labor management,' known as Taylorism. Was this a good thing? William Morris, the British socialist and artist, had criticized rationalization as merely wanting to squeeze costs and yield higher profits. The only good kind of rationalization was one that made work easier and more meaningful *for the worker*. Criticism of this kind also occurred in Sweden. According to the typographers' journal *Grafia* in 1913, 'The Taylor system is an infernal method of labor invented by capitalists and their helpers in the engineering trade.'

There were, however, also positive voices. A young publicist by the name of Nils Jönsson, who had studied at Brunnsvik, the labor movement's oldest college of adult education, was of the opinion that Taylor's system would be labor-saving and raise production. Nils Jönsson was later to become famous under the name of Karleby, and to argue for a more pragmatic socialism that consisted less of high-flown ideals and more of measures geared towards production.

MAKING THE CAKE LARGER

In 1920 the Social Democrats formed a minority government, making it possible to confront the problem of power. And gradually an increasingly cautious attitude was taken towards the demands for socialization. However, and this was important, the party did not give up its faith in progress and development. It was rather a shift of emphasis: from the ideal of the enlightened citizen to the defense of material progress.

Numerous documents from the early 1920s point in this direction. One of the most characteristic is a speech given by Gustav Möller in 1920. In it, Möller says that socialism cannot simply mean that exploitation has been stopped, it must also 'increase the general prosperity.' He continued:

> The machinery [of production] must be employed in such a way that a greater yield can be achieved than the one that the capitalists were able to take from it…It is rational organization, the creation of this higher form of our production, that is the higher aim of the socialization process.

The labor movement could not play Robin Hood, taking from the rich and giving to the poor. The whole cake must become larger. At the same time, this was an argument for gradual change – for development, not revolution. A socialization of everything at once would simply mean that society would 'fall to pieces in our hands,' said Möller.

Here the Social Democratic faith in the idea of development is formulated more clearly than perhaps anywhere else. Gustav Möller's reflection may appear trivial, but in my opinion it is the result of a profound reinterpretation of the meaning of Socialism. What Möller does is to give the idea of development a higher priority than socialization. Socialism is not rejected, quite the contrary, but it becomes, as it were, the subordinate concept.

CRITICS OF MODERNITY

Modernization was not a self-evident blessing. Early industrialism could equally well be interpreted as a reckless Moloch. People were forced into the towns, where they fell ill and were seized by rootlessness and despair; luxury, immorality and speculative commerce were rife. The division of labor created alienation in work.

The public figures who launched this critique of civilization belonged mainly to the conservative camp, but even the most radical took it up. One impassioned preacher of the

gospel of the countryside was the first rector of the adult education college at Brunnsvik, Karl-Erik Forsslund. He wanted to unite poetry with astronomy and handcraft with athletics, and in springtime he assembled his pupils for the neo-pagan rite of sun and soil. Forsslund was in his own way an early environmentalist, an embracer of trees and maypoles, and a cultural purist: he was opposed to hotels, snuff and hydroelectric power. His preferred dances were the waltz and the polka, 'not negro capers, idiotic South American pirouettes, or Parisian Apache abominations.'

But there were many others: Carl Lindhagen, Fabian Månsson, Kata Dalström, Fredrik Ström. Fabian Månsson, the agrarian socialist from the Blekinge archipelago, felt a warm sympathy for farmers, especially the small ones. In words that were sometimes reminiscent of those used by more militaristic critics he spoke of farmers as 'that great reservoir from which new, healthy blood is pumped into our centers of industry... [they] are the solid protection against which the waves of reaction and oppression are powerless.' The ideas of the critics of modernity might diverge on many points, but they were united in their skepticism about large-scale production and the cult of the machine. They placed more faith in small farming than in agricultural collectives, and they preferred manual production to the conveyor belt. Socialist man was only possible within a manageable context.

In 1911 the critics of civilization formed a leftist faction within the Social Democrats that gradually became the Left Party, formed in 1917. It is, however, significant that very few joined the Communist Party after the split of 1921. Bolshevism in Russia worshipped technology to a greater degree than was the case with any political movement in Sweden. At New Year 1919, the Mayor of Stockholm, Carl Lindhagen, was granted a few minutes' audience with the impatient Lenin; he was disappointed. From a party-political point of view, Red–Green radicalism became homeless. Between faith in technological development and the pastoral ideal there was an ancient tension that lived on far into the century that has just passed.

The same critical attitude towards modernity is found in both the conservative and – though the term is inadequate – the populist camp. Viktor Vallberg, an eccentric chapel preacher in Risbäck, on the Lapland border with Norway, wrote a pamphlet with the title *Front To The Right And The Left* (1908), in which he launched into a homage to China, with its strong family unity and fair distribution of land. Industry was risky, bureaucracy was parasitical, companies and trusts a threat to the small farmer.

An ideologically abstruse but interesting figure is Per Jönsson Rösiö, one of those who inspired much of the popular critique of civilization that flourished after the turn of the century. With powerful rhetoric he launched his racial mysticism and vitalism and campaigned furiously against modernity and coffee-house culture. Radical intellectuals and politicians testified to Rösiö's importance, among them: Ture Nerman, Lindhagen, Per-Edvin Sköld, Anders Örne. Rösiö's distrust of the cities knew no bounds, and trade was sheer crookery. Correctly cared for, the Swedish soil could support 150 million people, he announced in a patriotic speech at Mösseberg in 1907.

MODERNITY IN LITERATURE

This ambivalence about modernity, which divided parties and ideologies, was also present among artists and poets. The theme has been dealt with in a number of studies – for example Kjell Espmark's *Artur Lundkvist, Life-Worshipper* (1964) and Martin Kylhammar's study of the authors Verner von Heidenstam's and August Strindberg's view of technology (1985). As yet, however, there is no complete review of the subject.

The ambivalence may be seen clearly in Sten Selander, who was both widely read and influential in his own day. His name has come to be associated with the so-called 'incomprehensibility' debate of the 1940s, where he fell out of step with the age through his inability to appreciate the innovation in the poetry of Erik Lindegren and Gunnar Ekelöf. Though few people recall it today Sten Selander had a special place in the Stockholm Exhibition of 1930, as he was invited to write the festive cantata, performed by the 'Swedes'

male choir from a rooftop at Bengtas Lund. Selander earned this honorable commission by writing poetry during the second half of the 1920s in which he treated the city as a symphony, as, for better or worse, the embodiment of plurality, the song of the collective and the arena of the individual: 'I am just one among the many thousands / who build the city day by day anew, / while hours like hammer blows in blue / from bell-towers ring above the houses,' we read in *The City And Other Poems* (1926). The same idea could be found in the work of more determined Modernists. The most pregnant statement came from Artur Lundkvist: 'Cannot the relationship value of the asphalt street and the crane be just as great as that of a field of wood anemones or an old plank?'

The city was 'a great poem only waiting for its bard,' Selander wrote in a program note in 1930 that became his ticket to the commission for the Stockholm Exhibition. The organizers also knew that they were getting a poet who at the same time espoused a traditional kind of poetry; this was to be no Arnold Ljungdal, with his appeals for revolution, or an Artur Lundkvist singing the praises of sensuality in extreme tones.

Nor was Selander, it turned out, an especially loyal Functionalist. He soon began to have doubts, and when Markelius, Uno Åhrén and the others published their manifesto *accept* (1931) Selander felt called on to intervene in the debate, which he did both on the radio and in *Dagens Nyheter*, where he still wrote at the time; later he was to become *Svenska Dagbladet*'s leading critic. He collected his journalism in a book entitled *The 'Modern'* (1931), where, rather typically, he put the word itself in quotation marks. Selander made an assault on technology and machine civilization. Technological culture engendered a senseless pursuit of novelty and was unhealthily obsessed with quantities – the sale of more and more goods in order to satisfy imaginary needs, fanned by the grotesque symbol-language of the age, more primitive than that of the cave paintings: publicity – 'every billboard and advertisement is proof of the superfluous nature of what is being advertised.' The value of human beings was judged by 'the figures in the rate-payers' directory.' Everything was aimed at empty activities and outlets for the instincts: sport, motoring, dancing, sexuality, stock-market speculation, popular music – 'ever increasing quantity, ever heightening speed, ever new records'; 'men tear one another to pieces like wild beasts in the struggle for money and women'; we were acquiring 'disintegrated bodies and suffocated souls.'

The inspiration for this protest came from philosophers like Ortega y Gasset and, above all, from the American sociologist and student of Thorstein Veblen, Stuart Chase. And their argument was not simply an emotional rejection of all that was new; it contained several subtle ideas. One concept that Selander took from Stuart Chase was 'technical fragility': a systematic society became increasingly vulnerable; it was enough for a single technical component to break down for the whole system to fall apart. Another idea concerned overproduction. Advertising and the absurd competition between the producers were inextricably connected with the fact that technology created an inevitable excess of goods, and the struggle on the world market this led to might sooner or later result in war, if there was not a return to a national small and home industry.

Another factor was unemployment, which became impossible to do without. The same factory just north of Sundsvall which Ludvig Nordström had seen and of which he had sung the praises was also visited, at the beginning of the 1930s, by Selander, who experienced despair at the sight of the clean, silent and empty factory building, a frightening pagan cathedral, proof of machine culture's striving 'to make man superfluous.' Another observation concerned the squandering of resources; in a manner that recalls the debate of the early 1970s about the Club of Rome's report *Limits of Growth* (1972), Selander talked of how minerals, forest and oil would sooner or later run out, probably within a generation. In the usual manner of civilization critics he points to agriculture as the superior form of livelihood, as in agriculture something is always left behind; people live on the interest from nature's capital and increase the earth's returns with culture. Industrial technology merely drains and empties.

These ideas circulated in the intellectual debate. From Olaf Stapledon's negative view of the future, *Last And First Men,* Selander took the idea that the struggle for diminishing natural resources would lead to global war; with striking frequency Selander talks of how man would wipe himself out within a few days by means of new weapons of destruction such as bacteriological poisons. Behind the pessimism lay a historical–philosophical reflection which posited the idea that civilization would inevitably undermine the conditions for its own existence and enter on a period of barbaric disintegration. Barbarism would then reign for 'several hundred thousand years' until a new cultural superstructure could begin to be erected – and so on, in an eternal cyclic repetition.

It is especially interesting that this civilization-critical pessimism should come from a person who only a short time before had had quite a different interpretation of civilization. Just like Ludvig Nordström, Selander had pointed out how technology produced solidarity and fellowship in work, and how the city became a possible way of life. In the course of the 1930s, Selander drew precisely the opposite conclusion. Where Nordström had praised factories, warships and railway bridges, Sten Selander moved further and further into high-flown nature-worship. In 1936 he became chairman of the Swedish Natural Protection League and thereby sought actively to prevent the *nemesis naturalis* he was convinced must come sooner or later, if deluded mankind did not turn over a new leaf. When Lubbe – and later in his wake the *acceptera* group – talked of the 'A-Europe' of the cities, Selander agreed with them to a large extent, until he perceived that it was in backward and rural 'B-Europe' that the eternal values were to be found. It was also as nature poet, biological researcher and essayist that Selander was to reach full maturity as an author, and his enduring major work remains *The Living Landscape In Sweden* (1955). It is a vast natural history essay that is poetic without being poetry. It begins with the bedrock, the sea and the lakes, and continues with those types of nature where man has had an influence. The finale deals with the cultivated landscape. In contrast to homages to Swedish nature of earlier decades, however, many of them written by Selander himself, a minor note also sounded here. There was a threat to things that were loved. The environmental issue, not yet formulated with this name, had begun to cast its projected shadow over the value-landscape of modernity; within a few more decades it would start to influence the political agenda.

Selander was a representative of the values of a conservative humanism that had a hard time in party politics but was unquestionably one of the fundamental attitudes towards modernity. Other poets, who occupied quite different places in the political spectrum, sometimes shared the values, or some of them. In the poetry he wrote during the 1930s Harry Martinson was often critical of technology. Gunnar Mascoll Silfverstolpe lamented the closure of small farms. Elin Wägner, Elisabet Tamm and others at the Women's Civic College at Fogelstad expressed apprehensions about technological civilization and wanted *Peace With The Earth,* the title of their 1941 pamphlet. So did essayists and nature writers like Carl Fries – head of Skansen open air museum at the time of the Stockholm Exhibition – Mårten Sjöbeck and Nils Dahlbeck. In popular culture we find a sentimental portrayal of the countryside in the films that starred Edvard Persson and in the work of variety artistes like Skånska Lasse. People were forced into the towns, but in their souls a pang of longing for the old way of life remained. Side by side with this, a politically agrarian conservative opinion took shape, which sought, through enthusiasm for the peasantry and old-fashioned Swedishness, to stop the transformation of society, or at any rate to steer it along new paths.

MODERNITY AND IDYLL

At the same time, we should remember two things. Firstly, this was by no means the only possible attitude, or even the most common one, quite the contrary. In Sweden modernity has been the rule and the idyll its counterpart; indeed, so much a part of the welfare state did the modern become that it, too, in its freedom from conflict, was sometimes called an 'idyll,' as the political scientist and liberal newspaper editor Herbert Tingsten did when he talked about the 'death of ideologies' and about social progress beyond the slogans of the class struggle.

The deepest part of the current was occupied by machine romantics like Ludvig Nordström, Artur Lundkvist and those Social Democratic court poets and champions of Modernism who formulated their homage to progress and growth. But around them a whole society was taking shape, composed of public officials, bureaucrats, professionals and experts, ready to adjust the lives of citizens according to the latest doctrines of expert knowledge.

Secondly, we should remember that the critics of modernity also dreamed of a time when technological development would have reached an even higher stage. Harry Martinson, later a Nobel laureate of lietrature (1973), sometimes said that the machines of the future would be quite different, 'simple and quiet, silent servants that do not attract much attention but make life better for all,' as Artur Lundkvist put it. Strindberg had once paid homage to the flying autocycle. Martinson praised the bicycle, and the helicopter: 'I think it will wear out the world much less than the car. It will be the bicycle of the air. It will make it possible for the individual to be airminded in an individual, a personal way.' Even Artur Lundkvist sometimes associated the cult of the machine with a kind of pastoral idyll, or with ideas of another possible life-form. When on his Freud-impregnated tour of Africa in *Negro Coast* of 1933 he sees the black engineer lovingly smear the locomotive with oily fingers, it is the union of the organic and the mechanical he witnesses, a synthesis on a higher plane of civilization in the depths of a conti-nent that has maintained its contact with the healthy basis of the instincts.

These visions did not lose their hold, and during the latter part of the twentieth century they became topical again in the rhetoric concerning so-called 'post-industrial society.' Beyond dirty industrialism waited an electronic, digital silent epoch where the great values were produced in beautiful environments, by beautiful people, surrounded by palms, pools and works of art purchased at the auction house of Bukowski. There was creativity, there productivity cohabited with the plastic card. The business landscape of the future became more or less identical with the recreation idyll. The efficient person was not a heavy-footed Tungus, or a taciturn slave of the machine. He was a free-moving, extrovert and life-affirming person, with an appetite for life and this world. A well-behaved hedonist, though Artur Lundkvist's organic machine eroticism had long been overlaid with politically incor-rect associations and banished to the rusty margins of modernity.

In this rhetoric a traditional technological ideal of progress and modernity was combined with a vision of a peaceful idyll. Thus, pastoral does not have to be backward-looking – it can be aimed forward. As Harry Martinson wrote in 1939: 'We will live more freely in the future than we do now, with greater mobility, more sensibly and essentially. More meditation, together with more movement in the world space.' Prophetic words.

REFERENCES
Gunnar Asplund et al., *acceptera (accept)*, 1931.
Christine M. Boyer, *The City of Collective Memory: Its Historical Imagery and Architectural Entertainments*, 1996.
Lena Eskilsson, *Drömmen om kamratsamhället: Kvinnliga medborgarskolan på Fogelstad 1925–1935* (The Dream of the Companionate Society: The Women's Civic College at Fogelstad 1925–1935), 1991.
Kjell Espmark, *Livsdyrkaren Artur Lundkvist: Studier i hans lyrik till och med Vit man* (Artur Lundkvist, Life-Worshipper: Studies in His Poetry up to and Including 'White Man'), 1964.
Otto Fagerstedt and Sverker Sörlin, *Framtidsvittnet: Ludvig Nordström och drömmen om Sverige* (Witness Of The Future: Ludvig Nordström and the Dream of Sweden), 1987.
Martin Kylhammar: *Maskin och idyll: Teknik och pastorala ideal hos Strindberg och Heidenstam* (Machine And Idyll: Technology and Pastoral Ideals in Strindberg and Heidenstam), 1985.
Martin Kylhammar: *Sten Selander – en borgerlig intellektuell* (Sten Selander – A Bourgeois Intellectual), 1990.⁰

Martin Kylhammar: *Frejdiga framstegsmän och visionära världsmedborgare: Epokskiftet 20-tal-30-tal genom fem unga och Lubbe Nordström* (Bold Progressives and Visionary World Citizens: The Turn of the 20s and 30s through Five Young Men And Lubbe Nordström), 1994.
Alva and Gunnar Myrdal, *Kris i befolkningsfrågan* (Crisis in the Population Question), 1934.
Friedrich Nietzsche: *Vom Nützen und Nachteil der Historie für das Leben*, 1874.
Eva Rudberg: *Sven Markelius, arkitekt* (Sven Markelius, Architect), 1989.
'Socialdemokratin och utvecklingstanken,' *Socialdemokraternas jubileumskonferens 1989* ('Social Democracy And The Idea Of Development,' Social Democratic Jubilee Conference 1989), 1989.
Sverker Sörlin: *Framtidslandet: Debatten om Norrland och naturresurserna under det industriella genombrottet* (The Land of the Future: The Debate About Norrland and Natural Resources during the Industrial Breakthrough),1988.
Sverker Sörlin, 'The Modern Vision And Its Critics,' in *Vision and Reality: Social Aspects of Architecture and Urban Planning in the Modern Movement*, 1999.

PETER CORNELL

SCRIPTS

The Artist's Role in Focus

In the theory of twentieth century art the focus has shifted from the artist to the work, and onward, to the viewer; from biography to structural analysis to the study of reception. At first nearly all attention was directed towards the person of the work's creator. I should like here to return to the question of the artist, though in a slightly different light from before. The biographical genre in Sweden was carefully built at around the turn of the last century with the long series of biographies published by the Swedish Public Art Association (SAK), which can trace its lineage back to the Renaissance, and to Giorgio Vasari's *Lives of Artists*. The SAK series has followed, mirrored but also colored the picture of twentieth century Swedish art. Who, then, is the Artist in Swedish Modernism? Or is there only a collection of individual artists?

Every artist's biography describes a unique life and destiny, but if several biographies are placed side by side, certain patterns that cross the boundaries of the individual stand out. An artist's biography is a genre which, though sometimes a scholarly one, is even more so a literary one that is guided by its own laws, rules and traditions. In a study of biography as a genre reflecting the sociology of art, Ernst Kris has examined recurrent patterns of this kind, which he calls formulae. There is, for example, often an episode concerning the way in which a divinely gifted artistic talent is discovered by someone who happens to be passing, almost by chance: the peasant boy Giotto is discovered by Cimabue, when like an infant prodigy he draws his father's cattle in the sand; the same event recurs in the discovery of the eighteenth-century artist Messerschmidt, who carves small wooden sculptures of the sheep he tends as a boy. And in our own time a reporter on the *Village Voice* discovers, as if by chance, a miraculous gift in the untrained African-American adolescent Basquiat, who is then crowned with honor by being admitted to the circle around Andy Warhol, though on closer examination it turns out that the wild Basquiat really came from a well-to-do family, and his parents – especially his mother – provided early encouragement of his interest in art: by the age of six he was already a regular visitor to the Brooklyn Museum. And in Basquiat's apparently spontaneous scrawling a conscious strategy is glimpsed,

3. In this photograph from Bengt O. Österblom's sketchbook his friend Björn Rubinstein reads cosmic poetry, wearing Österblom's Radio Tower of 1925. [no.80]

Svårt att säga något
i dessa dagar då
nazismen krossats. Ar-
tikeln kom inte fram
på recensionsbordet
bland de andra
(Orne Wedel skrev han en
han var "pervers"!
Ty jag – han är nog
pervers själv, den
äckliga masskribenten.
Jan Lindström tycker att
han är "sympatisk".)

Artikeln verkar ansträngd
på något sätt. Han
går inte med på
varken psykoanalys
eller abstrakt, men
tycker ändå att
konsekvenserna av
dessa innehållsform.
En särsam logik!

"Utsökta färgackord
och vacker linjespel!
i sin egenart inte kan
lämna någon oberörd
"Sträng komposition"
Konstnären har något att
att säga oss om människan oss att
känna..."

Kanske var det
allvarligt menat...

Kanske var det bara
för att jag pratade.
Men vänligt med
honom om inte
hoppade undan som
för en personkult
då han presenterade
mig som [representant]
för Dagsposten.

Det vet man aldrig!

**Paris, rue
Cels 24, 1925**

"RADIOTORN I"

Pappskulptur,
svart nedtill, silver
upptill. Paris 1925

Min bäste vän i
Paris, Björn
Rubinstein,
med "tornet"
skämtsamt som
hatt läsande
kosmisk lyrik.
Numera psykoana-
lytiska dr Benny
Rubinstein, Park
Aveny, New York

"Sovjet-realismen".
Och nu: Hitler-realism!

((Vår GUGGENHEIM
))

for with suspicious frequency he managed to place his graffiti in much-publicized private views held in SoHo and the East Village. While this may possibly undermine the legend, it does not diminish Basquiat's artistic ability.

Kris writes: 'One receives the impression that the actual behavior of some of the famous artists of the time has been used as a prototype; it has been frozen in a formula that is passed on to future generations.'[1] To this extent, an artist's biography may be said to be a kind of dramatic script. It formulates a general idea of the artist and it is often this clichéd idea that the artist encounters while still a child, forming his initial fantasy of the Artist: 'I want to be someone like that!' However, after the suspicion cast by Michel Foucault on such seemingly eternal and naturally given grandiose concepts as the Man of Humanism, must not the Artist, too, be judged as a social construction, conditioned by a certain time and culture? Or are there, in spite of everything, certain qualities to be found in him that are fragments of a more overarching and universal identity, an artistic nature?

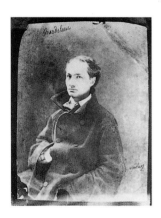

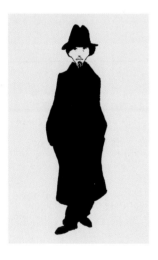

The problem is reminiscent of the feminist discussion between uterine feminists and those who view sex as a cultural construction – as Simone de Beauvoir put it: 'One is not born a woman, one becomes one.' And the Artist – is he born an artist or does he become one? In the group of formulae contained in the biography of artists, the first alternative has dominated the second. But the distinction turns out to be a tricky one, as the artists are assigned several given roles. They exist like a kind of projection of society's expectations before the future artist even enters the scene.

The dramaturgical perspective of modern sociology has been formulated in various role theories, by Erving Goffman,[2] among others. They see society as a theater in which everyone plays different roles: gender roles, professional roles, family roles. The individual learns to manage his roles and communicates by means of them, as though they were a system of signs in a shared language. They are silent agreements and conventions that can function as a straitjacket but may also provide a kind of freedom for those who learn to master them. This role-playing does not necessarily involve determinism, for one need not follow one's role and identify with it exactly: one can play it to the full without omitting anything, but also use it as a mask, or take time off from it now and then, in a sense of freedom that is indicated by the Greek word 'ecstasy,' to step out of.

Can artistic talent exist before and outside these roles? Jean Dubuffet was of the view that the avant-garde art of the established art world was mere trickery and superficial role-playing. True art existed outside the establishment, among the outcast, deviant, untrained, maladapted and different. These autodidacts created an art that was undisturbed by culture, in a raw state, an 'Art Brut' that rose directly and abruptly from the wellsprings of art. In the course of his research in the archives of mental hospitals, Dubuffet discovered a number of overlooked artistic talents which he documented in his Lausanne collection. It remains a moot question, however, whether the biographies of these supposedly role-less artists are a construction that follows the script remarkably well according to formulae of precisely the kind that Ernst Kris observed.

Yes, the artists of Art Brut often appear like extreme cases of the romantic artist's role that flourished in pioneering, heroic Modernism: the role of the outsider. Early Modernism pursued its growth in conflict with the public and was fringed by rejections, scandals and lawsuits. Charles Baudelaire was instantly prosecuted for *Les Fleurs du mal* (1857) and Gustave Courbet and the Impressionists were rejected time after time by the Salon. These artists were pushed away by the bourgeois public as opponents and

4, 5. The bohemian role, personified by Charles Baudelaire (1821–67) in a photograph by Nadar. Below, the Swedish artist Ivar Arosenius captured as a *Living Model*, 1904

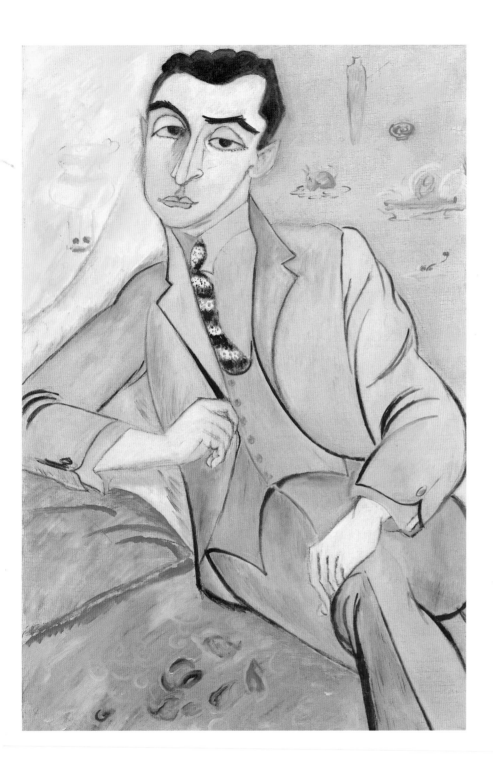

6. Sigrid Hjertén
Portrait of Isaac Grünewald, 1918.
Private collection

breakers of the rules, and they therefore felt an affinity with other deviants: maladapted children, the lumpen proletariat, the mentally ill, the 'savages' of Europe's colonies – and the gypsies, whose French name *bohème* also became the designation of a new, rebellious cast of artists and outsiders; a name that not only indicates the status of outsider but also lights a romantic glow.

The impoverished lifestyle of bohemianism was initially determined by material necessity, but soon developed into a role with codified attributes and a uniform dress. Ivar Arosenius is the archetypal Swedish bohemian, and he plays his role with great refinement: his characteristic conical hat is not a cast-off that he happened to find in a junk shop, but a brand new one on which he had spent a great deal of money and had taken pains to trim and knock out of shape like the original in Henri Murger's novel *Scenes from Bohemian Life*. The bohemian wants to be in every respect the philistine's opposite, but this does not obscure the fact that each is mutually dependent on the other – culturally, financially, socially – and in a complicated drama each elucidates the other's role. The bohemian acts on the philistine's stage. We are told, for example, of Arosenius at the restaurant of the Grand Hotel: 'Etiquette must have been less strict then than it is nowadays, for Ivar, who had neither collar nor tie, was never refused admittance to the most distinguished restaurant in this city. Through unusual channels we learned many years later that the hotel manager had given instructions that the "Bohemians" were to be treated well – for they drew the clientele! We sat there before an open curtain, facing a full and clearly very interested house.'[3]

The same theatrical role-playing appears in an anecdote about Isaac Grünewald's meeting with the Danish patron Tetzen-Lund. In a 1949 biography, J.-P. Hodin writes that Grünewald used to wear 'second-hand clothes and in a photograph from that time he looks like a living illustration from Murger's *Bohème*.' But before his meeting with the patron the young artist was uncertain of the rules of the game, and arrived smartly dressed in a suit and hat he had purchased on credit. In the course of the conversation the patron became more and more upset: '"You are a great disappointment to me, Mr Grünewald." Grünewald turned pale: "In what way have I sinned?" "You are well dressed, even well-groomed. You have a watch, and one that tells the right time. You cannot be a real artist!"'[4] Grünewald perceived his mistake and defended himself by asserting that the suit was not yet paid for and that the watch was a cheap imitation.

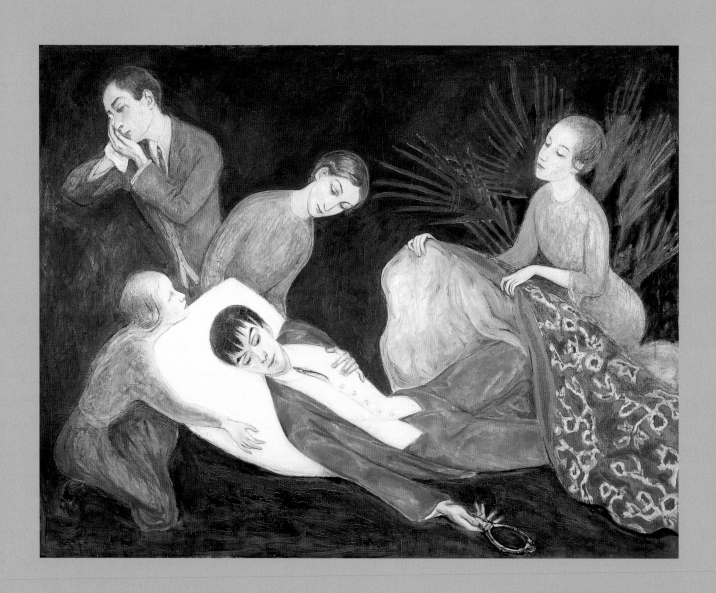

In reality, however, Grünewald wanted to dress fashionably, and so by gradual stages – the role demanded healthier finances – he acquired the elegance of a dandy; this is how he appears in several well-known paintings by Sigrid Hjertén (Fig. 6).

If the bohemian rebels against the bourgeois by mimicking the lumpen proletariat, the dandy stands out by adopting an extreme aristocratic bearing. A studied adherence to gentlemen's fashion becomes the symbol of his inner refinement and spiritual superiority. He views himself as a work of art, too sensitive for this materialistic and vulgar, mercenary world, which he will only reluctantly touch with his gloved hands. His art exists for its own sake, not in the service of usefulness. The dandy knows the details of fashion like a complicated syntax. The script itself was drafted by Baudelaire, who, it is related, dressed like a 'British Embassy secretary' (Fig. 4) In his essay *Le Peintre de la vie moderne* of 1860 the illustrator, flâneur, correspondent and artist Constantin Guys provides an incarnation of the dandy. Baudelaire's view is that the dandy aspires to make himself original, yet without quite overstepping the limits of propriety. Dandyism is about something more than an elegant mode of dress; it is nothing less than a kind of religion to which one consecrates one's life. The dandy moves about the world as a rebel and provocateur who is constantly surprising those around him but never, in his cool remoteness, being surprised himself. Like the setting sun he 'glows without heat, and is full of melancholy.' The decades around the turn of the last century teem with dandies, like Robert de Montesquiou, the model for both Marcel Proust's Charlus and Huysmans' Des Esseintes, Oscar Wilde and his Lord Henry in *The Picture of Dorian Gray*, the Belgian symbolist Fernand Khnopff, the Futurist Mayakovsky or the Dadaist Tristan Tzara. The unsurpassed prototype of Swedish dandyism is of course Nils Dardel, who painted portraits of Einar Jolin and Rolf de Maré, dandies from his own circle (Fig. 7). The role is played slightly less convincingly by the athletic artist Otte Sköld.

The dandy is infected with melancholy, a temperament that has long been associated with the role of the outsider and with artistic creation, a combination Erwin Panofsky, Fritz Saxl and Raymond Klibansky, historians of art and ideas have charted in their scholarly research.[5] The melancholic with black gall is an introverted brooder, influenced by the sad, heavy planet Saturn. We find his description in Albrecht Dürer's copper-engraving *Melancholia*, the artist's spiritual self-portrait, which the great modernist Swedish poet Gunnar Ekelöf, incidentally, had on his wall for several decades. Later writers and artists are usually, in Dürer's footsteps, portrayed leaning their heads in their hands as a sign to the initiate that they belong to the league of melancholics. In the crowded seventeenth-century treatise *The Anatomy of Melancholy* by the British author Robert Burton, melancholy appears as a seedbed of artistic creation and, as the final scene in the most destructive version of the romantic mythology of the artist, 'a shoehorn for suicide'.

Melancholy became a collective name for many different psychological disturbances and states of crisis, including those which are nowadays diagnosed as schizophrenia. This form of melancholy seems to have beset a good many artists in the late nineteenth century, among them Carl Fredrik Hill and Ernst Josephson, the two precursors of Swedish Modernism. Their work done in periods of illness has generated many questions about the connection between mental illness and artistic ability. The view has been expressed that in certain cases schizophrenia may stimulate artistic creation, as it gives access to the kind of thinking that Freud assigned to the primary process, where the creation of symbols takes place, and is controlled by the same mechanisms as the dream. The surrealists were convinced of the poetic potential of mental illness and in their collection *L'Immaculée Conception* of 1930, André Breton and Paul Eluard simulated five different kinds of madness in order to gain new metaphors and a new poetics. With the same motives, Salvador Dalí practiced a paranoid-critical method that became the cornerstone of his art, while at the Rodez mental clinic Antonin Artaud intensely identified himself with Van Gogh's critic in his book *Van Gogh Le Suicidé par la Société*. To speak of roles in this context may appear cynical, for real mental illness is something one does not act but suffers. But the context is complicated by the public's expectation of the artist's melancholy, and mental deviance is a living reality in the post-war period, too, spurred on by both Art Brut and Cobra, and thus forms one of the roles that is on offer. In twentieth-century Sweden mental crisis is interwoven with the image of several important artists, often expressionists like Sigrid Hjertén, Åke Göransson, Inge Schiöler, Erland Cullberg or Lena Cronqvist.

On the borders of the melancholics' circle one finds the psychopath to whom Norman Mailer refers, when in his essay *The White Negro* (1957) he draws the portrait of the hipster, a 'rebel without a cause'. The hipster's lifestyle resembles that of the black American, for both exist as outsiders in constant danger and in the proximity of violence. The hipster is physical, always on the go, addicted to jazz, marijuana, sex and ecstasy. He lives completely in the present and never defers enjoyment to an uncertain tomorrow. He develops a secret language that is based not on the meanings of individual words but on rhythms and intonations; like Marlon Brando in *The Wild One*, Mailer likens this meandering language to abstract hieroglyphics, and it is hard not to make the association with the painting of Jackson Pollock, an artist who in his violent way of life also embodied 'the white negro'. The hipster belongs to the Beat Generation, and of course we meet his ideal in that generation's mouthpiece, Jack Kerouac, and in Dean Moriarty, the hero of Kerouac's novel *On the Road*. The hipster has a generational comrade called the beatnik, who is his gentler, more intellectual and introverted brother. Both are bohemians and existentialists, though of an American vintage. In Sweden we can still glimpse the features of the hipster in Elis Eriksson, Lars Hillersberg and Kjartan Slettemark.

The roles I have mentioned are all different versions of an overarching outsider role. It had a continuous life within Modernism far into the 1950s, and it was confirmed as late as 1956 when the outsider became the subject of a much-noticed study by Colin Wilson which acquired the status of a cult book. And even in 1998 one could read a convincing plea for the outsider in Jan Håfström's essay *Room With a View. Notes On Åke Göransson* (Enrummare med utsikt. Anteckningar om Åke Göransson). Is the outsider an arbitrary sign? Does not outsider status have a deeper and more authentic connection with artistic ability? Only by placing himself at a point outside can the artist give a new perspective on the otherwise familiar – though of course this does not mean that everyone must follow Åke Göransson's formula.

As an outsider, the artist tests new and different languages and forms of life. To the accompaniment of privation, mockery and ridicule the artist devotes himself to the experiment that is to put him at the head and show the way into the future. In this way the artist imagines that he is entering society's advance guard, that small elite that goes out ahead of the main force, an 'avant garde'. From the outset this aggressive military term became a collective name for the twentieth century's innovative and experimental artists. It was the French utopian socialists before Marx who first began to use the term within the cultural sphere to designate an art that was at once artistically and politically radical – later the emphasis came to be placed on purely formal and aesthetic experiments.

The avant-garde goes on in advance but still adopts romantic attitudes and does not necessarily affirm modernity in social development. On the contrary, it is often critical of new technology and rapid industrialization and feels alienated in modern capitalist society. But the avant-garde also contains artists and movements that impatiently desired to put themselves at the service of modernity and progress: for example, the Futurists and Constructivists. After the great upheavals in Russia and Germany at the end of the second decade of the twentieth century, a new type of artist was born: the artist-engineer (Fig. 8). That role dominates in 1920s Russia, where El Lissitsky's portrait of Vladimir Tatlin at work on his tower or Varvara Stepanova's portrait of Alexander Rodchenko and other Constructivists define the new ideal. We also encounter it in the Bauhaus in a teacher like László Moholy-Nagy, who in photographs looks more like a factory foreman than a bohemian or dandy. The artist-engineer is distinguished by rationality and a scientific attitude that is stripped of romantic subjectivism, and in this respect Moholy-Nagy is exemplary: he was able to produce works of art over the telephone with the aid of a color chart, a sheet of cross-ruled paper and a list of geometric primary forms.

The artist-engineer grappled with architectural and public tasks, on commission or on his own initiative. In Sweden Bengt O. Österblom began a project to build a Radio Tower after seeing an exhibition of Russian Constructivism in Germany (Fig. 3). Otto G. Carlsund painted various monumental murals closely connected with the architecture of Functionalism, of which the most famous was in the restaurant of the 1930 Stockholm Exhibition. Carlsund was himself a co-author of the Art Concret manifesto of 1930, in

8. Erik Olson
The Constructor, 1925.
Moderna Museet [no.71]

which among other things it was announced: 'We are painters who measure and think' (i.e. who do not improvise and feel). In the later concretist '1947 Group' there was also much interest in playing a part in the physical shaping of the common space of the welfare state, in close collaboration with architects and master builders. In the welfare state utopia Årsta Torg the architects Erik and Thore Ahlsén built an artist's studio next to the Community Center (Folkets Hus) and library, as if to bind the artist in as a member of the collective community, from now on more an insider than an outsider. In 1949 a large group of Concretists under the direction of Pierre Olofsson involved themselves in the color scheme and design of a residential district in Västertorp. Lennart Rodhe's many works for public spaces are typical of this anti-romantic and anti-bohemian attitude, in which the artist approaches the engineer and the architect and takes on assignments that take their starting-point in people's everyday lives – whether it was, as in Rodhe's case, Ängby New Elementary School (Fig. 9), the staff canteen at

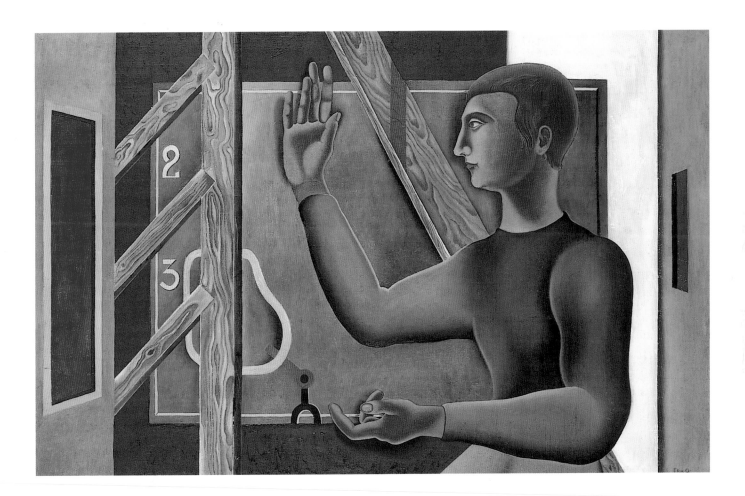

8. Erik Olson
The Constructor, 1925.
Moderna Museet [no.71]

ASTRA in Södertälje or Östersund Post Office. Concretists outside the '1947 Group' also willingly took part in the shaping of the public space: although Olle Baertling's titanic metaphysics separated him from the more sober, rational Swedish Concretists, he involved himself in similar commissions, for example in the works he produced in Stockholm for the University of Frescati, a monumental curtain in the Cultural House or murals in the first Hötorg high-rise blocks, where he worked together with the architect David Helldén. Artist and architect were to participate on equal terms as two equal partners from two disciplines that sometimes seemed to overlap. 'Both the architect and the artist will find that their shared architectural works lose in quality according to the degree of self-assertion. They ought to strive for an *objective* spirit of collaboration,' Olle Bonniér wrote in 1954.[6] 'Very early on the Concretists were eager to carry out an artistic decoration of the subway that was then being planned in Stockholm. In the 1960s, Lars Englund and Einar Höste pursued the artist-engineer/artist-architect route.

9. *The Staircase Theme*, mural painting by Lennart Rodhe in Ängby Elementary School, Stockholm, 1947–53

It was sometimes asserted that Concretism was by its very nature classless and democratic, as it did not require any special education; indeed, its spatial dynamic was founded on laws of Gestalt psychology that were determined by man's biologically-based power of perception. At any rate, perception and seeing were also the basis of Rodhe's art – and of his teaching methods. A strikingly large number of leading twentieth-century artists combined artistic ability with the work of teaching. The role of educator may seem hard to reconcile with that of the outsider, but in general it has worked well – at least before art schools were organized into a university system with extensive demands on administrative ability in their professors. Together with a select group the teacher was free to formulate, test and sometimes preach an aesthetic attitude, and the pupils could in their turn choose to study with the professor with whose program they sympathized. Joseph Beuys, professor at the Düsseldorf Academy of Art in the 1960s, put it plainly: 'being a teacher is my greatest work of art'. Among his works are also included the diagrams he drew on the blackboard in connection with his teaching. The role of teacher became one of the artist's roles, in which the artist like a master imparted his secrets to an initiated group, and was at the same time, in his own creative work, stimulated by the dialogue with young, emerging artists. It involved a socialized and outward-looking aspect of a profession that is otherwise usually practiced in the solitude of the studio – and of course a welcome means of livelihood within the framework of an artist's life.

Kasimir Malevich was a dynamic teacher at the new art schools of the Russian revolution, while Vasily Kandinsky, Paul Klee and Johannes Itten were legendary teachers at the Bauhaus. Josef Albers also worked there until 1933, when he went into exile and acquired a key role at the unusually creative Black Mountain College in the United States. Henri Matisse still had pupils and, like that of Fernand Léger, his teaching was of special significance for Scandinavian artists. In Sweden a number of major artists have been attached to art schools, from the Artists' Association School with teachers like Carl Wilhelmson and Richard Bergh, to Otte Sköld's School of

Painting and Académie Libre. A free method of teaching was also soon introduced at the Art Academy and other state art colleges. In several contexts – from the point of view of both pupil and professor – Peter Dahl has drawn attention to the artist as teacher and compared the various teaching methods of different artists, as for example the modes of instruction employed by Evert Lundquist and Lennart Rodhe. Lundquist did not say much on his sporadic visits and seemed to exert his influence by merely being present: 'Once a week he let his face beam over us...and by virtue of his great artistic ability spread inspiration and knowledge from his fragrant pipe. After a few weeks, however, I began to wonder if he was going to start teaching properly.'[7] Rodhe, on the other hand, did not hesitate to provide a detailed and harsh critique. His rigorous instruction at the Art Academy was described as an 'artistic commando camp', and it was rumored that 'big, strong men wept like infants' after his inspections. He taught his adepts the difficult art of seeing.

As a teacher the artist imparts insights and secrets to a small circle. The instructor is not infrequently tempted to speak as a mystic and esoteric whose instruction acquires the character of an initiation. The artist claims to be in contact with supra-sensory sources of knowledge and a secret gnosis in which alchemy often recurs as a metaphor for the artist's difficult work. The role of esoteric is accessible only to a select minority. It is an artist's part that has exerted a strong power of attraction, and one that has stimulated the imagination. At the Bauhaus the charismatic Johannes Itten was initiated into the Mazdaznan sect, and he wore its special costume at lessons and lectures. Beuys borrowed features of the shaman in his various performances, during which he established a peculiar contact with totem animals like the deer, the hare and the prairie wolf. He had obscure connections with anthroposophical and Rosicrucian teachings. In France at about the same time Yves Klein, also a Rosicrucian, was appearing in ritual costume as an initiate of the order of San Sebastian, the main theme of which, space, the void, the monochrome and gold reflect Klein's own occult leanings. The rationalistic climate of Sweden is less favorable to occult gestures and pretensions. But

10. Group portrait with Ivan Aguéli (first left), Enrico Insabato, and others

in the homeland of Swedenborg there are other exceptions: first and foremost Ivan Aguéli (Fig. 10), whose art and aesthetics were interwoven with the inner aspect of Islam, Sufism. He was himself initiated into an authentic Sufi chain under the name Abdul-Hâdi (servant of God) and lived for many years in Egypt, deeply familiar with the Arabic language and Islamic mysticism. He had himself initiated into the same chain the great French esoteric René Guénon, in whose journal *La Gnose* Aguéli presented his Sufi-inspired aesthetics concerning pure art, solar logic, motionless time and the fourth dimension. One of the pioneers of abstract art, Hilma af Klint, was a dedicated esoteric, engaged in spiritualism, theosophy and anthroposophy; she was first introduced in 1986 at the large American exhibition *The Spiritual in Art*, which attempted to document a historical connection between abstract art and occultism. Outside non-figurative art one can think of a mystic like Carl Kylberg and his self-portrait *The Holy Painter* or Rune Hagberg, like John Cage strongly and fruitfully influenced by Zen Buddhism.

The esoteric's counterpart is the exoteric, who directs himself with a universal program towards a large public: he is the artist as political activist. The important international models are associated with periods of political unrest, like the revolutionary years in Russia or the Weimar Republic in Germany between the Empire and Hitler. After a period as Dadaists and outsiders, both Georg Grosz and John Heartfield wanted to put their art at the service of the working class, and joined the German Communist Party. They opposed abstract art as being 'bourgeois' and agitated violently and satirically against the social divisions and the Nazism that was breaking out in mass-produced newspapers and magazines. In Sweden, Albin Amelin was the

most genuine example of a politically agitating artist, who introduced socially critical subjects into Swedish Expressionism, such as the shooting at Ådalen, the Spanish Civil War and the workers' collective. He wanted to spread his message beyond the art galleries, and so worked for publications like *Humanity* (Fig. 13) and *Culture Front*. In the years after 1968 a new generation of artists took up the role of political activist and they, too, chose the poster and the satirical, illustrated journal as their medium, for example, Lars Hillersberg or Lena Svedberg in *Puss*, but others – Gerhard Nordström, Birgit Ståhl-Nyberg, Peter Dahl and Anna Sjödahl – continued to employ oil painting to convey their message. The political activist behaved either as an independent critic of society or as a loyal member of a political organization, and sometimes even as the mouthpiece of a totalitarian ideology or state.

The roles mentioned here are universal in modern Western art. Is there a specifically Swedish artist's role? If there is, it would take its starting-point in a Swedish Expressionism, which was characterized by a lyrical naivism peculiar to the North, close to the forest and permeated by an awkward poetic refinement. Hilding Linnqvist, Eric Hallström, Bror Hjorth and Sven X:et Erixson all cultivated a childlike perspective in their art. One might possibly dare to assert that a childlike role of this kind is an especially Swedish characteristic, a certain lack of experience that can be traced further back in time, for C.J.L. Almqvist observed a Swedish childishness in his both shrewd and bizarre *The Meaning of Swedish Poverty* of 1838; bizarre when he traces the origins of childishness in the Swedish mentality to the chilly climate that makes all growth and development stop for a large part of the year. This made the Swedish individual develop more slowly and mature later than his Mediterranean counterpart. In the North it is 'ten o'clock in the morning'. It is an idyll and a childlike quality that does not, however, lack muted, somber tones, and of these Ernst Josephson's art depicting illness is a living source – as is also the work of contemporary expressionists like Hans Wigert and Lena Cronqvist.

Most of these examples were done by male artists, since early Modernism and the twentieth-century avant-garde were dominated by men. The adoption of many of the roles of the period has therefore been problematic for female artists, who were easily overshadowed by their male colleagues and given the subordinate role of muse. But there are none the less, especially in literature, a few women who acted out the bohemian role without reserve, for example the spontaneously combusting German poet Else Lasker-Schüler. In Sweden one could point to the writer Ulla Bjerne (Fig. 14) who moved like a fish in water among the artists' circles of Paris in the 1910s and 20s, though it emerges from her autobiographical novels that this was not without its casualties. Siri Derkert and Vera Nilsson were also obliged to occupy the same art scene, and there they maneuvered under great difficulties. They then gradually left the scene in order – something which was not then normally a matter for bohemians and dandies – to look after their children, and staked out their own paths and networks in a no-man's land. For those who had the strength to assert their own artistic talent, the inability to fit into the given roles seems to have provided opportunities for innovation and new departures: in Denmark Franciska Clausen introduced irregular circles and curves into Mondrian's rectangular system, just as Eva Hesse created disorder in clinically geometrical American minimalism. Female artists often found it easier to approach 'inferior' genres which were linked to practical utility: Siri Derkert made her living for a while as a fashion designer and Sonia Delaunay moved effortlessly between pure art and design in Paris, while the many eminent female Constructivists in Russia worked in the pattern studios of the textile factories. They were artist-designers, who broke the taboo-ridden barrier between utility and non-utility, between applied and pure art. The role borders on that of the artist-engineer, but without the engineer's ideological enthusiasm for the gigantic projects of the new technology.

This list of roles could of course be made longer. The roles resemble the hardened castings of an era, the expectations of a public. Like harlequin figures they are clichés and masks that form the signs of a language the artist must enter into. It is not necessarily, however, a clear-cut and legally binding language, for the artist has the freedom to exaggerate, play with or distance himself from its signs. Sometimes the mask is experienced as transparent and nonexistent, sometimes it is a shield; behind the mask of the bohemian the artist can hide his normality and behind the mask of

12. Olle Olsson Hagalund
Jewish Funeral, c. 1945
Moderna Museet [no. 166]

13. Albin Amelin *The Last
Arians*, from the journal
Mänsklighet (Humanity), 1933
Moderna Museet [no.156]

DE SISTA ARIERNA.

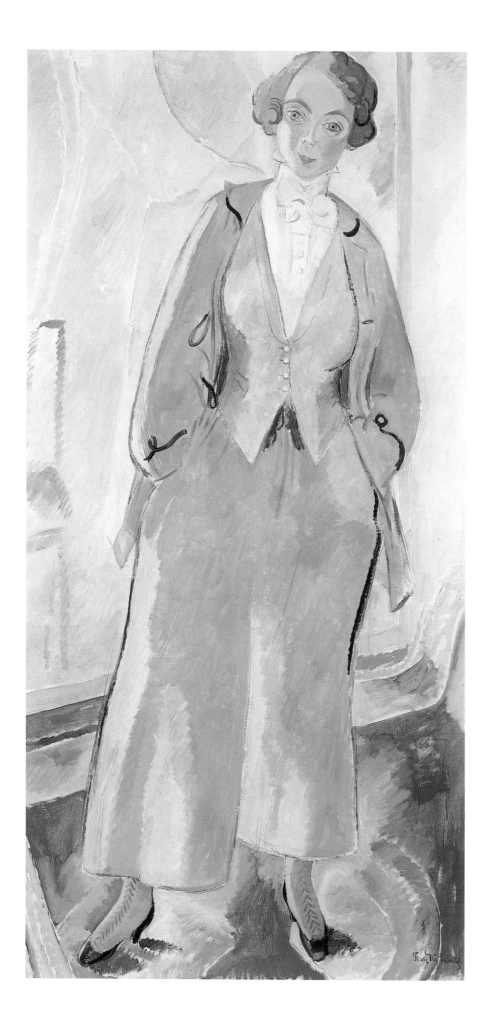

14. Isaac Grünewald
The Authoress Ulla Bjerne,
1916. Moderna Museet [no.9]

normality his deviance. The artist can also change roles during his career, exchange the dandy for the engineer, the politician for the melancholic, to and fro at will. Thus, the roles do not form a static system. Are its signs quite arbitrary, as in Saussure's semiotics, or do they have a natural basis? Is one born an artist or does one become one? Or is it a question of an ensemble? The question is hopelessly entangled, but always interesting to discuss.

NOTES

1. Ernst Kris, 'The Image of the Artist,' *Psychoanalytic Explorations in Art*, 1952.

2. See *inter alia*, Erving Goffman, *The Presentation of Self in Everyday Life*, 1959.

3. Signe Lagerlöw Sandell, Ivar Arosenius, 'En minnesteckning' (A memoir) from *Ivar Arosenius, Ole Kruse, Gerhard Henning*, 1956.

4. J.-P. Hodin, *Isaac Grünewald*, 1949, p. 97.

5. Raymond Klibansky, Erwin Panofsky and Fritz Saxl, *Saturn and Melancholy*, 1964.

6. *Konstrevy* 1954:2, quoted from Thomas Millroth, *Rum utan filial* (Room without branch), 1977.

7. Peter Dahl, *Med mina ögon* (With my eyes), 1977.

CECILIA WIDENHEIM

UTOPIA AND REALITY

Aspects of Modernism in Swedish Visual Art During the First Half of the Twentieth Century

Swedish Modernism cannot be summed up in one simple description or definition, but by following various strands of its history we can focus on Modernism's complex legacy of ideas seen from a Swedish perspective. The artists of the early twentieth century lived in a time when society was undergoing major changes. The railway, the telegraph and telephone – the nineteenth century's revolutionary progress in communications – came to be of benefit to a larger public. The radio, the airplane and the phonograph altered people's relation to the outside world and prepared the way for a new conception of reality. In the world of art the dream of a new technology, a new society and a new human being was created, sometimes with forms derived from a rational machine culture, sometimes in the form of politically and socially committed art.

Modernism contains within itself many different features and it is more correct to talk of Modernisms in the plural than of one unified, homogeneous movement. The encounter with the modern can assume both modernistic and anti-modernistic expressions. Exoticism and Primitivism, the yearning for elsewhere or sometimes the yearning for home may be reactions to urbanization, the obverse sides of civilization and optimism about progress, but at the same time they were strong driving forces in the pre-Modernist movement. Swedish Naivism, a 'new objectivity' and the Expressionism of the inter-war years have in certain contexts been interpreted as anti-Modernism. If one chooses to see Modernism as a gathering of expressions for experiences of the modern, one obtains a more complex picture which also embraces the contradictory aspects of the movement, from belief in progress to the critique of civilization, and cultural pessimism. A portrayal of Modernism must also throw light on the reason why certain currents or artistic talents have periodically been excluded from the history books, just as a portrayal of the modern vision only becomes interesting when it also embraces the critics of that vision.

In Modernism there is a striving to isolate expression and form, to assert the

15. Gösta Adrian-Nilsson
Der Sturm, 1922
Private collection [no.100]

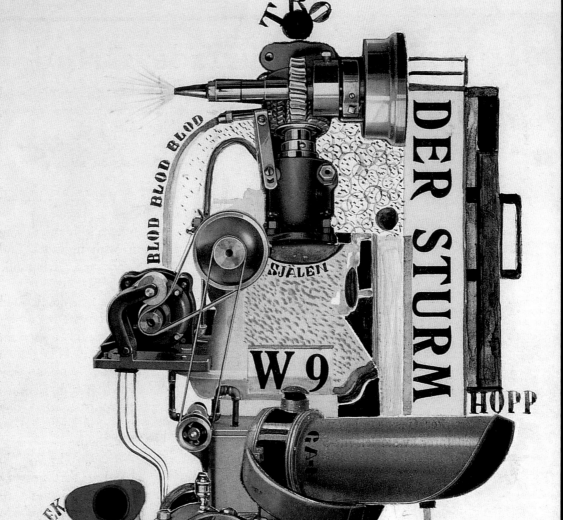

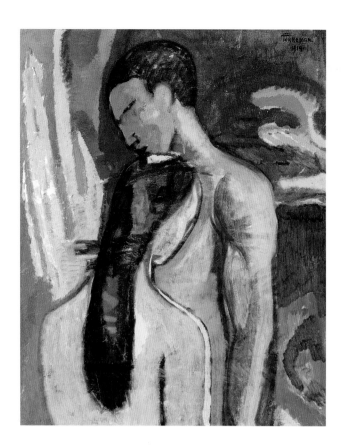

16. Axel Törneman
Youth, 1919
Per Ekström Museum [no. 14]

freedom of art to create new worlds, far from the depiction of reality, or literary motifs. Some cherished the hope that 'pure nature,' a primitive force unsullied by modern culture and academicism, would set us free from conventions and the apparatus of artistic rules. Others likened the artist to a freely playing child. Creativity, originality and authenticity became the key words. The affirmation of the new became for many synonymous with progress. Others called it the cult of youth. Contemporary with Modernism is the cult of the artistic genius, the outsider on the margins of society who in his creation maintains a balance between madness and genius. Not infrequently avant-garde art has also had a metaphysical dimension. The artist is then the visionary who prophesies the future and provides contact with a higher reality. The spiritual movements of the turn of the century such as theosophy and spiritualism permeated the utopian visions of art's ability to attain a world beyond the materialism of the contemporary age.

Modernism has often been portrayed as a universal movement which none the less found different expressions in different parts of the Western world. In Italy the Futurists cherished the dream that sports cars and powerful machines would save mankind from all that was old and out-of-date. War was the only hygiene that could 'purify' mankind of all that was reminiscent of history and tradition. The dream ended in the blood bath of the First World War and Marinetti ended as Mussolini's marionette. In the new Soviet state radical art was initially at the service of the revolution and society. Later re-readings of Modernism alter the picture of a unified movement. In particular, since the fall of the Berlin wall in 1989 a re-writing of traditional history has been introduced from the horizon of the so-called periphery. The Romanian origins of the Dadaist movement, the Catalan painters, Central European avant-garde culture, Russian Constructivism – it can now be asked whether it was not the case that Modernism really took shape on the outskirts of Europe.

Is there a Swedish Modernism? One may imagine a swing between the desire to raise art above the representation of reality and the everyday, and the ambition of giving it a function in society, asserting its role in the social space. On the one hand, a form-

fixated, more or less abstract Modernism, and on the other a striving to fill a liberated form with content – a desire to tell a story, driven by the conviction that art must be about something in order to exist. Swedish Modernism has often been described as provincial: reference has been made to the country's geographical situation and its relatively late industrialization. Modernity entails social change but also inevitably brings with it a need to make up for the loss of the old, of a lost wholeness. Fragmentation is another sign of modernity. Modernity participates in the deconstruction of established values, but also in the creation of new ones. In the shadow of the First World War the old image of the world and of man fell apart as much within art as in technology, science, culture and politics. Consequently collage, film and montage are modern hybrids that break a literary art tradition, open the way for new motifs and a new narrative. The subject leads easily to Modernism's contradictory nature. But it also presages the late 1950s reaction against high Modernism and its emphasis on art's unique and formal qualities. In the 1960s a new orientation takes place within art, involving a confrontation with Modernism, at the same time as certain structures are carried on to the next generation. It is possible to observe a dividing-line where the exaltation of form for its own sake becomes fixed in formalism – high Modernism. New Realism may be seen as a marker for this new orientation, or the committed art that corresponds to the political radicalism of the 1960s. The disintegration of high Modernism results in a new pluralism of form and content – mass and popular culture infiltrate high cultural style, painting is declared dead, pure form becomes viewed with suspicion, the poster is acclaimed as the most democratic form of art, the concept of art is expanded.

The confrontation with high Modernism can be interpreted as one more revolt in the series of upheavals in the twentieth century, or as an early sign of an incipient postmodern era. Each attempt at dissociation is in any case dependent on which part of Modernism one aims to break with. It is impossible to give an exhaustive picture of the art of the first half of the twentieth century in this connection. This essay sheds light on some of the foundations of Modernism and the forms they have taken in Sweden.

INTERNATIONAL AVANTGARDISM IN SWEDEN

Knowledge of early international Modernism came to Sweden through members of the Artists' Association as early as the 1890s. For the initiated there were works by Van Gogh in the Thiel Gallery in Stockholm, and in 1894 one could see Edvard Munch at Galerie Blanche. But the buying policy of the art institutions bears witness to a large degree of caution towards the new. The Nationalmuseum did not acquire a work by Paul Gauguin until 1911, in 1914 a painting by Van Gogh and sixteen works by Paul Cézanne, who had been represented the previous year at Gothenburg Art Museum. Cubism made its entrance in 1913 when André Lhote was invited to exhibit at the Swedish Public Art Association in Stockholm.[1]

In spite of world events, 1914 was an active year for art in the Nordic region. A travelling exhibition of work by artists from the Sturm and Blaue Reiter groups visited Gothenburg, Helsinki, Kristiania and Trondheim. At the Baltic Exhibition at Malmö in 1914 there were showings by Vasily Kandinsky, Alexei Yavlensky, the Brücke members Max Pechstein, E.L. Kirchner, and Erich Heckel, as well as by Käthe Kollwitz, Ernst Barlach and others. Sweden was represented by Isaac Grünewald, Sigrid Hjertén, Leander-Engström, Einar Jolin and Nils Dardel, who took part with ninety-one works. Apart from the Baltic Exhibition, few attempts were made to introduce international Modernism to Southern Sweden in the century's first decade. One exception was in 1916 when in Malmö one could see works by Fernand Léger and Pablo Picasso.

During the first decade of the century Gummeson's Art Gallery in Stockholm introduced several modernists of high international caliber. In 1915 there was an exhibition of graphics by Franz Marc, a member of the Sturm group in Berlin, and in the same year one could see work by Gabriele Münter and Lilly Rydström. In 1916 the first major exhibition of Kandinsky's work took place there. Then followed Emil Nolde, Paul

Klee, Nell Walden and Jacoba von Heemskerck, Chagall and Kokoschka. Nor did the First World War prevent an exchange in another direction. In 1915 the exhibition of Swedish Expressionists took place at the Sturm Gallery in Berlin that included Gösta Adrian-Nilsson, Grünewald, Edward Hald, Jolin and Hjertén.[2]

At the New Art Gallery in Stockholm, which was opened in 1915 by the Italian modernist Arturo Ciacelli, there were showings of work by Lhote, André Derain, Robert and Sonia Delaunay, Jean Metzinger, Henri Le Fauconnier, Marie Laurencin and Picasso. In 1919 the Gothenburg public could on the other hand see work by artists from Die Brücke and Der Blaue Reiter at the Valand, and in 1923 a Sturm exhibition included work by Alexander Archipenko, Ossip Zadkine, Nell Walden, Franz Marc, Willi Baumeister, Albert Gleizes and Léger alongside Hjalmar Gabrielson's unique collection of international avant-garde art. These radical expressions aroused the palpable wrath

17. *Der Sturm*'s July issue, 1915 with cover by Sigrid Hjertén Konstbiblioteket, Stockholm [no. 163]

18. The journal *flamman* (the flame), 1919, with illustration by Gösta Adrian-Nilsson. Konstbiblioteket. Stockholm [no.151]

of the Gothenburg public, however, and in the newspaper one could read that Kurt Schwitters' *Arbeiterbild* had been attacked.

An early attempt to spread knowledge of the new art was the journal *flamman* ('the flame'), which was published from 1917 to 1921 by the artist and art theoretician Georg Pauli (Fig. 18). In it Pauli, Gregor Paulsson, André Lhote and Ivan Aguéli introduced a new theory of art in a sometimes boldly modernistic typography, designed by Yngve Berg and Eigil Schwab. In content and appearance *flamman* was strongly influenced by its model, the French journal *L'Élan*, published by Ozenfant.

Liljevalchs Konsthall, which opened in Stockholm in 1916, was initially a meeting-place for the Artists' Association generation and the young Swedish modernists, but also a forum for international Modernism. Here there were showings of Kokoschka and Schiele among other Austrians in 1917, the Danish artist Vilhelm Lundstrøm in 1919, a major exhibition of French Cubism in 1920, with Juan Gris, Auguste Herbin, Henri Laurens, Gino Severini, Georges Braque, Léger and Jacques Lipchitz. 1922 saw the exhibition *New German Art*, with work by Paula Modersohn-Becker, Emil Nolde, Karl Schmidt-Rotluff, Käthe Kollwitz, and others. An exhibition that was to mean a great deal to the generation that broke through after the Second World War was the one held at Liljevalch in 1938, with work by Matisse, Picasso, Braque and Laurens, where Picasso's *Guernica* was also shown. The Stockholm Artists' Association worked mainly with Swedish art, but in 1919 Parisian art dealers were invited to show works by several artists including Matisse, Picasso and Metzinger. In 1918–19, Gösta Olson started the Swedish–French Art Gallery with Modigliani as its first artist. Marquet, Picasso, Matisse and Braque were presented on various occasions, as were Léger, Pierre Bonnard and Derain. In 1923 Olson hosted one of the few special shows of British modernists, with Roger Fry, Vanessa Bell, and others.[3]

It was not until the 1920s that the Nationalmuseum began to show international

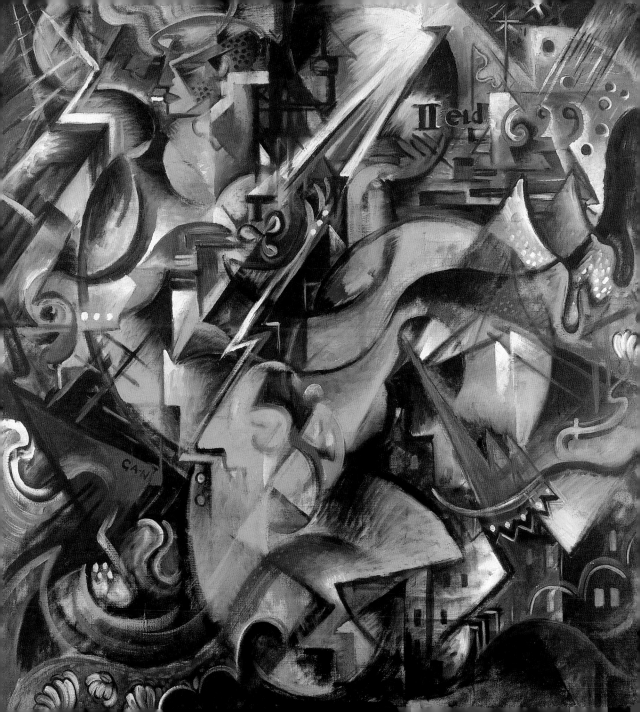

foreign modern art of large format. In 1924 ninety-one works by Matisse were shown, and in 1929 the exhibition *Contemporary German Graphic Art*, included work by Georg Grosz. The 1930s began with the display of Art Concret arranged by Otto G. Carlsund at the Stockholm Exhibition 1930. This comprised work by the Art Concret group which Carlsund had formed in Paris with Van Doesburg, Jean Hélion, Léon Tutundjian and others, and also works by international Modernists like Jean Arp, Léger, Piet Mondrian, Van Tongerloo, Ozenfant, László Moholy-Nagy, Pevsner and Sophie Täuber-Arp. Several of the artists returned in the exhibition of avant-garde French art in 1931, and a year later at the Nationalmuseum in the exhibition Paris 1932, with post-Cubist and Surrealist art. But by comparison with the lively flood of international impulses that characterized the early decades of the century, the 1930s came to appear as a time of isolation and later, during the war, as a time of forced national awareness.

THE DYNAMICS OF THE CITY

The city has often been called the battleground of the modern, the field of conflict whose dynamics the avant-garde sought in opposition to the bourgeois home and its conservative milieu. Another theme is closely linked to the great migration to the city. The artists depict the winding path between town and country, and in between the suburbs – that nostalgic interstice that is formed in the period of modernization between old and new, between town, factory environment and provinces, which is dealt with in the next chapter (pp. 86–97).

Contacts abroad were of great importance to the breakthrough of modern art in Sweden. Berlin was a meeting-place for Scandinavian intellectuals as early as the end of the nineteenth century. In the 1910s Nell Walden played an important role as a cultural personality. She was from Landskrona, and introduced many Swedish artists, including Gösta Adrian-Nilsson (Fig. 15), to the circle around her husband influential Herwarth Walden and his gallery Der Sturm in Berlin, where she herself took part in a number of exhibitions. Berlin was at this time the epicenter of international avant-garde activities. In 1922 Bengt O. Österblom went there and saw the First Russian Art Exhibition with work by El Lissitzky, Malevich, Rodchenko and Tatlin. Österblom and many others like him dreamt of a world state, and radical Russian art held out the hope of a new 'world language'. He thought that 'the abstract geometrical style should symbolize the indivisible unity of world culture, and the non-figurative formal language should be so totally international that it can be understood as a language by everyone who is interested in art the world over...'[4]

20. Arvid Fougstedt
Matisse teaching in Paris, 1912
Borås Art Museum [no. 146]

Others traveled to Paris. 'The turbulent life of the big city, the nocturnal cafés, the tango, and the underground railways, the automobiles and the electric neon signs, this all sang a new song to a new melody. The solemn atmosphere of the Louvre's great galleries became ever more heavy and oppressive.'[5] The encounter of the Swedish pupils of Matisse with modern art in Paris in 1908 is usually described as the breakthrough of Modernism (Fig. 20). Facing a wall of Matisse's paintings, one of them, Isaac Grünewald, exclaimed that it sang with color and shone with light. They had encountered the Fauvistes, painters who like monsters made the colors roar. August Brunius was to call this alliance of young male artists 'the men of 1909.' Opinion of the day turned against the young artists' tendency to deform the human body, and against the manner in which everything – people or trees – seemed to turn into notes in a color scale. From 1912 they called themselves De Åtta (The Eight) – Grünewald, Nils Dardel, Leander-Engström, Einar Jolin, August Lundberg, Gösta Sandels, Tor Bjurström and the first woman in the field, Sigrid Hjertén. The painters Agnes Cleve and her husband John

21. Gösta Adrian-Nilsson
The Express Train, 1916
Malmö Museum

22. Otte Sköld
The Changing of the Guard
Copenhagen, 1917
Moderna Museet

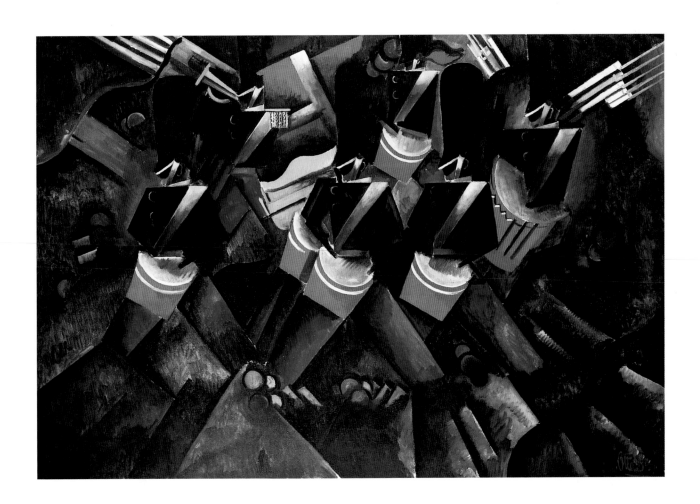

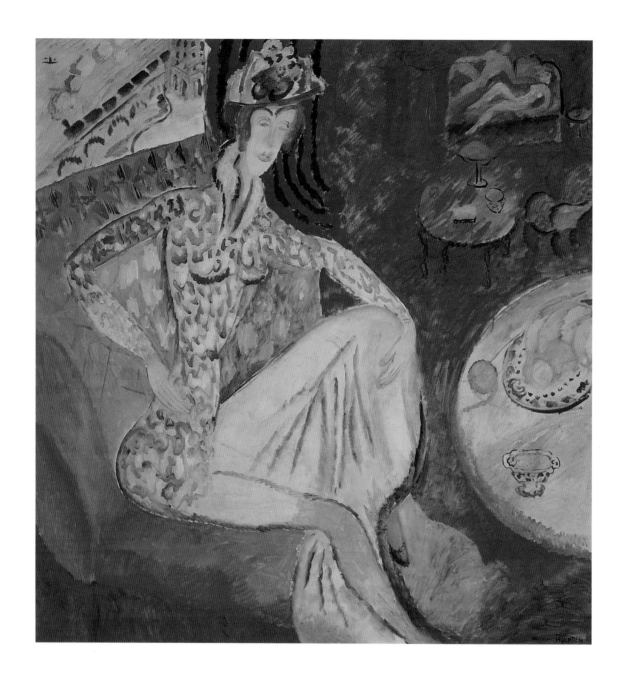

23. Sigrid Hjertén
Woman in Red Interior, 1916.
Private collection [no.6]

24. Isaac Grünewald
The Crane, 1915
Moderna Museet [no.11]

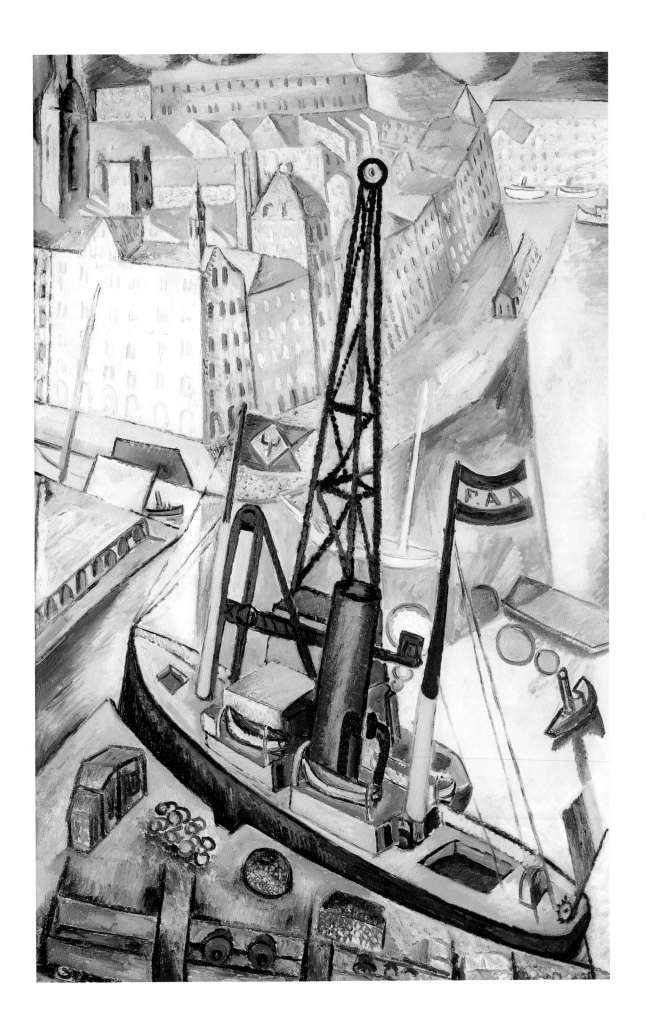

25. Vera Nilsson
Umbrellas, Paris, 1910s
Moderna Museet [no.133]

26. Vera Nilsson
Street in Malaga II, 1920–22
Private collection [no.16]

Jon-And were contemporary with the pupils of Matisse, but represented a more Cubist-oriented Modernism. They studied with the Cubist Henri Le Fauconnier in Paris, were strongly influenced by Vasily Kandinsky and Gabriele Münter in the 1910s, but never attracted the same attention in the contemporary art world as the French-oriented pupils of Matisse.

When they returned home the Swedish artists depicted the pulse of modern life in Stockholm, the hoisting cranes of Stadsgården and the rushing traffic of Slussen from a bird's-eye perspective (Figs. 24, 85). Others interpreted the coastline of Bohuslän or the Swedish fjelds in a decorative coloristic style. Hjertén turned inward. Her portraits of her son Ivàn, her domestic home environment and her life as a woman who was also a modernist are some of the most highly appreciated works of the period (Figs. 23, 82, 84). 'The paintings of Sigrid Hjertén have decorative firmness, and her interest in various problems of light make it possible for her to employ imaginative color contrasts.'[6] Isaac Grünewald's words about his wife's art may seem to reduce her work to mere color and form. At the same time, his words can be interpreted as an attempt to give her redress against the totally uncomprehending critics who, faced with her portraits of children and women, spoke of 'monstrosities', 'disablement' and 'naïve child drawing style' compared to the decorative elegance and bravura they appreciated in her husband's painting.

For Vera Nilsson the experience of Van Gogh's Expressionist painting at the Sonderbund exhibition at Cologne in 1912 was a decisive one (Figs. 25, 26). At Liljevalch's show *Young Swedish Artists* in 1918 she exhibited alongside the pupils of Matisse. The exhibition has come to be known as 'the Expressionist Exhibition' and Vera Nilsson's landscape studies of Öland on the east coast of Sweden were praised by the critic August Brunnius in *Svenska Dagbladet*. 'I should like to say that here there is only one really consistent expressionist: Vera Nilsson. She has both wild temperament and wild technique. Give her the most gentle and pallid landscape as a theme and she will transform it into an engulfing apocalyptic vision! It is as though an earthquake had broken the earth's crust, or as though the graves were just about to open and let out their dead, or as though a world war had ravaged the neighborhood.'

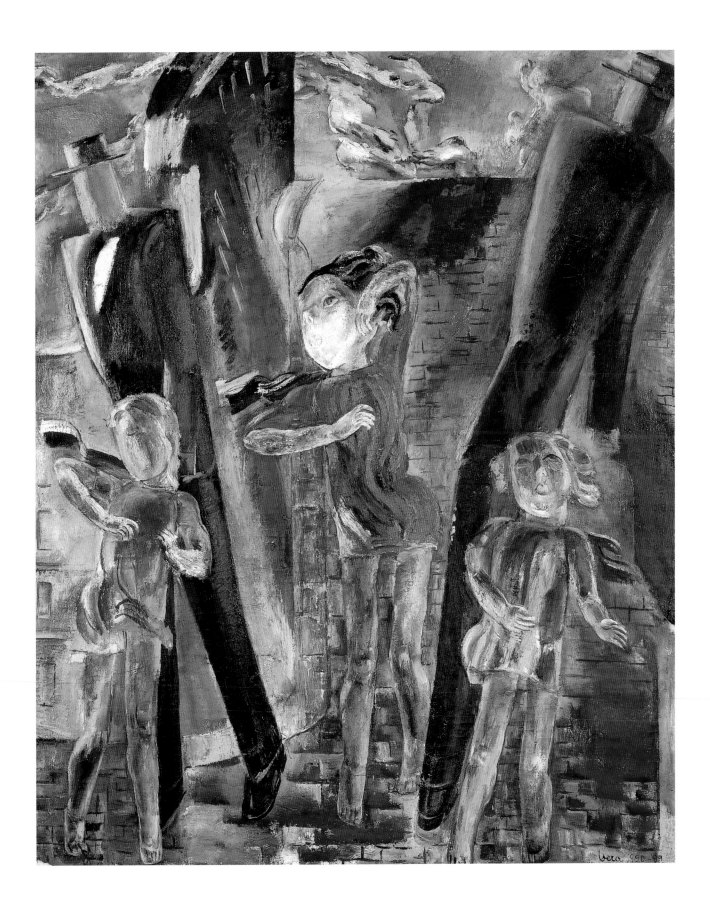

Art is a reflection of its time, August Brunius considered. 'The times are cold, hard and brutal – and so is the art.'[7] In 1914 the First World War broke out, and the artists returned home, one by one. During the war Copenhagen became a breathing-hole for Otte Sköld, Einar Jolin, Vera Nilsson, Gösta Nystroem, Siri Rathsman, Kurt Jungstedt, along with several intellectuals such as Pär Lagerqvist, Ulla Bjerne and Ragnar Hoppe. Here there were private art collections in which a new generation of Swedish Modernists encountered Cubism and international art (Fig. 22).

27. Eric Hallström
New Year's Eve at Skansen, 1918
Moderna Museet [no.93]

'THE FIRST AND FATEFUL ACT IN THE DRAMA OF INDUSTRIALIZATION' [8]

But what happened to those who did not go to Berlin or Paris? What captured the artists who remained at home? In 1917 the painters Victor Axelson, Alf Munthe and Torsten Palm exhibited quiet landscape paintings in a light and low-keyed range of colors at Galerie Blanche in Stockholm. Someone described them as 'intimists.' Hilding Linnqvist, Eric Hallström, Axel Nilsson and Gideon Börje, the so-called 'naivists,' reacted simultaneously against 'the modern' (Figs. 27–9, 31) They turned away from Cubism and the internationally influenced Expressionism of the pupils of Matisse. Instead they explored a native tradition: the work of Ernst Josephson's and Carl Fredrik Hills created during their mental illness (Fig. 33), the Swedish peasant painters, the fairytales, folk-songs, Eric Stagnelius and C.J.L. Almqvist – the 'poets of the heart.' They found their roots in the ideas of romanticism, where the poet is a bard and is driven by a 'demon of art.' In the 1830s, Almqvist had expressed it like this: 'If a thunderbolt passes through your soul, if a heaven (in your own way) dawns in it – then sing, paint or write, and you will be an artist, woe betide you otherwise!'[9] 'to see God's creation from the artistic horizon, to see it in its original form, and much like a child. All becomes play then, and yet also the most serious.'[10]

Hilding Linnqvist had left the Academy of Art in 1912 in order to seek paths other than that of the learned professor. His encounter with the eighteenth-century painter Pehr Hörberg made Linnqvist aware of the merits of amateur art, of not allowing technique or routine to govern emotion. Linnqvist, Hallström and Börje portrayed the

28. Hilding Linnqvist
The Heart's Song, 1920.
Moderna Museet [no.94]

29. Axel Nilsson
Still Life with White Jug, 1922
Moderna Museet

30. Sven X:et Erixson
Picture of the Times, 1937
Moderna Museet [no.170]

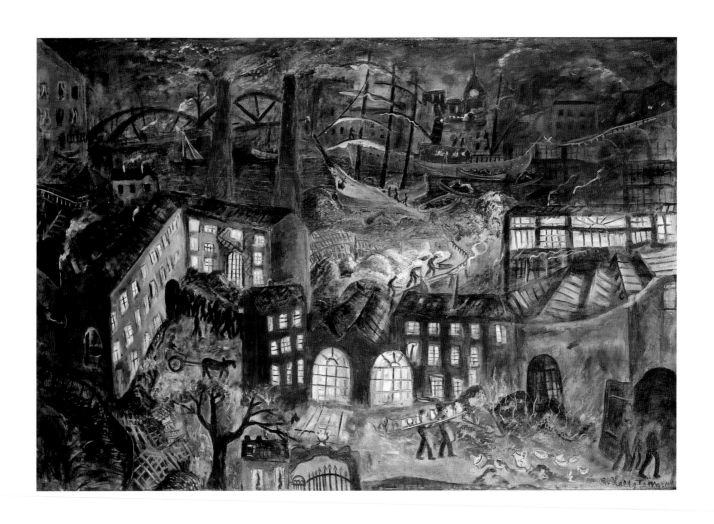

31. Eric Hallström
Rörstrand's Porcelain Factory, 1918
Stockholm City Museum [no.90]

outskirts of Stockholm where the obverse side of industrialism met the idyll of rural life around Klara sjö, Beckomberga, Karlberg, Haga and Rörstrand's porcelain factory (Fig. 31). 'The enduring element of the whole tendency is the independent and intense comprehension of certain aspects of contemporary life; industrialization, the character of the proletariat, the rear courtyards and the life of the city outskirts,' noted August Brunius in 1919, in connection with an exhibition at Liljevalch Art Gallery. In 1934 the socialist critic Erik Blomberg wrote: 'It is the first and fateful act in the drama of industrialization, which these young painters have experienced.[...] The city is growing and slowly grinding the small town away between its iron hands, but gently, carefully, after first having pushed its way out to the periphery and created this strange intermediate thing between old and new, of factory society and province that the suburbs constitute.'[11] Perhaps these reflections can be illustrated by means of the conceptual pair *Gemeinschaft* and *Gesellschaft* – *Gemeinschaft* in the sense of a traditional social community in contrast to *Gesellschaft* – an artificial culture of consumption that celebrates the triumphs of superficiality in the modern urban environment.[12]

The 'naive' runs like a constant thread through Swedish twentieth century art, a feature that has often been described as authentically Swedish, genuine and characteristic. Is the native an expression of provincialism, a Swedish identity? The theme leads easily to questions about what happens when an internationally influenced movement like Modernism comes face to face with the periphery. Is naïvity a reaction against modernization and internationalization? When art abandons the myth, the fairy-tale and the ability to tell a story it is not long before amateur art, peasant painting and medieval church painting make an appearance. Pehr Hörberg, Ivar Arosenius, Nils Dardel, Bror Hjorth and Sven X:et Erixson form a line that could be linked to contemporary artists such as Marie-Louise Ekman, Carin Ellberg, Ernst Billgren or Peter Geschwind. The naive can be a disarming strategy against the view of art as technical finesse and brilliance. It can be the expression of vulnerability, playfulness, popular and everyday reality, or sheer artistic coquetry. But also a reaction against academicism, or the tendency to assert the intrinsic value of line, form and color.

In connection with the Stockholm Exhibition of 1930 several critics had sought 'associative values' in art, i.e. something that related to the essence of the viewer's own life and times, as opposed to what was conceived of as 'content-denying' art. There was a movement away from the decorative emphasis Matisse's influence had had on Swedish art. This was probably one of the reasons for the great appreciation of the 1930s 'Primitivists' – Hjorth, Hallström, Olle Olsson-Hagalund, X:et and Albin Amelin – acquired in welfare state Sweden. The second generation have often been put on a par with the proletarian authors Ivar Lo-Johansson, Jan Fridegård, Moa Martinson and Nils Ferlin. They all depict a society in change, the great migration to the town and the yearning for the countryside, in words and images. X:et's *Picture of the Times* of 1937 conveys the pulse of the big city and its motley street life, but without a political subtext (Fig. 30). When he first entered a competition for a public commission, he chose Nils Holgersson as his motif (Fig. 72); his painter colleagues continued their pilgrimage in the footsteps of the 1910s naivists in the unglamorous intermediate zone between town and country. Early Swedish Naivism seems to reflect on a lost agrarian society. It nurtured a homesick dream of a rural utopia in opposition to the homelessness that international Modernism made its own. In a broader perspective the pastoral idyll can involve both a nostalgic reverie and a futuristic vision of a post-industrial society.

SIGNPOSTS AND VISIONARIES

The idea of the subjective, free artist who is not subordinate to social, historical, or cultural traditions permeates the conceptual thinking of Modernism. But the idea is not a new one. It is a legacy of romanticism, and its image of the artist. Any discussion of Modernism, its origins and breakthrough must unquestionably take its starting-point in the nineteenth century. To what extent did the symbolism, synthetism and primitivism of the 1890s prepare the way for Modernism? How can the late nineteenth century's

32. August Strindberg
Wonderland, Dornach, 1894
Nationalmuseum [no.1]

33. Ernst Josephson
Goose Lisa, 1888–89
Collection of Prince Eugen
Waldermarsudde

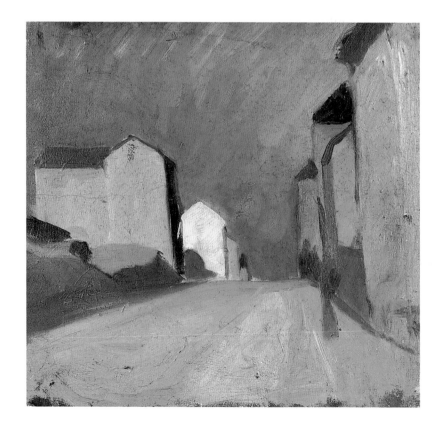

34. Ivan Aguéli
The City amidst the Hills, c.1895
Moderna Museet

35. Ivan Aguéli
Stockholm Streetscape, c. 1892
Moderna Museet

ideas about art, spiritual renewal and social utopia be linked to similar ideas in the modernists' manifesto? Had expressionism really reached Sweden long before it is said to have had its breakthrough with De Unga 'The Young Ones' in 1909? The Swedish opposition movement had already set the avant-garde tone as early as the 1880s. A number of those who are usually considered to be the first generation of Modernists had been students at the Artists' Association College around the turn of the century. The College had started in opposition to the Academy of Art, 'the patriarchal headquarters of academic bureaucratism and formalism,' to borrow the words of Richard Bergh. Oppositionists like Bergh, Karl Nordström, Nils Kreuger and Christian Eriksson were the teachers, and 'the liberation of the artistic personality' was the guiding star of the instruction. The new radical art was to prevail in a battle, something that is also described in the title of the oppositionists' memorial publication of 1905, *What Our Struggle Is About*, a struggle which in the modernist spirit presupposed resistance from a conservative art establishment. Modernism's relation to the late nineteenth century in Sweden is, however, a subject that requires a deeper analysis than space allows here.

Nonetheless, a study of those artistic eccentrics who were considered to be the vanguard of modern art in Sweden, those who were thought to be before their time, avant-garde, provides an interesting picture of what was construed as Modernism's origin and its kernel. When the spirits took charge of Ernst Josephson's brush (he lived from 1851 to 1906) in 1888 he was thirty-seven years old (Fig. 33). Josephson abandoned his role as the leading debater within the opposition movement and began to act as a painterly medium for great, long dead masters like Rembrandt, Velázquez and Rubens. He consorted with personalities from the past, made mental journeys to exotic latitudes, explored the paths of spiritualism and allowed his pen to run beyond the control of reason. Today the diagnosis would be schizophrenia. Josephson was considered to be the first, if unconscious, Swedish Expressionist of modern times, and has often been viewed as the precursor of Modernism. The pupils of Matisse found a prototype of Expressionism in the drawings that Ernst Josephson made during his mental illness, a homespun 'primitive' quality, where art was freed from the straitjacket of reality. Isaac Grünewald had already encountered these works in Karl Nordström's studio as a pupil at the Artists' Association College in 1905–8. Through an exhibition at the Berliner Secession in 1909 Josephson won international renown. Many were fascinated – including Kokoshka, Picasso, Emil Nolde, Gabriele Münter and later Asger Jorn. As early as 1892 Ivan Aguéli (1869–1917) had shown Josephson's remarkable drawings to his colleagues in Georg and Hanna Pauli's salon. In 1918 the illness drawings of 1888–1906 were published in facsimile by Gregor Paulsson and Ragnar Hoppe, and the extent to which Josephson's unconventional mode of expression should be considered as avant-gardism or as the symptom of an illness was publicly debated.[13]

The psychiatrist Bror Gadenius was interested in the connection of mental illness with poetry and visual art. With Gustaf Fröding, Josephson and Hill as illustrative examples, Gadenius wondered if these mad geniuses pointed to a modern need to flee reality.[14] The work of Carl Fredrik Hill (1849–1911) was long unknown to the general public, but nowadays it is mentioned along with Josephson as a portent of the modernist breakthrough. Hill has gained appreciation as a surrealistic visionary, before Surrealism and as an outsider. For poets like Gunnar Ekelöf, Erik Lindegren and Artur Lundkvist, Hill's art became a major source of inspiration, and his drawn visions of another reality seem to articulate the twentieth century's fascination with the subconscious.[15]

'One should distrust the panoramic, the illustrative and literary, including theater and sometimes even poetry; avoid these three demons with the help of 'a nature morte.' Thus did Ivan Aguéli express the dangers of art in a letter to his friend Richard Bergh in 1913. Together with Karl Isakson (1878-1922) Aguéli has had to shoulder the double role of pioneer and classic of early Swedish Modernism. Aguéli spoke out for the art in which 'spirit conquers matter', and his quiet landscapes and still-lifes have been described as 'timeless' (Figs. 34, 35) In Cézanne's footsteps both Isakson and Aguéli strove for simplification and the liberation of form from illustrative or literary content. But Ivan

Aguéli's art also provides important keys to the world of ideas that reigned at the turn of the century. At the beginning of the 1890s he came into contact with occultism, theosophy and anarchism in Paris, and associated with the circle around Emile Bernard, which was close to Gauguin, Cézanne and Van Gogh. Aguéli sought spiritual renewal by turning to the East. He pursued the study of orientalism, traveled in Egypt and India, and converted to Islam (Fig. 10).[16] Under the pseudonym Abd al Hâdi he published 'L'art pur' (Pure Art) in the journal *La Gnose* in 1911, the same article was republished in Swedish in *flamman* in 1918. Today Aguéli is also recognized as an important theoretician; as early as 1901 he pointed out Cézanne's importance to modern art and early drew attention to the art of Picasso, as well as that of Léger and Le Fauconnier.

SPIRITUAL SOURCES

Modernism emerged in the tension between the rational and the mystical, the spiritual and the material. The art world was surprised when in 1986 a hitherto completely unknown Swedish artist who was also female was presented as a pioneer of abstract art, together with prominent male figures of Modernism like Mondrian, Kandinsky, Kupka and Malevich in the exhibition *The Spiritual in Art*. Hilma af Klint (1862–1944; Fig. 37) is one of a number of female artist talents – the second avant-garde – who were brought to prominence during the 1980s with the aim of writing women into the male-dominated history of Modernism (see pp. 108–21). Like many others, af Klint sought movements like spiritualism, theosophy and anthroposophy, and was, arguably, the first non-representational artist. But many are of the opinion that af Klint's art cannot be classed as Modernist, as it was not the result of a deliberate attempt to progress from realism. Af Klint's work does not fit into an avant-garde notion of progress. Since her work was not shown in public until the 1980s, some have maintained that she ought to be considered outside the framework of current art history. Was spirituality Hilma af Klint's excuse or alibi for overstepping the conventions of early twentieth-century artistic production? The fact remains that exceptional courage was unquestionably demanded to exhibit that kind of most unconventional paintings during the early decades of the twentieth century.

Another pioneer who sought a higher metaphysical reality in his art was Gösta Adrian-Nilsson (GAN). In his booklet *The Divine Geometry*, published in 1922, he describes the laws of geometrical construction and the mystical character of the artistic creative process. Geometry is divine, and is present as much in carved tribal idols as in medieval ecclesiastical painting, according to GAN. In *The Stages of Life* (1920; Fig. 36), a painting dedicated to the theosophist Annie Besant, GAN portrays the triumph of humanity over matter.[17] The artist is the chosen one whose task it is to lead mankind onwards and upwards.

August Strindberg assumed the role of an *enfant terrible* of art (Fig. 32). He mastered the balance between genius and madness. Critics wanting to see Strindberg's work within the tradition of a unification of life and art have interpreted his paintings as reflections of their maker's inner self, believing it possible for each brushstroke to be traced back to the creative genius's psyche. 'If I were to compose music, I would throw out the whole theory of harmony that binds us. I should merely put my hands on the keyboard, listen within me and without me for a rhythm, seek my way to new harmonies, for they are there, seek modulations with my hands; and when I had established the theme simply and clearly, vary it somewhat, but at once introduce a new motif in a new rhythm. I wonder if it was not always done like that, except in the writing of scholarly music, which is an abomination.' This letter written in August 1908 shows that Strindberg – writer, scientist and artistic eccentric – possessed many of the qualities that distinguish a pioneer Modernist. He was unschooled, and rebelled against academic rules, he found new paths by attuning himself to the inward sounds of the subjective and outward rhythms of the modern. Strindberg's brutal method of painting with fingers and palette knife has been likened to Abstract Expressionism, and his interest in the role of chance in the creative process has been seen as a harbinger of Surrealism.[18] But is his painting modernist? The interpretation of his work bears witness to the different phases of Modernism during the twentieth century. In the 1920s he was described as a realist, in

36. Gösta Adrian-Nilsson
The Stages of Life (*The Steps*)
1920
Private collection

37. Hilma af Klint
The Swan no. 17, 1914–17
Hilma af Klint Foundation

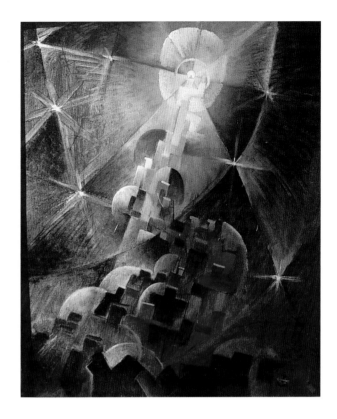

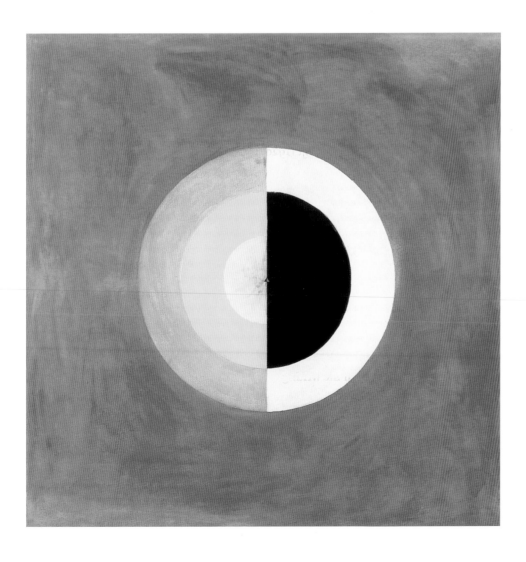

the 1940s as an expressionist, in the 1960s as a spontanist, informalist and precursor of tachisme, and in 1992 he was exhibited, together with Carl Kylberg and Max Book, as one of the three heroes of modern Swedish painting.[19] In retrospect Strindberg's multi-faceted artistic production – drama, science, photography, painting and literature – may be said to constitute a modern laboratory of the subjective.

THE DREAM OF A WILD AND PURE ORIGIN

Where do we come from, what are we, where are we going? Paul Gauguin had raised the question in his great painting that reflects his flight to the exotic culture of the South Seas in the 1890s. Was there a way out of a paralyzing civilization, a chance of finding another and more genuine 'I' in what on the face of it seemed crazy, exotic or savage? Did the future of art lie in the primitive, in the life of the instincts and in the unschooled? Did tradition have anything to give in the search for modern forms of expression? Paradoxically enough, the 'primitive' is a central part of the image of the avant-garde, which is most frequently designated in terms of ahistoricism and innovation. Primitivism is the dream of the future that receives its sustenance from the longing for a primordial past and of becoming a child again. The German author Rainer Maria Rilke chose Ellen Key as the mother of modernity at the turn of the century for the simple reason that in her publication *The Century of the Child* (1900) she equated the freely creating child with the artist. The interest in the foreign, the Other, has also come to be described as the myth of the primitive within Modernism. In 1913 Pär Lagerkvist asserted in *Verbal Art and Visual Art* that literature had become decadent by virtue of a 'female' symbolism, and the new age preached 'manly, controlled suffering'. Cubism's vital source of renewal was the art of the 'primitive' peoples and the ancient Asiatic or Egyptian cultures. Swedish literature should be able to learn from Cubism's search for models of 'purity and primitiveness'. Our own forefathers were, however, closest to us, the denizens of the North. According to Lagerkvist, *The Edda,* the Icelandic saga, or the old Swedish provincial laws, had the primitive energy and pared-down simplicity that could serve as a 'health-giving bath' for Swedish literature.[20]

38. Scene from *La Maison de Fous* (The Mad House) Ballet Suédois, Paris, 1920 Set Design by Nils Dardel Dance Museum, Stockholm

Isaac Grünewald maintained that 'the Expressionist knew that he had to create a new language, clean his palette and change his drawing pencil. He stood on new ground, he was a primitive.' The Expressionist could not accept his sources in the Louvre but directed his steps towards the ethnographic museums' collections of folk art. The Expressionist preferred to establish an acquaintance with primitivists of earlier times.[21] Hjertén and Grünewald had gone to school with the Fauvist Matisse, the painter who was likened to a king of the wild beasts because of his powerful colors. But the other side of Matisse's palette shows an oriental splendor with exotic odalisques, that were explored by Sigrid Hjertén in her article 'On Modern and Oriental Art' (1911). Tom Sandqvist has shown how Hjertén turned to exoticism as an 'artistic and conceptual element', not only in this article but also in her painting. She may be said to have fallen victim herself to an 'orientalism' in which she plays the role of exotic figure, gypsy woman or mother (Figs. 82, 84).[22] Later research shows that the few opportunities female artists had to take part in male-dominated modernist circles were precisely as women with a talent for untutored spontaneity, 'wild ones' and dilettantes.

Another artist who made a strong impression on the modernist generation in Paris around the turn of the century was the untrained painter Henri Rousseau. In the small town of Senlis, Nils Dardel met the German art historian Wilhelm Udhe who was just about to publish a book about Douanier Rousseau and his fantastic, naive jungle motif. After a journey to North Africa with Rolf de Maré in 1914, Dardel's cubist pictorial space and surreal fantasy world melted down into a peculiarly naivistic style, with colors borrowed from ornamental oriental textiles.

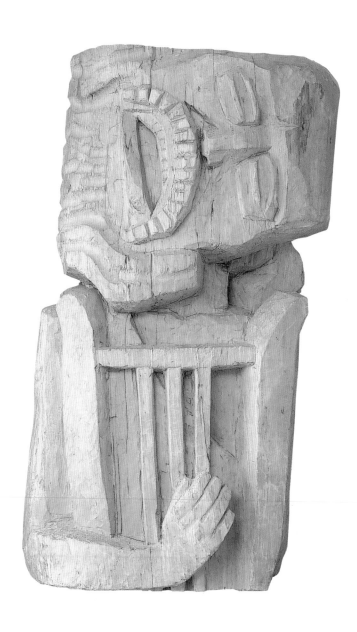

39. Bror Hjorth
Fröding, 1922
Bror Hjorth's House, Uppsala
[no.128]

40. Gösta Adrian-Nilsson
The Loudspeaker, c. 1920
Moderna Museet [no.125]

Gauguin's depictions of an exotic primitive reality spurred Bror Hjorth to seek his own roots. He found them on the soil of his home district, the county of Uppland. The untrained folk art painter who had inspired him to his first brushstrokes was later given a place of honor in Hjorth's own collection in Uppsala, together with the bent figures of Axel Petersson Döderhultarn and Hjorth's own rough-hewn sculpture of the poet Fröding.[23] For Bror Hjorth the naïve stood in contrast to intellectualism and ossified artificiality (Fig. 39). The primary thing was to assert emotion's direct interpretation of reality, but instead of seeking the exotic in the non-European, he asserted his own culture. In an article on Eric Hallström in 1935 Hjorth wrote: 'Swedish art must have its roots in Swedishness. Be poor, sparing and simple. We find it far too easy to give ourselves unnecessary trouble. Not to look among ourselves, in ourselves. Afraid to be primitive and show ourselves as we are, a people who have recently begun their

culture[...] It is from Swedish soil that our art must grow.' Eric Grate encountered 'primitive' art in the ethnographic museums of Germany at the beginning of the 1920s. The inexhaustible wealth of imagery, the magic and sensuality he found in the plant and mineral kingdom as well as in Pre-Columbian, Oceanic and African art was to fascinate Grate all his life. In 1923 Grate composed in watercolor on brown paper the series of humorous improvisations that presage the surrealist period of his oeuvre.[24]

From 1920 to 1925 the exoticism of Ballet Suédois also influenced Parisian Modernism. The Ballet was a unique experimental modernist project in which composers, visual artists, choreographers and poets collaborated. Under the direction of the Swede Rolf de Maré, the Ballet Suédois was a collaboration that transcended national and, above all, academic boundaries. Here the mechanical ballets of Léger encounter primitive dances; the dream of a primordial reality able to liberate us from the conventions and paralyzing tradition of ballet was nourished.

The Swiss poet Blaise Cendrars gave an expressive picture of Jean Börlin, dancer and choreographer of Swedish Ballet. Börlin was a modern man, on a par with a seaman, a soldier, a mulatto or negro. He was the wild man from Hawaii. He had left the old-fashioned opera ballet and sought new forms for the body in movement. In Paris people would dance on the boulevards, at the railway stations, at the motor racing track or the velodrome. Posters and loudspeakers would make the dancers of the new age forget the Ballet Academy's theory, reserve and taste, all of it artificial and virtuosic. When was the ballet *Outre-Atlantique* going to arrive, wondered Cendrars. When was the great dance of the democratic masses to take place, or the open-air ballet *Sportif*? As a matter of fact a ballet about modern life on the other side of the Atlantic was included in the company's tour of America in 1923–4, with performances of *Within the Quota* by Gerald Murphy and Cole Porter, to which Börlin added fashionable dances like the shimmy and the fox-trot. African sculpture, popular hit dances and jazz were 'low' forms of culture that were capable of breaking the mould of art ballet. Jean Börlin had shown an interest in African

41. *Sculpture Nègre*, choreography by Jean Börlin to music by Francis Poulenc 1920. Dance Museum Stockholm

formal vocabulary as early as 1920, when he performed his choreography *Sculpture Nègre* to music by Francis Poulenc (Fig. 41). In 1925 Rolf de Maré launched Josephine Baker in *La Revue Nègre* at the Théâtre des Champs-Elysées, and in the music to *La Création du Monde* Milhaud brought classical music face to face with jazz.[25] One of the Ballet Suédois's most popular numbers, however, was the 1920 *Midsummer Vigil* with music by Hugo Alfvén. This folk comedy must have seemed like a piquant exoticism from northern latitudes to the Parisian public, who fifteen years earlier had been able to acquaint themselves with the cubism of Picasso and Braque, with influences from African sculpture. The ballet *La Maison de Fous* (The Madhouse) caused a scandal that same year (Fig. 38). Against Nils Dardel's expressionistic backdrop the dancers performed a wild, angst-ridden dance like deranged souls in a mental hospital, to Viking Dahl's avant-garde madhouse music.

The encounter with the dynamic oeuvre of Gösta Adrian-Nilsson (GAN) inspired both Viking Dahl and Moses Pergament to compose music with expressionistic nonsense texts and elements of exoticism (Fig. 40). In 1920 Pergament wrote *The Dream of Samoa*, a piece inspired by GAN's painting named after the Polynesian island of Samoa, and the plot of the ballet *The Arctic Ocean* is set in the world of the Eskimos. As he did for *Krelantems and Eldeling*, GAN designed both sets and costumes in a modernist style. *The Arctic Ocean*, with music by Gösta Nystroem, did not receive its first performance until 1928, and then as a symphonic poem, not as a ballet, as GAN's costumes were thought impossible to dance in.[26]

A NEW REALITY – A NEW OBJECTIVITY

Realism is also a part of the multi-faceted early twentieth-century Modernism. Swedish artists expressed different approaches to figurative painting and sculpture. The sculptor Carl Milles, for example, created classically archaic forms, while Bror Hjorth sought to give his rough-hewn figures a touch of primitive authenticity. The depictions of reality reveal a wide range, from Otte Sköld's cubist experiments with form (Fig. 43) and Arvid Fougstedt's objective reporting from Paris to Vera Nilsson's and Siri Derkert's portraits of children (Figs. 89, 90), and Tyra Lundgren (Fig. 44), who in the 1920s established contacts with the Italian group Valori Plastici. Precisely because of their realistic features, currents like the New Objectivity and other more classical tendencies have been pushed to the margins of Modernism or left out of art history all together.

42. Arvid Fougstedt
Picasso and Fellow Artists, 1919
Moderna Museet

In Germany the *neue Sachlichkeit* (New Objectivity) represented political satire and excoriating social criticism in the void created after the end of the First World War. Artists like Otto Dix, George Grosz and Max Beckmann emphasized realism and objectivity in their attempts to bind art to society once more. In France New Objectivity acquired a more classical character. The nineteenth-century painter Jean-Dominique Ingres had pleaded for the 'purity and truth' of drawing, and was now nominated 'the first cubist-impressionist' by André Lhote. Picasso made no distinction between Cubism and Classicism: he wanted to remain a realist. The New Objectivity was, along with Cubism, one of the 'dialects' he began to avail himself of in the 1910s, and is closely allied to his great classical compositions, such as *La Source* (The Spring), of the 1920s. Are not Cubism and New Objectivity, arts of observation, a kind of reflection on the modern age? Do they mirror the modern vision?

In 1915 Arvid Fougstedt visited Paris as an observer in the New Objective Style. Max Jacob took him to Picasso's studio (Fig. 42) and Fougstedt made drawings of bohemian life in the cafés and at the Lyre and Palette art galleries. At Café de la Rotonde he met Modigliani and Picasso. But Fougstedt could not be bothered with the 'modern disharmonies', and his visit to Matisse's school was brief. Instead, Fougstedt went to the Louvre to study the classical realism of the old masters: Hans Holbein, Hans Memling and Ingres. Fougstedt's depictions of the intimate milieus of the bourgeoisie with their

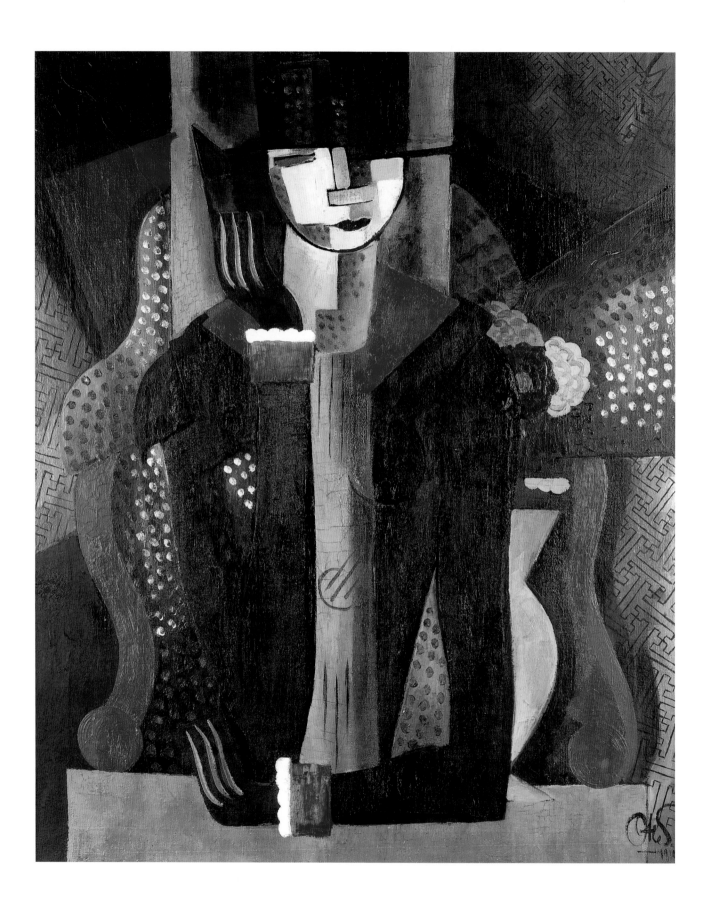

43. Otte Sköld
Lady with Cat, 1918
Malmö Art Museum

44. Tyra Lundgren
Self Portrait, 1921
Moderna Museet

inherited furniture and gloomy colors have later come to be viewed in opposition to Functionalism's puritanical white spaces without lampshades that gather dust.

The critic Erik Blomberg was one of those who in the 1920s rejoiced that Swedish painting was once again willing to tell a story, in contrast to those 'decorative Swedes' (i.e. pupils of Matisse). 'The Expressionists keep to the surface of life and the canvas, they capture modern life in glossy colors from a bird's eye view. Without bitterness they uncritically portray the modern age and dissolution,' wrote Blomberg. For him classical realism was the style of the new age, sprung from Cubism's 'absolute demand for truth', and Otte Sköld's still-life-like portraits were cited as examples of the new narrative.[27]

Peter Cornell (pp. 26–41) has described the connection between the poetics of the New Objectivity and the new visual art of the early twentieth century. The concentration on seeing – objects and their representation – seemed to function as a salvation from the emotional and the subjective, a 'defensive bulwark' against the literary pretensions and the patterns of interpretation that had become the burden of the nineteenth century.[28] Rainer Maria Rilke had called it 'Dingwerdung' – 'thing-becoming'. Cézanne called it 'réalisation', the process of making real that happens in a *nature morte*, or still life. From this point of view, realism is an existential strategy for attaining the impression of a pure being, an objective poetry. The work of art becomes autonomous and concrete, a breathing-space far from expressionist acting-out. Cornell extends his line of thought to the self-referring object of Minimalism, and objectivity can also be related to the Swedish neo-realism of the 1960s.

In the striving for 'objectivity' which the Swedish pupils encountered in the studios of Léger and Ozenfant in the 1920s there is a link to the New Objectivity that was appearing at the same time in architecture – L'Ésprit Nouveau (the new spirit) (Fig. 8). But historical sources were also pursued. In Italian fresco painting of the Middle Ages and Renaissance Erik Olson and many others found a model for the aspiration of art towards building and architectonic construction, but also for the function of art itself – its integration into the public spaces of society.[29]

THE ARCHITECTURE OF BOXING

The inter-war period has been described as the era of the cult of the body. Within the sporting movement healthy energy, exercise and discipline were cultivated, qualities that contemporary public opinion associated with rationalization and belief in progress, but also with the hope of a healthier soul in a healthier body. The modern age's cult of technology held out the temptation of likening man to a machine. Sport and technology were new territories that fascinated modernists the world over, from the Constructivists in Russia and the puritanical artists of the Bauhaus to the press photographers of modern times. In Le Corbusier's and Ozenfant's journal *L'Ésprit Nouveau* articles about art rubbed shoulders with sports results. With its cubist-oriented formal language, Georg Pauli's monumental painting *Mens sana in corpore sano*, 1912 (Fig. 66), in Jönköping High School connects the turn of the century's dogmatic

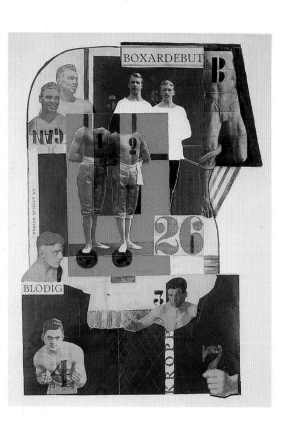

45. Gösta Adrian-Nilsson
Bloody Boxing Debut, c. 1922
Kulturen i Lund [no.58]

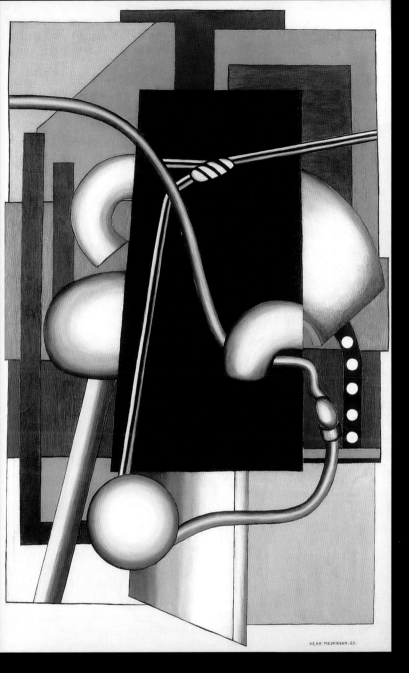

46. Vera Meyerson
Composition mécanique
Paris, 1925
Private collection[no.79]

47. Otto G. Carlsund
The Fireman, 1926
Moderna Museet [no.48]

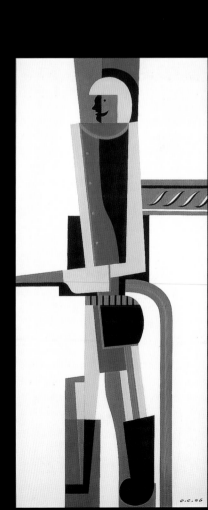

vitalism and ideals of pure living with the modern era's cult of the body.

When the provincial Swedish boy Erik Olson walked into Fernand Léger's studio in Paris in 1924, he found photographs of machines on the walls. All the master's pictures had 'a construction the strength of which is only found elsewhere in those machines.' Léger's encounter with machines during the First World War had given him the impulse to compose with the elements of modern life: cylinders, propellers and ball-bearings. These mechanical elements – 'éléments mécaniques' – are the basis of Léger's constructions in pure, contrasting colors. Here there are no misgivings. The mechanical world still functions as a metaphor for progress and development, and the engineer is appointed to the new human type of radical intellectuals in the USA. Léger's film *Ballet Mécanique* of 1924 is a montage of representational and abstract elements that is driven by a fragmented, mobile vision. One of his Swedish pupils, Otto G. Carlsund, helped in the making of the film. For Léger, Carlsund and the other Nordic pupils represented 'a new Nordic sense of order and measure, freed from all sentimental romanticism,' which was well-suited to the art of the new age. Among Léger's Nordic pupils were Carlsund, Franciska Clausen, Rudolf Gowenius, Waldemar Lorentzon, Elsa Lystad, Siri Meyer, Vera Meyerson and Erik Olson (Figs. 46–8). Should man become more and more like the machine, a geometrical athlete in a rational society? The faith in the dynamics of the human body and a new man was influenced by Nietzschean ideals and fascinated many artists. 'Glorious, powerful, hard age! Strength, and triumph of manly will!' The words are those of Gösta Adrian-Nilsson (GAN). In his work of the 1910s and 20s we find a unique interpretation of sports and muscle-power as signs of modernity and its relation to contemporary artistic expression (Fig. 45). In the work of the Italian futurists GAN had encountered both the worship of aggressive male strength and the desire to capture movement in visual art. The 1924 Paris Olympic Games made a strong impression on him. In his own paintings footballers, shot-putters and bloodstained boxers making their debut appear as heroes of movement, often with a strongly homosexual approach. In the collages of the early 1920s the cult of the body is combined with clippings from newspapers of the day, in a dynamic assertion of the present.[30]

The nineteenth-century interest in sport had grown after the century's turn into a mass movement, whose members believed that sport should unite all nations and all social classes, an idea borrowed from the labor and world citizen movements. Others were less sure. In his book *Jag tvivlar på idrotten*, 1930 (*I Do Not Believe In Sport*), Ivar Lo-Johansson gave expression to the reactions against the negative aspects of the mass movement and competitive sports. Sven X:et Erixson's work of the same period – *I Also Don't Believe In Sport* and *The Gospel of our Time* (Fig. 49) – reveal the same skepticism. In 1936 the *Fritiden* (*Leisure*) exhibition was held in Ystad, at which an attempt was made to tone down the much-criticized competitive sports in favor of aspects of national health, and fitness training in a collective spirit. That same year the Berlin Olympics became a sporting event staged as a pro-Nazi demonstration, and in the Soviet Union sport and athletics became instruments of political propaganda.[31]

AN ART AS PURE AS MUSIC

'Through all that is modern runs the definite wish to seek to attain a pure art,' wrote Pär Lagerkvist in *Ordkonst och Bildkonst*, 1913 (*Verbal and Visual Art*). From one point of view

48. Fernand Léger (center) with his pupils Francisca Clausen Erik Olson and Otto G. Carlsund in Paris, 1927

49. Sven X:et Erixson
The Gospel of our Time
from the journal *Mänsklighet*
no. 2, 1934
Moderna Museet [no. 156]

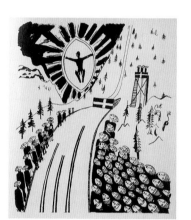

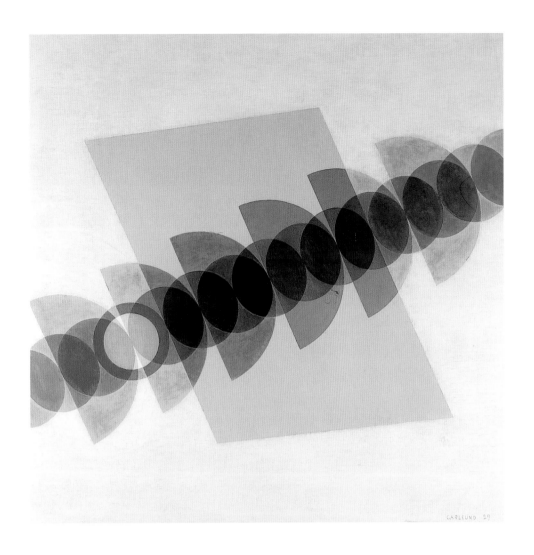

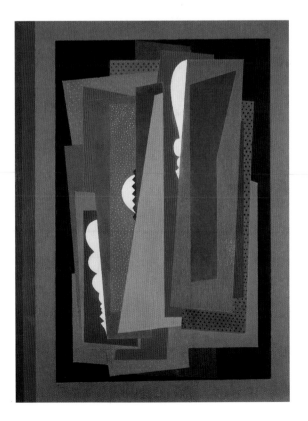

50. Otto G Carlsund
Sequence of Notes, 1929
Private Collection [nr 53]

51. Knut Lundström
Chord, Paris 1924
Per Ekströmmuseet [nr 88]

Modernism is a process of liberation, a striving for the independence of the image from everyday reality. It works on purely artistic problems, with color and form as the primary driving forces. Another of the manifesto-like publications of early Modernism is August Brunius's *Färg och Form* (*Color and Form*), of the same year. For Brunius modern art was an 'art of reaction' in terms of a return to simplicity and pure forms – 'a formalism at once naive and meditated.'[32]

For those who strove to give art the freedom not to represent anything, a comparison with a musical sphere lay close at hand. In music they found the total collapse of tonality, the dissolution of form, but also a concrete formal language without literary references. Art ought to aspire to the condition of music, where form influenced content. Vasily Kandinsky had taken an interest in the relation between color and sound in his essay *On the Spiritual in Art*, published in 1911. In connection with Kandinsky's 1916 exhibition at Gummeson's Art Gallery in Stockholm Gösta Adrian-Nilsson introduced Kandinsky's thoughts about the ability of colors to arouse a kind of inner sound in the spectator. GAN maintained that music had already raised itself to 'pure art' and constituted an example of a new contact of a spiritual character between observer and artwork. In 1914 GAN worked on the showing of the German Expressionist architect Bruno Taut's *Glashaus* at the Deutscher Werkbund exhibition in Cologne. For many of the German avant-gardists, Expressionism was a neo-spiritual movement. Cathedrals should be seen as a prelude to the glass architecture of the modern age, Taut explained.[33] The enormous kaleidoscope of colors that rotated from time to time in Taut's prismatic glass cupola was a dramatic revelation for the Swedish artist. GAN was certainly informed on Taut's view that the Gothic cathedral symbolized the unity between the arts and the life of the spirit. GAN was to return to the theme in a number of paintings in which the twelfth-century cathedral of his home town of Lund became the focal point of cubo-futurist syntheses.[34]

Music was influential for many of the Swedish artists who were active in Paris in the 1920s. Knut Lundström had gone there in 1919 in order to study with Lhote, and was later one of the founders of the group Les Artistes musicalistes. In his abstract painting he aspired to form chords and motions with colors (Fig. 51). Each color was to function like the timbre of a note, and the abstract compositions bear musical tempo-markings.[35] In the productions of the Ballet Suédois in Paris several modernist visual artists of the 1920s encountered the most innovative tonal worlds of the time in the work of Erik Satie, Cole Porter and Les Six, with Honegger, Auric, Milhaud, Tailleferre and Poulenc. Both Gösta Nystroem and Viking Dahl moved between visual art and music, and Eric Grate came into contact with the world of atonality in the work of Schönberg, Hindemith and Webern in Munich in the first decades of the century.

The role of music in the medium of film was the subject of lively discussion in avant-garde circles as early as the 1910s. But the idea of applying musical composition to film was first realized by the Swedish-born Viking Eggeling – a painter whose journey to abstraction passed through music. His abstract film *Diagonal Symphony* of 1924–5 was composed as a piece in sonata form, but was probably shown without accompaniment. The sketches and preliminary studies for the film reels were called 'instrumental exercises.' Put together, they form a pattern of movement akin to a musical composition, and also add a temporal dimension to the traditionally static image. When the film was premiered in Berlin in 1924, one critic maintained that the flood of images should be experienced in musical rather than purely visual terms, like a music for the eye.[36] When Otto G. Carlsund was commissioned to decorate one of the walls of the restaurant at the Stockholm Exhibition in 1930 he had been interested in musical composition for some time. In Carlsund's mural *Rapid*, the geometrical elements represent sound, light and electricity.[37] In the 1920s he worked on mural compositions for concert halls, related to the music of Bach and taking the form of acoustic backdrops that recall Carlsund's time at the Académie Moderne in Paris, when the Purist Ozenfant had been his teacher. *The Note's Vibration* and *Sequence of Notes* of 1929 form an abstract acoustic space, but also a musical time continuum (Fig. 50).

This interest in the formal aspects of art, in music and the striving for a 'pure' or concrete art was to become topical with the second breakthrough of Modernism after the war. The collaboration between groups like the Concretists, the Monday Group and the Chamber Music Association opened out into the 'correspondences', between word, image and music, of the 1940s literary avant-garde movement in Sweden, something that is described in Sören Engblom's essay 'Happy Transitions' (pp.288–97).

53. *Art Concret*, exhibition organized by Otto G. Carlsund in the Park Restaurant's Puck Café at the Stockholm Exhibition, 1930

'FUNCTIONALISM FOR THE SOUL'?

Carlsund's *Art Concret* exhibition of 1930 is said to have been the only truly significant attempt to introduce post-Cubist art to Sweden before the Second World War (Figs. 52, 53). In the critical response of the exhibition it is possible to sense the polarity between abstract and representational art, the forces that supported concrete art and those that supported the utilitarian aspects of art, its social function. The event took place under the direction of the Stockholm Exhibition and showed works by the Art Concret group, including Van Doesburg, Jean Hélion and L. Tutundjian, but also major international figures such as Arp, Léger, Mondrian, Van Tongerloo, Ozenfant, Moholy-Nagy, Pevsner, Charcoune, Sophie Täuber-Arp, and others. Sweden was represented by GAN, Christian Berg, Lennart Gram, Eric Grate, Sven Jonson, Erik Olson, Stellan Mörner, Wiwen Nilsson, Esaias Thorén, Bengt O. Österblom, Greta Knutson-Tzara and, of course, Carlsund himself. In the foreword to the exhibition Carlsund had declared that the art on display represented those schools that strove to 'free the spectator from the compulsion of reflecting on "motifs",' and aimed instead to let compositions in color or form 'play directly on the mind.'[38] Several critics proved uncomprehending in the face of this attempt to apply the name 'concrete' to abstract art and allow it to meddle 'in the business of mathematics.' Possibly 'some of the art works on show betray a decorative talent of the kind that has found its most stylish expression in the simpler industrial utility art.' Interestingly enough, the art critic Gustaf Näsström objected to the fact that Art Concret had made common cause with functionalism in architecture. That houses should be functional and practical to live in was self-evident to Näsström, who could not, on the other hand, accept avant-garde painting. It was machine romanticism. 'Art Concret is not a functionalism for the soul, it is an artistic materials testing plant and has its own value as such.'[39] One of the reviewers regretted the lack of 'associative values,' something that could be related to the viewer's own life and times. Karl Asplund declared that only when we became robots would we be able to pray to Christian Berg's concrete *Venus* (a semi-abstract monumental sculpture that today stands in the garden of the Architecture Museum and Moderna Museet). Until the robot age arrived he asked to be allowed to continue to pray to 'the *Venus* in the Termi Museum at Rome.'[40] Ragnar Hoppe was one of those who supported the new art and he went so far as to assert that the movement away from literary associations, ancient themes and the depiction of nature was 'a hygienic measure that has sprung from a need for clarity and purity.'[41]

Erik Olson's painting *The Gauntlet Is Thrown* of 1930–31 (Fig. 55) has been seen as a symbol for the transition from Léger's formal language to Surrealism. Constructivism no longer satisfied, a new era stood at the door. Surrealism could be interpreted as a reaction against the plain, arid formalism that was dominant, Otto G. Carlsund explained. It was a reaction in the guise of 'unrestrained romanticism that sometimes takes on rather morbid forms.'[42] At the Art Concret exhibition in 1930 Eric Grate, Hans Arp and the Russian Sergei Charcoune were presented as Surrealists. Under the label of 'surimpressionism' – a hybrid between surrealism and post-impressionism – we find, tellingly enough, one of the few women in the exhibition, Greta Knutson-Tzara. As has

54. Esaias Thorén
The Game Has Begun, 1938
Nanne Collection
Halmstad Commune [no.76]

55. Erik Olson
The Gauntlet Is Thrown
1930–31
Nanne Collection
Halmstad kommun [no.72]

been pointed out, Carlsund's display was perhaps not *too early* for Swedish cultural life, but rather *too late* – the possibility of interesting the general public in the problems of abstract art was past.[43] Did the future belong to an art of associative values?

ART FOR ART'S SAKE - OR ART FOR THE PEOPLE?

'Let the writers look after that political tendency business,' Sven X:et Erixson considered. 'A painter works with color and form. What sort of tendency is there in a still life?' Albin Amelin pointed out that a still life is nearly always art for the bourgeoisie: 'All that stuff about art's intrinsic value is a load of crap.' In his book *Tröskeln (The Threshold)*, Ivar Lo-Johansson looks back at the discussions of the inter-war years in radical circles about the meaning of art and recounts a conversation between Sven X:et Erixson, Albin Amelin and himself.[44] Must not art have a function, be socially useful? How does a socialist

paint? Lo-Johansson put literature before visual art, as he was convinced that one could do more with a book. The discussion about representational and non-representational art is on one level closely linked to the question of art's possible social function. Several of Modernism's classical manifestoes were to campaign for the role of art as the spearhead of social progress. Early Modernism had asserted the liberating of art from an outdated social order, and a new artistic identity had emerged in relation to an ever stronger bourgeoisie and a modern art market. Should art find another route than that of functioning as easel art for a well-to-do bourgeoisie or as a monument to the nation's values, geniuses and great men?

Contact with the labor movement and other popular movements had already been established during the nineteenth century in Sweden. There was a desire to break art's isolation by means of socio-aesthetic projects and to carry on popular education. In her publication *Skönhet för alla*, 1899 (*Beauty for All*), Ellen Key had asserted the role of aesthetics in a wider social context founded on democracy and increased equality. With the slogan *All Have a Right to Art and Beauty* she drew close to the party program of the Social Democrats, and at the Stockholm Labor Institute that same year one could see examples of interior decoration that showed how beautiful art in a clean and attractive home would ennoble the human psyche. The critique of the negative aspects of industrialism and the undertone of education in taste are unmistakable. The belief that art should develop by means of a greater public presence was held by many radical art experts at the time. With the motto 'form is everything – content nothing' one will never achieve anything that is alive, the artist Richard Bergh maintained. During his short time as chief curator of the Nationalmuseum he had succeeded in starting both the museum's art education program and its program in the province, all under the slogan 'Art to the people!' What Bergh saw as a stylistic problem of modern art could be solved with a new public social art. In league with art handicraft and architecture art was to receive motivation as a new social art.[45] The artist and theoretician Georg Pauli also had the ambition of distributing art to a wider public and thereby 'develop and ennoble the nation's sense of beauty.' In the 1915 publication *Konstens socialisering (The Socialization of Art)*, he goes in quest of a more modern museum system. Pauli proposes an aesthetic economy, an artistic politics that is based on the decentralization of a museum's collections. Instead of producing easel artists who create brilliant 'masterpieces' directly intended for a museum, the teachers at the academy ought, in medieval style, to let their pupils take part in the execution of monumental work in public environments. A training in the art of functioning 'in our daily lives' would bring about a socialization of art.

The great Swedish art education organs had from the outset the character of cultural-political projects. The State Association for Educative Arts (Riksförbundet för

56. 'The Pillory' in the *Good Art In Home and Community Center* exhibition at the Nationalmuseum, 1945–6

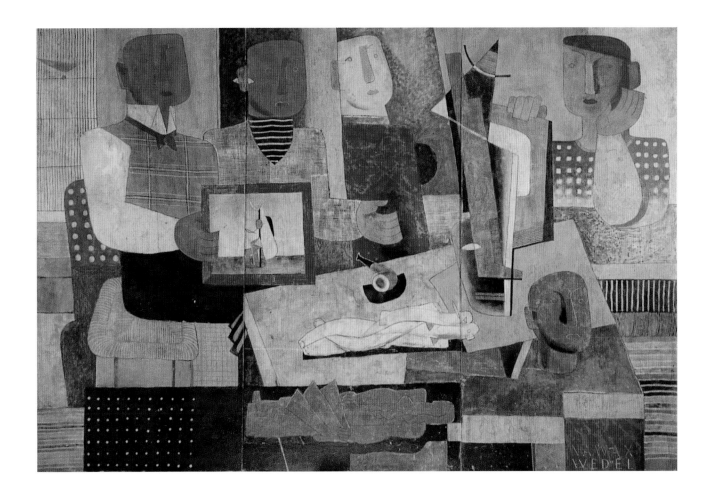

57. Nils Wedel
Jury (Censorship), 1938
Moderna Museet[no.103]

58. Albin Amelin
Racial Hygiene, 1934
Private collection [no.150]

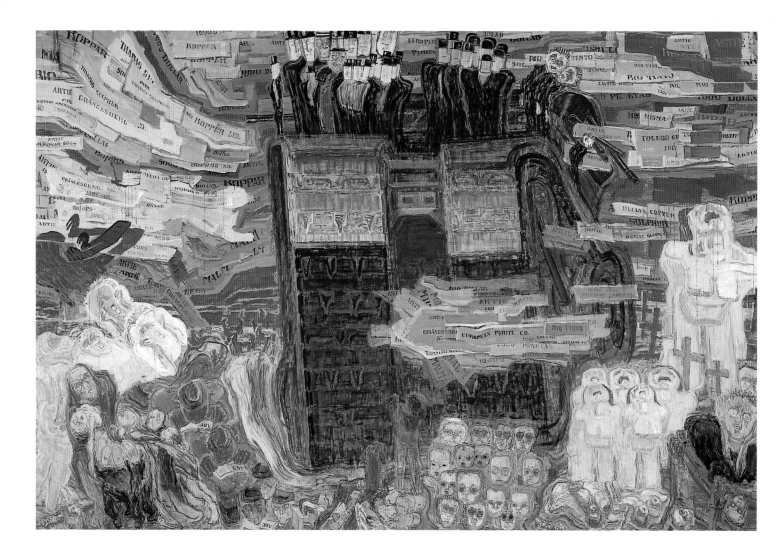

bildande konst) was founded in 1930 and arranged courses and travelling exhibitions. As the name suggests, it was more involved in education than in the supplying of pictures. 1937 saw the establishment of the State Art Council, the purpose of which was to give artists a wider role in society and, with the aim of popular education, to disseminate art to public institutions like hospitals and schools. Behind this indirect support for artists there was also a desire to counteract the influence of commercial forces on the cultural sphere. With the exhibition *Good Art In Home and Community Center*, held in 1945, the Nationalmuseum took the popular education tradition further. Here instruction was given in the art of distinguishing between bad and good art, and in one section samples of so-called 'trash art' were shown – *Horror Art Pilloried* (Fig. 56). Voices were raised in the press against the attempt by the organizers to 'educate the ignorant'. Some felt outraged that the pioneers of the labor movement were now to be replaced by modernistic 'rebuses'[46] in the community halls, which may seem surprising in view of the fact that what was exhibited can hardly be considered exceptionally modernistic. For the exhibition at the Nationalmuseum thirteen new lithographs were created by Albin Amelin, Tor Bjurström, Sven X:et Erixson, Grünewald, Lennart Rodhe, Otte Sköld and others, which became the starting-point for the National Art Promotion Movement (Konstfrämjandet) and its graphics production. In 1947 its work began with the aim of giving access at reasonable prices to high quality art to groups that had not previously had the chance of obtaining it.[47] The relation between Modernism, its ideological and aesthetic dimensions, the labor movement and Social Democracy still awaits a more thorough analysis.

59. Vera Nilsson
Money against Lives, 1938
Skövde Cultural Center

JUST COLOR OR COLORED COMMITMENT?

Throughout the whole of the twentieth century there is a constant dynamic between a committed art, where content and message stand in the center, and the wing that asserted art's right to be the expression of color and form, art for art's sake. Between contextualism, which stresses the connection of time and space, and essentialism, for which the value of art in itself is the basis. Swedish Expressionism contains a desire for story-telling that is at times naive and is at times driven by a deep involvement in social conditions, which can be illustrated by a number of elements of the artistic life of the 1930s. Contributors to *Humanity* (1933) and the journal *Mänsklighet* (1934), both published by Albin Amelin, included artists and writers such as X:et, Vera Nilsson, Moa Martinson and Eric Gnista. *Mänsklighet*, which worked against Nazism, racial oppression and dictatorship had only published two issues when the Press Bureau stopped its distribution because of its radical content (Fig. 49). In 1935 some of Bror Hjorth's erotic sculptures were confiscated by the police at the artist-run Color and Form Gallery, which was set up in 1932. The sculptor was reported for immoral activity. In 1937 the purchase for the Nationalmuseum of Carl Kylberg's *The New Start* was stopped by Arthur Engberg on the grounds that the then Minister of Education and ecclesiastical affairs found the painting immature, thematically unclear and also incomprehensible to the general public. However, the actress Tora Teje bought the painting and donated it to the Museum. In Nils Wedels' *Jury (Censorship)* of 1938 (Fig. 57) we find a commentary on Hitler's attempt in 1937 to ridicule and censor Expressionism and abstract art with propaganda as 'degenerate'. In the same year Nils Nilsson's painting *Refugees* was donated to the Nationalmuseum by Prince Eugen.

Swedish west and east coast art has often been polarized in art-historical writing. Reference has been made to a lyrical color-based painting on the west coast in contrast to a more extroverted, socially conscious and formally disciplined Stockholm painting. Artists like Vera Nilsson and Siri Derkert have been considered to represent a 'pathetic expressionism,' in the sense of the expression of strong and passionate emotion, while Carl Kylberg and Inge Schiöler have been dubbed 'color romanticists' (Fig. 61). In a number of exhibitions the so-called Gothenburg colorists have been treated as a group – the painters of the shimmering west coast. The colorists have been viewed as apolitical by comparison to the more politically conscious Stockholm painters. The west coast painters' treatment of color has often been thought to be associated with individual artists such as Ivan Ivarson, Nils Nilsson, Inge Schiöler, Ragnar Sandberg and Åke Göranson, to name a few. Possible perspectives of content have been toned down (Figs. 60, 62).[48] The Gothenburg artist Nils Wedel, with his Cubist-influenced painting, belonged more to Gösta Adrian-Nilsson's circle than to a coloristic tradition. Ragnar Sandberg moved between west and east coast. They both illustrate the problems of letting geography be a guide to the writing of the history of west and east coast art. However one chooses to define this painting, the artistic life of Gothenburg changed radically in 1947 when the Hungarian Endre Nemes became a teacher at Valand Art College and established a link with Central European Modernism.

After the war new generations made their debut, and Modernism was to have 'a second breakthrough,' now more or less linked to the social space. In radical circles there was once again talk of taking art into factories, schools, hospitals and community halls. Randi Fisher, the only woman among the Concretist group 'The Men of 1947,' devoted her attention to apartment block staircases in the suburbs. The Concretists held that the new art was not themeless and abstract, but concrete, tangible reality. Olle Bonniér expressed his view of the matter in *Prisma* 2/1948. 'There is only one universal idea of painting: to create a picture by means of color and form, and with the effect it makes create expression. The more closely the painter approaches the purity of this idea, the more objective does his mode of expression become, the more monumental his simplest intentions.' Olle Baertling and others were active in the international movement which, under headings like *Clear Form, Swedish Abstract* and *Réalités Nouvelles* once again

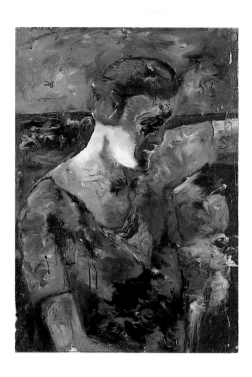

60. Åke Göransson
Woman in Blue and Lilac, 1933/7
Gothenburg Art Museum

61. Carl Kylberg
The New Start, 1935
Moderna Museet [no.17]

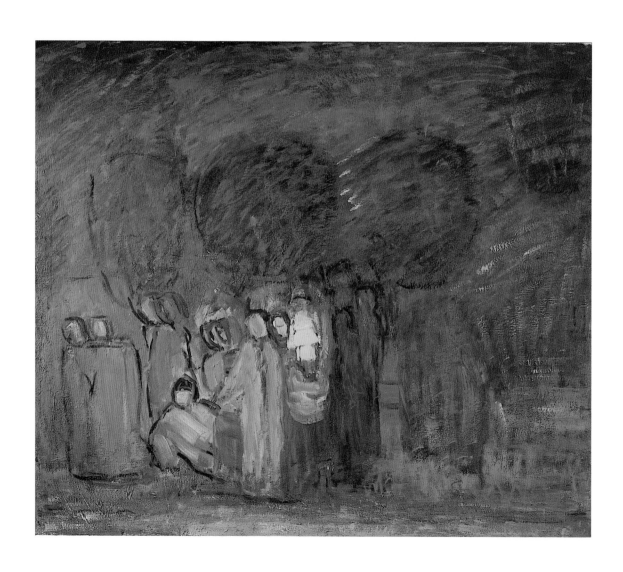

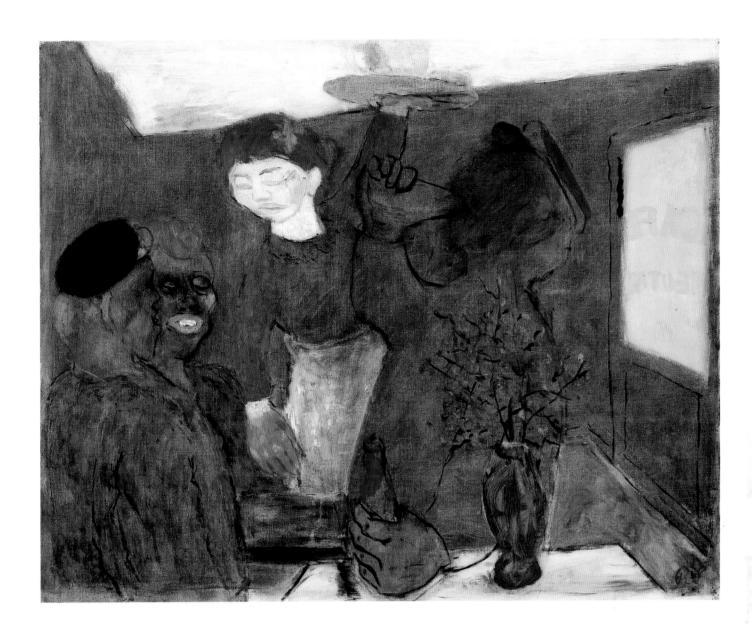

62. Ragnar Sandberg
The Lilla Bommen Café, 1938
Moderna Museet

discussed the question of art's inner necessity and a spiritualized content. The hope of the non-representational as a universal idiom was again woken to life. On the cultural pages of *Svenska Dagbladet* there was a debate about 'pure and impure' art. Overstepping the limits of easel painting was sometimes also a dream of bridging the gap between modern art and society. According to Otto G. Carlsund, the Cubist experiment at the beginning of the century led to the discovery of 'a new plasticity of space.' The urban environment represented the present age. Cinema, the laboratory and the factory had opened new spaces in the public realm. The modernist synthesis of architecture and painting of which Carlsund dreamt in the 1930s was to be realized by Olle Baertling in 1959–60, in one of the high-rise blocks at Hötorget in Stockholm (Fig. 63). The critic Ulf Hård of Segerstad was one of the many who argued for the introduction of the modernist formal language to the public at large. 'What use to us are all those frescoes and symphony orchestras, if we lack a sense for the expressive power of simple things?'[49] A number of post-war Modernists were to devote themselves to the design of book-covers, magazines and textiles, but also of industrial equipment. The discussion of 'more beautiful things for everyday use' and the artist's role in society was resumed.

In the work of Siri Derkert and Vera Nilsson we encounter a fundamental interest in the human social situation, in women and children, the world citizen movement, and the peace and environmental movements. In 1936 both, for example, cherished the dream of

involving themselves like war correspondents in the struggle of the Spanish people against the Franco regime. For Vera Nilsson this involvement resulted in the 4 x 6 meter monumental painting *Money Against Lives* of 1938 (Fig. 59). In the shadow of the profit-hungry battle-wagon of capitalism crouch civilians, grieving mothers, and soldiers. Around them sail share certificates from the world's war industries, with Bofors and Grängesberg as Swedish representatives. The painting was intended to be seen by the general public on a house-end in Stockholm, and is unique in its position as politically conscious monumental art applied to the public space. It would, however, be a long time until the time was right for this pacifist work, which according to the opinion of the day was executed in 'the style of degenerate art'.[50] Not until 1964 did the painting receive a place in Skövde Cultural Center.

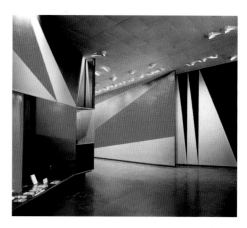

The gender positions in Swedish artistic life at the beginning of the twentieth century have more recently been put in focus, and have contributed to the view of Modernism becoming differentiated, something that is examined in Shulamith Behr's essay (pp.108–21). The work of Vera Nilsson, Siri Derkert, Sigrid Hjertén and Tora Vega Holmström among others, provides an insight into what it was like to be a self-supporting woman, artist, modernist and in some cases mother in a male-dominated artistic climate. Ninna Santesson, who studied in Paris in the 1910s expressed her faith in the role of women in the new art in a letter to her mother in 1913: 'I have tried to talk politics, religion and female suffrage with our boys and it was like water off a duck's back. Politics, an artist mustn't have anything to do with politics, it's an occupation for philistines! [...]Religion: "Art is our religion." – Art, as they conceive it! – female suffrage they don't concern themselves with[...]Statements like those can make me see red and completely forget myself. Those blind idiots, do they not see that it's precisely the women who will bring the new to art.'[51] For Siri Derkert, an artist of the same generation, Modernism was above all a matter of emancipation. 'Movements in all directions breed life. Clichés are equivalent to approaching death,' maintained Siri Derkert in connection with an exhibition in 1960. There is a defiance about Derkert's work, a child's defiance that turns into the artist's struggle against any impediment to thought. A few years earlier, true to her conviction, she had abandoned traditional techniques, and tackled a material that was modern in an artistic context – concrete. In this intractable medium she scratched and cut images from the political struggle for women's liberation and from everyday life. On the *Women's Pillar* that was completed in 1957–8 and stands in the Stockholm metro we meet the typist, the bricklayer, life in the traffic jam, children at play and female rowers (Fig. 64). At the same time, not many meters away, in the entrance to one of the Hötorg high-rise blocks, Olle Baertling's abstract composition of open forms (Fig. 63) was begun – two strong artistic expressions in a public environment – two Swedish Modernisms.

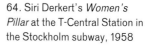
63. Olle Baertling's design for the entrance lobby to the first Hötorg building, Stockholm 1958–9, architect David Helldén.

64. Siri Derkert's *Women's Pillar* at the T-Central Station in the Stockholm subway, 1958

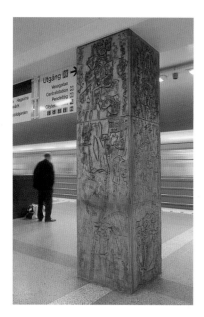

NOTES

1. Gösta Lilja, 'Det moderna måleriet i svensk kritik 1905–14,' (Modern Painting in Swedish Criticism) (diss.) 1955, pp. 240ff. The then twenty-eight-year-old Lhote, who had been the teacher of Georg Pauli and Prince Eugen, came to play an important role in the way that Cubism was understood in Sweden. Lhote was democratic and primitive, unlike Picasso and Braque, whose Cubism August Brunius found over-refined.

2. For a discussion of the cultural exchange between Scandinavia and Germany, see Marit Werenskiold's essay in Skandinavien och Tyskland (Scandinavia and Germany), Stockholm, Nationalmuseum (1997).

3. For a further analysis of international avant-gardism in Sweden, see Lilja, op.cit., and Bengt Lärkner, Det internationella avantgardet och Sverige 1914–1925 (The International Avant-Garde and Sweden 1914–1925), 1984.

4. Quoted from Folke Lalander's article in Nordisk konst i 1920-talets avantgarde (Nordic Art in the 1920s Avant-Garde), 1995, p.36.

5. Isaac Grünewald, 'Den nya renässansen inom konsten' (The New Renaissance In Art), speech given at the Uppsala Aesthetics Society, 1918, p. 31.

6. Ibid., p.43.

7. August Brunius in Svenska Dagbladet May 15, 1918.

8. Erik Blomberg, Hilding Linnqvist,1934.

9. C.J.L. Almqvist, 'Naturlighet i konst?' (Naturalness in Art?) from the essay series Några drag (Some Strokes) 1833–4.

10. C.J.L. Almqvist, Poesi i sak till åtskillnad ifrån poesi i blott ord (Poetry in Things As Distinct from Poetry In Mere Words), 1829.

11. See note 8.

12. For a further discussion, see Johan Asplund, Essä om Gemeinschaft och Gesellschaft, (Essay about Gemeinschaft and Gesellschaft) 1991.

13. Bror Gadelius, 'Om sinnessjukdom, diktning och skapande,' (On Mental Illness, Writing and Creation) in Ord och Bild, 1915.

14. Lärkner, op. cit., p.194.

15. Sten Åke Nilsson, 'Hill och poeterna' (Hill and the Poets) in Carl Fredrik Hill, Stockholm, Nationalmuseum, 1999, p. 197.

16. For a further discussion of Aguéli's life and art see Peter Cornell, Den hemliga källan. Om initiationsriter i konst, litteratur och politik (The Secret Source. On Initiation Rites in Art, Literature and Politics), 1988.

17. The Stages of Life is also the title of a publication by the theosophist Annie Besant, see Jan Torsten Ahlstrand, Gösta Adrian-Nilsson, 1985, pp. 176ff.

18. For a further analysis of Swedish precursors of Surrealism see Ragnar von Holten, Surrealism i svensk konst (Surrealism in Swedish Art), 1969.

19. Nina di Ponziano Hatt, 'Bildkonstnären August Strundberg i svensk press 1892–1996' (August Strindberg the Pictorial Artist in the Swedish Press 1892–1996) Uppsala University, 1996.

20. Pär Lagerkvist, Ordkonst och Bildkonst – Om modärn skönlitteraturs dekadens – om den modärna konstens vitalitet (Verbal Art and Visual Art – On the Decadence of Modern Belles-Lettres – On The Vitality of Modern Art), 1913, pp. 47ff.

21. Grünewald, op.cit.

22. Tom Sandqvist, 'Den tragiska paradoxen, Sigrid Hjertén och exotismen' (The Tragic Paradox, Sigrid Hjertén and Exoticism), Stockholm, Liljevalchs konsthall, 1995, p. 183.

23. See Küllike Montgomery, Bror Hjorths Hus. En katalog över huset och samlingarna (Bror Hjorth's House. A Catalogue of the House and the Collections), 1996.

24. Pontus Grate in Nordisk konst i 1920-talets avant-garde (Nordic Art in the 1920s Avant-garde) 1995, pp. 26ff.

25. Erik Näslund, Svenska Baletten i Paris 1920–1925 (The Ballet Suédois in Paris 1920–1925), 1995, p.52.

26. Anders Edling in Nordisk konst i 1920-talets avant-garde, 1995, pp.65ff.

27. Erik Blomberg, 'Några riktningar inom yngre svenskt måleri, II. Kubister och realister' (Some tendencies within young Swedish painting, II. Cubists and Realists), Stockholms-Tidningen, November 5, 1921.

28. Peter Cornell, Saker. Om tingens synlighet (Objects. On the Visibility of Things), 1993.

29. Viveka Bosson in Nordisk konst i 1920-talets avant-garde, 1995, pp. 5 ff.

30. For a further discussion of GAN's relation to athletics and primitive features see Jan Torsten Ahlstrand and Anna Landberg in Aspekter på Modernismen (Aspects of Modernism), Lund, 1997.

31. For a further discussion of sport as an expression of rationalism and moral order in the iconography of Modernism see Gladys C. Fabre in Léger et l'Ésprit Moderne, 1982, pp.161ff.

32. August Brunius, 'Kubismens förutsättningar' (The Assumptions of Cubism) in Konst och Konstnärer, 1913: 3–4, pp. 42ff.

33. For a further discussion see Ahlstrand, op.cit.

34. For a further discussion see Staffan Källström, Framtidens katedral. Medeltidsdröm och utopisk modernism (The Cathedral of the Future. Medieval Dream and Utopian Modernism) 2000, pp. 81ff.

35. Ulf Thomas Moberg in Nordisk konst i 1920-talets avant-garde, 1995, pp. 42ff.

36. For a wider interpretation see Viking Eggeling Diagonal-symfonin: Spjutspets i återvändsgränd, Tolkning av Gösta Werner och Bengt Edlund (Viking Eggeling. The Diagonal Symphony: Spearhead in a Cul-de-Sac. Interpretation by Gösta Werner and Bengt Edlund), 1997.

37. Oscar Reutersvärd, Otto G. Carlsund i fjärrperspektiv (Otto G. Carlsund in Long Perspective), 1988, pp. 82ff.

38. Exhibition catalogue for 'Art Concret International Exhibition of Post-Cubist Art', 1930, reprinted in Om och Av Otto G. Carlsund (On And By Otto G. Carlsund), Teddy Brunius and Ulf Thomas Moberg (ed.), 1989.

39. Gustaf Näsström in StD September 2, 1930, quoted from Barbro Schaffer, Analys och värdering. En studie i svensk konstkritik, 1930–35, 1982.

40. Karl Asplund in SvD 19/8 1930, quoted from Schaffer, 1982.

41. Konstrevy no.4/1930, quoted from Schaffer, 1982.

42. See note 26.

43. Reutersvärd op.cit., p.98.

44. Ivar Lo-Johansson, Tröskeln, 1957, pp. 368ff.

45. Richard Bergh, Stilproblemet i den moderna konsten (The Problem of Style In Modern Art), 1919.

46. Quoted from Per Bjurström, Nationalmuseum 1792–1992, 1992, pp. 273ff.

47. Konstfrämjandet 50 år (50 Years of Art Promotion), Stockholm, Nationalmuseum 1997, pp. 22ff.

48. For a wider discussion see Jeff Werner, 'Nils Nilsson,' (diss.) 1997, pp. 124ff.

49. Quoted from Thomas Millroth, Rum utan filial – 1947 års män (Room without branch – the Men of 1947).

50. Edvard Wallenqvist quoted from Göran M. Silfverstolpe, Vera Nilsson, 1986, p. 110.

51. Quoted from Tom Sandqvist, Han finns, förstår du (He exists, you understand), 1986, p. 26f.

PER HEDSTRÖM

MODERNISM AND PUBLIC ART

For several hundred years public art and ecclesiastical art had been more or less synonymous. During the nineteenth century this situation altered. As part of a resurgence in public building in the rapidly expanding cities of Europe, public art made a widespread impact in tandem with the construction of railway stations, town halls, schools and museums – buildings that were often decorated with murals and sculptures.

The growth of industrialism at the end of the nineteenth century had created economic conditions conducive to increased public building in Sweden. At the same time, the aesthetic debate focussed on the universal art work and the interplay between pictorial and architectural art. Another central idea was that art should be something more than a luxury commodity for the wealthy and educated. Inspired by John Ruskin, William Morris and Alfred Lichtwark, Ellen Key and Carl G. Laurin campaigned for the dissemination throughout society of art and an interest in aesthetics.

While Swedish mural painting during the period from 1890 to 1920 appeared in a number of stylistic guises, from the baroque-influenced ceilings of Julius Kronberg to the Byzantine style of Einar Forseth and Olle Hjortzberg, late nineteenth-century France was undoubtedly the principal source. The surface-plane-oriented decorative painting of Pierre Puvis de Chavanne was an important influence on the work of Prince Eugen, Carl Larsson and Georg Pauli, among others. Indeed, the genre's most important theoretician was Pauli, who discussed the specific problems of public art in a number of publications. For Pauli it was self-evident that a mural should be adapted to the architecture of a building, and that the artist should take second place to the architect. The mural painter should strive to ensure that the surface character of the wall is preserved. He should also adapt the subjectmatter to the function of the building.[1]

Georg Pauli's wall-paintings in the stairway of Jönköping High School (now Per Brahe High School) have earlier been regarded as the first murals in Sweden influenced by a modernist idiom (Fig. 66).[2] At the age of fifty-six, Pauli had encountered Cubism in Paris in the fall of 1911. He had taken lessons from André Lhote and thought he saw in

65. *The Musician (Le musicien construit)* by Otto G. Carlsund was planned as part of the permanent decoration of a cinema in Montmartre, Paris, which was to be designed by Le Corbusier in 1925. The mural paintings were supposed to be three meters tall. Its figures were derived by Carlsund from the world of film – both in front of the screen and behind it – the actors, the musicians, the director with his megaphone, but also the fireman, the projectionist and his film projector. Unfortunately the cinema was never built, and like many other planned modernist public works during the 1920s, Carlsund's cinema paintings were never able to decorate the place for which they were intended

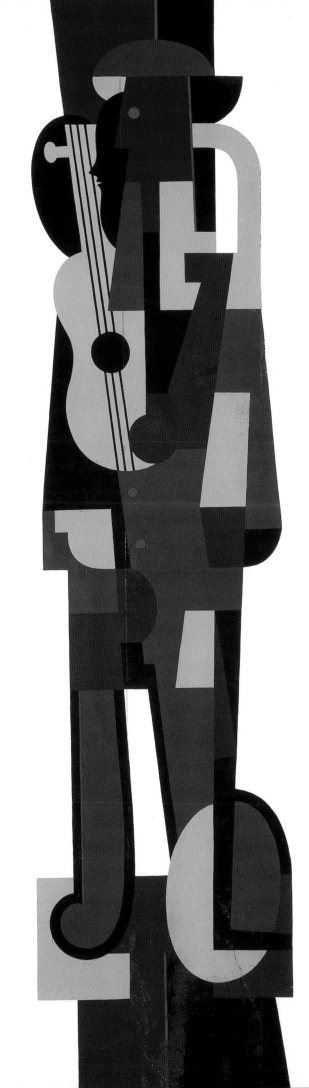

Lhote's moderate version of Cubism a style which in its architectonic structure was particularly well-suited to wall painting.

However, it is debatable if Pauli's work is truly Cubist. There is little to indicate that he had studied the theories of Cubism with any particular thoroughness.[3] From André Lhote Pauli learned a technique that was based on simplifying volumes by means of geometric forms. In the stairway of Jönköping High School the stylization is very modest. The impression is of an angular classicism and a striving for relief-oriented surface planes, as well as compositional and coloristic simplification. Pauli has aligned the figures on the surface plane and restricted his range of colors. Pauli himself never claimed to be a radical Cubist. A few years later, however, at Stockholm Technical College, he did execute wall paintings in which the treatment of form is closer to truly abstract Cubism.

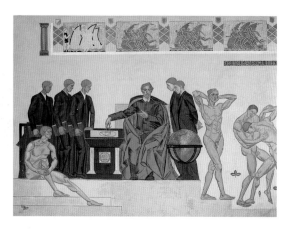

At the beginning of the 1910s, public art was faced with two problems relating to the impact of Modernism. The tradition that public art should be subordinate to architecture began to be called into question, and at the same time a problem arose associated with the general public's reluctance to appreciate Modernist art. It proved hard to produce works of modern art that could be appreciated by more than a few.

In the spring of 1912 a competition was announced in Stockholm for the decoration of the wedding chamber in the newly built Town Hall. It was to bring about one of the major conflicts in the history of Swedish art, a conflict that centered on the suitability of Modernist art to occupy a position in a public space.

66. *Mens sana in corpore sano*, by Georg Pauli, 1912. Wall painting in the stairwell of Jönköping High School (now Per Brahe High School)

A number of voices were heard in the debate, but the strongest and most contradictory were those of Isaac Grünewald and Carl Westman. For Westman, the Town Hall's architect, the competition was intended to find a proposal that was appropriate to the building's Vasa Renaissance-inspired architecture. For Grünewald, it was about the freedom of art and the artist's right to work in a modern formal language. According to Grünewald, there was a modern style in painting, but not in Swedish architecture. It was therefore unreasonable to demand that a painter should paint in a style adapted to a historical mode of architecture.[4]

Several of the entries in the competition were influenced by Modernist trends. Grünewald and Sigrid Hjertén submitted proposals that bore clear traces of their time as pupils of Matisse (Figs. 67, 68), while those of John Sten and Georg Pauli were in differing degrees inspired by Cubism. In a number of letters to the editor of *Stockholms Dagblad* Grünewald's proposals were the focus of the public attack.[5] The majority of the entries were influenced by the decorative effects of Jugendstil and several of them were national romantic attempts to harmonize with the Town Hall's architecture.

The wedding chamber competition went through several rounds before producing a result. In the end, all the entries were rejected, and the decorative painter Filip Månsson executed the mural paintings according to Carl Westman's own designs. The decoration of the wedding chamber thus became an ornamental work, which in its pale and decorative design was suited to the building's style.

During the 1910s and 1920s ideas about the interaction of Modernist art with contemporary architecture were formulated in several parts of Europe. Radical concepts of post-Cubist and non-figurative, architecturally oriented pictorial art were developed by, among others, Fernand Léger, Amédée Ozenfant and Theo van Doesburg. These theories rarely led, however, to realized works of art.[6]

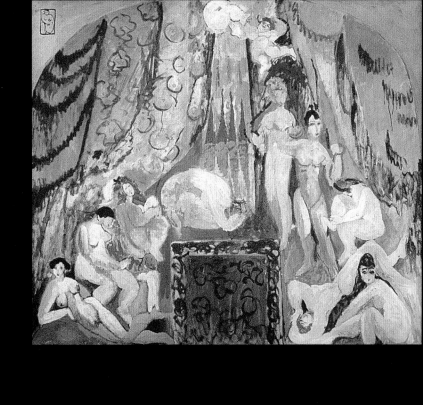

67, 68. Two proposals for the decoration of the wedding chamber in Stockholm Town Hall, 1913. On the right, Sigrid Hjertén's *Figure* [no,159] and below Isaac Grünewald's *Triangle*. None of the proposals were carried out. Sketch Museum, Lund

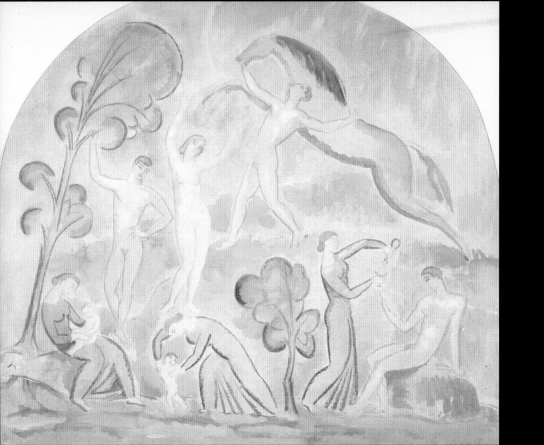

International ideas about Modernist art in public environments did not acquire great importance in Sweden. However, a few artists, perhaps mainly Otto G. Carlsund and Bengt O. Österblom, did know about these ideas and themselves made proposals for non-figurative or abstract wall paintings. In 1926 Österblom entered a work entitled *The Pitcher's Projection* in the competition for the decoration of the periodicals room at Stockholm City Library (Fig. 70). Österblom also added an explanation to his proposal. As the modern periodicals that were to be kept in the room had such a variable content, the room's decorations should be abstract and not naturalistic or classicist. Unlike a naturalistic one, an abstract presentation would give no definite 'object association', Österblom explained.[7]

Carlsund, who was a pupil of Fernand Léger, has been described as a muralist without walls.[8] During the 1920s he was intensely engaged in creating a mural art that could be synthesized with modern architecture. His only extensive public artwork was, however, the twenty-three-meter long Concretist wall painting *Rapid* in the Lilla Paris (Little Paris) restaurant at the Stockholm Exhibition of 1930 (Fig. 69). He had previously been commissioned to decorate the foyer of a cinema that Le Corbusier had designed in Paris (Fig. 65), and in 1930 he drew up a proposal for a wall painting for the students' union building at Stockholm Royal College of Technology (Fig. 114). None of these projects was realized.[9]

THE 1930S DEBATE ABOUT THE ROLE OF ART IN SOCIETY

The harsh economic climate of the 1930s kindled a new debate about public art.[10] The discussion now involved not merely the forms of monumental painting and public art, but also the role of art and artists in society. Artists found themselves in a difficult financial situation, and it was proposed that one way of improving their conditions might be to give them public commissions. So in 1937 the State Art Council was set up, and at the same time the Swedish Parliament decided that a percentage of the costs of

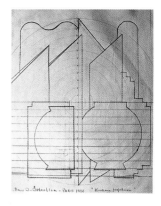

70. *The Pitcher's Projection* was Bengt O. Österblom's proposal for the decoration of the periodicals room in Stockholm City Library, 1926. The proposal was never carried out. Norrköping Art Museum [no. 149]

69. The mural *Rapid* by Otto G. Carlsund in the 'Little Paris' park restaurant at the Stockholm Exhibition 1930

new public buildings should be devoted to artistic decoration.[11] The State Art Council was charged with the task of administering these funds, transferring financial responsibility for public art from the private to the public sector.

Like the debate during the 1910s, much of the discussion in the early 1930s was focussed on the conflict between pictorial artists and architects. The debate began with Sven X:et Erixson making a fierce attack on the architectural establishment.[12] Erixson considered that architects worked against good art, as they primarily had recourse to artists who created pastiches adapted to a contemporary architecture that was dominated by classicism. In general it may be said that Erixson's critique was the same as that formulated by Grünewald in the 1910s – in general architects were not interested in letting truly independent modern artists participate in their buildings. Erixson did, however, place some hope in the young Functionalist architects.

He also received a reply from one of the leading Functionalists – Uno Åhrén.[13] Erixson must, however, have found the reply disappointing. Åhrén articulated the Functionalists' characteristic dislike of the Jugendstil era's delight in decoration, but also expressed a general distrust of public art. 'I for my part do not believe in putting works of art in places where people always have them in sight, in a stairway, for example, for then it will not be many days before they no longer see them.' If pictorial artists wanted to have a more important role in society, they could work on drawings that had a political content, Åhrén believed. That was a truly opinion-forming area of work. Another field of social importance was industrial design. Similar views were also put forward by the critic Gotthard Johansson, who was a leading advocate for Functionalist architecture in the press.[14]

In 1932 two competitions were announced in Stockholm that concerned the decoration of new school buildings. One was Katarina Realskola, the playground of which was to be furnished with sculptural decoration, and the other was Olovslund School in Bromma, where the backdrop of the school assembly hall was to be decorated with a mural. Both competitions became the subject of debate in the press.

Eric Grate's proposal for the decoration of the playground of Katarina Realskola was one of the few attempts made during the 1930s to create a Modernist sculpture for a public place.[15] Grate had composed a Surrealist fountain sculpture built from genuinely organic forms (Fig. 71). The sculpture could be interpreted as a stylized plant, the stems of which formed its framework. The design was awarded joint first prize in the competition, together with Stig Blomberg's *Before the Great Adventure*. Blomberg's sculpture represented a standing boy flexing the muscles of his right arm. Neither of the winners was, however, considered good enough to stand unaltered in the school playground. In the press Grate's proposal was harshly criticized, while Blomberg's boy figure received a more mixed reception.

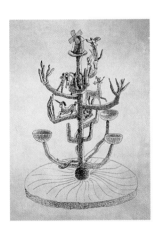

71. Eric Grate's decoration of the courtyard of the Katarina Realskola in Stockholm, 1932. Above, the first proposal, and right, the realized version

72. *Nils Holgersson*, Sven X:et Erixson's mural in the Olovslund School in Bromma

Even though Blomberg's sculpture can hardly be considered Modernist, the criticism it attracted also tells us much about the problems of public modernist art. Demands for either realism or idealization are characteristic. Several of the critics were annoyed that Blomberg's boy was thin. The artist and journalist Marc Hentzel thought it wrong, for example, that the competition had been won by a boy sculpture which he saw as an 'emaciated and rachitic abortion.'[16]

The episode of the decoration of the Katarina Realskola playground was only resolved after the inconclusive competition, when Blomberg and Grate were requested to rework their respective proposals (Fig. 71). Grate altered his fountain almost beyond recognition. The result was a design originating in the form of a baptismal font, with large relief plates on the sides. The reliefs were naturalistic representations of children and fairy-tale creatures. Thus, Grate had gone from a Surrealist imaginative composition towards a more conventional basin with naturalistic figures.

Sven Erixson, who initiated the debate about pictorial art and architecture, actually took part in the competition for the decoration of the Olovslund school assembly hall. Erixson had derived his motif from Selma Lagerlöf's *Nils Holgersson's Wonderful Journey Through Sweden* 1906–7. His entry was moderately modernist and executed in an expressive and naïve style, unhampered by the laws of central perspective (Fig. 72).

After Erixson's proposal won the competition, events took a surprising turn. The Stockholm Elementary Schools Board announced that it did not want Erixson's painting in the assembly hall. The board considered that the subject was unsuitable for an elementary school. *Nils Holgersson's Wonderful Journey Through Sweden* was used as a reading text in the school, but it was doubtful whether it would continue to be used in the future. The board considered that there was too great a risk that the painting's subject would be incomprehensible to future generations of schoolchildren.[17]

The behavior of the Elementary Schools Board triggered a number of reactions in

the press. In *Svenska Dagbladet* Gotthard Johansson wrote that the real reasons for the board not liking the picture were aesthetic ones. However, the board did not dare to dismiss the painting on aesthetic grounds, for fear of ending up in a debate with artists and art critics. Instead, Johansson considered, it opted to attack the choice of subject.[18]

The conflict was finally resolved when the Elementary Schools Board agreed to accept Erixson's painting on a trial basis. The painting was therefore executed on a canvas so that it could later be removed from the site. The removal never took place, however. The finished painting in the assembly hall elicited a positive response in the press. Gotthard Johansson now wrote that the painting had been successfully adapted to the building's architecture: 'There is a free balance between painting and space of precisely the kind one hopes to experience in a modern, decorative, neutral architecture. Not the least important aspect of this artwork is that it shows that a collaboration between architecture and liberal arts is possible even in the age of functionalism.'[19]

During the 1930s and 1940s Swedish monumental art was dominated by figurative paintings of a narrative and illustrative character, often with a tendency towards the idyllic. The figures are usually depicted naturalistically or in a slightly decorative and stylized manner. The pictorial space, on the other hand, is as a rule not naturalistically reproduced but assembled like a montage from various different pictorial spaces that are interwoven like episodes in a narrative.[20]

The montage technique was also common outside Sweden during the 1930s. Much of Mexican mural art was executed in this way, as were many of the wall paintings produced in Norway during the same period. Norwegian wall art was highly regarded in Sweden, and during the 1930s and 40s Swedish mural artists were often clearly dependent on Norwegian prototypes. Sketches and cartoons for Norwegian wall paintings were shown in a large exhibition at the Liljevalchs gallery, Stockholm, and in the journal *Konstrevy* Erik Blomberg presented the so-called Norwegian 'fresco-era' in a series of articles.

Numerous examples of this type of painting were among the entries for the competition for the decoration of the Sveaplan Higher Public Grammar School for Girls in Stockholm in 1939 (now the premises of the School of Social Studies). The majority of the entries included idealized depictions of young people in pleasant summer landscapes. The competition was won by Bo Beskow, whose painting *Chaos-Cosmos* was also one of the typical ones (Fig. 73). Beskow portrays the life of modern woman, from childhood to old age, in a series of scenes running from left to right. The left half of the picture represents childhood and the right half adult life. The figures are depicted in a realistic style, while the pictorial space is more freely structured. However, Beskow also introduces an element that conflicts with the idyllic atmosphere, alluding to the world war that was breaking out at that moment. In a study for the painting we see a woman with a child in front of a factory district that is the target of an air raid.[21] In the final version of the painting Beskow toned down the threat of war, which is now only marked by the fact that the people in front of the factory are wearing gas-masks.

73. *Chaos-Cosmos*, mural by Bo Beskow in Stockholm Higher Public Grammar School for Girls, 1939

In the spring of 1939 the competing proposals for the decoration of the girls' school were exhibited at Liljevalchs Konsthall. The painting that stood out against the pervading atmosphere of green leaves and summer in the large number of contributions was Vera Nilsson's expressive *Money Against Lives* (Fig. 59), which was exhibited in the gallery even though it was not entered for the competition. The picture's content was political, and anything but idyllic. It was strongly anti-capitalist and anti-militarist.

But Sven Jonsson's competition entry *Budding Life* also deviated from the idyllic. The proposal was a surrealistic dream landscape with elements of coulisse architecture and symbolic depictions that concerned the growth of man and nature. The proposal did not receive an award from the jury.

THE TRIUMPH OF NON-REPRESENTATIONAL PUBLIC ART

Otto G. Carlsund continued to involve himself in the problems of public art after the Second World War. In 1947, in an article in the journal *Byggmästaren*, he attacked the prevailing status quo. He saw the previous decades of Swedish mural painting as a kind of retarded nineteenth-century art, quite out of harmony with modern architecture.[22] 'What are all these old men and women under large trees, with or without spinning wheels, doing in a functionalist space? Or all these springtime girls picking flowering chestnuts with upstretched arms, or children diving down into lakes of summer leaves, etcetera, to all eternity?' Carlsund wanted to see a modern mural art that was created in accordance with the architect's intentions.

Thus we encounter Grünewald's approach of the 1910s in inverted form. Now it is architecture, not pictorial art, that speaks a modern language. At the same time there is a return of the twentieth century's demand for conformity and of the demand that the pictorial artist should adapt himself to the architect. Carlsund died in 1948. But had he lived for a few more years, he would have seen his wish fulfilled. Now the breakthrough of non-representational public art arrived.

The period after the Second World War saw a new upsurge in public building. At the same time, the State Art Council now had resources to work for the realization of new public artworks. Together, these circumstances led to a new flowering of public art in Sweden. The period saw a second wave of activity for the country's art education movement and for art instruction in general.

Just as at the turn of the century, there was now once again talk of the importance of quality art being shared by more than a minority. One important manifestation of this was the exhibition *Good Art in Home and Community Center* at the Nationalmuseum in 1945. The event was expressly directed at the working class, and its aim was to offer an alternative to 'trashy art' and inferior reproductions of famous artworks. The alternative was in the first instance supposed to be the presentation of inexpensive color lithographs by eminent artists. But part of the exhibition also contained proposals for mural paintings in a community center.

The exhibition aroused a number of reactions from the public. The Nationalmuseum's initiative was regarded as aesthetic guardianship, and the art on display was seen as incomprehensible, in spite of the fact that it was not strikingly modernistic. One letter to *Aftonbladet* said that many workers 'are quite happy with their "trashy Art" on the wall.'[23]

It was the so-called 'Men of 1947', or Concretists, who were to dominate the public art scene in post-war Sweden. This loosely connected group of artists, with Lennart Rodhe, Pierre Olofsson, Olle Bonniér, Karl-Axel Pehrson, Lage Lindell and Arne Jones as the most eminent

73. *Lots of Parcels*, Lennart Rodhe's sketch for the decoration of Östersund Post Office, 1948–52

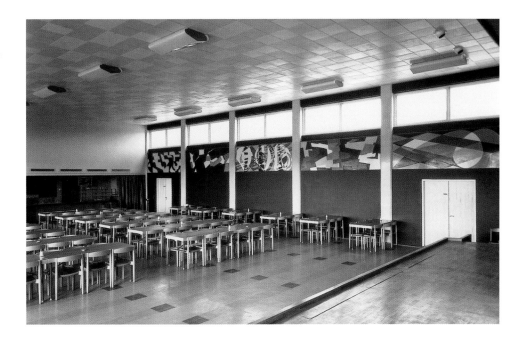

75. The staff canteen at ASTRA in Södertälje, 1955-56, with murals by (from the left) Lennart Rodhe, Lage Lindell, Karl-Axel Pehrson, Olle Bonniér and Pierre Olofsson

names, were both together and individually to carry out a number of decorations of residential districts, schools and workplaces (Fig. 75). The first artworks of this kind were Lennart Rodhe's decorations of the New Elementary Grammar School in Ängby (1948–53) and the Östersund Post Office (1948–52; Fig. 74).

The most radical artist, in his way of working with non-figurative monumental art, was, however, Olle Baertling whose wall paintings in the first Hötorg high-rise block in Stockholm city must be seen as the period's boldest spatial structuring by a pictorial artist (Fig. 63). The project was carried out jointly with the Hötorg building's architect, David Helldén, in 1959–60. Baertling worked with characteristic open triangular forms, and created a space of almost shocking dynamic effect. Baertling himself considered that the entrance hall to the Hötorg building realized 'the idea of aesthetic space.'[24]

A persistent ambition of the Concretist artists who worked with public art was to create a synthesis of pictorial art and architecture. Pictorial art was not to be a loosely applied decoration, but an integrated part of the architecture. In many ways the ideas of the late 1940s and 1950s corresponded to those that had been developed during the 1920s. The post-war period's concept of the relations between pictorial art and architecture were, however, not clear-cut.

One of the projects that created discussion was Årsta Center, where in 1953–4 the architect brothers Erik and Tore Ahlsén furnished the buildings around the square with Concretist facade decorations. Gotthard Johansson was profoundly critical of the project, stating that the facade paintings lacked a formal connection with the architecture. According to Johansson architecture and pictorial art had developed in different directions during the 1940s in Sweden. While architecture had become less strict by comparison with the functionalism of the 1930s, painting had moved towards a harsher expression, towards pure Concretism.[25] The architecture professor Sven Ivar Lind saw the facade paintings in Årsta as an attempt to relieve the monotony and depressing drabness that threatened to become dominant features of new Swedish suburbs. But he thought that the attempt was a failure.[26] The fundamental architectonic and planning problems remained unsolved, and the facade paintings were a kind of cosmetic.

The value of striving for a synthesis between the forms of art was debated on a number of occasions. Director of Moderna Museet Pontus Hultén, for example, took the view that the quest for synthesis was meaningless.[27] Artists and architects were forced to choose which form of art should have priority in each individual case: 'either decoration

or pictorial expression, either architecture or painting.' Hultén considered that all really good monumental art was created by artists who were supremely skilled in their work, artists who did not care about paying regard to the surrounding architecture.

A real innovation in public sculpture was made by Egon Møller-Nielsen with *Tufsen*, the first version of which was completed in 1949 (Fig. 76). *Tufsen* was a non-representational artwork built of gentle shapes that may suggest parts of a skeleton or stones worn smooth by water. But it also functioned as a climbing frame where it was sited in a sandpit at a play area in Stockholm's Humlegården. Here the boundary between utility object and work of art has become blurred.[28] Møller-Nielsen also took part in the first phase of what became the country's largest continuous public art project, in a class of its own – the decoration of the stations on the Stockholm metro. His organically formed sculptures that also functioned as benches were installed at T-Central subway station.

There were, however, also alternatives to Concretist public art after the war. The idyllic landscape was still a common feature. But pictures with subjects from the everyday life of manual workers and the history of the labor movement also began to appear during the 1940s. In 1944 Albin Amelin and Torsten Billman executed large wall paintings in Gothenburg depicting the lives of shipyard workers and seamen. The motif of Amelin's social realist mural in Burgården High School (formerly Council Intermediate School) is derived from the Götaverken ship repair yard. The vigorous workers in the foreground are almost presented as heroes.[29]

Torsten Billman's wall paintings in the Seamen's Home at Masthugget in Gothenburg are more dramatic, and more highly charged with political content. The work of the sailors is portrayed as both difficult and dangerous. In one of the scenes a vessel is attacked by German warplanes and a wounded seaman lies on the deck.

Amelin and Billman executed several murals of workers during the 1950s. Their wall paintings are of course an attempt to focus attention to the work and lives of people engaged in manual labor. In this, the pictures are related to Soviet social realism and Mexican mural painting. But they also have their predecessors in many of the French murals of the late nineteenth century, where manual labor is presented as the basis of prosperity in Republican France.[30] Amelin's mural work can certainly be seen as almost anti-modernistic in its use of realistic figure-painting and a coherent pictorial space. Billman, on the other hand, especially in his wall paintings in the Gothenburg Seamen's Home, worked according to a model that is closer to the Mexican one, and especially to the painting of Diego Rivera.[31]

One may wonder why non-figurative public art achieved such a wide breakthrough after the Second World War, both in Sweden and in the rest of Western Europe. It seems that Concretism was welcomed as an alternative to the ideologically meaning-saturated propagandistic public art of Hitler's Germany and Stalin's Soviet Union. Concrete art lacked literary content, historical references and national characteristics. Concretism could be experienced as an ideologically neutral artistic language, a language well-suited to public places in the modern democracies of the post-war period.

A more general reason for the late penetration of non-figurative art into the public space lies of course in the essential nature of public art. Public art must suit everyone. It is easier to be radical when one addresses oneself to a few people who are really interested than if one tries to reach everyone. One of the fundamental problems of Modernism emerges here with particular clarity. The problem involves the conflict between the desire to create a radically new art and the desire to make this art accessible to all. After the Second World War non-figurative art was no longer a novelty.

76. *Tufsen*, play sculpture by Egon Möller-Nielsen in Stockholm, 1949

NOTES

1. Per Hedström, 'Monumentalmålaren Georg Pauli' (The Monumental Painter Georg Pauli), in *Konstnärsparet Hanna och Georg Pauli* (The Artist Couple Hanna and Georg Pauli), 1997, pp.100–1.

2. Bengt Olvång, 'Kubistisk ingress' (Cubist Preamble), in *Bilden på muren. Studier i Arkiv för dekorativ konst i Lund* (The Picture on the Wall. Studies in the Lund Archive for Decorative Art), 1965, p.106.

3. Jan Torsten Ahlstrand, 'Kubistisk ingress?' (Cubist Preamble?), in *Konstnärsparet Hanna och Georg Pauli*, 1997.

4. Gösta Lilja, *Det moderna måleriet i svensk kritik 1905–1914* (Modern Swedish Painting in Swedish Criticism 1905–1914), 1955, pp.185–86.

5. Ibid.

6. Viveka Bosson has characterized 1920s Concretism as easel painting with mural ambitions. Viveka Bosson, 'Erik Olson och drömmen om muren', in *Nordisk konst i 1920-talets avantgarde* (Nordic Art in the 1920s Avant-garde), (ed.) Ulf Thomas Moberg, 1995, p. 12.

7. Folke Lalander, 'Bengt O. Österblom', *Nordisk konst i 1920-talets avantgarde*, p. 40.

8. Gunnar Bråhammar and Kristina Garmer, *Vägar till konstverket. Arkiv för dekorativ konst i Lund* (Paths to the Artwork. Lund Archive for Decorative Art), 1981, p.14.

9. On Carlsund's monumental painting, see, among others: Gunnar Bråhammar, 'Konkretisterna' (The Concretists), in *Bilden på muren. Bilden på muren. Studier i Arkiv för dekorativ konst i Lund*, 1965, pp.205–7, and Oscar Reutersvärd, 'Carlsund och muralmåleriet' (Carlsund and Mural Painting), *Impressionister och purister* (Impressionists and Purists), 1976, pp.104–9.

10. The Swedish debate of the early 1930s about the artist's role in society is discussed in Barbro Schaffer, *Analys och värdering. En studie i svensk konstkritik 1930–1935* (Analysis and Evaluation. A Study in Swedish Art Criticism 1930–1935), 1982, pp. 59ff.

11. Mailis Stensman, 'Konsten är på väg att bliva allas...' (Art is on the Way to becoming Everyone's...,' in *Statens Konstråd* (State Art Council) 1937–87, 1987, p.9.

12. Sven Erixson, 'Arkitekterna och konsten' (Architects and Art), in *Fönstret* 1932:2, p.5.

13. Uno Åhrén, 'Konsten och samhället' (The Artist and Society), *Fönstret* 1932:2,p.5

14. Gotthard Johansson, 'Konstnären och samhället', *Svenska Dagbladet*, February 18, 1933.

15. On Grate's proposal, see Pontus, Grate & Ragnar von Holten, *Eric Grate*, SAK Publikation 87, 1978, pp. 65–67, 70.

16. Marc Hentzel, 'Hälsning till Eva Bonniers-nämnden' (Greeting to the Eva Bonniers Committee), in *Nya Dagligt Allehanda* December 19, 1932.

17. The maneuverings around Sven Erixson's Nils Holgersson painting are discussed in: Lars Erik Åström, *Sven Erixsons konst* (The Art of Sven Erixson), 1967.

18. Gotthard Johansson, 'Den senaste "konstskandalen"' (The Latest 'Art Scandal'), *Svenska Dagbladet* May 3, 1935.

19. Johansson, art.cit.

20. Rolf Söderberg states that Hilding Linnqvist was the first artist in Sweden to use the montage technique in a public artwork. Rolf Söderberg, *Den svenska konsten under 1900-talet*, 1955, pp.285–6.

21. The study is in Skissernas Museum, Lund.

22. Otto G. Carlsund, 'Byggnadens konstnärliga utsmyckning' (The Artistic Decoration of Buildings), *Byggmästaren* 1947:10, p.149.

23. Per Bjurström, *Nationalmuseum 1792–1992*, p. 274.

24. Teddy Brunius, *Baertling. Mannen. Verket.* (Baertling. The Man. The Work.) SAK Publikation 99, 1990, p. 131.

25. Gotthard Johansson, 'Perspektiv på 40-talet' (Perspective on the 40s), *Svenska Dagbladet*, May 10, 1951.

26. 'Färg över stan? – en enkät' (Color for the City? An Inquiry), *Konstrevy* 1954:2, pp.78–9.

27. Karl G. (Pontus) Hultén, 'Syntes mellan konstarterna eller En dålig idé' (Synthesis between genre), *Byggmästaren* 1957, pp. 73–4.

28. On 'The Tangle' ('Tufsen'), see: Sven Sandström, 'Konsten i det öppna rummet' (Art in Open Space), *Konstverkens liv i offentlig miljö* (The Life of Artworks in Public Environments). SAK publikation 91, 1982, pp. 23–5.

29. Lars Göran Oredson has characterized this type of painting as 'classical heroic poems in overalls'. See Lars-Göran Oredsson, *Rumsbildning. Om Lennart Rodhes arbete med Paket i långa banor i Östersunds posthus* (Shaping Space. On Lennart Rodhe's Work on 'Lots of Parcels' in Östersund Post Office), 1991, p.16.

30. See Thérèse Burollet, 'Prolégomènes à l'étude du mur républicain', *Le triomphe des mairies. Grands décors républicains à Paris 1870–1914*, Musée du Petit Palais 1986–87, Paris 1986, pp. 33–35.

31. Küllike Montgomery, *Torsten Billman*, 1986, p. 100. Montgomery has pointed out that Billman had seen examples of Mexican mural painting in illustrated volumes in the home of the art collector Conrad Pinaeus.

JEFF WERNER

TURNPIKES AND BLIND ALLEYS

Modernism from the Perspective of the Provinces

77. Ivar Kamke, *Sleeping Model* (1915), private collection. For several reasons Kamke's work has never been in great favor with the historians of Modernism, and he has been effectively erased from the historical surveys. It is, however, part of the history of twentieth-century Swedish art, just as the Swedish Nationalist Socialist Nils Flyg is a part of Sweden's political history. How can we relate to our history if we cannot acquaint ourselves with it

78. Olle Bonniér, mural, 1954, in one of Svenska Bostäder's apartment houses in Vällingby. There are several Modernisms – each generation has proclaimed its own. The art critic Thomas Millroth was born in 1947, considered the year of the modernist breakthrough. He had his first important artistic experience in 1955, when he encountered this mural. In his book *Rum utan filial* (Room Without Branch) Millroth presents Concretism as the first Swedish Modernism

To envisage a good painter coming out of Sweden would be as absurd as imagining one from the tropics. So says Salvador Dalí, in Olle Granath's book *Another Light: Swedish Art after 1945*, in a chapter headed 'A Province in Transformation.'[1] The image of Sweden as a province, and the idea of Swedish art as provincial, have been a fundamental topic in Swedish art-historical writing.

The former director of Moderna Museet Granath (b.1940) tones down the contradiction between center and periphery. Isolation and provincialism are certainly not, he writes, a good alternative to the great traditions, but are even worse than the form of provincialism that involved 'a smaller cultural area surrendering to a stronger tradition and subordinating itself to its conventions of form and content.'[2] I concur with Granath about this. But the 'stronger tradition' we must not surrender to involves not only the form and content of art, but also those of art history. As long as we continue to tell the history of Swedish art according to the same model we use for its international counterpart, Swedish Modernism will look like a pale cousin from the countryside. This problem does not merely affect Modernism, of course, but also older art history. It gains its acuteness, however, from Modernism's preoccupation with capturing the present, or, as in avant-gardism, even to be *before* its time.

The history of Modernism is one of development. In the way it has been written, it concerns with the development of new formal languages, new techniques, new art forms, new exhibition institutions, etc. These have been written into the story of Modernism by being presented and accepted by important authorities in the art world. Authorities who exist in something they themselves have defined as the center. This center has both a geographical and a social position (certain galleries, certain countries, certain cities – certain circles of friends and acquaintances with specific class, gender and ethnic structures). What happens outside the center is seldom written into the story apart from as an exception, as otherwise the effect would be a shifting of the center.

ONE OR SEVERAL MODERNISMS?

Modernism is concerned with what is modern, what is new. Not very surprisingly, therefore, each new generation of artists during the modern age, the age that has been preoccupied with being modern, has, with the help of critics and historians portrayed its art as the most modern. This is particularly true of the avant-garde, which needs historians who later confirm that it was ahead of its time. As a consequence there are several 'Modernisms', each of which considers itself to be the first.

For the generation that encountered art for the first time at the turn of the last century, post-Impressionist art appeared as the first modern art.[3] The young critics, art historians and artists of the inter-war years associated the birth of Modernism with the Swedish pupils of Matisse, while those who had their first decisive encounter with art after the end of the Second World War thought they saw the birth of Swedish Modernism with the Concretist Group 'The Men of 1947'. The most recent generation to proclaim its own Modernism were the so-called Postmodernists in the 1980s, whether they defined the art of their own time as a radical new start or sought continuity by post-modernizing earlier artistic oeuvres, like Dick Bengtsson and Öyvind Fahlström.

THE BOOKS AND THE STORYTELLERS

A handful of Swedish art histories have been written that deal with the art of the twentieth century. Among the most widely distributed of these are Rolf Söderberg's *Swedish Art during the twentieth Century*, 1950. Gösta Lilja's *Swedish Painting during the twentieth Century: from Ernst Josephson to Max Walter Svanberg* of 1968 has, together with its companion study guide, also had a great influence, like the final part, written by Elisabeth Lidén and Sven Sandström, and published in 1974, of *Art in Sweden*, which was published in large editions and used as course reading for university classes in art history. In later years the same is also true of *The History of Swedish Art* (1986) in which Louise Lyberg discusses modern art. At the time of writing, the Swedish Public Art Association (SAK) is publishing three volumes entitled *Swedish Art during the twentieth Century*. The first, covering the period 1900-1947, is by Elisabeth Lidén.[4]

Rolf Söderberg's book has the most precedent-forming character. It was intended to form the 'third volume' of Henrik Cornell's *History of Swedish Art*, and was published in several editions until 1970.[5] The book is the first to deal exclusively with Swedish Modernism. Its selection and emphases, as well as the structure of its narrative, have had a major influence on the way Swedish Modernism has come to be regarded, and also upon the work of later authors.[6] Söderberg himself, who is a contemporary of 'The Men of 1947', represents a high Modernist view of art. The combination of an overarching story of development – the birth, struggle and triumph of Modernist art – with a large number of chronicle-like portraits is the internationally prevalent one. In 1968 an alternative to Söderberg arrived, though it confined itself to the field of painting, in the form of Lilja's *Swedish Art during the twentieth Century*. Gösta Lilja (b. 1922) is a qualified art historian who specializes in early Swedish Modernism, and was a curator of Norrköping Art Museum. He does not share Söderberg's ambitions of covering every artist – often one or two are chosen to stand for a whole tendency in art. In other words, his text is more recapitulatory. Another important difference is that Lilja places a much greater emphasis on indigenous continuity. Perhaps this is a result of his art-historical perspective, for continuity is a precondition of there being history, not merely chronicle; perhaps it is a sign that the times have changed. The internationalism of the late 1960s had widened the field of vision beyond the western world, and had raised the problem of the relation between center and periphery. Neither the 1890s nor the war years of the 1940s appear as such isolated periods as they do in Söderberg's book. The changed *Zeitgeist* is even more strongly expressed in the work of Elisabeth Lidén (b. 1939) and Sven Sandström (b. 1927), both qualified art historians. For the 1974 volume in the series *Art in Sweden*, they wrote the sections on 'Pictorial Art 1909–1945' and 'Art after 1945' respectively. Here art is set in relation to economic and social change. This book's strong contextualization gives less of an impression of chronicling,

even if a basic structure of that kind still remains. The socially committed art of the 1930s acquires considerable weight in the presentation. It was an art that gained increased interest through the political art of the day, in which realism was dominant. In retrospect it can be seen that the art of the late 1940s was not non-representational, either: 'Concretism only appears clear-cut by contrast with the dominant tendencies immediately before it. The current contained within itself both abstract tendencies and statements of a strongly depictive visual effect. What is clear-cut, however, is that it asserted the intrinsic ability of form to create articulated and adequate impressions without the aid of the motif.'[7]

Elisabeth Lidén's recently published *Sveriges konst 1900-talet* (The Art of Sweden in the Twentieth Century, Part One) is written in intimate dialogue with the book of twenty-five years earlier. The economic and social-historical sections are toned down, however, and this makes the book more chronicle-like, even though the selection of artists is more rigorous. August Strindberg, Ivan Aguéli and Hilma af Klint form the preamble. Af Klint is of particular interest. Her 'discovery' is one of the few rewritings of Swedish Modernism that have taken place. Lidén's book is also the first Swedish historical survey to make the assertion that with Postmodernism in the 1980s Modernism reached its end.[8]

E.NERMAN·10.

E.NERMAN S.ULLMAN K·RYD G·AMINOFF K·JANSSON L·ENGSTRÖM
A·NILSSON T.BJURSTRÖM T·ANDER B·SIMONSSON E·JOLIN
G.LUND I·GRÜNWALD G·SANDELS
A·CARLSSON-PERCY

"DE UNGA"

A History of Swedish Art is a clear example of the fact that it is hard to write a history of Swedish art that is not just a wearisome enumeration of artists but a coherent narrative. Auction house director Louise Lyberg (b. 1932) attaches a Swedish chronicle to the major fixed stars in the international art firmament (Matisse, Picasso, Rodin, etc.) There is no overarching narrative structure,[9] and the section on the modern period ends with the resigned statement in the Swedish edition: 'The development of twentieth century art has involved a constant process of disintegration and reintegration. One '-ism' has followed on the heels of another, and none has been as inactive and scorned as the one that has just been rejected. When new trends have appeared, old ones have been rediscovered and given new freshness.'[10]

The last decade has seen the launch of digital art histories. The technical and pedagogical form of these is tentative as yet, but the technology is opening up new possibilities. Moving pictures and sound, important features of modern art, can be reproduced. In addition, it is not necessary to choose whether the art is to be presented in biographical, chronological or thematic fashion. The narrative problem is solved (but is of course replaced by others). In 1997 Norrköping Art Museum and Moderna Museet, with Norstedts, published the CD-ROM *Swedish Modernism – the Will Forwards 1905–40*. Here it is the first appearance of the Fauvistes in Paris, not the first exhibition of the Swedish pupils of Matisse as De Unga (The Young Ones; Fig. 79) in Stockholm, that constitutes the birth of Modernism. The production is permeated by 'center-periphery' thinking – the technology is new but the content is traditional.

THE STRUCTURE OF THE MODERNIST STORY

In order to understand why it is so hard to produce a stimulating and engaging history of Swedish art, we must shift our attention away from the tellers and the stories to the structures that lie behind the narratives: the history of Swedish Modernism needs both

demarcations (chronological, geographical, selection-related, etc.) and generalizing operations (evolution, Swedish tradition, and the like).[11] By way of introduction it can be stated that it takes place against the background of international Modernism, which is in its turn a chronological section from general art history.[12] The demarcation varies, but in those surveys that have had the widest circulation (for example, those by Alfred Barr and Herbert Read), the birth of real Modernism is usually dated from the breakthrough of Fauvism and Cubism in the 1900s, with a pre-history that at least includes Cézanne, Gauguin and Van Gogh. Opinion is divided as to what extent we have seen the end of Modernism. In Sweden there is a large consensus for moving the birth of Modernism forward to 3 May 1909, the date on which De Unga opened its first exhibition in Hallin's art gallery on Drottninggatan in Stockholm. Though the works on display were created in the spirit of the Artists' Association, the exhibition has been viewed as a breath of fresh air from France, which blew away the Nordic 'twilight painting'.[13]

Almost all the chronological points of reference in Swedish art history indicate international influences. The most common years of emphasis are 1930, 1947 and 1958. 1930 has a paradoxical position in Swedish art history. Within the field of design and architecture the Stockholm Exhibition is connected with the definitive breakthrough of Modernism in Sweden, while in pictorial art it is associated with the deathblow for the most modernist art of the time – non-figurative painting – when Otto G. Carlsund's exhibition failed.[14] For this reason, 1947 is represented as the year of Concretism's delayed breakthrough. It is also the year when the immigrant surrealist painter Endre Nemes broke the hegemony of Gothenburg colorism and became director of the Valand Art College. The date has almost the same resonance in the historical literature as 1909. Where Moderna Museet is concerned, the historical literature talks about a time-span rather than a fixed date. But according to many, 1958 marks the beginning of a dynamic period in Swedish cultural life. 'At last Sweden had acquired a forum for international exhibitions and art debates, a forum which under the leadership of K.G. Hultén quickly put Sweden on the international art scene.'[15] Even before it was opened, the museum was associated in public opinion with international impulses. With words that have associations both with the eighteenth-century poet Bellman and with the artistic inflow, in 1956 Folke Holmér, curator of Liljevalchs Konsthall, described the site of the future museum as 'Skeppsholmen, caressed by fresh breezes, the archipelago island in Stockholm with the widest view of incoming vessels,' but also close to the Nationalmuseum, in other words, close to Swedish tradition.[16] The closer to the present we come, the less unanimity there is about which points in time brought important changes to Swedish art. The struggle for definitions is not yet over. For example, there is a disagreement about the extent to which the mid-1960s are a watershed period. Apolitical Postmodernism looked for sudden change at earlier stage, in connection with Neodadaism and Pop Art, while those who identify with 'progressive culture' now emphasize the politicization of art around 1965 and the return of realism as decisive.[17] The influence of the Vietnam War on the world of art is one example of an international impulse radically different in kind from those discussed above.

The geographical demarcations of the historical literature can be summed up as follows: to Swedish Modernism belongs everything that Swedish artists have done in Sweden and abroad, as well as what foreign artists resident in Sweden have done here. Emigré Swedish artists like Karl Isakson and Waldemar Sjölander are as much a part of Swedish Modernism as immigrants like Endre Nemes and Peter Weiss. Art history is generous – at least where Western Europe and North America are concerned. During the war years there are also strong tendencies to seek regional demarcations within the country. In the introduction to *Nutida Svenskt måleri – ny följd* (Contemporary Swedish Painting – New Series), the first edition of which was published in 1945, Nils Palmgren (1890–1955), art critic of several publications including the daily evening tabloid *Aftonbladet*, sketches a detailed picture of development from 1909 to his own time. In this he partly structures the artists according to landscape schools: the Scanian school of painters, the Halmstad group, the Gothenburg school, Norrland painting, Öland art, etc.

It was one way of bringing order to the multiplicity of artists and styles. Even though it has not been quite without followers, especially in regional art histories, in later surveys the region has been abandoned as a structural principle. It is hard to connect stylistic characteristics with adherence to geographical location. Most artists are moreover active in many different places, during different periods of their lives.

But not everything can be included between the covers of a book. Only a small number of all the active artists in Sweden can be mentioned by name in an art historical survey. It is probable that in Söderberg's art history only about two percent of the registered artists in Sweden during the first half of the century were included.[18] As the corps of artists has grown exponentially since then, in later works we are probably talking about a figure per thousand. Today there are said to be more living Swedish artists than dead ones. The exclusions that have subsequently taken place have, as indicated earlier, done so for stylistic reasons. Artists who have worked in ways that resemble the canon of international Modernism have been favored. Other reasons for exclusion concern genre and technique. Portrait painters have not been included,[19] and graphic artists have found it harder to be included than those who worked with unique art objects. There are also excluding and including structures that involve gender, ethnicity and regional affiliation. It seems clear that it has been an advantage to live in Stockholm, or to have good contacts with the city's art world, even though it is also possible to exploit alternatives (the Halmstad group, for example). The question of ethnicity is most acute during the late twentieth century, when immigrant artists have often had difficulty in finding the key to the Swedish art world, particularly if they come from Latin America, Africa or Asia. Thousands of artists of both sexes have fallen into oblivion. I know of no statistics relating to the numbers of practicing artists broken down by gender into male and female. But if one refers to earlier books, for example Palmgren's selection in *Contemporary Swedish Painting – New Series*, one finds a large number of female artists who disappeared from later presentations and who today are unknown; Beth Zeeh, Greta Gerell and Laila Prytz, to name but a few.[20] In Olle Granath's *Swedish Art After 1945* the proportion of female artists is 10%, and in Louise Lyberg's section of *A History of Swedish Art* it is 10.5%.[21] In the most recently published work, Elisabeth Lidén's *Sveriges konst 1900-talet* (The Art of Sweden in the Twentieth Century, Part One) 1900–1947 the proportion of Swedish female artists mentioned in the text is approximately 17%. Exclusions of portrait artists and artists whose work is executed in 'outdated' styles may be assumed to have reduced the proportion of female artists in the surveys.

The discourse of Modernism is strictly gender-hierarchical. Modern art is often described as 'masculine,' in a positive sense. This is true of the earliest writings on the subject. For example, Pär Lagerkvist gives prominence to the new art as being 'virile,' in contrast to decadent, feminine symbolism.[22] The surveys contain recurrent characterizations of rugged, virile modernists, often taken from art criticism.

In order to keep the narrative together, generalizing operations are required. I introduced this text by stating that art history is written as a story of development. Where Modernism is concerned it has been able to formulate it as a development towards abstraction, the liberation of color, or surface orientation. The way in which the development is viewed has been dependent on the angle of vision adopted by the historian. If one stood on the 1950s art scene, with works by Olle Bonniér (Fig. 78) and Olle Baertling around one, Modernism looked like a striving for abstraction, something that was not felt to be so relevant to those who were surrounded by the 'brigade painting' of the 1970s. There is a conflict between being consistent and being up-to-date. The modern artist must work in a style that is part of the age. It must also be in his own style. Working in someone else's style is not looked on kindly in our time. One important reason why a painting by Baertling is good is that it is made in Baertling's personal style, which he worked on consistently over a long time. If the painting we have just admired turns out to have been done by someone else in *Baertling's style*, we soon lose interest. The dating is a proof that the painting is of its time. A plane geometrical painting of the 1920s is of great interest, but one dating from the 1980s is not, unless it paraphrases the former in a postmodernist manner. Artists who are consistent, and purposefully work in their

own personal style all their lives, consequently risk becoming less and less interesting the further and deeper they penetrate their own thematic world. A paradoxical solution resorted to under Modernism has been to lift art out of the current of time, and like Baertling, attempt to create an art that is timeless (Fig. 80).

One way to rescue Swedish Modernism from being merely a form of retardation is to emphasize features that distinguish it from international developments. A common theme that recurs in all the books under discussion here is that impulses have been received from outside, but have been shaped into something distinctive and good in the encounter with the Swedish tradition. But every time this encounter takes place a new road of development is created, one that does not follow the highway of international Modernism. From the point of view of general art history, therefore, every distinctively Swedish stylistic development is a cul-de-sac. And sooner or later Swedish art history has to drive out on to the modernist highway again.

The utmost example of quintessential Swedish art of the twentieth century is Naivism.[23] In 1948 Nils Palmgren described naivism as 'a trend with a distinctively Swedish tone.'[24] 'No other country can show anything like it,' wrote Gösta Lilja twenty years later.[25] In 1974 Elisabeth Lidén stated that naivism was 'one of our country's most popular and most genuine forms of art.'[26] With his strong sympathy for Concretism, Rolf Söderberg has a more ambivalent relation to naivism.[27] For him, it is connected with isolation and provincialism and is, like the New Objectivity, an anti-modernist movement. Herbert Read's influential *History of Modern Painting* (1960) lends support to Söderberg's approach. Read does not class as modernists naivists and artists who work in a realist style. Douanier Rousseau is therefore not included in his survey, and neither are Edward Hopper, Balthus, Stanley Spencer or Diego Rivera.[28] That the most genuinely Swedish twentieth-century art is, from a high Modernist perspective, not a part of Modernism, is not, however, something that troubles later generations of historians. Particularly not after the return of realism in the 1960s.

Another constant theme in the history is that Cubism never really gained a foothold in Sweden, and that in the case of most artists one can at best speak of a 'cubicization' of motifs. This is generally portrayed as a defect. The absence of Cubism means that Modernism never really got started, as Cubism is an important link in its development. In the historical literature on international Modernism the idea of development was given a leading priority, for example the double-lane road towards abstraction: from Cubism through Mondrian to Neoplasticism, or from Expressionism through Kandinsky to Abstract Expressionism in various forms. But it is not necessary or self-evident to see nonrepresentational art as the result of a developmental chain, something the painting of Hilma af Klint clearly demonstrates.

MODERNISM IS A STORY OF CONTRADICTIONS

During the last decade international scholarship has taken an interest in those parts of the history of twentieth-century art that are not Modernism: the realist tradition in the USA and England, the traditionalism of the inter-war period and the art of the totalitarian states. A much more complex and interesting picture of the past century has begun to emerge. In Sweden not much has been done in this field, especially where pictorial art is concerned, not even the definition of what Swedish Modernism is, something that is still unclear. Sometimes the Expressionism, Naivism and Intimism of the inter-war years are excluded, but they can also be seen as one of the aspects of a multi-faceted Modernism. The experience of nature, or of the conflict of the individual with the collective, is after all based in a modern experience. Nostalgia can be an expression of modernity, rather than a reaction against it. It is therefore with good reason that one may count as Modernist all art that catches, expresses or affirms the sense of modernity. This does not mean that all twentieth-century art is Modernist. As an extreme example, there is art that has come into being in environments that have not been sucked into the whirlpools of modern society. Some 'outsider art' may belong here, along with art from long-isolated sects. But there is also art that very consciously turns against everything that pertains to modern art and the

80. Olle Baertling
Iru, 1958
Moderna Museet

modern world, that does not avail itself of modernist technique or composition, of modern motifs or effective resources. There are as far as I can see no compelling reasons for classifying the art of Ivar Kamke as Modernism. He is, however, as one of the most successful Swedish artists of the inter-war period, an important part of the history of Swedish art. And significantly he is missing from the surveys discussed here (Fig. 77).[29]

Against the background of this discussion of narratives and structures, inclusions and exclusions, highways and cul-de-sacs, it is my view that the story of Modernism must be written as a story of contradictions, for Modernism is in itself, on its most fundamental level, deeply contradictory. Every attempt to present it as simple, homo-geneous and unified is to fabricate a lie. In spite of the fact that Modernism has a passion for the present, for innovations, revolutions and confrontations, it is written into a continuity where it becomes just one tradition among others. Perhaps, with Antoine Compagnon, we ought to ask ourselves if the true history of modernity is not really that of the ideas that ended in nothing.[30] The history of twentieth-century Swedish art has become a synonym for the history of Modernism. Rarely has the cliché that it is the victor who writes history proved to be more true. The hegemony of Modernism is so complete that it is hard to imagine what a *different* history would look like. In this connection Postmodernism has not offered any new perspective. On the contrary, the critics who established themselves during the 1980s have an even narrower view of Swedish Modernism in relation to the question of which perspectives, oeuvres and trends are of interest. In this context, Moderna Museet is symptomatic. Today the museum's task is, among other things, to display twentieth-century painting and sculpture. Nowhere is it stated that the art of Modernism should be exclusively dealt with, but this seems to have been a foregone conclusion during the museum's entire history. In architecture the situation is different, as anyone can see that the architecture that surrounds us does not coincide with that recorded in the surveys of Modernism. The worst thing about the identification of the history of Modernism with the history of the twentieth century is not that a large number of interesting oeuvres and artworks are forgotten, but that it has given a distorted perspective on history. Of course the historian must make a narrow selection, and only exemplify or discuss a small portion of all the art that has been produced. If, however, the selection one makes is not representative of the art that has been put on display, acclaimed and discussed by its own time, our chances of under-standing the twentieth century are extremely small. It may very well be that art of the non-modernistic kind is worse, more ugly and depressing, but it is hard to know, as we cannot see it in any museum or book. My objection concerns not questions of taste, but the way in which history is written. How would it look if in political history we weeded out anything that was not to our taste? Erased Josef Stalin, the Swedish extradition of Balts to the Soviet Union after World War II, and the controversial politician of 'New Democracy' Ian Wachtmeiser from our history books?

THE WAY OUT OF PROVINCIALISM

The logic of adaption leads to a provincial perspective in spite of, or because of, the emphasis it puts on international impulses. To widen the field of vision something other than Modernism's evolutionary center–periphery thinking is needed. The modernistic hierarchies concerning genre, technique, gender and ethnicity must be broken up.

At the same time as the general history of Modernism has been formulated during the past century, it has acquired a certain degree of routine acceptance in canonized works, and a narrative that unites them. No matter which gallery in the world one visits, one encounters the same artists and the same story. The hegemony of the modernistic canon has led to erasure. When Cindy Sherman visited Gothenburg Art Museum, in

81. Ivar Arosenius
Intoxication, 1906
Gothenburg Art Museum

connection with her award of the Hasselblad Prize, she fastened on the Ivar Arosenius collection (Fig. 81). This provincial art, when placed alongside the international currents, may looks surprising as it does not resemble the canonized painting. And what if Salvador Dalí was wrong? In the global art world there are influential artists from both the tropics and Sweden. This change in contemporary artistic life will hopefully lead to new perspectives on the art of the twentieth century, and different narratives about it.

NOTES

1. Olle Granath, *Svensk konst efter 1945* (Another Light: Swedish Art After 1945), 1975 p.6. The book exists in several editions in Swedish and English, with various formats and certain changes in the text.

2. Granath, 1975, p.6.

3. See for example, August Brunius, *Färg och form* (Color and Form), 1913.

4. The two following parts, by Beate Sydhoff and Mårten Castenfors, had not been published when this text was written. This also applies to Folke Edwards' book *Från modernism till postmodernism, Svensk konst 1900–2000* (From Modernism to Postmodernism), published by Signums förlag.

5. According to the preface to the 1970 edition. The first edition was written in 1948 and published in 1950. Söderberg 1970, p.5.

6. Lidén refers to Söderberg in her introduction. Elisabeth Lidén, *Sveriges konst 1900-talet, del 1 1900–1947* (Swedish Art of the Twentieth Century vol. 1 1900–1947), SAK publikation 108, 1999, p.7. For reasons of space I cannot deal with Söderberg's precursors. For example Ragnar Hoppe (ed.) *Nutida svenskt måleri* (Contemporary Swedish Painting), 1936, 1940 and 1948, a wide-ranging introductory history of modern art, and Nils Palmgren (ed.) *Nutida svenskt måleri – ny följd* (Contemporary Swedish Painting – New Series) 1945 and 1948. Historical surveys of Swedish art have generally tried to follow the development of art to the present day. One example is Andreas Lindblom, *Sveriges konsthistoria, tredje delen. Från Gustav III till våra dagar* (A History of Swedish Art, Part Three. From Gustav III To Our Own Day), Stockholm 1946, which also covers modern design, including that of automobiles. Another most interesting work where questions of selection are concerned is *Svensk konstkrönika under 100 år,* (Swedish Art Chronicle of 100 years) Ragnar Josephson (ed.), 1944.

7. Sven Sandström, *Konsten i Sverige. 1900-talets konst* (Art in Sweden, The Art of the twentieth Century), 1988 (1974), vol.2, p.400.

8. Lidén, 1999, p.7.

9. By narrative structures I mean the underlying patterns, including the generalizing operations that are performed in the text. In art history they concern for example the story's beginning and end, its overarching theme and dramaturgy, as well as the use of e.g. rhetorical figures. A study of the narrative structures involves posing the questions of how the history is conceived and reported in the center. The art historian shapes the material, whether he/she is conscious of this or not, through the choice of narrative structures.

10. Lyberg, 1984, p.475.

11. Herbert Read discusses the principles behind the writing of art history in the introduction to his book on modern sculpture: Herbert Read, *Modern Sculpture: A Concise History*, 1964, p.9.

12. For an analytical discussion of the creation of a general art history, see: Dan Karlholm, 'Handböckerna i konsthistoria: om skapandet av "allmän konsthistoria" i Tyskland under 1800-talet' (Handbooks in Art History:

On the Creation of 'General Art History' in Germany during the nineteenth Century) (diss.)1996.

13. Internationalism was already an important aspect in reception by contemporary opinion, for both adherents and opponents of the new art. See Gösta Lilja, 'Det moderna måleriet i svensk kritik 1905–1914,' (diss.) 1955.

14. The relevance of these two ideas can be and has been called into question. Re Carlsund's exhibition, see: Lidén, 1999, p. 104.

15. Lyberg, 1984, p. 457.

16. Folke Holmér, 'Förord till den svenska upplagan' (Preface to the Swedish Edition) in *Den moderna konstens mästare* (Masters of Modern Art), Alfred Barr Jr. (ed.), 1956, p.7.

17. For reasons of space, I cannot discuss Bengt Olvång's interesting *Våga se! Svensk konst 1945–1980* (Dare to See! Swedish Art 1945–1980), 1983. It is written as a polemical debate with Olle Granath, among others, and emphasizes the importance of politicization and the return of realism to Swedish art.

18. According to Söderberg himself, he has included about 200 of the 10,000 registered artists during the time in question (1900–1950).

19. For a discussion of the status of portrait art under Modernism, see Jeff Werner, *Nils Nilsson* (diss.) 1997, pp.152–4. That portrait artists were not included is explicitly stated by Ragnar Hoppe in *Nutida svensk konst* (Contemporary Swedish Art), 1948, vol.1, p.5.

20. See for example the comparison between art-historical surveys and *Svenskt Porträttgalleri* in Lena Johannesson, '... Och Karl Nordström hade en duktig fru' (... And Karl Nordström had an accomplished wife) in *Kvinnor som konstnärer* (Women as Artists) Anna Lena Lindberg and Barbro Werkmäster (eds.), 1975.

21. Eva Knuts, 'Det har blivit bättre...: en undersökande uppsats om kvinnliga konstnärer i Sverige' (It has improved... an investigative study of women artists in Sweden.) University of Gothenburg, autumn 1999.

22. Pär Lagerkvist, 1913, p.43.

23. The expression *äktsvensk* (quintessentially Swedish) is Lyberg's own. Lyberg, 1984, p. 427.

24. Nils Palmgren in *Nutida svensk konst – ny följd* 1948, p. xxxv.

25. Gösta Lilja, *Svenskt måleri under 1900-talet: från Ernst Josephson till Max Walter Svanberg* (Swedish Painting during the Twentieth Century: from Ernst Josephson to Max Walter Svanberg, 1968), p. 70.

26. Elisabeth Lidén, 1981 (1974), p. 51.

27. Rolf Söderberg, *Den svenska konsten under 1900-talet*, 1950, pp. 75-85.

28. They are mentioned in the book only as examples of non-Modernism. See further in the preface to the book. Herbert Read, *History of Modern Painting*, 1960. The English edition is still available.

29. In addition to stylistic and genre-related reasons for exclusion, there have probably also been political ones.

30. Antoine Compagnon, *The Five Paradoxes of Modernity*, 1994 (1990), pp.44–5.

SHULAMITH BEHR

DIFFERENCING MODERNISM

Swedish Women Artists in Early Twentieth-Century Avant-Garde Culture

Mrs Hjertström-Grünewald I do not even consider. For her work is complete idiocy. She has her models in the Eugenia Home for the Disabled and seems to possess a perverted longing for malformations. I swear to God that there is nothing artistic in her idiotic doodles. Let me confirm that her attempts are *humbug*. Her colours are ugly and thin and foolishly coquettish. Her husband's colours are also thin but coquettish in an intelligent manner.[1]

82. Sigrid Hjertén
The Red Blind, 1916
Moderna Museet [no.2]

In this extract, the art critic Albert Engström revealed the tremendous prejudice women artists encountered in the early twentieth century. In May 1918, Sigrid Hjertén (1885–1948; Mrs Hjertström-Grünewald) contributed a sizeable collection of 168 works to the important Expressionist Exhibition held at Liljevalchs Konsthall (Fig. 83). Engström dismissed her figural works as reliant on deformed or disfigured models. Her drawing was regarded as 'idiotic doodles' and her colour application as superficial. However, this attribution of deviance from the norm, as well as of lunacy to her works, was not limited to Hjertén. Indeed, the conservative press virulently rejected Grünewald's 'decadence' and the prolific nature of his oeuvre exhibited at the Expressionist exhibition.[2] Instead of conveying an aura of traditional art, the multitude of images drawn from modern life reminded the critic Thor Thörnblad of the processes of mass production.[3] Yet, the association drawn in these instances between modernism, modernity and notions of 'degeneracy' was not a totally new phenomenon.

Between 1890 and 1920, the period in which women artists became increasingly visible in the public sphere, conservative critical reception viewed the modern art world as an attack on the social body. The ideas propounded by the Hungarian-born physician and art historian Max Nordau were well circulated in Sweden through frequent reissues of his book *Entartung* (Degeneracy), published in two volumes between 1892 and 1893.[4] In this text, he employed terminology evolved within the legal and medical disciplines, equating modern stylistic tendencies with criminality and hysteria. Indeed, in dedicating his book to the Turin based anthropologist and psychiatrist Cesare Lombroso, Nordau

declared that 'degenerates are not always criminals, prostitutes, anarchists and pronounced lunatics; they are often authors and artists.'[5] Such terminology entered the language and became common to the rhetoric of both the detractors and supporters of Modernism. In an article in 1915, the Swedish psychiatrist Bror Gadelius disparagingly associated Expressionism with insanity and schizophrenia.[6]

Interestingly, however, the well-known psychiatrist and pacifist Dr Poul Bjerre, who was responsible for introducing Freud's theories into Sweden, patronised the Russian artist Vasily Kandinsky during his visit to Stockholm in 1916.[7] Bjerre was intrigued by parapsychology and hypnosis and also sought the possibility of interpreting the relationship between representation and abstraction from a psychoanalytical viewpoint. The presence of Hjertén and Grünewald at a gathering for Kandinsky at the home of Dr Bjerre on February 12, 1916 points to the importance of this modern discipline within their social milieu. The couple's interest in the work of outsiders, such as those of the insane artist Ernst Josephson,[8] possibly encouraged Hjertén to transpose a more routine preparatory study *The Red Interior* of 1916 into the departure for the radical painting *The Red Blind* of the same year (Fig. 82). As in the compositions of Josephson, the figure is turned towards the flattened picture plane and the radiating spokes of artificial light spreading out from the lamp are similar to those surrounding the apparitions in his paintings.[9] Here too Hjertén deploys the female body as the departure for modern picture making, appropriating this discourse from male avant-garde practice. Yet, at the same time, the unexpected disproportion and deformity of the body parody the tradition and raise issues of ambivalent desire, eroticism and sexuality, which subvert the mastering and controlling gaze.[10]

While nowadays these transgressions of masculine normative practice are viewed as constituting powerful contributions to early modernist painting, it is clear from Engström's review above that he aligned Hjertén with the dilettante. She could only impersonate ('dumt kokett') Isaac Grünewald's sensitive creativity ('intelligent kokett'). While bearing likeness, her work was also considered unlike her husband's – 'humbug'. The notion of *différance*, as espoused by the cultural philosopher Jacques Derrida, well characterises the movement of signification that welds together difference and deferral, 'presence-absence' that typified women artists' relationship to modernism.[11] Only isolated critics, such as August Brunius,[12] reviewed their contribution favorably, other male critics lacking the experience and vocabulary to assess this phenomenon of the emergent 'new woman.'[13] From its inception then and over the century, the critical discourse on modernism was explicitly gendered, harbouring the paradigm of male artistic genius.[14] Though absent from and unacknowledged in this narrative, modernism's 'Other' was a volatile presence, one that embraced the implications of modernity and the conflicting challenges of pre-emancipation womanhood.

How did women artists negotiate this precarious existence within the structures of

83. Sigrid Hjertén's wall at the so-called 'Expressionist Exhibition' at Liljevalchs Konsthall in Stockholm, 1918

early avant-garde culture? While the term avant-garde implies the acceptance of a progressive, modern cultural identity, its meanings have been inscribed primarily through the male artistic canon. Indeed, the semantic definitions offered by the cultural historian Peter Bürger in his *Theory of the Avant-Garde*, whereby he differentiates chronologically between an aestheticist-orientated avant-garde and that which altered the praxis and institutions of art, exclude consideration of gendered identity.[15] Given women's lack of political voice and their tenuous role, the feminist art historian Susan Suleiman regards the historical status of the female practitioner as one of 'double marginality,' viewed by patriarchal society as incompatible with professional commitment and regarded as peripheral within avant-garde communities.[16] Indeed, in Sweden, a conservative attitude was apparent in the policies of vanguard associations. De Unga (The Yong Ones), for instance, a group to whom the term Expressionist was first applied in 1911, only allowed male membership when it was established in 1907 (Fig. 79). However, in 1910, women artists responded by founding their own exhibiting and support group, the Svenska konstnärinnors förening (Association of Swedish Women Artists).[17] Even if not directly active in feminist and socialist circles, women practitioners were informed by a milieu in which social, economic and sexual reform was publicly addressed. The process of democratisation was speeded up once the Swedish Social Democratic Party won the second chamber election in 1907.

The professional status of artists underwent immense transformation during the 1890s, as they rejected the traditional channels of training in state academies in favour of the studios of progressive and established mentors. Women artists too, who were allowed access to academic training in Sweden,[18] preferred the cosmopolitan and liberating ambience of private studio tuition in Paris, Munich or Düsseldorf. Travel provided both a release from the strictures of bourgeois society and the experience abroad of avant-garde subcultures and metropolitan life. In the meantime, debates in Sweden over sexuality and related issues like prostitution, free love, contraception and abortion were especially lively around 1910. Evidently, the regulation of women's bodies was closely linked to matters of morality, class, race and nation.[19] As will be seen, this ironic conjunction/disjunction between relative emancipation and legislative surveillance appears to inform the ways in which women artists configured and embodied the spaces of modernity in their works.[20] Before considering specific examples, however, it is instructive to outline the equivocal status and debates surrounding the so-called 'woman question' during the first two decades of the twentieth century.

MATERNALIST POLITICS, INVENTING TRADITIONS OF MODERNISM AND WOMEN'S CULTURE

While Sweden remained neutral during the First World War, it did not follow Norway in 1913 or Denmark in 1915 in enfranchising women, but joined Austria, Luxembourg, Great Britain and Germany in doing so in 1919.[21] In 1921, the new reformed constitution allowed men and women to vote in free elections for the first time. Although the women's movement had been active since the mid nineteenth century, the articulation of feminism in Swedish debates was highlighted by the novelist, dramatist and polemicist Frida Steenhoff (1865–1945) in her 1903 lecture 'Feminismens moral,' (The Moral of Feminism) which publicised her ideas on social equality, sexual reform and social welfare.[22] Neither contemporary feminists nor the Social Democrats were in agreement with Steenhoff's support of birth control and, indeed, the so-called 'contraceptive law', which prohibited contraceptive propaganda, was debated in parliament in 1910.[23] In order to subvert the impact of this law, the journalist and agitator Hinke Bergegren (1861–1936) formed the association called Sällskapet för humanitär barnalstring (Society for Humanitarian Procreation), which sought to provide advice about contraception and to improve the conditions of unmarried mothers.[24]

Less radical, though no less influential, were the views of the Swedish women's rights advocate and writer Ellen Key (1849–1926), who was based in Stockholm from

1880 onwards. Between 1883 and 1903 she gave weekly lectures on feminism, social reform and educational issues at the Workers' Institute in Stockholm. Her well-known book *Barnets århundrade* (The Century of the Child), published in 1900, argued against child labour and in favour of children's welfare and rights. Education was regarded as a key element of achieving equal rights for boys and girls. This and a more flexible and creative curriculum should cater for the child's individual talents and needs. Key's emphasis on the crucial role of motherhood in facilitating these utopian ideals was reliant on eugenic and Social Darwinist ideas that were so much part of national aspirations and race romanticism at the turn of the century. Having as few impediments as possible to the processes of natural selection were regarded as a way of preserving a culturally progressive people from downfall and race degeneration.

Key's more controversial views on sexual ethics and her defence of women's property rights compensated for the questionable reduction of female virtues to that of 'spiritual motherhood', which she regarded as women's principal career. In her 1903 book *Livslinjer I: Kärleken och äktenskapet* (Lifelines 1: Love and Marriage), she attacked conventional expectations of marriage and sexual roles, stressing that love was the only moral criterion. It is understandable that Key's patronage of women artists would not extend to modernists, Hanna Hirsch Pauli's fine realistic pastel rendering of *Ellen Key in the Stockholm's Workers' Institute* being more sympathetic to the conservative reformist aims of the patron.[25] Yet, as Hjördis Levin suggests, the debates outlined above reveal clear signs of the development of new patterns of reproduction, sexual and family relationships.[26] Traditional marriage, with reproduction and inheritance as its focus, was replaced by a new pattern of sexuality that stressed the importance of health, pleasure, sexual attraction, birth control and heredity. The transition involved a shift from a pre-industrialised to a consumer society, which, clearly, had a bearing on women artists' construction of cultural identity.

On the whole, of those women who were considered modernist, most derived from the upper middle class. Hjertén was in the minority in combining a lengthier marriage with an artistic career. While her relationship with Grünewald may have proved mutually conducive at the outset,[27] during the 1920s she unwittingly revealed the conflicts that arose between family commitments and her chosen profession: 'I do not paint very much nowadays ... I concern myself with my husband's work. His successes, setbacks, dreams and struggles are mine and, besides, I have our son and the household. That is enough and I am happy with it. Now when I paint it is mostly for pleasure.'[28] Vera Nilsson (1888–1979), Mollie Faustman (1883–1966) and Siri Derkert (1883–1966) led unusual lives for the time, Nilsson and Derkert bearing children outside marriage. This was not an easy choice, since Derkert, as an unwed mother, was forced to give birth to one of her daughters in Denmark in 1918.[29] Her marriage to the artist Bertil Lybeck, the father of her daughters Liv and Sara, lasted from 1921 until 1925.

Evidently, their choice of unconventional life-styles made these women artists' prime candidates for avant-garde activities, their relative independence being assisted by the emergence of notable private dealers and exhibiting outlets in the rapidly expanding urban centres.[30] They embraced the technical radicalism associated with Parisian modernism. Hjertén, Faustman and Maj Bring (1880–1971) benefited from their pre-war sojourns as students in the studio of Matisse, in particular in painting directly from the model without preliminary studies. In his studio, the primary use of colour was encouraged but not at the expense of form. By this stage, Matisse had passed his Fauvist outburst and his treatise *Notes d'un peintre*, published in 1908, proclaimed the superiority and the harmony of the aesthetic process over verisimilitude.[31] Hjertén took aspects of his theoretical argument, in particular the function of line and ornament, further in her essay 'Modern och österländsk konst', published in 1911.[32] Furthermore, in the same year, she demonstrated her familiarity with major trends in early Modernism by publishing the first biography of Cézanne in the Swedish press.[33] Faustman too invaded the spaces of male culture by taking on the role of art critic for the cultural journal *Ares* from October 1921 until September 1922.[34]

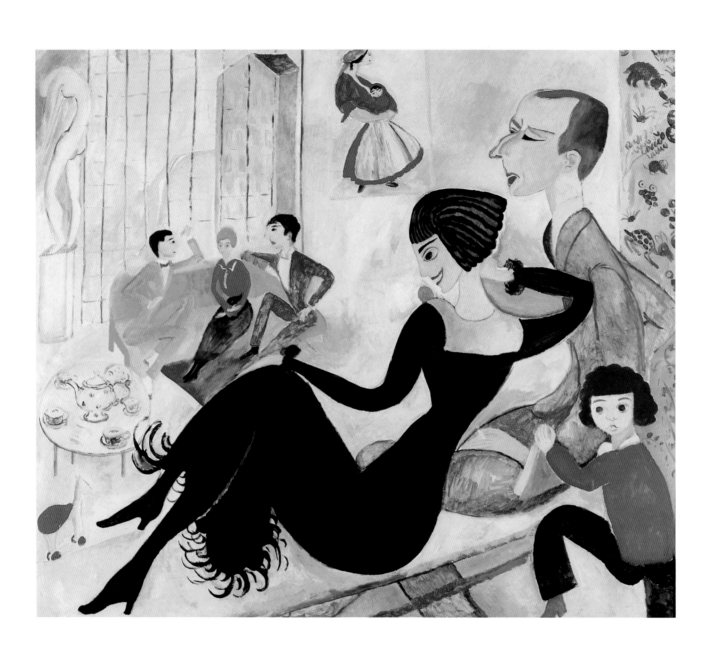

84. Sigrid Hjertén
Studio Interior, 1917
Moderna Museet

85. Sigrid Hjertén
Harvesting Machines, 1915
Moderna Museet [no.8]

86. Agnes Cleve
Fire in New York, 1916
Per Ekström Museum [no.28]

In Paris, Lilly Rydström-Wickelberg (1891–1957), Agnes Cleve (1876–1951) and Nilsson followed a different route in Le Fauconnier's studio *La Palette*. They were trained to draw from the model, observing and stressing the fundamental, geometric shapes akin to Cubist formal analysis. Between 1913 and 1914, Derkert studied in Marie Vasilieff's studio, where Léger was one of the teachers. In landscapes, still-lives and portraits painted in Italy in 1915-16, Derkert subtly adapted Cubist devices to the domestic sphere. Her *Still Life with Teapot* (Fig. 88) reinvigorates the genre by juxtaposing the tilted tabletop with landscape motifs, the shifting quasi-geometric facets and shaded tonalities providing a floating, undulating surface.[35] Agnes Cleve's contemporary painting *Fire in New York* of 1916 (Fig. 86) similarly draws on Cubo-futurist compositional elements. However, the tonalities are combined with a stronger variation of Fauvist-like color accents, which naturalise and disintegrate the rectangular verticality of the skyscrapers.

Here, modernity is reinscribed not from the viewpoint of the *flâneur* or invisible *flâneuse*, but from the perspective of a studio or domestic window. Characteristic of avant-garde practice, the experience of the city serves as a vehicle to explore the autonomy of picture formation. Similarly, Hjertén's paintings of central Stockholm, such as *Harvesting Machines*, 1915 (Fig. 85), are usually aerial views painted from the window of the combined studio and residential interior. The flattened portrayal of the quay and rail-tracks are separated from the rollers, the circular accents of which contribute to the ornamental quality of the scene. At one and the same time, the city landscape is distanced conceptually but placed within hand's reach by virtue of its vivid surface treatment and coloration. It is as if control of these public spaces could only be made more palpable by viewing them from the distance of the domestic sphere.

While Hjertén does on occasion render the spectacle of city-life and entertainment, as in *På teatern* 1915 (At the Theater), the figures devoted most attention are invariably images of her husband, child, self-portraits, extended family or colleagues from their social milieu. Critics noticed this tendency in her works and commented: 'Mrs Sigrid Hjertén Grünewald seems to adore her husband. He appears on every other of her paintings. At balls, at home and at the theatre.'[36] In other words, it is not the fugitive glimpse of the city and its furtive inhabitants that provided the departure for her works but the paralleling of the public venue with personal social performance. In the back- and foreground of the *Studio Interior* of 1917 (Fig. 84), the figures of Isaac Grünewald and Nils Dardel are portrayed as narrow-waisted, suit-clad dandies, possessing the type of body culture associated with decadence by conservative critics. By contemporary standards, moral judgement of these fashionable people would deem them foreign and bewildering elements in society and Hjertén exaggerates their difference.

This discourse of morality and fashion in Modernism is nowhere better represented than in Hjertén's oeuvre.[37] Evidently, her initial training in the applied arts and fashion design prepared her for contemporary debates on the relevance of 'primitive', folk and oriental ornamentation to modern painting. Indeed, her porcelain ware exhibited at the Expressionist Exhibition in 1918 received a favourable review by the critic of the *Socialdemokraten* and he commented: 'Mrs Hjertén would seem to be most interesting on account of her attempts to make use of expressionist ideals for tableware.'[38] It is revealing that socialists regarded avant-garde efforts to model life around art as equivalent to their policies of reform. Between 1918 and 1921, Derkert also designed and marketed fashion-ware for the Birgitta School when she returned to Stockholm (see Fig. 87). While this was equally the consequence of economic necessity, her engagement in the world of fashion was symptomatic both of modern female identity and of interaction with consumer culture.[39]

These artists' positioning of their femininity in relation to modernity extended to representations of their children in the domestic sphere. In numerous works of this period Hjertén repeatedly depicted her son Ivan as model and as the object of much indulgence by his parents. Clothed in his fashionable sailor suit, his image adorns

87. Siri Derkert
Fashion design, 1917–21
Private collection [no. 168]

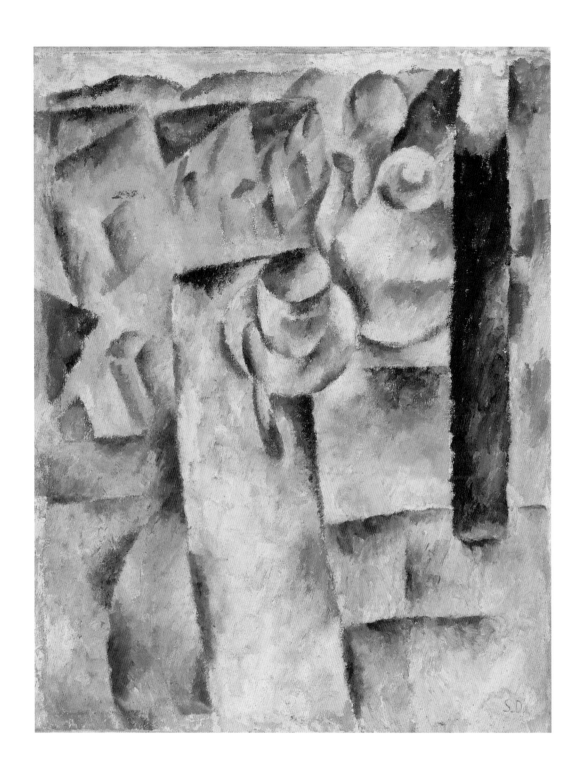

88. Siri Derkert
Still Life with Teapot, 1915
Moderna Museet [no.26]

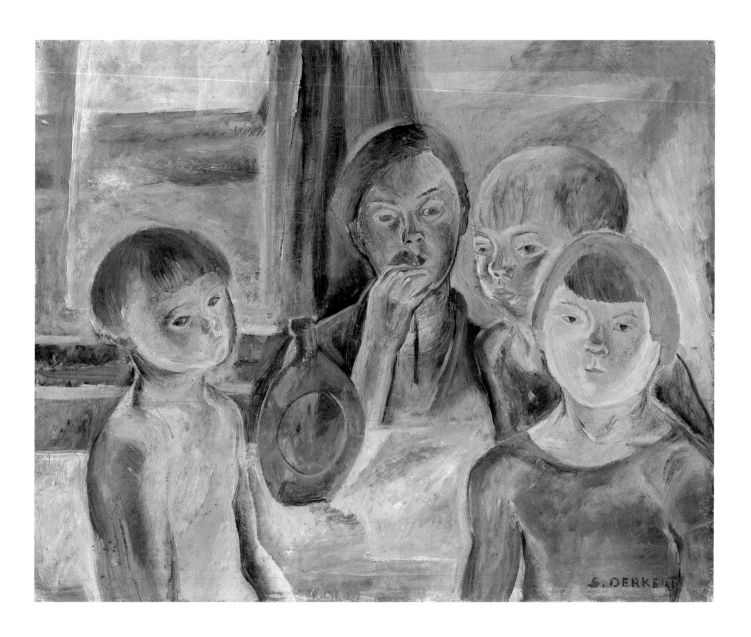

89. Siri Derkert
Children around a Table, 1927
Private collection

90. Vera Nilsson
Grandmother and Little Girl
1925. Moderna Museet [no.19]

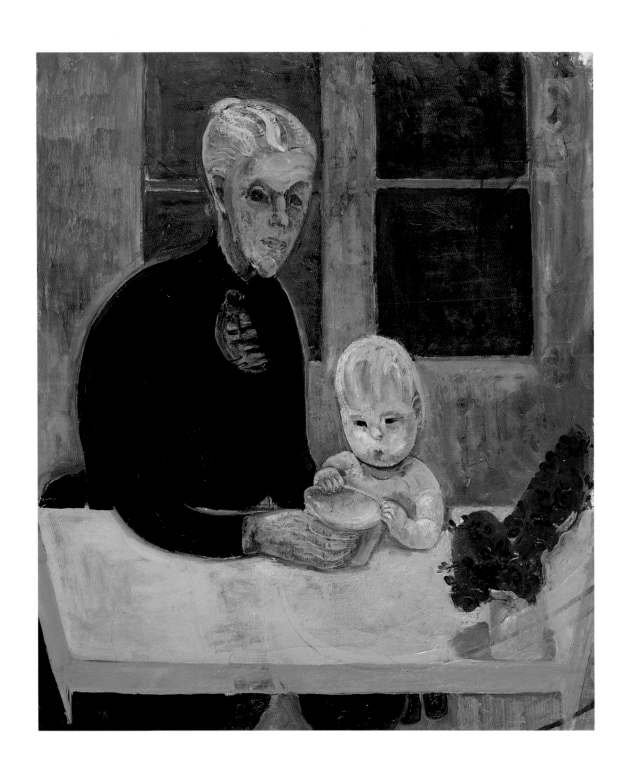

various portrayals of the studio interior. From a sociological viewpoint, these works reveal much about the effects of birth control on family life and of the upbringing of the single child. As in Ellen Key's recommendations outlined above, discipline is non-evident, primacy being given to the child's individuality and stages of development. Derkert turned to portrayals of her children during the 1920s and 1930s, her *Children around a Table* of 1927 (Fig. 89) including depictions of her three children Carlo, Liv and Sara. While the features of the figures are largely generalised, the psychological relationship between the siblings is stressed, by virtue of their positioning in the shallow, light-filled space. All in all, the atmosphere is hauntingly modern.

For Vera Nilsson, the birth of her child Catharina in 1922 signalled a change in her independent life style. Though her daughter served as a model close at hand, one can detect as well an invention of a tradition that was to dominate Nilsson's oeuvre. In her painting *Grandmother and Little Girl* of 1925 (Fig. 90), the matrilineal line of heredity is sensitively engaged with so that one can speak quite confidently of the primacy of *kvinnokultur* (women's culture) as subject matter. The starkness of the silhouettes and broad treatment of the setting offers a foil for the capturing of resemblance between the grey-haired elderly woman and three-year-old blonde girl. Nilsson's ability to show close observation of the child's curiosity does not forfeit the impact of the painting's flatness and the gestured markings of the facture.

Evidently women artists were not limited to modernist reinvention of the lesser genres of landscape, still life, interiors and portraiture. In the case of Hilma af Klint (1862–1944), she chose to remain unmarried, preferring instead to be an inspirational force among a group of women. Both her social and working life were governed by her interest in esoteric religions, in particular from 1908 onwards in Theosophy and Anthroposophy. The importance of Rudolf Steiner's ideas to a growing audience of creative women throughout Northern Europe and Scandinavia signified the appeal of a unifying belief at a time of increasing secularisation of religion. Though af Klint trained at the Royal Academy of Fine Arts in Stockholm between 1882 and 1887 and joined the Association of Swedish Women Artists when it was established in 1910, her abstractions were viewed privately within a small circle of women. For this reason, art historians hesitate to include af Klint within modernist discourse.[40]

Yet here we can speak of an avant-garde subculture directed towards the private sphere – one dominated by *kvinnokultur* (women's culture) in a social sense. The works proclaim their autonomy and partake of a rhetoric of utopianism associated with spiritual evolution via aesthetic means. The abandoning of the external object in af Klint's paintings and the justification of this in her theoretical manuscript 'Studier över själslivet' (1917–18) gives eloquent testimony to the fact that Modernism's history has yet to be written.

NOTES

1. Albert Engström, Strix, 22 May 1918: 'Fru Hjertström-Grünewald tar jag alldeles ur räkningen. Ty hennes arbeten är rena rama idiotin. Hon har sina modeller i Eugeniahemmet och ser ut att äga en pervers längtan efter vanskaplighheter. Det finns vid Gud intet av konst I hennes idiotiska kråkspråk. Låt mig slå fast att hennes försök är humbug. Hennes färg är ful och tunn dumt kokett. Hennes mans färg är också tunn, menn intelligent kokett.'

2. Together with Leander Engström, Hjertén and Grünewald exhibited 500 works, half of them oil paintings. Hjertén also contributed porcelain ware and a ceramic tiled painting.

3. Thor Thörnblad, 'Dekadens. Den Grünewaldska massfabrikationen,' Nya Dagligt Allehanda, May 10, 1918. Grünewald's Jewish identity also marked him as different and he was aligned with the negative features of modernity, materialism and the mass market. For the anti-Semitic referents of the critical reception of modernism consult Lars M. Andersson, En jude är en jude är en jude: Representationer av "juden" i svensk skämtpress omkring 1900–1930, Lund, 2000, pp. 371–414.

4. M. Nordau, Degeneration, translated from the second edition of the German work (New York, 1895).

5. Ibid., dedication. Lombroso's Genio e Folio (Genius and Insanity, 1863) was one of the principle sources of inspiration for Nordau's Degeneration. George L. Mosse provides an illuminating account of Nordau's life and writings in his introduction to the translation (Lincoln and London, 1993), pp. xiii–xxxiii.

6. Bror Gadelius, 'Om sinnesjukdom, diktning och skapande konst,' Ord och Bild, vol. XXIV no. 7, July 12, 1915, pp. 337–58. For further commentary on accusations of 'dysmorphism,' see Marit Werenskiold, The Concept of Expressionism: Origins and Metamorphoses, Universitetsforlaget, Oslo, 1984, pp. 160–2.

7. See Vivian Endicott Barnett, Kandinsky and Sweden, Malmö Konsthall and Moderna Museet, Malmö and Stockholm, 1989, p. 41, quoting from Poul Bjerre's papers in the Handskriftssektionen of the Kungliga Biblioteket, Stockholm.

8. Grünewald had at least seven drawings and one watercolour by Ernst Josephson (1888–1906) in his collection and, in his manifesto Den nya renässansen inom konsten (1918), Grünewald described Josephson as 'the first, even if unconscious, expressionist of modern times' (p. 35).

9. See Marit Werenskiold, 'Sigrid Hjertén som ekspresjonist: En analyse av "Självporträtt," Kunsthistorisk Tidskrift, vol. LII, no. I, pp. 31–43.

10. This painting is analysed further in Shulamith Behr, 'Sigrid Hjertén och kvinnokroppen,' in Sigrid Hjertén, catalogue, Liljevalchs Konsthall, 1995, pp. 163–8. The tropes of avant-garde practice – the male artist, the studio and the nude model – have been the substance of immense critical scrutiny. The implied domination or control of the model as the object of the male gaze has been central to understanding the historical role of the male artist within the hegemonic structures of patriarchy. The debate was initiated by feminist art historians, as conveyed in the pivotal essay by C. Duncan, 'Virility and domination in early twentieth-century vanguard painting,' in Art Forum, December 1973, pp. 177–99.

11. See Jacques Derrida, 'La Différance' in Marges de la philosophie, Editions de Minuit, Paris, 1972. Translated in Jacques Derrida, A Derrida Reader: Between the Blinds, Peggy Kamuf (ed.), New York and London, 1991, pp. 59–79.

12. For August Brunius' favourable reception of Sigrid Hjertén see Svenska Dagbladet, May 15, 1918, and of Vera Nilsson, Svenska Dagbladet, October 31, 1918.

13. Apart from Brunius, criticism of the Expressionistutställningen was unanimous in viewing Hjertén's work as secondary to that of Grünewald's. For a comprehensive outline of press reviews see Katarina Borgh Bertorp, 'Sigrid Hjertén. Kritiken och Liljevalchs,' in Sigrid Hjertén, catalogue, Liljevalchs Konsthall, 1995, pp. 11–21.

14. For a discussion of the genealogy of this concept see Christine Battersby, Gender and Genius: Towards Feminist Aesthetics, London, 1989.

15. Peter Bürger, Theory of the Avant-Garde, Minneapolis, 1984 (German original 1974).

16. Susan Rubin Suleiman, Subversive Intent: Gender, Politics and the Avant-Garde, Cambridge (Mass.), 1990.

17. See Charlotte Christensen, 'Training and Professionalism: Nordic Countries,' Dictionary of Women Artists, Delia Gaze (ed.), London, 1998, p. 114.

18. Ibid. p. 112. As early as 1864 a 'Section for Women' was established at the Royal Academy of Fine Arts in Stockholm, with eighteen students in attendance in its first year.

19. Here the terminology employed, i.e. 'matter [of the body],' with its multiple implications as a material form and as a topic of discourse, derives from Judith Butler, Bodies that Matter: On the discursive limits of "Sex," New York and London, 1993.

20. Griselda Pollock developed this notion of positionality in relation to late nineteenth-century artists such as Berthe Morisot and Mary Cassatt. See her essay 'Modernity and the spaces of femininity' in Vision and Difference: Femininity, Feminism and the Histories of Art, London, 1988.

21. See Bonnie S. Anderson and Judith P. Zinsser, A History of Their Own: Women in Europe from Prehistory to the Present, Vol. II, New York, 1989, p. 200.

22. Frida (Frideborg) Steenhof, Feminismens moral. Föredrag hållet i Sundsvall den 30 Juni 1903, Stockholm, 1903.

23. For a comprehensive account of these debates consult Hjördis Levin, Masken uti i rosen: Nymalthusianism och födelsekontroll i Sverige 1880–1910, Stockholm, 1994, pp. 475ff. Also see Hjördis Levin, 'Neo-Malthusianism in Sweden,' http:www.ehess.fr/populatique/Numero02/dear.html, April 12, 2000, pp. 1–12.

24. Levin, 'Neo-Malthusianism in Sweden,' pp. 6–7.

25. For a detailed account of Hirsch Pauli's life and work consult Margareta Gynning, Det Ambivalenta Perspektivet: Eva Bonnier och Hanna Hirsch-Pauli i 1880-talets konstliv, Stockholm, 1999.

26. Levin, p. 7, quoting the French philosopher Michel Foucault, The History of Sexuality Vol. I. An Introduction, New York, 1978.

27. Hjertén divorced in 1937. Her mental illness, which was diagnosed in 1932, recurred in 1938.

28. 'Intervju med Sigrid Hjertén,' Idun, vol. V, November 23, 1924.

29. Bo Nilsson, 'Siri Derkert,' Scandinavian Modernism: Painting in Denmark, Finland, Iceland, Norway and Sweden 1910–1920, catalogue, Göteborgs Konstmuseum and elsewhere, 1989, p. 102.

30. For an overview of this phenomenon in Germany, Sweden and Holland, see Shulamith Behr, Women Expressionists, Oxford, 1988.

31. Henri Matisse, 'Notes d'un peintre,' La Grande Revue (Paris), December 25, 1908, pp. 731–45. For further commentary on impact of Matisse see Behr, 1995, pp. 164–7.

32. Sigrid Hjertén, 'Modern och österländsk konst,' Svenska Dagbladet, February 24, 1911.

33. Sigrid Hjertéen, 'Paul Cézanne,' Svenska Dagbladet, November 24, 1911.

34. See 'Mollie Faustman,' in Louise Robbert, "Den otroliga verkligheten" 13 kvinnliga pionjärer, Borås, 1994, p. 134.

35. For further commentary see Annika Öhrner, 'Siri Derkert,' Dictionary of Women Artists, pp. 452–4 and Tom Sandqvist, Han finns, förstår du: Siri Derkert och Valle Rosenberg, Stockholm, 1986.

36. Nya Dagbladet, May 13, 1918.

37. For a recent interpretation of this phenomenon in relation to German Expressionism see Sherwin Simmons, 'Expressionism in the Discourse of Fashion,' Fashion Theory, vol. 4, issue 1, 2000, pp. 49–88.

38. Socialdemokraten, May 4, 1918.

39. This is expanded on by Maria Carlgren, 'Marginaliserad modernism. Siri Derkert som klädskapare och modeteckningen som estetiskt objekt,' (diss.), Lunds universitet, 1999.

40. For further detail see Annika Öhrner, 'Hilma af Klint,' Dictionary of Women Artists, pp. 784–6 and Folke Lalander 'Sweden and Modernism – The Art of the 1910s,' Scandinavian Modernism, p. 69.

SVEN-OLOV WALLENSTEIN

THE TECHNOLOGIES OF MODERNISM

A Brechtian maxim: Connect not with the good old days but with the bad new days.

Walter Benjamin

The question of the origin of Modernism and Modernity can give rise to the most varied answers. Depending on whether we focus on changes in politics, science or religion, on socio-economic development, on art or philosophy, we seem to be able to construct quite different narratives. Some trace the beginning of the new age back to Descartes, Galileo and science's break with the Church during the seventeenth century, while others prefer to give prominence to the birth of the idea of progress, romanticism's conception of philosophy as a critique of the present, the birth of aesthetic autonomy in the work of Kant as a constituent aspect of reason's division of labor in 'bourgeois public opinion', etc. All these perspectives come into play if we try to determine the birth of artistic Modernism, which can hardly be seen as an exclusively stylistic phenomenon: the break with inherited tradition occurs over an entire historical spectrum, and any isolated description of an individual trace tends to be artificial.

For Sweden, at the beginning of a new millennium, all such narratives acquire an extra significance with the postmodernist debate – what is it we have left behind us, if we really have? On the art-historical plane we describe ourselves as the inheritors of a tradition that is in many cases a diffuse stock of general knowledge, entrusted to the guardianship of museums but no longer the bearer of anything but a historical patina. The question of the extent to which the modern is an ongoing tradition or a closed one has provoked the writing of several histories which emphatically assert that today this tradition must be seen as exhausted, especially with regard to its utopian pretensions (in the words of the American historian Marshall Berman: 'all the isms have become

wasms'). Others point out – doubtless with greater historical accuracy but not necessarily greater sensitivity to the demands of the present – that this tradition can always be shown to be *more complex* than was thought, e.g. when it is described in an exclusively formalistic or style-historical manner, and still contains possibilities for further development and discussion, and that right from the outset it contained reflective elements of irony and self-criticism (the art-historical showcase example is the rediscovery of Marcel Duchamp, which seems mainly to have had a retroactive effect.)

'Modernism' is a highly unfocused concept in so far as it claims to denote a special style or 'ism', since in its extreme, primitivistic forms it sometimes turns away from the rationality of modern society, and sometimes, as in Futurism, tries to accelerate development towards an explosive nihilism, but in a way that breaks with other aspects of the modern. The concept of Modernism thus combines the most contradictory distinctive features: political romanticism and cults of revolution, the overthrow of the concept of art, the return of neo-classicism, cults of technology and planning, neocolonial projections and dreams of the primitive and the return of the unconscious life of the imagination. Perhaps, with Marshall Berman, we might distinguish between three levels: a *modernization* of society's economy and infrastructure, a *modernity* which constitutes a general condition in a culture with a sharpened sensibility for the contingent and changing, and whose description and analysis we can find in the modern social sciences which take the form of a reaction to the influence of the modern city on older collectives and ways of life (in the classical sociological texts of Ferdinand Tönnies, Georg Simmel, Max Weber, Émile Durkheim); and lastly various *Modernisms*, i.e. artistic reactions to and thematicizations of Modernity, which from a stylistic and ideological point of view can be diametrically opposed to one another, but still form a dialectically composite whole, a prism of expressive forms whose identity is not necessarily to be sought on a stylistic plane.

An important part of the energy of visual art-related Modernism seems to be released following the collapse of the academic tradition from Eugène Delacroix in the 1820s and onwards, which affected both the role and the career of the artist as the direct handwork of pictorial creation. It is in this context, where new alliances are formed, that we must see the origin of the idea of the avant-garde, its roots in a utopian socialism and its gradual transition from the dream of a fusion of art, politics and science to what we recognize as the alienated artist, the Bohemian in sharp opposition to the structures of established power and bourgeois public opinion.

Here the role of the salon becomes at once hated and desired: generations of artists from Edouard Manet to Paul Cézanne are locked out at the same time as they strive for the social acceptance that is offered by official distinctions. In this way the salon becomes a prototype of the commercial gallery as market place. Power over it, in terms of jury systems, prizes and distinctions, expresses the struggle for the public space that Modernism initiates when the artists free themselves from an earlier system. Patrons come and go, and soon a split between the official salon and a *salon des réfusés* gives birth to the classical contradiction of Modernism: revolt within the framework of an order that also constitutes the guarantee of the possibility of revolt. The rebellious attitude of Gustave Courbet, when he organizes his own exhibition room in opposition to the World Exhibition of 1855, is symptomatic in his reaction against a new system on which the artist is none the less totally dependent for his new role.

The precondition for this game is a new social mobility, the break-up of the traditional class society and the emergence of the bourgeoisie as buyers and public. Here art criticism (with roots in Diderot a century earlier) also becomes important through the development of the press, and 'taste' becomes a battlefield and a changing fashion.

In the intra-artistic discussions 'academicism,' both as style and technique, becomes a symbol of the oppressive legacy of tradition, something we can see, for example, in the increasing difficulty of using traditional mythology as a subject. Even in the struggle of the 1820s between classicists and romanticists, waged by Ingres and Delacroix, there is a

consolidation of the function of the romantic genius to break with established taste and with art's inherited system of rules. Honoré de Balzac's short novella *The Unknown Masterpiece* (1831) captures this situation in masterly condensed form. The young painter Poussin (modelled on the historical Poussin, but with unmistakably contemporary features) is torn between the contracting parties Pourbus, the representative of the golden mean, and Frenhofer, the genius who allows himself to make infinite demands on his work and is therefore destroyed together with it. The perfect painting, *La belle noiseuse*, turns out in the end to be a chaos of color in which drawing as the bearer of (academic) rationalism and form has collapsed as the artist in his Faust-like hubris has taken the liberty of 'philosophizing without a brush in hand.' The stable connection between thought and action that was guaranteed by tradition has now dissolved and a voyage on unknown oceans, with new promises and new threats, becomes possible. Frenhofer is its first victim, but we know the identifications to which the novella tempted artists, from Cézanne's exclamation 'Frenhofer, c'est moi' and onward in the process of Modernist painting.

One central aspect of the process of Modernism became crystallized quite early, namely the tense and ambivalent attitude of art towards technology, the first phase of which is represented by the encounter with photography. The legendary, possibly mythical exclamation of the academic historical painter Paul Delaroche when he was put in front of Daguerre's invention, first presented by Arago in front of a political and cultural public, has often been quoted – 'From today painting is dead!' The apparently superior reproductive capability of photography can be seen to advantage as a metaphor for industrialization as a whole, for the technologically based division of labor that increasingly allocates to art a place of retreat as the bearer of a humanist sensibility, of the expressive merits of the hand and the gesture in relation to a world of labor built on distancing, serialization and typicization. Modernistic painting as self-reflection and increasing abstraction can in this way be said to be a response to an inner problematic (the collapse of the academic language), but also to an outer challenge, the technological image-world that takes over the role of retelling the world. Modernism becomes a constant testing of criteria (What is an acceptable painting? How does one know it is finished? What are its indispensable components?), a process of 'unlearning' of skill and technique, a 'de-skilling' that accelerates from generation to generation. The harsh judgements of young artists come most often not from critics but from older artists (as in Courbet's contemptuous judgement of Manet's *Olympia* and its lack of modeling and depth: 'it's as flat as a playing-card!')

In all these different reactions one can unquestionably see a search for a new language. Impressionism, divisionism, pointillism, they are all on the lookout for the form that will be able to take over the legitimizing and stabilizing function of the academic tradition. In the literary field, in realism and naturalism we can find a similar breaking down of the traditional system of genres, with correspondingly violent reactions, lawsuits and exclusions; in the field of music the gradual dissolution of the tonal system and thereby also of classical large-scale form (the symphony, the sonata). The 'crisis of verse' that Stéphane Mallarmé encountered and diagnosed culminates in his great poem about the dice-throw. Its sentence-fragments lie scattered over the page like a cosmic constellation waiting for the Idea that will sublate it into a lost eternity – the crisis can stand for a dissolution of the principle of poetic form throughout the entire artistic field.

The splitting apart of uniform language necessarily generates a series of Utopian models that succeed one another in rapid succession – the beginning of the epoch of the 'isms' and the manifestoes, whose speed increases at the same rate as the academy and the salons cease to function as guiding principles. Arthur Rimbaud's letter about the poetic Seer ('Lettre du Voyant') and his 'il faut être absolument moderne', form the principle of this law of motion – the New that is to replace the Old with a new law, a 'dérèglement de tous les sens' not merely as chaos but as the source of a new, universal rule.

The place of Charles Baudelaire in this development has rightly been the subject of many studies. In him the role of the poet with roots in romanticism (correspondences, neo-Platonic elements, the poem as bridge to the realm of ideas) is combined with the experience of a new urbanism in which the value of art seems more uncertain than ever. Baudelaire gives us the definitive picture of the modern artist in his *Salon de 1846*, where in his famous preface addressed *Aux bourgeois* he attempts to build a bridge between the bourgeoisie and the new art, a project that in itself shows the degree to which taste had become a problem – it is no longer a problematic but none the less anthropologically given criterion, as it was once codified by Immanuel Kant, but a kind of *project*, a task to be realized via education for the new rising classes of society.

Baudelaire's 'modernité' is a composite and contradictory phenomenon, at once an active nihilism in Nietzsche's sense, grounded in fashion and perpetual change and therefore opposed to all eternal values, and at the same time in pursuit of a poetic transformation of the world into essence. In *Le Peintre de la Vie moderne* (1859) Baudelaire talks of how the important thing in modernity is to go right to the furthest limits of the contemporary age, but only in order to climb out of it in a final and paradoxical gesture and seek contact with the eternal forms of art: 'He [the artist] seeks that something we might be permitted to call *Modernity*; for there is no better word to express the idea in question. It is, for him, a matter of detaching from fashion whatever poetic elements of the historic it may contain, of extracting the eternal from the transitory[...]Modernity is the transitory, the fleeting, the contingent, one half of art, the other half of which is the eternal and immutable.' In a certainly false but none the less striking etymology *la modernité* is linked to *la mode* – fashion, the perpetually changing, but also a point of intersection between time and eternity, where innovation is in contact with the present as a passage to eternity, in other words a sense of being on the frontier of history, the absolute present, and of simultaneously stepping out of that history in an ecstatic, Utopian leap, in order to leave it behind.

This contradiction or dialectical tension lies at the center of Walter Benjamin's description of Baudelaire as the first writer to experience the impingement of capitalism and the commodity on the inner being of poetic language, something against which the poet also defends himself with all his might (something we can also see in his violent opposition to photography). Like the Parisian arcades, Baudelaire's poems and essays form themselves for Benjamin into a focal point in which the old and the new collide – Paris as 'the capital of the nineteenth century' constitutes the very battlefield of Modernity. It thus becomes possible to interpret the position of the *flâneur* and the dandy not only as a romantic echo, but above all as an image of the new alienation. At the center of the poet's attention is the crowd and the shocking collisions it gives rise to, the dissolution of experience in contingent intensities. The artist is caught between a hopeless aristocratic self-affirmation and a (death)wish to be swallowed up in the crowd, to dissolve in a larger whole. In one way Baudelaire is eminently ambivalent, he becomes a Modernist against his own will, in his striving to uphold the dignity of art he points to its inevitable integration into commercial society.

In a sketch for the large-scale and incomplete *Arcades* project, *Paris, Capital of the Nineteenth Century* (1935), Benjamin describes how the old and the new interpenetrate each other, but also the gap that exists between the different forms, their essential lack of simultaneity. Because of this time is divided from itself, and the crack frees up a retroactive possibility, gives us an otherwise unobtainable distance from the present. Thus for Benjamin the description of twentieth-century Paris becomes an image of the actual, a history of the present moment, and is not a distanced historiographical representation. Like the 'de-mystification of the world', the process of rationalization inherent in capitalism frees us from old myths, but also gives birth to new ones: commodity fetishism, the 'theological fads of the commodity' (K. Marx) as universal phantasmagoria – and Benjamin is at once their mythologist, proponent and sharpest critic.

In the new commodity world that is displayed in the arcades (and which then gradually moves over into the great department stores) art enters the service of the merchant. The growth of the arcades during the 1820s is connected, as Benjamin notes, with the rise of the textile trade, but also of a new type of iron construction in which the empire, significantly enough, saw a renewal of architecture in the *Ancient Greek* spirit. Benjamin quotes the German architectural historian Carl Bötticher and his *Principles of Hellenic and German Architecture*, and notes that here we find ourselves caught in the transition from a classical tradition to a modern industrial technology – a dialectical process characterized by an inner division, where the engineer confronts the architect and the new meets the old. Benjamin wants to free us from this dream in order to step all the way into Modernity.

If the engineer in this specific constellation stands against the architect, it is because his historical task is to *liberate us from art*, just as once the sciences liberated us from philosophy. The motif recurs often in Benjamin's work, e.g. in his essay of 1935 about the work of art in the age of reproduction, where the new productive forces of photography and film are breaking up the nineteenth century's aesthetic relations of production (genius, mystery, creative energy, a craftsmanlike relation to individual objects) and thereby the auratic artwork's aesthetic autonomy. Or as in *The Author as Producer*(1934): against the proletarian *Tendenzroman*'s focus on a new content, Benjamin asserts that progressive thinking cannot be a new content but must involve a transformation of the very conditions of literature's production and distribution in accordance with modern technology (he cites the factographical documentary novels of the Soviet critic Sergei Tretyakov, which alter the function of literary forms in an apparently 'non-artistic' way).

For Bötticher the aesthetic predicament of the age can be understood as an interplay between *Kernform* (technology) and *Kunstform* (tradition), and the question of the style of the future can only be answered in terms of a new synthesis of the classical with the modern. But if for Bötticher there is a continuity, for Benjamin the important thing is rather a dialectical contradiction in which the split between the new forms expresses a situation where the new pushes itself forward but is still in search of its form, still refuses to be born. Construction takes over the role of the unconscious, says Benjamin. It is in the constructive process that the new is prepared (in the same way as the future is dreamt, it is anticipated in a way that is still diffuse in the mass media, in the serial, in the photograph, in the whole way in which the process of industrialization penetrates everyday reality but without *sensing its own potential*), and not in its aesthetic over-layering with an art-form of the past. The inspiration for this figure of thought comes primarily from Sigfried Giedion (who was to become the great propagandist, historian and interpreter of Modernist architecture) and his first programmatic book about new industrial architecture, *Building in France* (1928). He traces a long morphological development from the late eighteenth century, blocked by traditionalism and eclecticism, but which can resume again in the twentieth century. The constructive unconscious, says Giedion in a formulation later adopted by Benjamin, is also thereby able to make the transition to *rational construction*, to a transparent condition. This inspired Benjamin profoundly: glass became the image of this social transparency, this new 'poverty' that is also a clarity, for which he sees the poet Paul Scheerbart's vision of a *Glasarchitektur* (1914) as yet another Utopian expression (other visions were soon to follow, in the work of Bruno Taut and the whole of the Expressionist movement that formed around the 'Crystal Chain', or in the work of Mies van der Rohe).

Both Giedion and Benjamin are of the opinion that this can fundamentally transform our ability to perceive, bring about a revolution in time and space, something that Benjamin also comments on in his essay on Reproduction, where film is seen in an analogy with psychoanalysis: it expands space and makes its unconscious visible, allows us to see totally new structures and possible patterns of action. In several notes for the

Arcades project Benjamin comments on Giedion's photographs of a bridge in the port of Marseille, 'Pont Transbordeur', a structure of maximum openness that fuses with its surroundings and forms the new transparency (Giedion speaks of 'mutual interpenetration', a *Durchdringung* that will no longer allow the individual objects to remain where they are but creates a single intense, mouldable space with fluctuating boundaries between subject and object). The bridge soon became a Modernist icon; it was photographed by Germaine Krull, Giedion, Man Ray and László Moholy-Nagy, who the year after Giedion's book also made a film, *Marseille, vieux port* (1929) with the bridge in one of the leading roles. Here for Benjamin and Giedion is expressed in concentrated form the same technological sensibility that is also found in the microscope, the telescope, the X-ray image, the aerial photograph – a fundamental restructuring of experience (unlike Giedion, Benjamin emphasizes the photographs that allow us to see the city and the social relations of labor in a new perspective; he stresses that technology in itself does not realize the new, so far it is only workers and engineers who see the future, though not quite clearly).

Like the arcades, the 'Pont Transbordeur' becomes for Benjamin an example of how old and new images interpenetrate one another like dream pictures, how they liberate an imagistic fantasy that leads us 'back to primordial times', to a vision of a complete different society, with different physical relations, different connections between subject and object, all the way to the positive form of 'barbarism' and the 'poverty' he speaks of in another essay from the same period, "Erfarung und Armut". If Benjamin, in the retrospective descriptions of nineteenth century Paris, follows the development of the differentiation between private and public, the whole of the phantasmagoria and psychological world that are the obverse side of universal commodity fetishism, here the opposite is involved. Like the Constructivists, Benjamin imagines a future type of object that is in solidarity with desire, open to new social relations, produced by means of a technology that penetrates the body and alters its sensory fields. In this way, his fragmentary notes sketch one of the most essential lines of development from the birth of Modernism in the mid-nineteenth century, when art and industrial technology met as two external and antagonistic forces, on to the next phase, when their integration and mutual interpenetration formed the basis of the vision of a new social order.

SOURCES AND REFERENCES

For a general discussion of concepts like 'Modernity', 'Modernism' and 'avant-garde', see Matei Calinescu, *Five Faces of Modernity: Modernism, Avant-Garde, Decadence, Kitsch, Postmodernism* (Durham, N.C., 1987). A classical study of the social milieu of Impressionism is T.J. Clark, *The Painting of Modern Life: Paris in the Art of Manet and His Followers* (New York, 1985). There is a formalist-oriented reading of the same breakthrough in Michael Fried, *Manet's Modernism* (Chicago, 1996). The classical study of Constructivism is Christina Lodder, *Russian Constructivism* (New Haven and London, 1983).

For the discussion of the development of urban design in terms of increasing rootlessness, negativity and nihilism, see Francesco Dal Co, *Figures of Architecture and Thought: German Architecture Culture 1880–1920* (New York, 1990); other important contributions to the Venice School are Massimo Cacciari, *Architecture and Nihilism* (New Haven and London, 1993); the whole of the monumental analysis is Modernist architecture that is developed throughout the works of Manfredo Tafuri: *Theories and History of Architecture* (London, 1980; Italian orig. 1968); *Architecture and Utopia: Design and Capitalist Development* (Cambridge, Mass., 1976; Italian orig. 1973); *Modern Architecture* (with Francesco Dal Co) (New York, 1986; Italian orig, 1976); *The Sphere and the Labyrinth* (Cambridge, Mass.: MIT, 1990; ital. orig. 1980). Tafuri is discussed in a many-faceted way in a special issue of *Casabella* 619–620, 1995, and of *Any* 25–26, 2000. A review of the debates about architecture and Modernity in the perspective of the Frankfurt School can be found in Hilde Heynen, *Architecture and Modernity: A Critique* (Cambridge, Mass., 1999).

Benjamin's texts can be found in *Illuminationen* (Frankfurt am Main, 1961), and *Das Passagen-Werk* (Frankfurt am Main, 1983). Giedion's *Bauen in Frankreich* is most easily available in a newly annotated American edition, *Building in France* (Santa Monica, Cal., 1995); the relationship between Giedion and Benjamin concerning it is examined in detail by Detlef Mertins, 'Walter Benjamin's Tectonic Unconscious,' *Any* 14, 1996.

GERTRUD SANDQVIST

THE WISH MUSEUM

The Art Museum and Modernism

We agreed that we would not go in for representative masterworks from the artists' 'mature' period but would look for works where there was a fresh spark, where a new idea found expression – in short, where one sensed adventure. And I think we succeeded. The Tate Gallery, the Basel Kunstmuseum, the Sammlung Nordrhein-Westfalen are certainly richer in 'heavy' works. But if one wants to get an idea of the creative fever in art during this century, of the moments of grace, the exhilaration and the happiness, Moderna Museet is still superior.

Ulf Linde, from the catalogue of Moderna Museet's collections, 1976

91. The exhibition *Guernica. Pablo Picasso* at Moderna Museet, 1956

92. Museum director Pontus Hultén at *The Wish Museum* exhibition at Moderna Museet, 1964

The art historian and critic Ulf Linde is describing the period around *The Wish Museum* (Önskemuseet, 1963–64), the exhibition which, through a one-off state subsidy to the generous tune of 5 million kronor, made possible the purchase of what is now the kernel of Moderna Museet's collections. Linde's way of characterizing the museum's collections is so typical that the quotation is almost incidental – in reality what we read here is the museum's 'myth of origin': its view of itself and its role in the world.

The quotation also gives a good picture of how at least a part of Modernism wants to characterize itself, namely as a movement filled with life and youth, in opposition to the outdated historicism of the nineteenth century. The Spanish essayist Ortega y Gasset called Modernism 'the new art', and in his famous analysis *The Dehumanization of Art* (1925) he described it as a discriminating movement, a watershed between those who understood and those who did not. In this way an exclusive section of the public, represented by the comprehending art critic, collector and gallery owner, was able to join common cause with the artist in a struggle against the nineteenth century of 'old men and women', and work for a new art that was vital, provocative, often absurd (but able to laugh at itself), young and manly. This new art could only be understood through seeing, it existed in and for itself.

Even more explicit, of course, were the Futurists, who wanted to burn down all the museums and declared that a new automobile was much more beautiful than Nike of

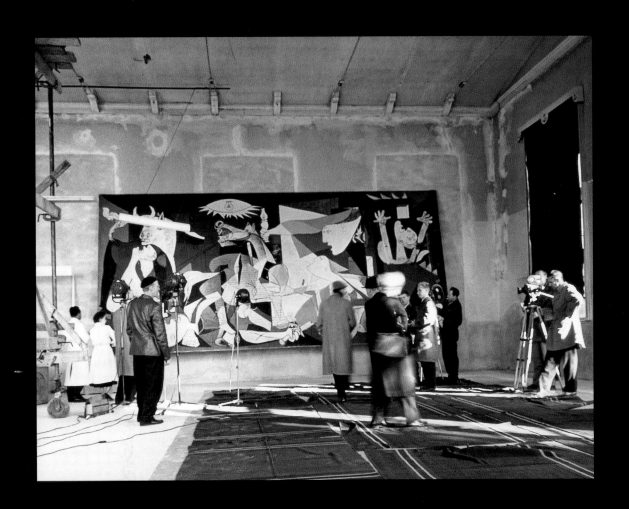

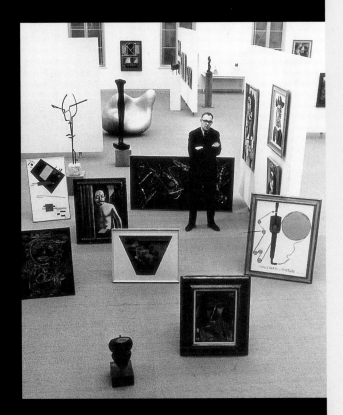

Samothrace (and who got what they wanted by means of the two world wars of which they were such passionate adherents). But the view of art held by Ortega y Gasset and the Futurists was not entirely alien to a Piet Mondrian, who wanted to destroy the old humanity so that a new one could exist, and annihilate the morbid dreaming that made some people like going to museums and looking at *clair-obscur* landscapes.

If as a museologist one identifies with this Modernism that longs for vitality, it follows that the modern museum's collections should be chosen using criteria like 'creative fever' and 'the moments of grace', thereby strengthening Modernism's self-image. Visitors are invited to take part in the exhilaration, to the see the moments of grace in the lives of creative artists rather than to see artworks in the conventional sense – and even less to see them as aspects of a larger cultural-historical context. In the famous phrase of the American abstract expressionist painter Barnett Newman: 'art history is to artists what ornithology is to birds'. For Newman, art is 'an adventure into an unknown world that can only be explored by those who are willing to take the risk.'

According to such a scenario museums are usually likened to mausoleums (sometimes indeed with approval, as in the work of Robert Smithson). The contradiction between vital modernity and the museum is, however, illusory. In reality they complement one another.

When we speak of the great inventions that changed pictorial art, we usually mention photography in relation to the nineteenth century and film in relation to the twentieth century. This focusing on artistic techniques is, however, an effect of the greatest invention of them all, namely the art museum. It started when the royal art collections in the Louvre were opened to the public in 1793, and when, in the same vein, Denis Diderot called art the new religion of the senses. The first building devoted exclusively to art was the Fredericianum in Kassel, built during the late eighteenth century, and in which nowadays *Documenta*, the world's most prestigious exhibition of contemporary art, has been held every five years since the 1950s. During the 1820s and 30s the first art museums in the modern sense were designed and built in Berlin and Munich. F.A. Stüler, the architect who designed one of them, the Neues Museum in Berlin, was also in the mid-nineteenth century the designer of the Nationalmuseum in Stockholm.

At about the same time the entirely new discipline of art history took shape. The idea that art has a history distinct from general cultural history made Modernism possible. The connection between artist, subject, buyer and viewer was broken, even if as late as 1924, in Marcel Proust's *À la recherche du temps perdu*, the narrator speaks of the valuable collection of royal portraits the model (!) has given to Madame de Villeparisis.

In place of this structure, which makes the artist a subsidiary figure in relation to his own art, art broke out of cultural history in the new German art-historical museums. The museums wanted to provide an intra-artistic total experience, for the enjoyment and education of the people.

Real art was considered to begin with the Renaissance, which was also seen as modern. Art was uplifting, educative, true, beautiful and eternal. It was of course easy for the modernists to reject such an idealized picture of art. As we have seen, however, the idea of its high value, and the need of some form of belief and devotion in relation to it, existed in a very high degree throughout the twentieth century. And it actually experienced a late flowering in the expectations in the new modern section of the Nationalmuseum, called Moderna Museet, in the 1950s. In the correspondence of the then curator, Bo Lindwall, concerning the museum, there is a letter from the artist Einar Jolin giving some good advice on how the museum should be built up – 'hang the best paintings side by side, then it will be fine! But don't forget that art is on the one hand something simple, natural and personal, while on the other it displays the true, the good and the beautiful.'

Michel Foucault was of the opinion that Edouard Manet's *Olympia* and *Déjeuner sur l'herbe* are the first paintings that were made in direct relation to the museum context. The Swedish art historian Dan Karlholm remarks on the German so-called 'art-history painters', who with large frescoes in the Renaissance manner made the art museums into

spaces for experience and took a commentating attitude towards the art that was displayed. But it was Manet who in relation to the art museum showed the ambivalence that was to be characteristic of Modernism. Just as *Olympia* and *Déjeuner sur l'herbe* comment directly on an earlier painting, which could be compared with works in the great museums, Manet asserted an art for its own sake, without sidelong glances and without references outside itself. Only by understanding how important the art museum was to the beginnings of Modernism and the 'art-for-art's-sake' movement can one avoid seeing Manet's standpoint as a paradox.

Indeed, one of the most typical aspects of Modernism is that all the 'isms' can be seen as a direct consequence of the museum's cataloguing and systematizing of visual art into painting, sculpture, drawing and graphic art, and further according to geography, time, school, motif, etc. It is so easy to classify artists into Impressionists, Fauvists, Symbolists, Expressionists, Cubists, Suprematists, Rayonnists, Cubo-Futurists, Futurists, Dadaists, Concretists and Surrealists that there almost seems to be a far-reaching collaboration between museologists and the artists of Modernism. This is reflected in the preliminary work for Moderna Museet's exhibition The Wish Museum, where the works of art were divided according to classical museum praxis into Cubist, Fauvist and Expressionist, Surrealist, Informal Painting, etc.

An artist like Pablo Picasso, who both invented and virtuosically employed one style after another (and often several together), is an all-too-clear example of the symbiosis between the museum and the Modernist (Fig. 91). Another is Piet Mondrian, who during the 1910s joined the De Stijl group and performed his abstraction of cherry trees and piers with an almost mathematical precision all the way to the variations of the definitive masterwork he produced in the 1920s and 30s (Fig. 93). His painting was unusually easy to place in terms of the scientifically-oriented art criticism and theory of his day, and its way of writing about art as a necessary result of the ability to see and give symbolic form to the seen. (Erwin Panofsky's pioneering work *Perspective as Symbolic Form* appeared in 1923). Mondrian painted for the museum context in a manner that he in other instances rejected. The common agreement between his way of guiding the comprehension of his art and the art historian's and museologist's way of supporting that comprehension extends a long way. Not until the 1990s did the still lifes with flowers that Mondrian painted in the 1920s at the same time as his fully developed 'new art' receive any attention from art historians or public display in a museum context – even though they are both dated and signed (Fig. 94).

The connections between the museum and Modernism are sometimes strained – it happens particularly when a modernist ceases to fulfill the criteria for a modernist. In the case of Giorgio de Chirico, only the paintings of his youth were considered to be innovative masterpieces that were among the precursors of Surrealism, while his work of the following sixty years was thought to be boring art-history-referring kitsch until he was re-evaluated by the postmodernists. It goes without saying that the de Chirico paintings that were shown at the *Wish Museum* exhibit belonged to his early period. One of them,

93. Piet Mondrian
Composition in Yellow and Blue
1933
Moderna Museet

94. Piet Mondrian
*Blue Roses with Yellow Background, c.*1922–6
Collection Fine Art Communication, Inc.
New York

The Child's Brain of 1914, was purchased for the museum's collections and is today one of its best-known works. The story of its purchase is of interest in the present context. It was bought directly from André Breton, after mediation by Marcel Duchamp. It was Breton who nominated de Chirico's Pittura Metafisica as the signpost to Surrealism, and was also the person who kicked de Chirico out of the Surrealist circle when he no longer painted in a way that suited Breton's aims. In the correspondence between Breton and the museum's then director, Pontus Hultén (Fig. 92), Breton emphasizes how hard he finds it to part with the painting, how he devotes a daily cult to it, etc. Not even Hultén's generous offer – your price shall be ours – is able to persuade him, while Duchamp's argument – that Moderna Museet's collection would become important as a result – was actually the one that clinched it. But de Chirico was still alive, and was an active artist (he died in 1978). In practically all the other cases concerning works for the *Wish Museum* exhibition and the purchases that accompanied it, the museum corresponded directly with the artists, their gallery-owners or their widows. Here, however, the museum was only interested in the paintings de Chirico had done in the 1910s, works sanctioned by art history. Had it only been during that period that de Chirico was feverishly creative? Moderna Museet wanted to convey an image of an artistically dynamic life, rather than 'the life' itself. There is nothing strange about this. That is the museum's task. The interesting thing is how important it was for Moderna Museet to conceal the fact that it is a museum. Was it perhaps the case that the mood references to modern art: fever, exhilaration and happiness alternating between artist and spectator, were thought to infect art itself, which then became alive? Was this Pygmalion dream to be understood as a mighty conjuration against the enormous accumulation of art that is gathered in museums, and that merely reminds us of our own mortality? Or are these constant references to bodies, to life and death that crop up in relation to art and museums just a reminiscence from the Romanticism that saw the origin (I was going to say 'the birth') of both the modern concept of art and the museums?

One of Pontus Hultén's first exhibitions at Moderna Museet was called *Movement in Art*, 1961. In a letter of the late 1950s to William Sandberg, then director of the Stedelijk Museum in Amsterdam, the unknown young curator Hultén wrote about the Suprematist works of Malevich, which he had first seen at the Stedelijk. Could they be purchased? Could they be shown at the new Moderna Museet? Hultén thought they were about movement and dynamic form. Did Sandberg know anything about that? For Hultén the interpretation of Modernism took place by means of entering a striving for dynamism, movement and life, and this striving was applied to Malevich, then unknown to Hultén.

In the titles of Moderna Museet's exhibitions during the 1960s one finds, like a recurring theme, references to movement, dynamism, human emotions – indeed, a kind of affective charge that almost makes us forget that it is a museum we are talking about. To choose some titles at random: *Sebastian Matta. 15 Forms of Doubt* (1959); *Movement in Art* (1961); *Visionary Architecture* (1963); *American Pop Art. 106 Forms of Love and Despair* (1964); *Inner and Outer Space* (1965); *Earth Heaven Hell; Wifredo Lam. The Heart's Undergrowth, Weapons, Fruits; The Palace of Minos. Communications – Closed Within Man and Open to the Cosmos; Lucio Fontana. Ideas About Space* (1967); *Julio Le Parc. Experimental Place for the Experience of the Movement of Eye, Body and Object; Poetry Must Be Made by Everyone! Change the World!* (1969).

The 1960s, watershed between late Modernism and Postmodernism and Moderna Museet's first heroic decade, were a time of faith in the future, prosperity and dreams of the colonization of space at the same time as the colonies of the earth were rebelling against their former usurpers. But it was also the age of the first pop stars, and of the breakthrough of American values in Sweden on a broad front. The keyword was vitality. It is, I believe, for this reason that art was described in these body-related terms – as though by this means it could acquire 'life.' I think that, more than anything else, it was the artist's role that museum curators and the public approached and appreciated. An artist's role that also appeared as non-analytical and uninterruptedly productive, in accordance

with the model sketched by Barnett Newman – the artist as the bold explorer of unknown territories. It was this dream of the happy human being in which the public were offered participation at Moderna Museet and which was reinforced by the uninterrupted event scheduling it offered. It was this dream that was manifested in the children's art classes and the creative workplace that were at an early stage arranged on the museum's premises, where both children and adults were given the opportunity of first being shown an exhibition and then afterwards, inspired, of creating something themselves – the adults with the rediscovered child within them as a model. Whole generations of Stockholmers (and the model soon spread to the rest of Sweden) were educated in this way by Moderna Museet in the idea of the artist as the happy creator and the child as possessor of a primordial creative power (Figs. 95, 96). Sometimes the roles collided – as on the day at the beginning of the 1990s when a little four-year-old began to happily jump about on a fragile wooden sculpture in one of the museum galleries while the young parents, who had grown up with the museum's childhood teaching methods, looked quietly on. The desperate museum director did not.

1962 saw the opening of an exhibition entitled *Four Americans: Jasper Johns, Alfred Leslie, Robert Rauschenberg, Richard Stankiewicz*. This was followed by the pop art exhibition of 1964, a one-man exhibition of work by James Rosenquist in 1965, with Claes Oldenburg in 1966 and Andy Warhol in 1968. It is symptomatic of the museum's vitalistic attitude that it developed such good contacts with the American pop artists but not with the minimalists who made their breakthrough in 1964, and not with conceptual art, even though it had a large international following from the early 1970s onwards. The first conceptual artist to be exhibited by the museum was On Kawara in 1980, followed by Marcel Broodthaers in 1982 and Daniel Buren in 1984. The first presentation of something approaching minimalism, twenty years after its breakthrough, was *Vanishing Points* of 1984. This included work by Mel Bochner, Tom Doyle, Dan Graham, Eva Hesse, Sol LeWitt, Robert Smithson and Ruth Vollmer. Of these LeWitt was the only member of the minimalist elite corps, while Graham and Bochner could be said to work in his footsteps. During the 1980s the museum's then director Olle Granath and the young curator Lars Nittve worked on filling awkward gaps that had emerged in the museum's exhibition program because of the earlier lack of interest in a more intellectual artistic tradition.

This is really strange. Ulf Linde and Pontus Hultén were in contact with Marcel Duchamp, the spiritual father – if such an anachronistic expression may be used – of Post-modernism and conceptual art, from 1961 onwards in connection with the exhibition Movement in Art. Duchamp's *Large Glass, La Mariée mise a nue par ses célibataires, même*, could not be borrowed from the Philadelphia Museum of Art and so a replica was made by Linde. Then Duchamp came, voluntarily, to supervise the work and turned out to be very respectful towards the museum, as a mediating link in connection with the purchase of several of its most important works, including, in addition to the de Chiricos, Salvador Dalí's *Enigma of William Tell*. Earlier Duchamp had actually played the same discreet mediating role concerning several American public and private collections. It was Duchamp's relation to the European and American avant-garde of the 1910s and 1920s that interested Moderna Museet, rather than the make-or-break intellectual implications his art and his texts about art had for the time, something that had already been noted in the mid-1950s by the young British pop artist Richard Hamilton. At the time of Duchamp's closest contacts with Moderna Museet he was arranging the exhibition with Hamilton and Walter Hopps in Pasadena, Los Angeles (1963) which was to be his second breakthrough and made him immensely influential for young up-and-coming conceptual artists such as Joseph Kosuth. At the time, Duchamp functioned as a middleman to purchase painting of the 1910s for Moderna Museet's collection. Once again it was the Duchamp of art historical interest with whom Moderna Museet had lively contact, rather than the enigmatic and intellectual renewer of the contemporary discussion about the state of art and its possibilities.

Pop art (the art with which, besides Picasso, Pollock and French kinetic art, Hultén and the museum were most allied) only brushed very lightly against Duchamp. But it was

actually in relation to one of most significant artists for Moderna Museet, Robert Rauschenberg, that in 1968 Leo Steinberg coined the concept of Postmodernism. Rauschenberg's flatbed graphics and their comments on, among other things, the function of the museum and its collections and the revolutionary effects of reproduction technology on our conception of art is, according to Steinberg, an analytical break with Modernism. In these graphic works Rauschenberg makes use of the referential character of art, not its closed-off-in-itself or vitalistic possibilities. These subtleties were, however, lost in the great new wave that swept over Moderna Museet at the end of the 1960s, namely the strongly politically oriented art that followed in the wake of May '68. Perhaps it had such a major breakthrough at Moderna Museet because, to start with, at least, it reinforced the image of the artist as living, struggling and dynamic? The question of whether it had any consequences for change in artistic intellectual life may be debated. In the work of artists like Hans Haacke, Dan Graham or Mary Kelly (none of them was

95. Curator and pedagogue Carlo Derkert holds a demonstration at Moderna Museet in the 1980s

96. The exhibition *Utopia and Vision*, Moderna Museet 1971

exhibited at Moderna Museet at the time) use is made of political radicalism, and in Kelly's case also of feminism, also for artistically radical choices, and in order to call into question, among other things, the vitalism and lack of awareness in the modernist artist's role. Nothing of this kind happened in Sweden.

In 1971 Swedish Parliamentary inspectors made a study of how Moderna Museet utilized its state-provided funds and came to the conclusion that they were being used for extreme left wing propaganda. The results of the study were, however, phrased in such a clumsy and bureaucratic way, with quite unpleasant overtones of censorship, that the appearance of the 'enemy' on the scene rather had the effect of strengthening the museum's view of itself as dynamic, struggling and creative, in solidarity with all people of good will and with its finger on the pulse of the age. The inspectors pointed out that, for example, there were never any protocols or other documents to show what kind of thinking surrounded the exhibitions during these first ten years. Recommendations were also made for a politically elected board of directors, so that Moderna Museet could acquire an insight into how democrats think... The reactions on the part of the museum were very indignant. In an internal memorandum it was the particularly unhappy choices of words that were found irritating, such as, for example, that the museum's director was supposed to 'govern' the enterprise, or the demand for minutes of meetings at which decisions were taken. Above all, the debate showed that the museum staff identified with the artist's role they acclaimed to such a degree that they could not see any difference between artistic freedom and the running of a museum.

The report of the parliamentary inspectors is also interesting from another point of view. Only seven years earlier Moderna Museet had been granted its unique one-off subsidy of 5 million kronor in order to purchase the works that had been borrowed for the *Wish Museum*. One can get an idea of the size of the subsidy if one compares it with the subsidy for the purchase of modern foreign art in 1963–64. That was 60,000 kronor.

The *Wish Museum* was held under the direction of the Friends of Moderna Museet, though it was Pontus Hultén and Ulf Linde who, together with the editor Gerard Bonnier,

made the selection, and the museum that arranged the exhibition itself. The ideas behind it were reminiscent of the aims of the first German museums: the Swedish people were to be given an opportunity of seeing the best art and acquiring 'an exhaustive picture of ...the currents that are and those that have been', and this art was to come to the museum to stay. A declaration signed by eighteen of the leading artists of the time underlined the importance of the future collection for artists and students of art.

'Being able to see the modern art tradition in the original, and the best of that tradition, at an early stage in one's life is of immeasurable value.'

The collection's importance was thus didactic and also aimed to make the public appreciate the higher values in life, manifested through art. This was traditional museum policy, and The Wish Museum was a great success. But when the museum got hold of this art that referred outside itself – which in translation to 1970 involved not only exhibiting communist poster art but also opening the museum's premises to the strike committee from Kiruna-Svappavaara, the communist cultural workers and the Black Panther Solidarity Committee – the Parliament's inspectors were given the task of conducting an inquiry into the institution, to see if it was, among other things, breaking the basic rules of democracy. Art was thus to be something one saw in museums, without importance to other aspects of society, without any reference to contexts outside itself. It could be politically radical as long as it did not have any consequences outside the intra-artistic context. Here two outlooks clashed. On the one hand, the idea that took Modernism and its approach to the art museum, and that made art self-referring in white-painted, neutral rooms, and on the other the dream that Moderna Museet should become one with the artist's life, vitality and dynamism and which in this case took a socially political expression.

The inspectors' report also reminds us of something else. Its possibly unintentional brutality was not only a reaction from the 'powers that be', but also equally from the traditional museum public, and reminds us that 'the public' is a modern phenomenon when we are talking about the viewing of art. The public appreciated a museum that selected 'the best' for individual or group contemplation, but not necessarily a museum that became identified with a context-based art that saw the painting as part of a political context.

If I were forced to choose one single factor as the decisive one for the development of Modernism, it would be the art museum and with it the introduction of art history. The famous loss of the artwork's aura, which Walter Benjamin describes in connection with photographic reproductions, has already taken place by the fact of the art work being moved from the place for which it was made and into the museum. The new techniques of photography, film, video, and installation, have so far proved to function brilliantly as new technical subdivisions in the context of the museum, and the artists have only had the chance of utilizing a very small part of those techniques' potential. Indeed, for the prototype of the modern museum, the Museum of Modern Art in New York, the context is so dominant that all the objects that are incorporated in the collections, whether they are military helicopters or oil paintings, are seen with the same eyes. And through a century that has radically altered our lives in more or less every area, the museum remains as the guarantee of the beauty of form, irrespective of its function.

SOURCES AND REFERENCES
Douglas Crimp, On the Museum's Ruins, 1993.
Ortega y Gasset, The Dehumanization of Art, (1925/1969)
Dan Karlholm, 'Handböckernas konsthistoria' (The Art History of the Handbooks), (diss.), 1996.
Estelle Högström, 'Önskemuseet' (The Wish Museum), diss. Stockholm University, 1996.
Moderna Museet, 1998.

Parliamentary Inspectorate, Granskningspromemoria (Inquiry Memoranda), no. 8/1971. Correspondence, lists of works, transportation documents, lecture notes, etc. from the archives of the Nationalmuseum and Moderna Museet concerning the birth of Moderna Museet and the work surrounding the Wish Museum exhibition.

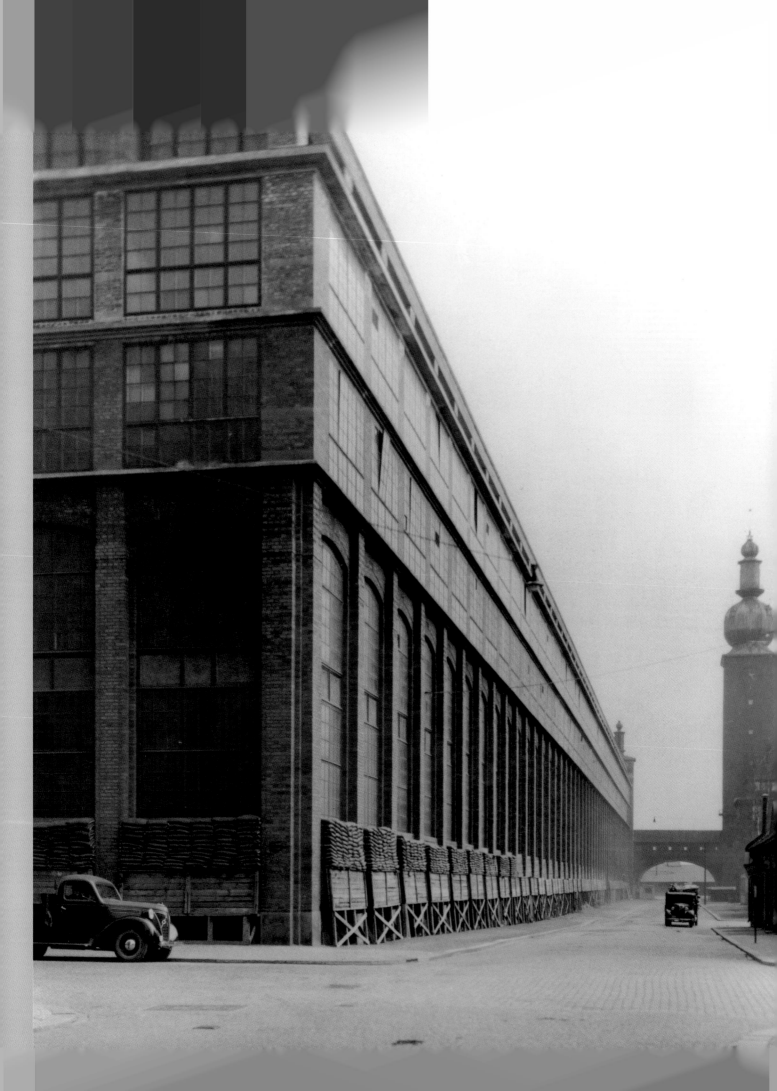

EVA ERIKSSON

THE ROOTS OF MODERNISM IN SWEDISH ARCHITECTURE

97. Asea's Mimer factory in Västerås, designed by Erik Hahr and built in two stages, in 1912 and 1915. An industrial building advanced for its time, with large glazed wall sections [no.403]

The word 'roots' evokes the image of a phenomenon that has attained its full maturity at a certain point in time, while the things that have gone before have been merely immature tendencies in that particular direction. The history of architecture has long followed this model. Modernism has been the undisputed player of the leading role in the historical development outlined by the textbooks. The nineteenth century is noted for its new materials and building designs, for its railway stations, galleries and great exhibitions – all of them considered to be preliminary stages of Modernism. Then the twentieth century is represented from the start by the continuation of modern architecture. Those architects and buildings that could be arranged into a logical line of development have been given secure places in the narrative of architectural history. After Otto Wagner follow Adolf Loos and Peter Behrens, then Walter Gropius, Mies van der Rohe and Le Corbusier. With them the movement had in principle reached its completion, the narrative its ultimate objective. A return to historical formal resources was then considered unthinkable, as they belonged to a previous phase of architecture's progressive development.

One central moral rule of Modernism was that architecture should be 'honest.' It should truthfully give expression to its design. If modern steel or concrete houses gave the appearance of being bricked in a traditional manner, this was, according to Modernism's point of view false. The same was true if architecture, with the help of historical forms, gave the appearance of being from another age than its own.

During the 1980s, Postmodernism turned this version of history on its head. It now became obvious that Modernism did not constitute a final phase in architectural development; the formal resources of architectural history were not some obsolete relic that been patterned out of modern architecture, but were on the contrary an indisputable and indispensable asset. The question is no longer whether the prototypes of architectural history have any value for the architecture of today, but how history and renewal can be combined.

These new perspectives have changed the view of Modernism – or Functionalism, as we call its counterpart in Swedish architecture. Today it is an unquestionably dated phenomenon that has become part of our historical heritage in the same way as Jugendstil or 1920s Classicism. It was a movement that was conditioned by its time, just as other styles were conditioned by theirs. The kernel of Functionalism was a certain conception of form, an aesthetic. But it was also associated with a set of ideas and values. In particular, it concerned the way in which the current transformation of society was perceived. Functionalism was closely interwoven with the technological optimism of the age. It encompassed a strong faith in the new possibilities that were opening up because of technical developments. The mass-produced T-model Ford, the aircraft, film and the cinema were products of the new age and became icons of a sort, representing infinitely expanded possibilities and a new future. An urban future, associated with the rapid pulse of the modern city.

The national currents of the turn of the century faded away, and in their place the world opened up. A new cultural freedom from boundaries developed within the European avant-garde. Modernization had similar features in country after country, and the characteristics of the modern were the same everywhere. This international sense of belonging united radical architects and created new bonds, stronger than identification with a region or a nation and its traditions. New means of communication tied countries and metropolises more closely together. The silent film was a new cultural phenomenon that spread regardless of linguistic boundaries, and the same was true of modern design. In 1932 Philip Johnson and H.R. Hitchcock launched the new Modernist architecture in the United States under the epithet 'The International Style,'[1] which emphasizes this freedom from boundaries.

Thus several components were bound together and together infused a convincing energy into the functionalist movement. What was involved was partly a style, a particular aesthetic and, in part, a cluster of ideas that were also used as an argument for the design. All this was in its turn associated with the material transformation that took place in society and was characterized among other things by technological progress, new systems of communication and production, a swift urbanization and an urban environment set in constant change. Taken together, this material transformation can be described as 'the modernization process.' In debate, the components were often seen as symbiotic. Modernist design was usually described as a more or less unavoidable consequence of current social change. A new society should produce a new form. In the search for the roots of Functionalism we discover a skein of rootlets, or preconditions, of various kinds – the process of modernization, the aesthetics and the ideology.

THE PROCESS OF MODERNIZATION

The material transformation that Western Europe has experienced since the beginning of industrialization was engendered by technology and economics. Technological progress had been cumulative, knowledge was added to knowledge and could be used for concrete alterations in a capitalist economy. Society changed, and the tempo of that change seemed constantly to accelerate. The question is then what direct expressions this process received in architecture.

Building techniques, materials and construction are indisputably the components of architecture. Since the early nineteenth century first cast iron and later steel construction had developed so that by the end of the century the traditional limits of building with regard to height and span had been broken. In the large cities of the United States, skyscrapers grew to new heights. It was possible to span light glass roofs over enormous spaces, with the help of slender iron arches. But perhaps most revolutionary of all was the fact that it was possible to liberate facades from their task of supporting roofs and joists, as they could now be supported by inner frames of steel or concrete. The facades could be opened up, and glass could replace the wall.

In spite of these possibilities, however, from a purely technical point of view building was for the most part relatively traditional. Brick was often the most

98. Rational housing production with prefabricated elements in the modern spirit, but with traditional design. The picture shows a self-build site, with the labor of the occupants, in Stockholm during the 1920s

economical alternative, especially in Sweden. Here in the 1930s houses were still being built of brick on concrete foundations, with frames of iron girders or concrete joists – mixing tradition and innovation. Although new technology existed, it was not invariably used, and above all it was by no means always likely to influence appearances. Houses continued to look like traditional brick dwellings, even though there was a modern concrete framework supporting the facade.

In some cases, however, the new possibilities tallied with economic requirements, and here it is possible to say that the modernization process directly propelled new forms in architecture. The buildings involved were those intended for commerce and production: shops, department stores and factories. During the latter part of the nineteenth century the increased supply of goods was displayed in large show windows. Department stores and galleries took shape in the large cities on the Continent. Technical developments made the use of glass and iron in commercial buildings feasible and thus a new architecture arose: boutiques with large glass facades, department stores several storeys tall under high glass roofs. As a rule, however, the new features were combined with historical details.

The same was true of industrial buildings, where the need for daylight in large halls also stimulated the manufacture of large window sections (Fig. 97). The 1910s and 1920s were a time of intensive rationalization of production. This movement spread from the United States, where the organization of labor was made more efficient under the influence of Taylorism. The conveyor belt in Henry Ford's automobile factories quickly acquired a following, and as a consequence industrial buildings began to be designed in order to suit the individual factory's production plans. The result was large-scale buildings with glass wall-sections supported on thin metal frames.[2] Modernization influenced these buildings directly. That did not, however, mean that the language of form was necessarily affected in other building projects.

The technical possibilities for an architecture in glass, steel and concrete existed and were utilized where there was also an economic requirement for such features. But for the same design to be used in a town hall or residential building as in a factory, it was necessary for architects and clients radically to alter their ideas about how such buildings ought to look. It was also necessary that the ideas about architectural form should alter and new ideals be developed.

Another aspect of the modernization process was the importance that, since the nineteenth century, had been attached to questions of hygiene and sanitation in city planning. In industrialization's infancy cholera had ravaged the large cities of Continental Europe. Swedish cities, too, had had cholera epidemics as a result of poor sanitary conditions. When the water and sewerage systems were built during the latter half of the nineteenth century, hygiene was a basic precondition for the development of modern cities. In other respects, too, hygienic considerations stood at the forefront of nineteenth-century planning. Fresh air and natural light were ensured by means of parks and plantations and light and airy designs were prioritized in schools and hospitals. Thus, improved hygiene became a means of mastering the epidemics that had plagued mankind in the past. The demand for air and light was a progressive one, it was perceived as rational and grounded in science, it was associated with progress and Modernity. In the early 1930s, when tuberculosis was a scourge that could be directly linked to the overcrowding in Swedish cities, questions of hygiene were as acute as they had been in the nineteenth century.

99. The industrial pavilion at the Norrköping Exhibition of 1906, designed by Carl Bergsten. Its avant-garde design was unique at this time, and based on aesthetic ideals, not modernization as such. [no.400]

The pressing need for housing that grew with the influx of people to the cities was another important factor in the modernization process. During the First World War private building came to a standstill as a result of a shortage of materials and rising prices. This led to an acute crisis that forced initiatives from other quarters. Communes and cooperative housing associations became important commissioners of building projects, and accommodation for the broad masses became the priority – small apartments for the great majority of Swedish families living on ordinary industrial workers' wages. If this enormous need was to be met, building must be done rationally and inexpensively. The construction of housing became a task that, in an entirely new way, was all about quantity. It was also influenced by the movement towards rationalization prevalent at this time. Even before the First World War small private residential districts were planned, with standardized housing that could be erected in large series, thus reducing cost. After the war the task of standardizing doors and other carpentry work was begun, so that these could be mass-produced. The planning and fitting of kitchens was studied systematically, with the same aim. During the 1920s housing construction began to be comparable to other factory-based manufacturing (Fig. 98). However, the strong undercurrent of rationalism in various fields did not necessitate the abandonment of traditional features that were part of the classical style of the time.

DESIGN AND AESTHETICS

Aesthetics lay at the heart of Functionalism, supported by arguments from other fields. But if we peel these away and try to uncover only the purely formal development within architecture from the turn of the century to the 1930s – how does the picture look then?

Around the turn of the century architecture was rich in form with a repertoire stretching from neo-gothic and neo-baroque to Jugendstil. This wealth of form spread quickly along the streets of the large cities during the increased building activity of the age. It is probable that the proliferation of houses was partly responsible for the intense criticism targeted at this 'architecture of style.' It was the beginning of a whole new endeavor among architects in Sweden and elsewhere. Instead of a form that was rich and flowing, the one sought now was simpler and more pared-down. There emerged a new interest in pure primary forms, simple volumes and smooth surfaces against which

100. The Forshuvudfors power station in Domnarvet, designed by Osvald Almqvist in 1917–21. A strict and economical design, but with clear roots in traditional form [no.406]

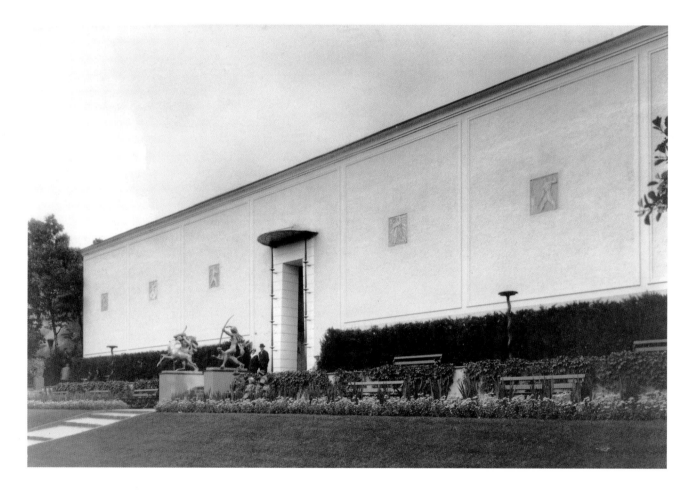

101. The Art Handicraft Pavilion at the Jubilee Exhibition in Gothenburg, 1923, designed by Hakon Ahlberg. Abstract design with smooth surfaces and brittle detail in the framework of 1920s Classicism [no.409]

a few pregnant details stood out all the more distinctly (Fig. 99). Architects sought such features in traditional building, in timeless, anonymous peasant houses in rural areas, in eighteenth-century millworks and in the simple burghers' houses of the early nineteenth century. At the beginning of the twentieth century, with inspiration from the English Arts and Crafts movement, architects like Carl Westman and Ragnar Östberg placed great emphasis on material. The unique color and surface character of stone and brick became important means of expression in architecture. But towards the 1920s this material-related weight disappeared, and light-colored plaster made a return.

During the 1920s this striving to reduce the form, to pare down the volumes found inspiration in the proportional system of classicism (Fig. 101). This was important, for the more paring-down was done, the greater was the importance acquired by size and proportion, balance and rhythm. Here there was a rich inheritance of prototypes to draw

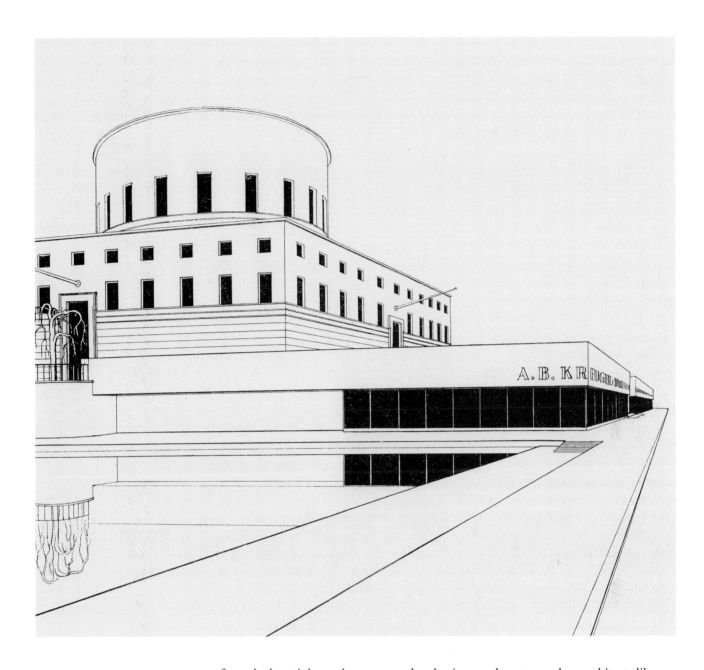

103. Above: Stockholm City Library, by Gunnar Asplund, opened in 1928, was a work at the transition between two trends. In this late perspective design, Asplund emphasizes the building's abstract character at the expense of the classical features. The modernist storefront is particularly noticeable [no.411]

102. Left: the Resurrection Chapel at the Forest Cemetery in Stockholm, designed by Sigurd Lewerentz, 1921–25. Classicism driven towards an increasingly abstract design, in which surface and volume are the expressive means. [no.410]

on from the late eighteenth century and early nineteenth century, when architects like Boullée and Ledoux in France, Schinkel in Germany and Hansen in Denmark employed a classicism that took its starting-point in clear, geometric volumes. It was also the case, however, that in the old wooden houses of the cities, where the dimensions of the timber provided definite sizes and proportions that were constantly repeated, architects found the quiet rhythm and balance they were now seeking in order to be able to master the swift spread of urban environments. Some of the architects who were active in the 1910s and 1920s made a more or less direct transition from a pared-down traditional form to a functionalist one. This was, for example, true of Osvald Almqvist when as early as the mid-1920s he designed power stations that are usually viewed as early examples of Functionalism in Sweden (Fig. 100). In 1919, Ivar Bentsen, one of the most devoted representatives of a traditional line in Danish architecture, designed a surprisingly radical 'modernistic' proposal for an opera house and concert hall in Copenhagen (which was not, however, built). In Germany Mies van der Rohe took his starting-point in classicism and especially the work of Schinkel in his increasingly reduced, abstract designs.

Classicism reached its full expression in Germany around 1910, in the work of Peter Behrens, Heinrich Tessenow and others. It began to take shape in Denmark and Sweden

in the years that followed and by the end of the First World War had made its breakthrough in Nordic architecture. It is then possible to follow how in certain works during the early 1920s classicism became increasingly abstract. Sigurd Lewerentz's Resurrection Chapel at Stockholm's Skogskyrkogården (Forest Cemetery) is an example of this tendency (Fig. 102). Here the details of classical style are, as Sven Markelius pointed out in his review,[3] almost irrelevant. It is the volume itself and its form that are important.

The climax of this change towards an increasingly abstract and geometrically based architecture within the framework of 1920s classicism was Asplund's Stockholm City Library (Fig. 103). But when it was completed in 1928 the times had already changed. Radical critics like Uno Åhrén and Gotthard Johansson saw the library's design as an incomplete and conflict-ridden compromise, in which formalism stood in the way of pure functional design. Now there were new models for a consistently modern design, developed by Gropius, Le Corbusier and others.

Thus, from a purely aesthetic point of view, the route from the turn of the century to the 1930s may seem straightforward, as a development towards an increasingly pared down and abstract design. Yet the step from 1920s classicism to Functionalism was a radical one, principally because all retrospective references were excised, and traditional features rejected.

IDEAS, ATTITUDES, VALUES

The material transformation had been dramatic and palpably visible in altered cityscapes around the turn of the century, and during the 1920s modernization found expression in a strong rationalization movement within industry, that was also evident in the field of housing construction. In Stockholm one-family houses were assembled on conveyor belts, with whole wall sections delivered direct from the factory. But in spite of these strong undercurrents of rationalism and increased efficiency, a traditional element had remained in the design. Thus Functionalist architecture was not a direct result of rationalization, but of the attitudes towards it, of the ideas and the ideals.

Seen from within the context of the history of ideas, there was a double inheritance from Romanticism and the Enlightenment tradition. It embraced different visions of history and the future, of cultural values and material progress. This had found expression in, among other things, a wide-ranging architectural debate during the nineteenth century. Perhaps the century's most influential architectural commentator was the British critic, John Ruskin, who represented a backward-looking intellectual tradition rooted in Romanticism. For him Gothic architecture inspired memories of a past age of greatness, which in aesthetic and social respects was immensely superior to

contemporary culture. According to Ruskin, contemporary capitalism had furthered egotism and ruthless exploitation, cultural values had been vulgarized, the quality of architecture and art handicraft had declined. His intellectual legacy lived on in Swedish National Romanticism, with its interest in historical values, continuity in the cityscape and striving for a timeless quality in architecture, uneroded by chance fashionable trends. This legacy had at the time been handed on through William Morris and the English Arts and Crafts Movement, which provided concrete prototypes for architecture and art handicraft.

But the Enlightenment tradition with its rationalism and progressive optimism had grown in influence during the nineteenth century. It had been nurtured by the enormous leaps forward that had been made in the fields of technology and science. The idea of constant progress made contemporary reality seem superior to past ages, and with it the vision of the future also acquired a powerful aura. In the

105. Store building for Myrstedts & Stern in Stockholm, designed by Ernst Stenhammar 1908–10. Stockholm's first reinforced concrete building with authentic skeleton construction and an early example of a modern construction also being employed in a design-conscious manner

104. The house of architect Georg A. Nilsson, Regeringsgatan 88 in Stockholm, 1906–7. A pared-down design that anticipates functionalist aesthetics

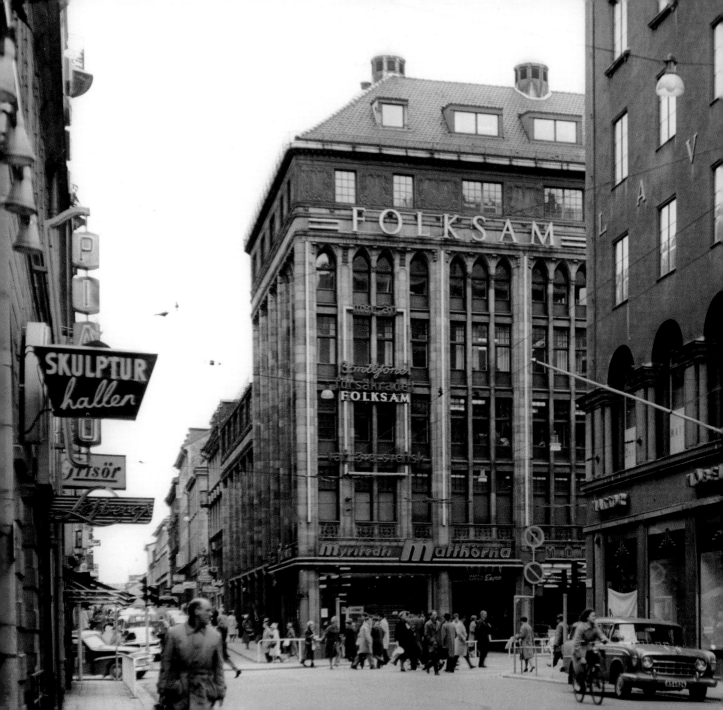

field of architecture, a rationalistic attitude of this kind had had its proponents in the nineteenth century. With Functionalism it broke through once again and simultaneously took the edge off the national romantic inheritance from the turn of the century.

The rationalists of the nineteenth century had asserted that architectural form should be a direct expression of a building's design and function. Such an attitude had been maintained in Sweden at the turn of the century, and the tendency could be seen, especially in the commercial sphere, where new buildings – for example Myrstedt & Stern's shop and office complex (Fig. 105) and Georg A. Nilsson's Stockholm work (Fig. 104) – had been style-forming. But brick and handicraft were fundamental to the building of the time, and consistent brick design equated with old-fashioned forms.

The new classicism of the 1910s was a natural consequence of the new concrete

106. Liljevalchs Konsthall in Stockholm, designed by Carl Bergsten, 1913–16. A reduced classical design has been employed as the expression for modern concrete construction

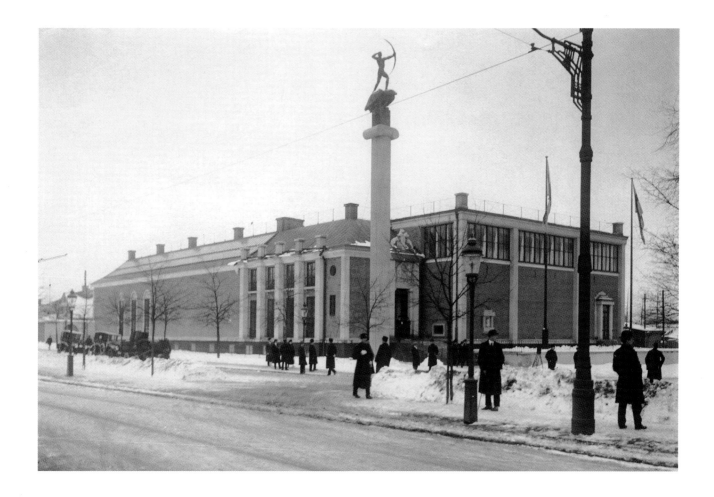

technique, with its system of load-bearing pillars and supported beams comparable to the classical model. This was how the rationalist architect Carl Bergsten viewed the situation (Fig. 106). But in reality the thesis that form should follow construction was discarded during the 1920s to accommodate other objectives. Gunnar Asplund, who now became the major leading figure in Swedish architecture, was in reality interested more in how people experience space, volume, light and movement in architecture. His goal was an architecture rich in experience, even though he himself did not express it like this.

With Functionalism the rationalistic vision of architecture re-emerged, but now in relation to materials and designs that were thought to lie in the future. Architecture should be forward-looking, not anchored in history. Continuity in design was no longer a value but was rather seen as a burdensome inertia. As early as 1916, though

Functionalism did not exist at that time, Gregor Paulsson had presented ideas in *The New Architecture* that tallied in many respects with what was being accepted fifteen years later. He had derived his concepts from the Deutscher Werkbund, and therefore his ideas were not directly dependent on current trends. With Functionalism the style acquired a graphic impact, which contributed to its success.

Until now architecture had been indisputably anchored in Western cultural heritage, though with varying interpretations. There had (with the possible exception of Jugendstil) always been a certain element of retrospection, of history. Now, instead, there was a relationship with future intentions, stemming from new construction methods, which were not yet being exploited to the full. Architecture was not merely giving expression to changes being experienced in contemporary society, but rather to future goals, not yet attained. It became a vision of the future.

The expectations of building commissions also changed. Previously architects and clients had made a distinction between public and private buildings. A hierarchy existed in which public commissions required a different sort of dignity from, for example, a factory. And this type of dignity was usually established through historical associations. This hierarchical view of the roles of buildings began to be dismantled, as Gregor Paulsson had advocated in 1916. Industrial buildings began to be seen in a heroic light, as bearers of Modernity representing the future. And therefore their designs could also be considered as models for other building commissions.

Another important ingredient of the ideas of Functionalism was the notion that the current aesthetic re-orientation was a historical change and not an accidental variation in taste. Thus functionalist design was qualitatively different from all previous styles. This idea had its roots in German art theory and was introduced in Sweden by Gregor Paulsson and Uno Åhrén. It was also convincingly supported by the link between aesthetics and the modernization process. Because new designs appeared concurrently with changes in other areas of society, it was seen as a part of the same process, an indispensable ingredient of modernization. For those who accepted the new aesthetic with open minds, the picture of the future became promising and exciting. Even today images from that time convey an enormous energy, almost a sense of euphoria.

NOTES
This essay is based on the author's dissertation, to be published by Ordfronts förlag as *Den moderna staden tar form* (The Modern City Takes Shape).
1. See Henry-Russell Hitchcock and Philip Johnson, *The International Style*, 1932.
2. Lisa Brunnström describes this development in her book *Den rationella fabriken* (The Rational Factory), 1990.
3. Sven Markelius, 'Uppståndelsekapellet' (The Resurrection Chapel), *Byggmästaren* 20-1926, pp. 233ff.

EVA RUDBERG

UTOPIA OF THE EVERYDAY

Swedish and Un-Swedish in the Architecture of Functionalism

Modernism in architecture – called Functionalism in Sweden – is an expressly international movement. Is there, however, something that can be characterized as typically Swedish in this type of building?

The international and the national in Swedish architecture are elusive identities. For example, national romanticism in architecture, which is viewed as distinctively Swedish, has many prototypes and parallels abroad. At the same time, ancient Swedish prototypes such as Visby Wall and Vadstena Castle are contained within this architecture. In a similar way, the profile of Modernism in other countries has its own national features, though they are often harder to identify.

This duality is demonstrated in the proposal submitted by the architects' office of the Swedish Co-operative Society for the 'Cheap Housing' competition held in Stockholm in 1932. Their entry bore the motto: 'One Day The Earth Shall Be Ours.' It was introduced with a painting that depicts a modernist terraced housing estate – an unusual form of housing in Sweden at that time – with a man digging in a garden; a woman is putting a tray on the garden table; a young man is reading a newspaper; and in the foreground sits the artist himself, portraying the scene – he is Arvid Fougstedt. The picture exudes the atmosphere of a Swedish idyll (Fig. 107). The motto, however, comes from the best known of all revolutionary songs – the Internationale: (*En dag skall jorden bliva vår* – 'One day the earth shall be ours' – in the English version: 'Let's claim the earth henceforth').

The perspective of international solidarity is combined with the Swedish dream of a garden of one's own; the farmer who has come to the city to become an industrial

108. The Stockholm Exhibition's tall advertisement mast with its press gallery was perhaps the closest that Sweden got to the spirit of Russian Constructivism. Here accentuated by the dramatic angle of the photograph taken by C.G. Rosenberg

107. *One Day The Earth Shall Be Ours*, the Co-operative Society architects' office entry for an 'affordable housing' competition in 1932, presented by Arvid Fougstedt [no.430]

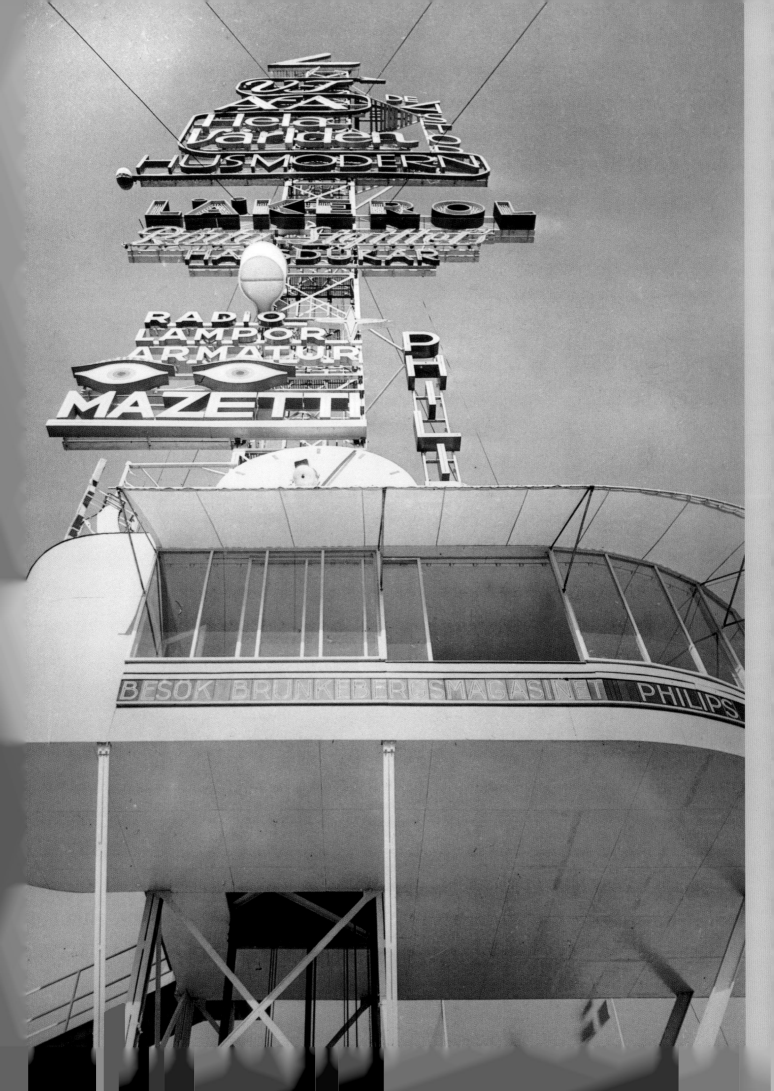

worker wins back a piece of his land. The international and the national are united in a common hope for the future.

INTERNATIONAL MODERNIST ARCHITECTURE

Modernism in architecture is a broad concept that embraces the whole era and all its modernist expressions from its inception in the 1910s all the way through to the 1970s – and perhaps even to today. The 'Modern Movement' has become another collective name for the trend. The 'New Objectivity' (Die neue Sachlichkeit) in architecture stands above all for the Modernism of the German Weimar Republic. In the United States the trend was christened 'The International Style' when it was introduced in the early 1930s. And in Sweden it was given the name 'Functionalism', a concept that reflects the method of working and is associated as an expression of style above all to the period from the late 1920s to the Second World War.

The architecture of early Modernism had several branches. A fundamental feature was the search for 'the expression of our own time' and a distancing from academicism. The nineteenth-century American architect Louis Sullivan's phrase 'Form follows function' became the slogan of the modernists. In Vienna as early as 1910 Adolf Loos designed a villa in reinforced concrete with 'cubist,' clear-cut undecorated volumes, and stated categorically that 'Ornament Is A Crime.' In 1913 artists and architects started the Constructivist movement in Russia, which with its utopian construction fantasies came a few years later to symbolize the young Soviet state's belief in the future. Mayakovsky formulated their battle cry: 'We alone represent the face of our time!' At about the same time, Marinetti, the spokesman of the Italian Futurists, declared his war on history: 'Set fire to the libraries, free us from the museums and professors, take your pickaxes and destroy the cities!' In Holland 1917 saw the founding of the de Stijl movement, in which artists and architects like Piet Mondrian, Theo van Doesburg and Gerrit Rietveld worked on abstract design using primary colors. From 1918, Le Corbusier followed Purism in his art and architecture, spreading his ideas via his journal L'Ésprit Nouveau. Walter Gropius started the Bauhaus School in Weimar in 1919, and moved it six years later to Dessau, where it became a focal point for modernist design and architecture for students from all over Europe. The school building itself, which he had designed, with its large, glazed facades and asymmetrical, function-divided planning became a symbol of the new movement. Ludwig Mies van der Rohe, director of the school during the final years before its closure by the Nazis in 1933, pursued that fastidious route furthest through his motto 'Less is more'.

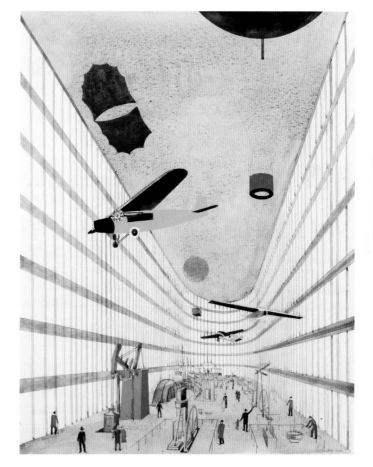

109. Above: Proposal for a museum of technology at Hötorget in Stockholm. Hans Qviding's project for the Art Academy's student examination in 1928 [no.412]

110. Right: Borohus followed the trend and presented prefabricated houses, including *Funken*, in its 1931 catalogue [no.428]

For some of the Swedish architects who encountered the architecture of Modernism in Le Corbusier's pavilion at the Paris Exhibition of 1925 it was a revelation. That was how it seemed to Uno Åhrén, who as he faced Le Corbusier's pavilion exclaimed:

> Here there is free space to move about in, to talk seriously or in jest in, as one pleases, free walls on which to hang works of art, free floor surfaces on which to group furniture according to everyone's taste.[1]

It was, however, above all the modernist architecture of Weimar Germany that influenced the Swedish architects. Here the first major comprehensive display was held in the form of the Die Wohnung exhibition in Stuttgart in 1927, and here the newly built residential areas of Berlin and Frankfurt were present as concrete examples of the new ideas.

THE SWEDISH HERITAGE

For Swedish architects Modernism – or Functionalism – must have appeared as an answer prepared long-ago to a number of problems and issues concerning architecture and society. In the new trend they thought they saw the comprehensive solution – moral, intellectual and practical.

The special relation to the light has left its mark on building in the North. The cold and lack of daylight during the dark season have created a pressing need to admit the greatest possible amount of daylight to apartments and workplaces. The emphasis placed by modernist architecture on large window surfaces could be seen as the answer to this need, and the characteristic tall windows as simply an adaptation to the low-lying sunlight. The incursion of sunlight also played a decisive role in Swedish town planning during the 1930s, and resulted in parallel-sited laminated houses oriented so that the apartments would receive the maximum and best distributed access to sunlight.

The use of daylight in architecture has historical roots. Stockholm's building ordinances of the eighteenth century contained a requirement that buildings in the city should have windows placed far enough out in the façades that they could catch the daylight and reflect it down into the narrow streets. Façade windows are a heritage that returns in Functionalism, where they contribute to the light, airy character that the movement aspired to. Stockholm's distinct architectural profile, with polished, bright often yellow façades, dates from that ancient time. It is a tradition that suited the aspirations of the Functionalists well.

The old striving of the hygienists for health, fresh air and cleanliness, and the long struggle with bedbugs, tuberculosis and other national afflictions also found a response in Functionalism's light spaces and shiny, smooth easily washed surfaces in kitchen and bathroom. Dirt can be seen in daylight and can be cleared away. Virtue and aesthetics went hand in hand.

Classicism is one example of a borrowed style that acquired a national character of its own. The charming simplicity and lightness that characterized both the Swedish architecture of the eighteenth century and interior decoration like the 'Swedish Grace' of 1920s classicism, have been valued highly by the outside world. This simplification was underpinned by poverty and lack of resources: C.J.L. Almqvist's title, The Significance of Swedish Poverty, did indeed have implications for the development of resource-economical solutions and inventions. The simplification and economy also had a moral aspect, anchored in the Lutheran heritage. Functionalism, which in Sweden was strongly marked by rationalism, simplicity and a fastidious attitude, falls in well with this heritage.

Diligently performed, the simplifications of resource-economy can give a resilient fullness of expression to architecture. In Functionalism, this is a virtue. The possibilities of the materials are forced to the utmost in thin walls and slender columns – designated by some as 'architects engineering romanticism.' It became popular to experiment with reinforced concrete and new materials such as masonite and plywood, which were well suited to this slender fashion.

One way to simplify is to rationalize – to make systematic use of time and labor resources. The standardization of building components and the rationalization of construction methods had historic roots. After the First World War the question of how to make the production of housing less expensive was more topical than ever. In 1919 The Swedish Industrial Association and the Swedish Technologists' Federation's division of house-building took the initiative to the Committee of Standardization, where the standardization of construction joinery and a functional study of kitchens were undertaken. These institutions were further strengthened when they became the grant-giving bodies in postwar housing policy. As a traditional centralized nation, Sweden was able to adopt building standards as an instrument of state control in order to produce better housing.

The choice of materials is one of the things that can give a country its special architectural features. In Sweden's case, wood has been a traditional construction material, and it also made its mark on many of Functionalism's buildings. Façades with vertical wooden panels have been a characteristic Swedish feature that has accompanied the development of Modernism. Prefabricated wooden dwellings – one-family houses and villas – that grew out of the sawmill industry adopted functionalist design on the outside but often preserved traditional planning. In the trend-sensitive 1931 catalogue of the timber firm Borohus the customer could choose between different designs: 'Granebo' in national-romantic style, 'Söderhaga' for classicism, and Modernism in the form of the expensive 'Hollywood' or the slightly less pretentious 'Funken' (Fig. 110).

An old patriarchal social form – the industrial community – received modernist dress and a more democratic content in the Co-operative Union's (KF) buildings on Kvarnholmen in Nacka (Figs. 111, 112). The complex, which consists of silos, factories and living quarters, was built around 1930. The housing estate, which was part of it, was a realization of the claim 'One Day The Earth Shall Be Ours'. Here there was accommodation for both clerical staff and workers. And instead of the industrial community's traditional church, there was a cooperative shop. The architects of the complex were Eskil Sundahl, Artur von Schmalensee and Olof Thunström.

Thus, Functionalism was an answer to many of the needs of the time, not only in the form of new solutions but also with the follow-up and development of earlier solutions. Parts of the Swedish architectural heritage reappear in the buildings of Functionalism.

THE FIRST IMPACT OF FUNCTIONALISM IN SWEDEN

By the end of the 1920s a few modernist buildings had been erected in Sweden: Osvald Almqvist's power stations, some of the above-mentioned silos on Kvarnholmen, an office block by Wolter Gahn, some villas and apartment blocks by Sven Markelius as well as villas by the Austrian architect Josef Frank. But a broader manifestation and breakthrough took place in 1930, with the Stockholm Exhibition.

The great exhibition was organized by the Swedish Society of Craft and Industrial Design, led by Gregor Paulsson, and it was given its modernistic form by Gunnar Asplund (Fig. 108). It was the simple exhibition halls, the small advertising pavilions, the glazed main restaurant with its awning, the lively, flag-decorated market street and the tall advertising mast which together with the water and trees on Djurgården made the exhibition such a convincing entity (Fig. 113). There was also a special housing section where the architects tried to produce well-designed apartments for families on low incomes. The result of the latter was somewhat discouraging and showed clearly

111, 112. KF's installation on Kvarnholmen outside Stockholm became a modern industrial site with factories, apartments and co-operative stores, and contains some of the earliest examples of Functionalist architecture. The silo building with mills in the picture above was designed in 1927 by KF architect Artur von Schmalensee. It is one of Sweden's first Functionalist buildings. The presentation technique has pronounced features of machine design in the engineering spirit sought by the architects

that superficial tricks were not enough. Architecture was not primarily technology – it was politics, the architects maintained; a conscious housing policy was needed in order to manage the housing question. But the exhibition also showed that workers' apartments and middle-class apartments were becoming more and more similar because of the functional studies that were being undertaken – with regard not to size, but to design.

The Stockholm Exhibition met with great acclaim, but also with harsh criticism both from the public and from professionals.[2] Among the younger architects there was much enthusiasm, while some of the older, celebrated architects, such as Ragnar Östberg, Ferdinand Boberg and Isak Gustaf Clason, took exception.

An important aspect of the criticism concerned the 'lack of Swedishness.' This in spite of the fact that all the objects that were exhibited and all the architects, designers and manufacturers involved were Swedish. The furniture designer Carl Malmsten, who was one of the most prominent critics, thought that the new architecture and design did not suit Swedish homes. The leading figure of the local history movement (hembygds-rörelse), Karl Erik Forsslund, parodied a popular expression and was of the opinion that 'Functionalism is frozen negro music.'[3] The art critic Carl G. Laurin, who took exception to Cubism and Futurism, was scathing, as was his daily colleague Torsten Fogelqvist, who wanted to 'scrap the whole fleet,' i.e. the whole exhibition. The conservative *Sydsvenska Dagbladet* thought that 'The most awkward and also true thing that can be said about the 1930 exhibition is that it was not Swedish.'[4] These were tones reminiscent of the reaction displayed by the Nazis to modernist architecture in Germany.

That criticism should be directed at the Functionalists from bourgeois and conservative quarters was not unexpected, but the fact that the left wing radicals also reacted negatively, making reference to un-Swedishness, was more surprising. (Though perhaps not entirely surprising, considering the later development of Stalinist architecture in the

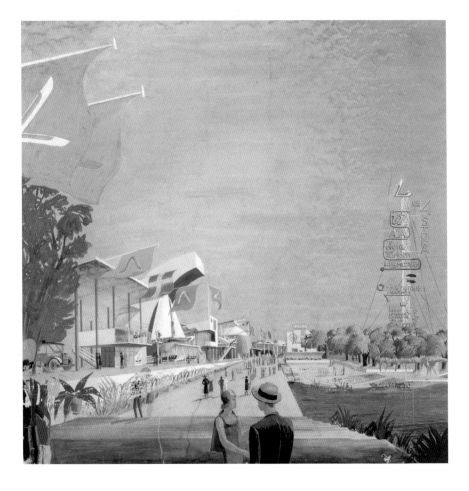

113. The Stockholm Exhibition of 1930 – the breakthrough of Functionalism in Sweden. Advertising was important in the architecture of Modernism, taking over the role of ornament in traditional architecture [no.414–423]

114. The students' union building of the Royal College of Technology was built in 1930 and fitted with furniture from the Stockholm Exhibition. The architects were Sven Markelius and Uno Åhrén. The building has all the characteristic features of Functionalism: the smooth, unbroken, unornamented surfaces and geometrical volumes without emphasized roof base and socle, the flat roofs, the long, unbarred window bands and the asymmetrical planning. It was in this building that Otto G. Carlsund's fresco with motifs from the university's different faculties would have been placed, had it not been rejected by the students' union

115. Sveaplan Higher Public Grammar School for Girls, designed by Nils Ahrbom and Helge Zimdal, was completed in 1936. It was a modernist statement about the strengthened position of women in society. The introduction of women's suffrage in Sweden in 1921 meant that women gradually acquired the right to occupy higher civil service posts. This in its turn meant that women had to be given access to the higher public grammar schools. As a consequence of this, five girls' schools were built in Sweden during the 1930s; one of them was sited at Sveaplan in Stockholm

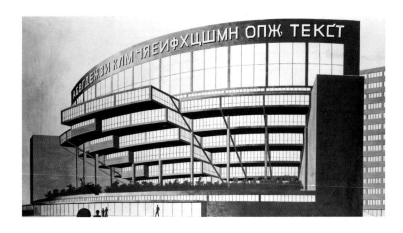

Soviet Union). Hinke Bergegren wrote in the socialist daily *Folkets Dagblad Politiken* of the Stockholm Exhibition that he 'felt really sentimental and patriotic with anger' and would rather see 'genuine peasant gaudiness.' He did, however, concede the value of mass production for making goods less expensive. 'One cannot simply reject Functionalism, any more than one can reject any other technology, just because it was created by capitalism.'[5]

The Functionalists countered the attacks by asserting that Swedishness ought to not lie in the copying of outdated stylistic decors, but in continuing the constructively honest and practical tradition that had characterized Swedish building art and now also Functionalism. Attention was drawn to that most Swedish of buildings in the most Swedish of provinces – the medieval Ornässtugan in Dalarna – and the opinion expressed that it was based on the same principles as those of the Functionalists. At the same time they recalled that all the Stockholm examples – The Nordic Museum, the Town Hall, Högalidskyrkan and Stockholm Court – which the critics wanted to pinpoint as typically Swedish, were based on foreign influences.[6]

The same argument is found in the cultural journalist Gustaf Näsström's *Swedish Functionalism* of 1930. Typification, standardization, practical objectivity and practical simplicity made up the Swedish heritage that was adopted by Functionalism, he thought, taking the eighteenth-century officers' houses of Långa raden on Skeppsholmen as one among many examples of older housing with which Functionalism associated itself.

There is an interesting American parallel to the arguments of Näsström and the others in Henry-Russell Hitchcock's book *American Cities* of 1934; the same Hitchcock who two years earlier, with Philip Johnson, launched European Modernism in the USA and created the concept of 'International Style.' In this book, with the help of a skillful photographer, he delineates the American cities of the first half of the nineteenth century, asserting that the same anonymous simplicity and consistency that characterizes them – and which he believes constitutes the best of the American tradition – recurs in the new architecture. Like Näsström and the others, he wanted to give legitimacy to the architecture of Modernism by proving that it is grounded in native tradition.

In other words the Swedishness in Functionalism is a question of which perspective one chooses: that the political starting-points of the judges mattered is beyond dispute. Functionalism stayed, survived and made such an impact for reasons connected with a political situation in which broad social investments were made in building. The outside world's appreciation of Swedish Functionalism is based precisely on the fact that it has been employed in everyday architecture. As such, it has been so durable and acquired such scope

116, 117. New ideas in Russian and German theater art provided impulses to architecture during the 1920s. A new, democratic society was reflected both in theater form and in building. An international theater building competition at Kharkov in the Soviet Union was advertised in 1930. Uno Åhrén, one of the most eminent names in Swedish Functionalism, contributed this proposal that 'thoroughly distanced itself from the type of theatre that belonged to bourgeois, class-divided society.' The audience sat in a semi-circle around the stage, and the actors could perform in the auditorium and in the galleries. The hall was to be subordinate to play, actors and audience, and provide infinite opportunities [no. 424]

118. Le Corbusier's drastic proposal for the transformation of Stockholm in the competition for the renovation of lower Norrmalm in 1933

119. Helsingborg Concert Hall, designed by Sven Markelius, underwent a metamorphosis from Classicism to Modernism during the design stage from 1926 until completion in 1932. Even the presentation designs altered character, from the careful gouaches to the clear-cut surfaces of the airbrush technique, which congenially mirrored the style of the new architecture

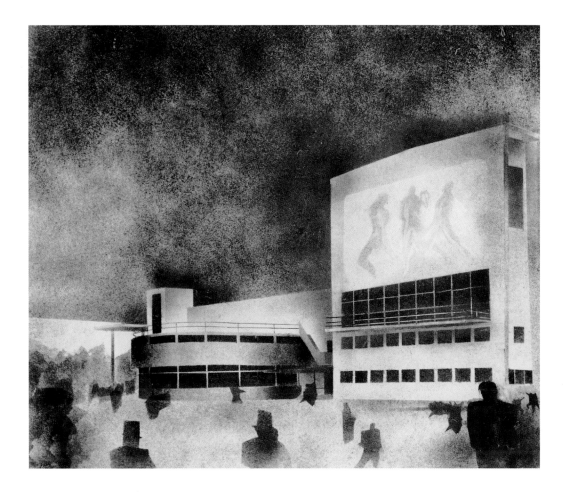

that even if it was not viewed as Swedish from the outset, it has now assumed a Swedish identity.

DEMOCRATIC DESIGN?

The breakthrough of Modernism coincided with important democratic advances. Yet Modernism and democracy have not always gone hand in hand. Futurism – the Italian form of Modernism – allied itself with the fascist forces in the country. But in Sweden Functionalism became the architectural expression of a society moving towards greater democracy. The Social Democrat Prime Minister Per Albin Hansson's symbol of the welfare society "Folkhem" (People's Home), was to a large extent designed by the Functionalists.

But Functionalists did not talk about 'democratic design.' Instead they talked about giving their own age an adequate expression in buildings that corresponded to the needs of the modern individual and the basic qualities of architecture. They wanted to make buildings and utility articles into 'flexible tools for life' by exploiting new technology and at the same time creating new aesthetic values. They wanted to 'accept the available reality' so as to be able to influence that reality and engage with the problems that existed in society – especially the housing question. When they formulated their program in the publication *accept* in 1931, the Functionalists stated critically that 'even though modern society gets most of its features from the new democracy, certain values are allowed to remain completely untouched, as pure relics of a bygone cultural era. This particularly concerns aesthetics.'[7]

They also stressed the role of art: 'The new architecture needs the help of free art. Painting and sculpture must emerge more strongly within architecture's framework. Not, however, as subservient "decorative" design[...]But as free, independent design.'[8]

121. Flight became one of the symbols of modern life, and Bromma Airport, designed by Paul Hedqvist, was completed in 1936 [no.437]

120. Horizontal designs dominate in the architecture of Functionalism, sometimes with strong associations with ship design, as here in Eric Rockström's co-operative store in Borlänge of 1931. Windows above corners help to moderate the building's weight. Co-operative stores were often the first Modernist buildings to be erected in country towns and in the countryside

122, 123. Sweden's first authentic service-flat block was built in 1935 after lively debates at John Ericssonsgatan in Stockholm. The initiators were Sven Markelius and Alva Myrdal. The aim was to relieve the professional married woman of responsibility for childcare, cooking, laundry and cleaning – as all these functions were installed in the block. Markelius and his family lived in the block for many years, and the anti-Nazi group Kulturfront, of which Markelius was chairman, held its meetings here during the 1930s. Today the block has been restored and the restaurant with its food elevators is, like the crèche, still in operation

124. Per Albin Hansson in front of his terraced house in Ålsten, designed by Paul Hedqvist and built by Olle Engkvist in 1932 [no.432]

125, 126. The *H55* exhibition in Helsingborg in 1955 marked a high point in post-war modernist architecture. *Right*, the *On Board* pavilion, designed by Carl-Axel Acking and, *overleaf*, the famous *Parapet*

received high priority. Overcrowding was worse in Sweden than in most other parts of Europe. It was natural that there should be a mutual exchange between politicians and those Functionalists who had been intensely involved in the issue, at the 1930 Stockholm Exhibition, among other places. Several of them were involved in the Social Housing Commission, started by the Social Democrat minister Gustav Möller in 1933, which eventually led to the successful housing policy after the war. Prime Minister Per Albin Hansson expressed his approval of the new architecture in a very tangible way by himself moving into one of the markedly functionalist terraced houses on Ålstensgatan in Bromma, designed by Paul Hedqvist and built by the legendary master builder Olle Engkvist in 1932 (Fig. 124).

Other sympathizers among the Social Democrats were Alva and Gunnar Myrdal, who were close friends of both Uno Åhrén and Sven Markelius, two of Functionalism's most prominent architects (Fig. 114). Gunnar Myrdal collaborated with Uno Åhrén in an investigation that preceded the Social Housing Commission, and Sven Markelius and Alva Myrdal made common propaganda for the service apartment block as a form of housing (Figs. 122, 123). Markelius also designed the Myrdals' villa in Bromma, which was completed in 1937.

But there were also Social Democrats who strongly disapproved of the new movement. The influential Artur Engberg, editor of *Social-Demokraten* and later minister of education and ecclesiastical affairs, preferred a more traditional architecture and defended his attitude in no uncertain terms: 'What has the labor movement done to deserve being made in its rise responsible for this trend in taste that marks a decline?'[9] he wondered. And Carl Lindhagen, Stockholm's mayor and the Social Democratic leader of the city council, saw Functionalism as a crass utilitarian architecture lacking interest in the beautiful, and he wanted to banish it to the city's back streets.[10]

THE POSTWAR PERIOD

From Town Plan to Cutlery was the evocative title of a Swedish exhibition held in Zürich in 1949. It can be viewed as the preamble to and symbol of the 1950s dream of being able to design everything in society and everyday life – from the whole to the smallest detail. During the 1950s there was a community of shared values that gave a picture of society as capable of being surveyed and planned, and that formed the basis of the emergence of the welfare society. Even the decade's architecture and utility art give an impression of homogeneity, control and wholeness – everything, from cutlery to town plans, followed the same code. The exhibition H55, held in Helsingborg in 1955, can be seen as a symbol of this outlook (Figs. 125, 126). But the sense of security is deceptive – in the outside world crises and wars were

taking place. The conformity of the 1950s was not only a strength – it also set limits. It was these limits and this shared community of values that, during the 1960s and 1970s, a younger generation wanted to break – socially, culturally and politically; a revolt that contained a rejection of Modernism as well as a further development of it.

After the war, the 'people's home' (*folkhem*) developed into a welfare state with a powerful influence on society. A revolutionary, state-controlled housing policy lay at the basis of a victory over overcrowding in Sweden. Through public utility companies the local communes were given a decisive role in the provision of housing and, through the new building regulations and building bylaws, far-reaching powers to make decisions about planning and building. The national old-age pension, child benefit and opportunities for education further reinforced the social responsibilities of the welfare state. The increased purchasing power, which was one of the results, was further strengthened by the strong upturn in the economy during the postwar period. At the same time,

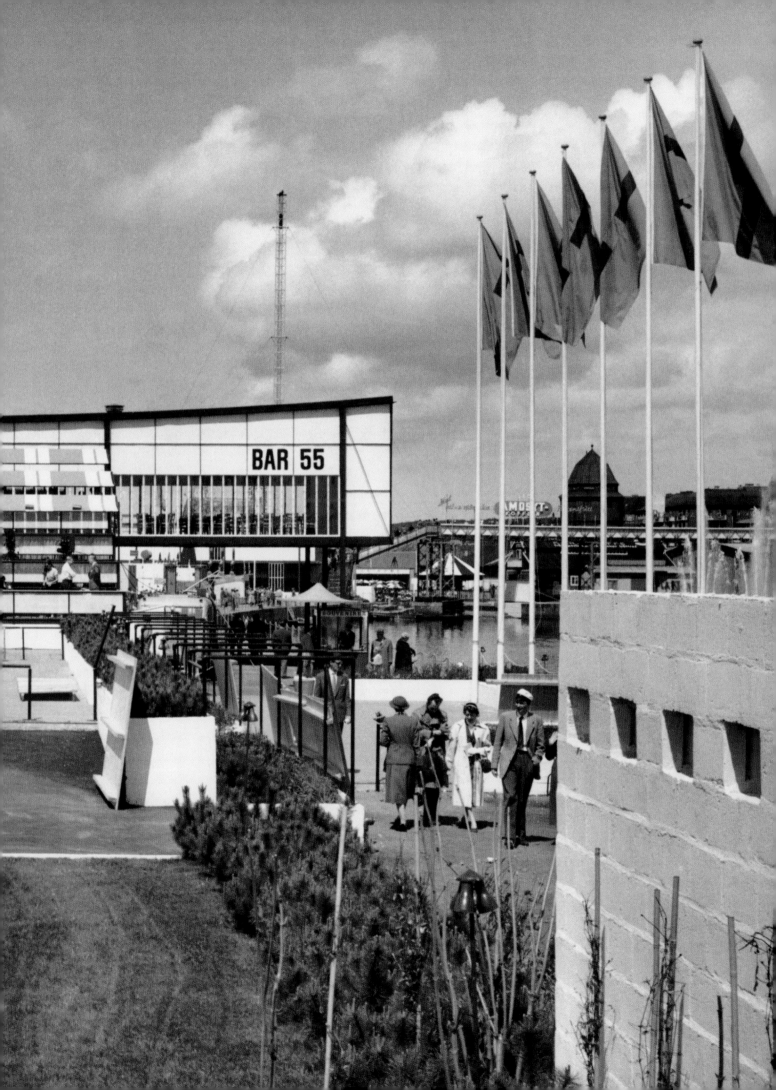

social management was called into question by bourgeois politicians and critics in the economic planning debate of the period.

These are features that are characteristic especially for Swedish society, and that formed some of the background to architecture, building and planning. They are usually grouped together under the heading 'The Swedish Model,' and include not only state control of certain social functions, but also the co-operative spirit that reigned between employers and employees, consolidated by the Saltsjöbad Agreement of 1938. This involved the large co-operatives that influenced the market, especially in the building sector – The National Association of Tenants' Saving and Building Societies (HSB), Riksbyggen, Cooperative Union (KF), etc. Part of the background was the lively activity of associations, political or non-profitmaking, temperance movements, study circles and other organized leisure activities, that have long distinguished Sweden. In 1937 the American Marquis Childs formulated the concept of 'Sweden – The Middle Way' – to denote what the outside world saw as a combination of capitalist market forces, co-operation and socialist/social-democratic management.

THE ARCHITECTURAL DEBATE

The war years had brought with them a decline in building activity in Sweden. But work was quickly resumed after the end of the war, even though shortage of materials caused problems. The architectural debate was, however, kept alive during the war and new influences from England – ideas about community centers and neighborhood as a part of democratic development – were discussed and implemented in the town plans of the postwar era. Foreign architects had already come to Sweden during the war, helped by their Swedish colleagues, but the influx grew after the war when many were curious about 'The New Empiricism', the pragmatic, Swedish development of Functionalism.

As early as 1937 Sune Lindström, himself a convinced Functionalist with a commitment to socialism and a short period of training at the Bauhaus behind him, stated that the general public were often critical of Functionalism and preferred the works of Ragnar Östberg and Carl Malmsten. It was not his aim to copy these, but he wanted to treat the public with greater sensitivity and win it over with 'more beautiful houses, and why not some persuasion, exhibitions and propaganda?'[11] He gave an example of what he meant a few years later in Karlskoga Town Hotel, a modernist building, in which the powerful textures of the materials stands in strong contrast to the smooth surfaces of the 1930s (Fig. 127).

The critique of orthodox Functionalism continued, and in the mid-1940s an architectural debate sprang up in the journal *Byggmästaren*. Apollo and Dionysus symbolized two ways of looking at the world: the former represented logic, analysis and rationality, and the latter spontaneous and artistic expressiveness. The Danish artist Asger Jorn was the initiator of the debate that was taken up by the Swedish architect Leif Reinius. Reinius was the spokesman for a more human, freer, less dogmatic Modernism with more room for sensualism. He and his colleagues contributed to the housing construction of the postwar era with some of the most interesting town plans and the best housing plans, based on functionalist thinking but enriched with expressive design and choice of materials and colors (Fig. 128). For them, good Modernism was represented by the American Frank Lloyd Wright, not Le Corbusier.

During and immediately after the war years, certain traditional features had returned to Swedish architecture. To a certain degree, this was related to the prevailing shortages and to purely pragmatic considerations, which can be designated as 'neo-

128. The architects Sven Backström and Leif Reinius gave Gröndal in Stockholm a varied housing project rich in form and color, with terraced houses, high-rise and tri-form ('star') blocks. They were built in 1946–52. The client and master builder was Olle Engkvist [no.442]

127. During the latter part of the 1930s the clear-cut, strictly geometrical Functionalism of the decade underwent a transition to a gentler style with warmer colors and more powerful material effects. Karlskoga town hall and hotel, designed by Sune Lindström, emphasizes materials as a reaction against the more abstract Functionalism of the 1930s. The building was completed in 1940 [no. 441]

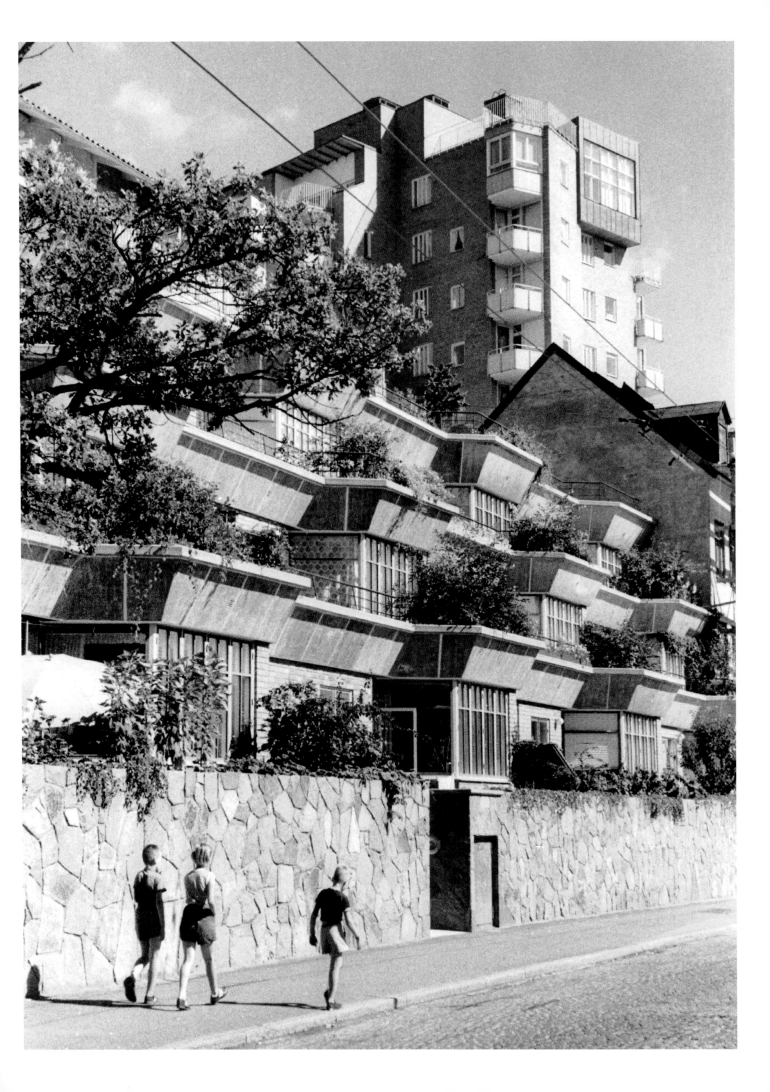

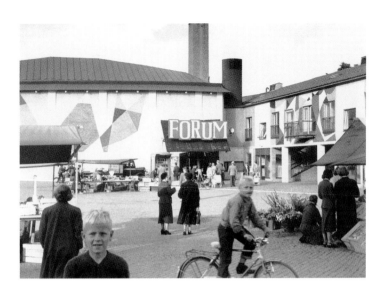

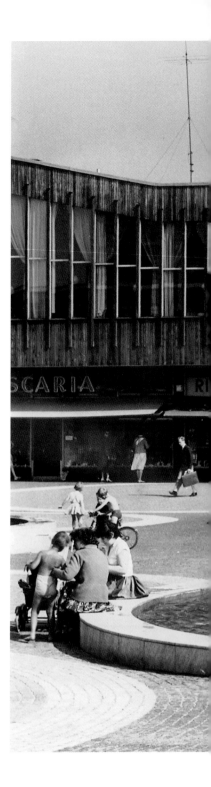

129. Årsta town centre –
everyday utopia. Begun in 1943,
completed in 1954. The
architects were Erik and Tore
Ahlsén [no. 444]

130. Luleå shopping mall of
1955 – an example of the
direction within Modernism that
is called Brutalism. The architect
was Ralph Erskine. Raw
concrete – *beton brut* – was one
of the 1950s expressions of
material authenticity

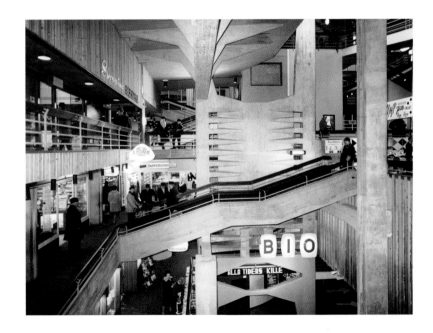

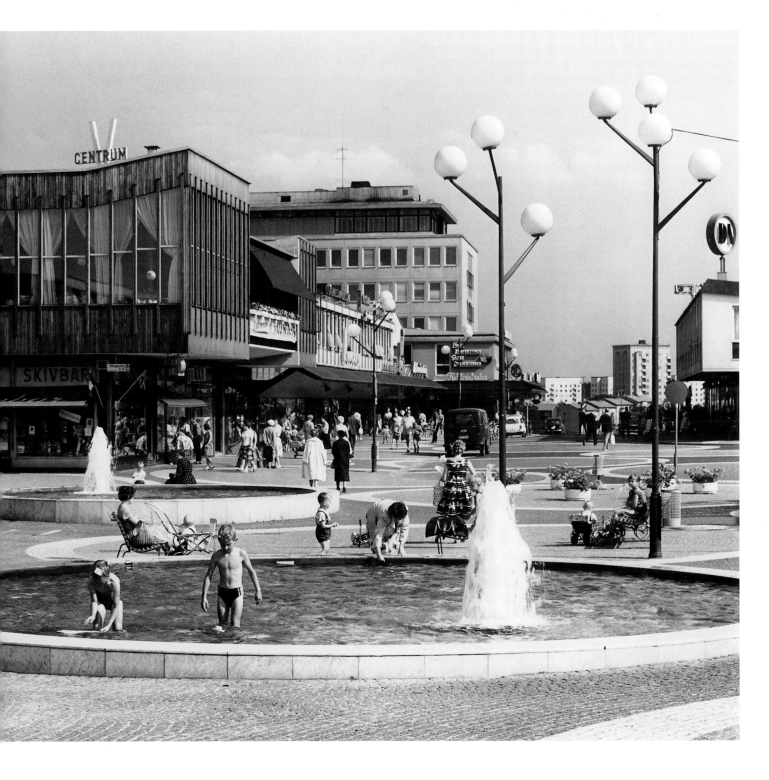

131. In the ABC suburb of
Vällingby work, housing and
center were to be united. The
complex was designed by Sven
Backström and Leif Reinius;
Peter Celsing and Carl Nyrén
each designed a church and the
market area, community center
and cinema were given artistic
decorations. Vällingby Center
was opened in 1954 [no.446]

realism' in architecture. A poor supply of reinforcing iron and steel led to more traditional choices of material and building methods; brick was chosen instead of reinforced concrete. A shortage of asphalt meant that the flat roofs were even less able to combat leakage. So more traditional and practical saddle roofs were chosen, which facilitated runoff and snow-load better. The fuel shortage of the war period was one reason why architects became less inclined to create large fenestrated surfaces, and in place of the long window rows and large picture windows houses were now given smaller, delimited and clearly marked windows. There was also an ideological background, reflected in the debate involving the search for a more sensual architecture with stronger expression of form, colour and materials. But even though the stricter forms of orthodox Functionalism were abandoned, work was still continued – and further developed – using Functionalism's empirical working methods and solutions. It was this that the British christened 'The New Empiricism.'

But critics in the architectural profession turned against what was called 'emergency architecture' and traditional motifs that found their way into façades. The architecture of Modernism was not supposed to be representational – it should express itself through its inner logic: technically, functionally and with regard to materials. These critics were firmly anchored in the style of early Functionalism but wanted to develop its demand for honesty by means of new techniques, new materials and new construction tasks.[12] Le Corbusier's neo-brutalist postwar architecture was one of their sources of inspiration (Fig. 130).

The same aspirations existed in the field of pictorial art, and that inspired the architects. It was not the abstract that was sought in these forms of art – art shorn of its materiality – but the concrete, creating a new and palpable reality, not merely images of reality. There were personal and professional contacts between architects and these groups, mostly with artists in and around the 1947 Group. One example of collaboration was the 1949 sports exhibition Lingiaden, held on the site of the 1930 Stockholm Exhibition. Bengt Gate was the exhibition architect, helped by the artists Olle Bonniér, Lage Lindell, Pierre Olofsson, Karl-Axel Pehrson and Einar Lynge-Ahlberg for the interiors and exteriors of the pavilions. Arne Jones contributed sculptures (Fig. 132) and the collaboration between architect and artists was much more wide-ranging and further developed than at the Stockholm Exhibition of 1930, as was obvious in the many public decorations, for which these artists among others were commissioned, often through the mediation of the architects. Olle Nyman was also engaged by several architects – Paul Hedqvist, Erik and Tore Ahlsén, Nils Tesch, Peter Celsing and others – for artistic decoration, and he also helped with the presentation designs of the architects' projects. One meeting place was the Art Academy, which trained both artists and architects, and professional boundaries could legitimately be crossed.

The provincial element of 'emergency architecture', which critics rejected, clearly moved in an international direction during the postwar period. This happened not only in the fields of architecture and art – in all artistic genres there was a search for the elementary grammar of expression, their own specific morality. In literature and music there was criticism of the traditional, provincial and idyllic in the same way as there was in architecture. In literature writers like Erik Lindegren and Karl Vennberg and the circle around the journal Fyrtiotal grappled with existential problems, with Franz Kafka and Albert Camus as their guiding stars. In music the Monday Group, which took up Paul Hindemith and atonal music, became a centre for radical composers like Karl-Birger Blomdahl and Ingvar Lidholm. In these circles, too, there were contacts with architects. For example, in 1948 the Lund Academic Association held a cultural week in which

132. Arne Jones' sculpture at the 1949 Lingiaden sports exhibition in Stockholm, which was an early example of close collaboration between artist and architect

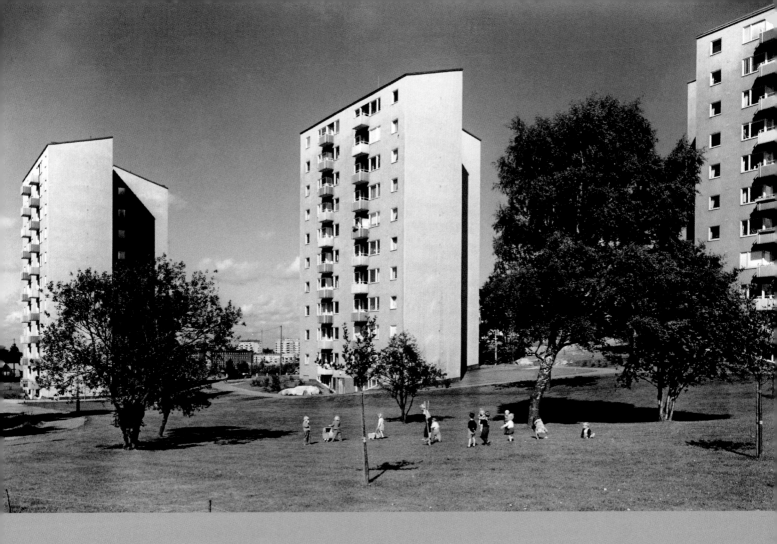

133. 'Houses In Parks' was the town planning ideal of Modernist architects, which here in Södra Guldheden in Gothenburg in 1953 resulted in high quality housing, both on the exterior and interior. The architects were Sven Brolid and Jan Wallinder [no.445]

134. The industrialization of building with prefabricated elements that were assembled on site with the help of cranes was developed from the mid-1950s. Here at Grimsta in Stockholm

artists, musicians, writers and architects representing the new modes of thought met across professional boundaries.

Årsta Center is a pioneering development by the architects Erik and Tore Ahlsén, begun in 1943 and finished in 1954 (Fig. 129). The commissioning authority was Svenska Riksbyggen. Here ideas of well-equipped developments with communal and commercial services, and also with meeting-places for the inhabitants, were realised. The community center, the theater, the community rooms and library were to create activity, a sense of domesticity, and the basis of a democratic evolution of society. This contrasted with the metropolis which, with the war fresh in memory was viewed as a seedbed of homelessness and anti-democratic mass movements. 'We have conceived the principal aim of the development to be the creation of a place for the forming of personal contacts between individuals and groups, to stimulate discussion and personal activity. It should serve both the interests of the individual members of society and the aspirations of a democratic society.' This was how the architects formulated their everyday utopia when they presented their work in *Byggmästaren* in 1954. The square was to function as a large living-room. The architects themselves painted the façades around the square in an abstract colour and style, in which the fields of colour were not limited by façade divisions into windows and doors but followed their own rules. This provoked both criticism and involvement – as intended. The originators of the project considered that a democratic society did not require definitive monuments, but an openness through everyday environments that aroused curiosity and debate, and in which the spectator was a co-creator.

One of the most important tasks of the post-war welfare society was the building of housing. School reforms and the increase in the number of kindergartens also brought the building of schools into focus (Fig. 135). Town halls and local government offices, as well as buildings for leisure – sports centers, saunas, libraries and civic centers – were other building tasks that became topical through the rationalization of local government in the early 1950s. It was here that public decorations came into their own. The strong

135. The increased investment in schools and colleges during the post-war period also affected higher education. The College of Arts, Crafts and Design (Konstfackskolan), designed by Gösta Åbergh, was completed in 1959, and has the graphic clarity of volumes and façade materials that characterize large parts of postwar Modernist architecture [no.451]

136. Sigurd Lewerentz's
Markus Church in Björkhagen
outside Stockholm, built in
1960, is one of the 'timeless',
modernist works. [no.453]

influx to the cities, the huge increase in traffic, the concentration of business and the industrialization of building that took place at the same time were other factors that altered the context in which town planning and architecture took place.

Architects were employed to solve these new building demands during the postwar era: to shape the framework of cultural and social life in the new welfare society – the transition from scarcity to economic security, from country to town, from handwork to industry, from the small scale to the large (Figs. 133, 134). This is Welfare State Modernism, which, particularly through its social clients and its vigorous public projects, can be characterized as 'typically Swedish.'

In the 1980s, Postmodernism's revolt against Modernism took the form of plentiful requirements for designs with traditional associations – an extravagant architecture that reflected an overheated economy. During the decade that followed, the economy weakened and architecture also tightened up. The style of early Functionalism was revived – but often only superficially. Within, well-tried, fashionably functional solutions are employed, and social ambitions have been replaced by speculation. The legacy of the welfare state has been gambled away, here as in many parts of the world.

NOTES
1. Uno Åhrén, 'Brytningar' (Divergences) in Svenska Slöjdföreningens årsbok (Swedish Society of Craft and Industrial Design Yearbook), 1925. See also Eva Rudberg, Uno Åhrén, 1981.
2. See among others P.G. Råberg, Funktionalistiskt genombrott (The Functionalist Breakthrough, 1971 and Eva Rudberg, 'Stockholmsutställningen 1930' Modernismens genombrott i svensk arkitektur (The Stockholm Exhibition of 1930, The Breakthrough of Modernism in Swedish Architecture), 1999. The latter deals with the 'Swedishness' debate surrounding the exhibition.
3. Göteborgs Morgonpost May 19, 1930.
4. Sydsvenska Dagbladet September 1930.

5. Folkets dagblad Politiken May 16, 1930.
6. See V. Göransson in Stockholms Dagblad October 1, 1930, and acceptera (1931).
7. acceptera, 1931, p.11 and p.198.
8. Ibid., p. 171.
9. Social-Demokraten July 13, 1931.
10. The journal Byggmästaren 1930, exhibition issue, p.44.
11. S. Lindström, Arkitektens anpassning ('The Architect's Adaptation'), in Byggmästaren 1930.
12. Lennart Holm develops this idea among others in 'Polyfon upptakt' (Polyphonic Preamble), in Femtiotal, Architectural Museum Yearbook 1995.

BJÖRN LINN

THE ARCHITECT IN FOCUS DURING THE FIRST HALF OF THE TWENTIETH CENTURY

Architects found themselves close to the focus of interest in the society of our period. During the 1890s, because of unease caused by the disorderly aftermath of early industrialization, great importance began to be attached to an aesthetically ordered environment and its significance for people and society. The environment ought to be designed as art, and the architect viewed as artist. The ideas came from England, in particular from William Morris and the Arts and Crafts movement, but they received their special Swedish form through the propaganda of the author Ellen Key – in *Beauty for All*, 1899 – and Karin Larsson's interior decoration in the artists' residence at Sundborn, which provided excellent illustrative examples. The fact that two women played such important roles is worth noting.

The housing question began to obtrude as a socio-political problem, primarily concerning the housing conditions of industrial workers. The liberal Staaff government appointed a housing commission, which from 1912 to 1918 studied the problems. The inquiry led to Sweden's first report on criteria for quality in small apartments, *Practical and Hygienic Housing*, published in 1921. It was followed by the first report on kitchens, carried out by the architect Osvald Almqvist from 1922 until 1934, the inquiry work for the housing section of the 1930 Stockholm Exhibition, and a lot more developments in architectural knowledge. Under the motto of *folkhemmet* (the Home of the People), the political *leitmotif* that was formulated in a parliamentary speech by the Social Democrat leader Per Albin Hansson in 1928, it was literally a question of *building* a society. Housing construction and social planning became the principal tasks of architects, and foreign experts and journalists came to study Sweden as a leading example. Swedish architects stood in the spotlight, but now in roles that had changed somewhat since the beginning of the century.

THE ARCHITECT IN THE BUILDING PROCESS
Unlike the pictorial artist, the architect has no immediate relation to the finished work.

137. The Co-operative Society Architects' Office played a leading role in modern Swedish architecture. This photograph from 1934 shows left, the office's director, Eskil Sundahl, who also acquired great importance as Professor at Royal College of Technology (KTH) from 1936 to 1957. He is surrounded by the office's departmental heads; especially famous among these were the three on the left: in order, Haqvin Carlheim-Gyllensköld, Artur von Schmalensee and Olof Thunström

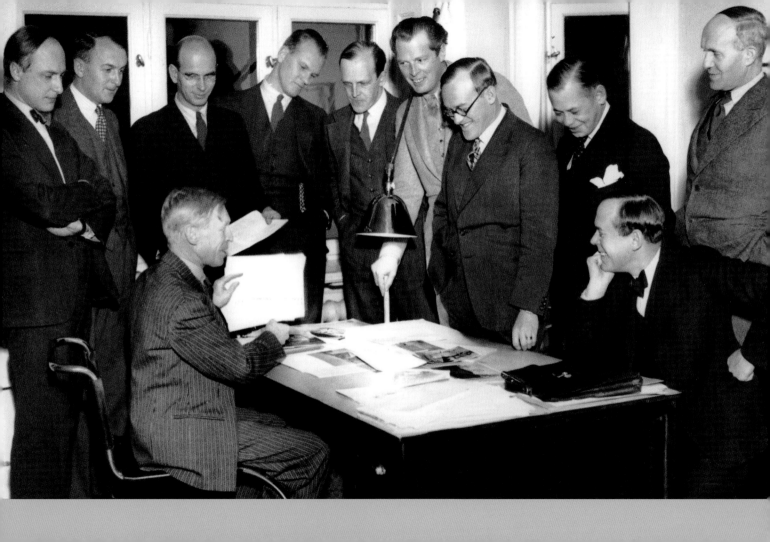

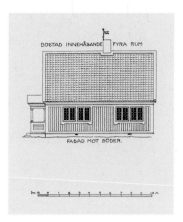

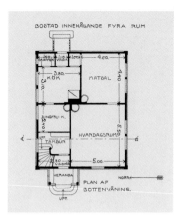

138, 139. Elevation and plan for a cottage with four rooms, servant's room and kitchen, by Ragnar Östberg from the book *A Home*, 1906. The plans show how little attention was paid to the study of housing functions at the time. The kitchen does not have much room for benches and cupboards, and the minimal servant's room is a passage between kitchen and entrance

The architect more resembles the composer, who writes notes and is then dependent on the performing musicians. The architect has a client who, with money in hand, has the last word, there are usually assistants at the office who draw up the detailed designs, in modern times there are also designing engineers for structures and installations, there are builders with their staff who convert designs into houses, there are authorities who inspect. Technical factors can influence the final result. Geological conditions may, for example, prove to be worse than expected, so that the house must be altered or moved; in times of crisis there may be a shortage of the materials that had been planned. To view the architect as the free and sole originator of the building is always an oversimplification. A good architect will, however, be able to provide something beyond what the client can imagine: the unexpected, which in a second view appears self-evident, the synthesis of all the circumstances.

In addition to the public evaluation of the significance of architecture, the architect's relatively strong position during the earlier period of Modernism was connected with the relationship between the parties in the building process. As long as house-building was done piecemeal and by craftsmen, the commissions depended to a large extent on personal trust, and an experienced architect was a major partner in the collaboration. A customary feature of apartment house building commissions was for a master builder to own a site and choose an architect he knew. He could then keep the finished house for himself, or sell it. For many well-known architects, this was the condition on which an important part of their activity was based; Albin Stark and Björn Hedvall were examples of skilful architects who from the 1920s until the 1950s worked mainly in this sector. On the other hand, Gunnar Asplund, who for posterity has become the most celebrated architect of the age, had no commissions of this kind, but was involved instead with building committees – governmental, municipal, or ecclesiastical. This meant that there were considerable differences in the way the commissions were handled.

The number of architects in Sweden grew quickly from about 200 in 1890 to 500 by the mid-1920s and continued to increase. Not until around 1960 did the changing trend in the apparatus of production towards large-scale building societies and contractor firms make itself felt, so that the architect began to be pushed towards the margins. Meeting this with 'production-oriented planning' – the message of the 1960s to the architects – was not a sound strategy. The golden age was over, and the status of architects fell.

'BESPOKE' AND 'READY-MADE'

The classical type of architectural commission can be compared to bespoke tailoring. It is a matter of designing a house for a client who is going to occupy the house himself, and therefore one of converting his wishes into a buildable and attractive form. The best example is the building of private houses which has often been a developing ground for new ideas. A committed and insightful client could carry on a dialogue with the architect

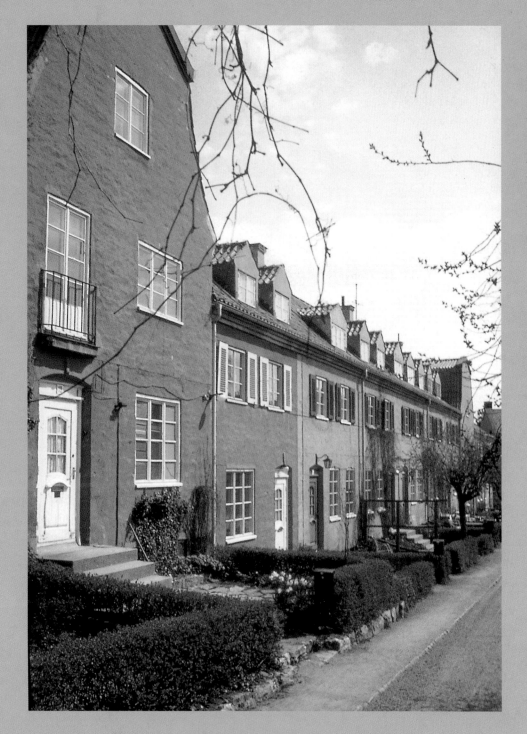

140. The Drivbänken estate in Bromma, 1919–20, consisting of terraced houses arranged in a perimeter pattern around an interior garden, designed by Gunnar Wetterling. The houses were built according to a rationalized system in order to economize on materials in a time of crisis. In spite of this, the district has proved to possess enduring quality. With this, Wetterling began a distinguished career, at first as town architect in Gävle, 1922–32

141. The Rosta estate in Örebro, 1949, designed by Sven Backström and Leif Reinius, an example of welfare state era housing, with the type of tri-form ('star') houses created by these leading architects

about his sketches and make his own contributions to the final form, as, for example, Prince Eugen seems to have done in the Waldemarsudde project with Ferdinand Boberg.

The multi-apartment house is another matter. Here the purpose is to design apartments for future occupants who are not yet known. In modern times this 'ready-made' building has become a major task. At the beginning of our period there was no housing policy offering subsidies, so that in those days one had to make do with what could be expected to sell (profitably) on the market. In Stockholm around 1900 there were large architects' offices specializing in apartment house commissions, like Dorph & Höög and Hagström & Ekman, which were good at exploiting sites to their maximum potential –the latter firm's large buildings at Strandvägen 5 and 7 in Stockholm are a good example.

The housing crisis around the time of the First World War could not be countered by the market, and led to the beginning of an active housing policy. Municipal and co-operative clients made sizeable units possible; in the field of block construction the perimeter model, large blocks of housing around planted courtyards, were one result. The forms of subsidy were discontinued during the 1920s, but from the 1930s onwards, with the rise of the welfare state, the construction of housing became an area of central political interest (Fig. 141). The goal of equivalent housing was expressed in the detached laminated houses, in which all the apartments were to have contact with air and light. Building was expanded outside the old town centers. The role of the architect came to center on participation in 'a planned construction of society', which was the title of Uno Åhrén's well-known appendix to the final committee report of the Ministry of Housing inquiry of 1945. Two years later, Åhrén became Sweden's first professor of town planning.

OTHER TYPES OF COMMISSION

From the 1880s onwards major commissions were increasingly preceded by competitions. It was by no means a foregone conclusion that the winner of the first prize received the commission; such, for example, was the outcome of the competitions for the Nordic Museum, the Stockholm Opera House and the Parliament building. Even where the first prize led to commissions, the period of time between the competition and the finished building could be a long one, with major revisions – as was the case with the Stockholm City Hall (Ragnar Östberg, 1904–23) and Gothenburg Law Courts(Gunnar Asplund, 1912–37).

A new type that became quite common from the 1890s onwards was the industrial commission, including factory buildings as well as housing. The first example of the design of a large-scale technological environment was the first project of Vattenfall (the National Hydro-Electric Power Board), the power station and canal project at Trollhättan (1906–21; Fig. 142), designed by Erik Josephson. Another famous project was Osvald Almqvist's work for Stora Kopparberg in Domnarvet (Borlänge), 1915–21, which among other things comprised Bergslagsbyn with its red wooden houses in a parkland enviroment. In 1924 under the direction of Eskil Sundahl the Co-operative Society's

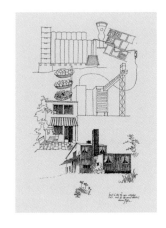

143. Eskil Sundahl was head of the Co-operative Society Architects' Office (KF) and, as Professor of Architecture at KTH, an important teacher. On his fiftieth birthday in 1940 he was honored with a collection of drawings by his colleagues. Rolf Engströmer made this summing-up of the work of KF and Sundahl. In the drawing can be seen the silo building of the Tre Kronor flour mill, store fittings, the Katarina elevator and a terraced house project, with, at the bottom, Sundahl's own summer villa at Södertörn, 1938

142. Trollhättan power station, the Olidan plant, 1906–10 (completed 1921), designed by Erik Josephson. The magnif-icent granite building is the center of one of Sweden's most handsome industrial sites, remarkable even in an international context

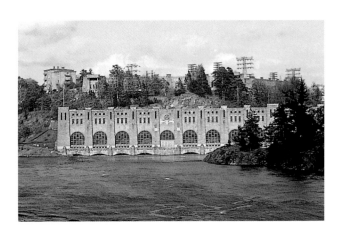

144. Detail of an entrance to the electricity generating station at the corner of Regeringsgatan and Smålandsgatan, in Stockholm 1889–92, designed by Ferdinand Boberg. Boberg demonstrates the building's modernity by decorating the portal with a frieze of light bulbs with cables, carved in limestone

architects' office was formed, working across the whole field: industry and shops, housing and interiors, town planning and detailed design (Fig. 137). This office was very important in the history of Swedish architecture.

Early in the twentieth century industrial commissions were often given to young architects. One explanation of this may be connected with contacts made during the period of training. The groups of students were small enough for everyone to know each other, and in the early period of training different departments studied many subjects together. Thus, engineers who entered the swiftly expanding industry knew architects to whom they could give commissions.

Through their design work, a number of architects also came to contribute more anonymously to the everyday surroundings of modern society. Ferdinand Boberg designed the well-known insignia of the Royal Automobile Club (KAK) in 1909, Ragnar Östberg's yellow mail box was designed in 1912 but not put into use until 1924, in the 1930s Eskil Sundahl designed the interior of a new type of tram for Stockholm Tramways (which always maintained a high standard of design), and in the 1940s Osvald Almqvist's white concrete urn (originally made for the 1930 Stockholm Exhibition) became a kind of international symbol for Stockholm's Parks Department.

A NEW ARCHITECTURE

At the turn of the century in 1900, Ferdinand Boberg was Sweden's most noted architect, known as the Modernist *par excellence*. Just like the architects of early Functionalism thirty years later, Boberg displayed his modernity explicitly in the designs he used. The difference was that he did it in a way that in principle was that of the nineteenth century. He availed himself of a representational and narrative symbolic decor. The most famous example is the portal of Stockholm's old electricity generating station on Regerings-gatan (1889–92, moved after the building's demolition to Tulegatan 11; Fig. 144), with its carved limestone frieze of light-bulbs with flexes. Ten years later, in the entrance of the

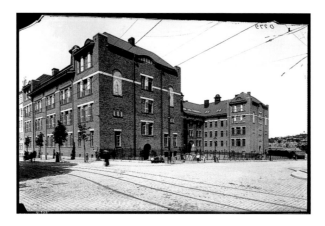

145. Matteus Elementary School, 1899–1901, designed by Georg A. Nilsson. The architect steered the design so that the construction workers, above all bricklayers and platers, were able to give the building its radically modern character. Thanks to this pioneering work Nilsson became Stockholm's leading school architect for thirty years

bank in the Rosenbad building facing Drottninggatan, the symbols consist of rows of coins and a cogwheel-bearing *putto*, but the principle is the same.

Here in the desire to express modernity sculpture is put into service, an exclusive solution requiring expensive handicraft. It is a solution that does not point forward to wider applications. One contemporary building that did this, however, was Georg A. Nilsson's pioneering work, the Matteus School at the corner of Vanadisvägen and Norrtullsgatan (completed in 1901; Fig. 145). Here the entire style is derived from normal building work – bricklaying, plastering, carpentry, metal-plating – but the architect has designed everything in an expressive manner with the straightforwardness of an industrial building, lacking all historical allusions. The principal decor is found in a plaster band under the base of the roof where figures and devices are drawn – a limited feature that rather emphasizes the down-to-earth character of the architecture. Hardly any other building of the same period makes such a thoroughly modern impression as this one.

Yet it is only one of many expressions of all that was happening in Swedish architecture during this time. The whole period from the 1890s to the 1950s comprises an intense working out of problems and a development of knowledge. It was a process of calling into question habitual ways of looking at materials, space and construction, in the way of viewing the building in landscape and city, of moving through building and built-up areas. We begin to understand that Functionalism around 1930 was seen as being so radical not because it fundamentally was, but because it came into being in order to give visible form to the new features that had actually been around since the turn of the century. It took the form of a manifesto, in the same way as Boberg's decorated buildings of the 1890s, but all these were parts of the same revolutionary and innovative process that had begun around 1890 and did not lose its impetus until after 1960.

FROM ORNAMENTALISM TO ARTWORK

The 1870s and 80s architecture of styles was rational, and so was the decor that was an integral part of it. In the plaster facades of the buildings in Stockholm of this time we see how ornament is used in a serially repeated manner, most often cast in materials like gypsum, cement, cast iron or terracotta. The material was subordinate, and a precise surface was the main thing.

At the same time as the buildings from around 1890 began to be individualized, each expressing its own special content of different spaces ('prefunctionalism'), the view of decor also changed. The building as sensuous reality was put into focus in place of the finely detailed design. The expression was achieved by materials and handicraft, while the décor was concentrated on important points. The architect's office engaged sculptors to model details that would later be cut in stone. One sculptor of this kind, who worked for several prominent architects (Boberg, Ernst Stenhammar) was Sven Boberg, best known for his realization of the irreverent Osvald Almqvist's idea for the sleeping Mother Svea, which effectively killed the National Monument competition of 1910. The brothers Aron and Gustaf Sandberg played a part in the design of both Östberg's town houses and Westman's terraced houses. Gustaf Cederwall worked in the office of Ivar Tengbom from the Enskilda Banken building at the beginning of the 1910s to the Tändstickspalatset (Swedish Match) at the end of the 1920s. But Tengbom also used a prestigious sculptor such as Carl Milles for the sculptures and urns of the Enskilda Banken façade.

The notion that Functionalism was hostile to all ornamentation is a misapprehension. In reality, the concentration and liberation of the décor led to a final stage. The shell of the building was to stand by itself in its clarity and simplicity, while the artwork was to appear within its frame as a work in its own right. Uno Åhrén, one of the most clear-thinking architecture critics we have had, formulated it in an article of 1926 as follows:

> Functional aesthetics are the great achievement of the modern movement. For most working design, however, free ornamentation is a necessary complement. We must just see that in the former we do not smuggle the latter back in and thereby spoil the clarity, the purity.

> And the situation with this fatal simplicity is like this: in its practicality it can hardly be taken too far, the beauty of functional simplification can hardly be valued too highly, while on the other hand the ornamental cannot be cultivated imaginatively and lovingly enough.

From the 1930s onwards, this program took shape in many buildings. Mural paintings, textiles or reliefs decorated interiors, while freestyle sculpture was found both indoors and outdoors. Through the 'one percent rule' that was passed by Parliament in 1937 stipulating that one percent of the construction costs for state buildings should be set aside for artistic ornamentation, this principle was adopted politically. In order to handle its introduction, the State Arts Council was set up at the same time. Behind the decision stood the culturally committed Minister of Education, Arthur Engberg.

The interplay of architecture and pictorial art on this principle can be illustrated by one of the finest spatial creations of the 1930s, the Draken cinema in Stockholm, designed by Ernst Grönwall in 1938 (Fig. 146). The hall carefully provides for all functions before, during and after the performance: surveyability, lighting, comfort,

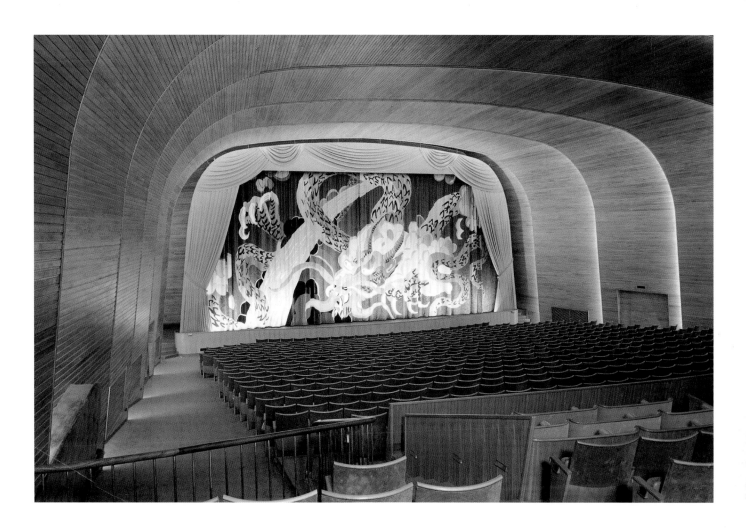

146. The Draken cinema at Fridhemsplan, 1938, designed by Ernst Grönwall with curtain by Isaac Grünewald. One of Functionalism's finest interiors in Sweden

visibility and acoustics. The beech panelling over walls and ceiling give a warm tone. The ornamentation is Isaac Grünewald's sparkling colored curtain with its dragon motif. The balance between artwork and space is complete.

TRAINING

Throughout this period, the course of architecture at the Royal Institute of Technology (KTH), established in 1877, lasted four years. Gothenburg's Chalmers Institute did not acquire university status until 1937, and before that gave a three-year course of training. The Academy of Art, which had previously been responsible for all architect training, remained as a 'higher artistic college' from 1909 with the name 'Royal College of Art.' At the beginning of the century it was considered that those who wanted to apply for a government post or become a city architect ought to have this higher training.

Course content remained relatively stable throughout the period. The names of certain subjects were modernized – thus, for example, the term 'ornamentics' was no longer current when the decor of the building itself disappeared, but it soon became 'material processing and theory of form', inspired by the German Bauhaus. The importance of planning for society was emphasized when a chair of town planning was established at KTH in 1947. The last stronghold of Beaux-Arts academicism had been the Royal College of Art with its old professor Claes Grundström (Fig. 148), who in 1910 caused a celebrated revolt when six of his students – including the big names of the younger generation, Asplund, Lewerentz and Almqvist – left to form their own private studio college for a year.

Who were the people who studied architecture? In general their background could be described as middle class. Their motives for choosing the profession varied. They often had artistic inclinations, but the profession of architect was viewed as being more stable than that of pictorial artist. Both Gunnar Asplund and Uno Åhrén had had ambitions in the latter direction. Of the older generation, both I.G. Clason and Ferdinand Boberg had begun as mechanical engineers.

Building draughtswomen had been trained at the Technical College (now the College of Art and Design) from as early as around 1880. On the other hand, women could not yet be accepted as ordinary students in higher technical education. Both Finland and Norway had female architects earlier than Sweden. The first female student at KTH came to the Faculty of Architecture in 1897 and read all the subjects, but was not allowed to take the final exam. Her name was Agnes Magnell and she later collaborated with her husband, the progressive civil engineer Otto Smith, in the designing of power stations, water towers and workers' apartments. After the death of her husband in 1919 she was unable to return to the profession. At that time the second female architect from KTH, the Norwegian Anna Mohr (married name Branzell; Fig. 147), completed her studies, and was followed by a steady trickle of women during the 1920s.

147. Anna Mohr (married name Branzell) was the second woman to graduate as an architect in Sweden (1919). She also studied in the United States, was one of the translators of Palladio's *The Four Books of Architecture* into Swedish and worked for Gothenburg city planning office on package planning, and participated in the debate on service-flat blocks.

THE STATE OF THE PROFESSION

Architects' offices were usually run on a small scale. Around 1905 there was at least one large office, Dorph & Höög in Stockholm, with between twenty-five and thirty people, but with the recession that began in 1907, and the decline in house building, the office quickly shrank in size. It was succeeded in its role as largest by an office of quite a different type. Ivar Tengbom made his major breakthrough with the commission (following a competition) to design the headquarters of Stockholm's Enskilda Bank, and thereby acquired a leading position in Swedish architecture. With a swiftly growing number of commissions from trade and industry and its leading figures, by 1914 his office employed thirty-three people.

The role of central practice was later taken over by the Co-operative Society's (KF) architects' office, which worked on an even larger scale. The office was organized into ten to twelve departments with eminent architects like Olof Thunström, Artur von Schmalensee and Ville Tommos in charge. A fair number of the famous names in Swedish architecture passed through the offices of Tengbom and KF.

148. Four professors of architecture: from left, Claes Grundström, I.G. Clason, Erik Lallerstedt and Ivar Tengbom. Drawing by the architect Carl Otto Hallström, 1912. The artist, who was a pupil of Lallerstedt and Grundström, commented: 'Lalle and Tengbom were clothes snobs (Wahlman was, too), Clason more neutral, Grundström always appeared in the same grey-green jacket'

It is possible that the Royal Corps of Civil Engineering, organized in 1851, played a certain role as prototype when one talked about an 'architects' corps'. At any rate, there was also an official structure on the architects' side centering on the special position in Swedish administrative practice established for the official building administration, which had the Royal Superintendent's Office (from 1918 the National Board of Public Building) as its nucleus. Until 1967 the office/board fulfilled the combined role of superintending board and commissioning authority, the latter for the civilian purposes of the State. From 1879 onwards a cadre of 'extra-staff architects' was attached to the office, who through probationary service qualified to receive or be recommended for consultative commissions. The system, which was in operation until 1934, functioned as a higher professional certification. In the lively body of legends surrounding the corps there is the story of a couple of such architects belonging to the Royal Board of Public Building who traveled in Italy and had their title translated in their passports as 'Royal

149. 1930s residential district: Lower Gärdet in Stockholm, Askrikegatan with its three-storey tower blocks, designed by young architects like Sture Frölén and Ernst Grönwall. The houses were built around 1937

Architect'. They made the best of the situation and were greeted at the railway stations by brass bands.

With Hakon Ahlberg as initiator, in 1936 a nationwide professional association was founded, in the form of the Swedish National Federation of Architects. It thereby became a professional corporation that guaranteed its members' competence. The transition from the narrower public certification was a sign of the times. In 1950 the association had 900 members, which meant the majority of the country's architects.

The top positions in the corps were occupied by college professors and officials of the Board of Public Building. The most brilliant career was that of Ivar Tengbom, who was first professor at the Royal College of Art (1916–20) and then director general of the Board of Public Building (1924–36). He had a predecessor in A.T. Gellerstedt, who around 1880 had been the first professor of architecture at KTH, and around 1900 was Superintendent. Other professors at the Royal College of Art were Ragnar Östberg, Carl Bergsten, Paul Hedqvist and Sven Ivar Lind, and at KTH I.G. Clason, Erik Lallerstedt, Lars Israel Wahlman, Gunnar Asplund, Eskil Sundahl, Nils Ahrbom and Uno Åhrén (Fig. 143). Among the building councilors (bureau chiefs at the Board of Public Building) were Clason, Bergsten and Hedqvist, Sigurd Curman, Georg A. Nilsson, Ragnar Hjorth and Sven Markelius. All are names of importance in Swedish architectural history.

SUMMARY

The history of the period concerns Modernism in different forms. It is not about a development from romanticism to realism, but about a complex whole in which both components constantly assume varying proportions. The ideal Functionalist was conceived, especially by Åhrén, as a cool calculating technician, but this was a romantic vision. Architecture has never been simply determined by technical or other factors, but by conceptions in which one factor or another has been the leading motif.

Swedish architecture and Swedish architects aroused great interest, both within their own cultural circle and internationally. The focus gradually shifted from individual works to the broad social program. An excellent summary of an outsider's view of the end of the period is the American architect Kidder Smith's *Sweden Builds*, a book that accompanied the exhibition at the Museum of Modern Art.

REFERENCES

Per Forsman, *Det gamla och det nya bygget. Bilder och betraktelser kring en metafor* (Building Old and New. Images and Reflections around a Metaphor), 1993.
Björn Linn, 'Arkitektyrket i Sverige' (The Architect's Profession in Sweden), in Thomas Hall and Katarina Dunér (ed.), *Den svenska staden* (The Swedish City), 1997.
G.E.Kidder Smith, *Sweden Builds*. 1st edn Bonniers 1950, 2nd edn Reinhold, New York 1957.
Rasmus Wærn, *Tävlingarnas tid. Arkitekttävlingarnas*

betydelse i borgerlighetens Sverige. (The Era of Competitions. The Importance of Architectural Competitions in Bourgeois Sweden.) Stockholm, Arkitekturmuseet 1996.
Uno Åhrén, 'Betraktelse över enkelheten' (Reflection on Simplicity), *Svenska Slöjdföreningens Tidskrift*, 1926. 'Ett planmässigt samhällsbyggande' (A Planned Construction of Society). Appendix to *Slutbetänkande angivet av Bostadssociala utredningen* (Final Report of the Ministry of Housing Inquiry), Part 1 (SOU 1945:63).

CILLA ROBACH

DESIGN FOR MODERN PEOPLE

THE DESIGNER – A NEW PROFESSIONAL CATEGORY

The technological developments of industrialization and consequent feasibility of mass-production brought fear that the aesthetic quality of the goods produced might suffer. Plans for industrial products were usually drafted by engineers and workers with drawing skills or copied from other manufacturers. Often they imitated the appearance of hand-crafted goods, a tendency which the radical architects and intellectuals of the day regarded as a false attitude towards the industrial process by which the product was being made and towards the new industrial society that was producing it.

With the aim of raising the aesthetic quality of industrial goods, the Swedish Society of Craft and Design (now 'Svensk Form'), worked to persuade industry to allow trained artists to design industrial products. In 1914 the Society started a agency to mediate contacts between artists and manufacturers. This was headed by the textile designer Elsa Gullberg, who oriented many artists towards industrial design. Before this only a few artists had designed for industry, among them Alf Wallander and Gunnar Wennerberg who had worked for the Rörstrand and Gustavsberg porcelain factories respectively around 1900. Now through the Swedish Society of Craft and Design's agency many artists came to work for industry and a new professional category, the designer, began to flourish. Other early designers who came from a background in fine arts were Wilhelm Kåge, who worked for Gustavsberg, and Simon Gate and Edward Hald for Orrefors.

During the first decades of the twentieth century designers mainly concentrated on 'industrial art', that is to say industrially mass-produced artifacts with roots in handicrafts. Among other things, this category included glass, ceramics, textiles and furniture. What we call 'industrial design,' that is, mass-produced objects whose technical characteristics and methods of manufacture were developed hand-in-hand with the growth of industrialism, did not reach Sweden until the 1940s. Industrial design principally involves machines and apparatus such as telephones, cars and typewriters, a subject covered in Gustaf Rosell's chapter (pp. 202–11).

150. Gunnar Asplund designed this armchair in leather and tubular steel for the boardroom of the Swedish Society of Craft and Design in 1931. The simple, clean form and well-balanced proportions of Asplund's chair inspired Swedish designers in the 1990s. Svensk Form [no 211]

The model for the Swedish Society of Craft and Design intermediary work between artists and industry was the German organization the Deutscher Werkbund, which had been founded in 1907 to promote co-operation between art, crafts and industry with the purpose of improving the aesthetic quality of manufactured objects. In accordance with the spirit of the times there was a desire in Germany to create a national aesthetic which would ensure that objects manufactured there were attractive and pleasing and thus in demand abroad as well as at home. This ideal of a successful national art industry based on high aesthetic quality could be found in most industrialized nations around 1900. The idea behind it can be compared with the philosophy behind the planning of new artifacts today, when design is considered one of the most important means of competition in the international market.

THE BIRTH OF THE SWEDISH ARTS AND CRAFTS MOVEMENT

With industrialization first-hand practical experience of the qualities of the materials used grew ever more distant from the act of manufacture. In an attempt to avoid losing this traditional knowledge altogether, a movement to encourage self-conscious handicraft work developed during the first decades of the twentieth century. Before industrialization all artifacts had been handmade by craftsmen and craftswomen. The aim of the Arts and Crafts Movement was to preserve and develop the quality of this traditional craftwork. Arts and crafts involved unique objects designed by artistically sensitive people and worked by hand with the help of simple tools. The materials most commonly used were ceramics, glass, precious metals, wood and textiles.

In arts and crafts the starting point was the material and the design idiom was rooted in the natural qualities of the material and the techniques available for working it, even if as often happened the worker liked to experiment and try to extend boundaries. But there was no deliberate attempt to find form specifically expressive of modern times as there was in the parallel movement working for the development of industrial art. The craftsman was not expected to have a social conscience and aim his work at the 'broad masses.' The slogan of Modernist architects and industrial designers was 'form follows function'; a corresponding slogan for the arts and crafts movement could well have been 'form follows material.'[1]

Thus those who produced craftwork took the innate qualities of the material used as their starting point and made no deliberate attempt to find a form of expression that might harmonize with modern industrial society. But of course this does not imply that they worked without any awareness of their time and its ideological debates; on the contrary, the idiom of many of them was influenced by the Modernist aesthetic.

TRAINING TO BE A DESIGNER

In Sweden one of the best places to train for artists ambitious to become industrial designers was the Stockholm School of Technology. This had been founded in 1846 as a Sunday School of Drawing in an attempt to safeguard artistic standards in the face of a threat to abolish the traditional training of handicraft workers within guilds.[2] In 1878 The Sunday School of Drawing was refounded as the School of Technology, offering artistic training with a slant towards industrial art and handicrafts. By 1912 technical drawing for industrial design was a compulsory subject for all students. Teaching was given in the design of furniture, glass, ceramics, textiles and metals. For the most part students only learned to make sketches and draw ornamentation, while the actual object they designed would be made by a craftsman or in a factory. The School introduced a course in furniture design in 1915; by the 1930s the furniture specialists had established themselves as a separate professional group under the name of 'furniture architects'. Earlier, furniture had often been designed either by master carpenters who also happened to be able draftsmen, or by architects.[3] During the 1940s the training offered by the School of Technology became increasingly oriented towards the actual manufacture of industrial art but it was not until the school was refounded again in 1945 as the College of Arts, Crafts and Design that its students began to do practical work more systematically in a variety of materials.

151. On the right Wilhelm Kåge's
'Workers' Service' with 'Lily
Blue' decoration and on the left
Edward Hald's 'Turbine Service'.
Both were presented at the Home
Exhibition of 1917. Kåge's service
with its blue ornamentation is
reminiscent of eighteenth-century
Swedish ceramics, while Hald's
striped design is more suitable for
industrial manufacture.
Nationalmuseum [no 227]

MODERNISM'S RURAL ROOTS

Most of the artists who began designing for industry in the 1910s entered early products in the Swedish Society of Craft and Design's Home Exhibition at the Liljevalch gallery in Stockholm in 1917. Glass, ceramics and furniture were shown, among other things. By working for industry artists hoped to improve the aesthetic quality of industrial products but the Society also had a social purpose in mounting this Home Exhibition. It had invited firms and architects to enter a competition for good-quality but inexpensive industrially manufactured objects and interior design for the less well-off sections of society (Fig. 155). The competition rules stated how much each article might cost. As a result the exhibition contained twenty three furnished interiors together with a quantity of separate artifacts for use in the home. At the opening there was talk of 'the democratization of beauty'.[4]

Much of the furniture and other objects shown in the 1917 Home Exhibition had no great originality of form. They were derived from prototypes in nineteenth-century rural homes and in the simplicity of eighteenth-century Swedish design. An example is Wilhelm Kåge's 'Workers' Table Service' for Gustavsberg (Fig. 151). This service was manufactured in glazed earthenware, a relatively cheap material, and came with three different types of ornamentation, the first called 'Lily Blue.' This flower decor recalls eighteenth-century Swedish table services. Perhaps it is not so much the design as the name that justified its description as a 'Workers' Service' and has ensured its place in history as one of the first products of modern industrial art. The Home Exhibition's products were specifically aimed at the working- and lower-middle classes.

For a substantially more modern form of expression we must turn to Edward Hald's 'Turbine Service' for Rörstrand, also shown in the Home Exhibition of 1917. Hald had suited his abstract striped decoration to modern techniques so that it could be quickly painted in on a spinning wheel. The very name 'Turbine Service' suggested a technically advanced product entirely in line with the new industrialized society.

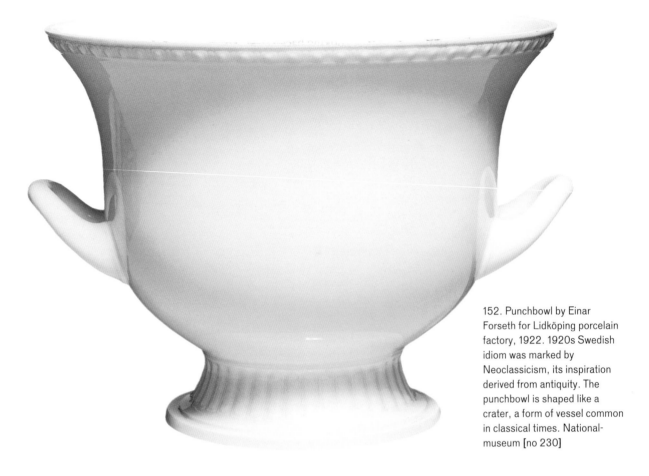

152. Punchbowl by Einar Forseth for Lidköping porcelain factory, 1922. 1920s Swedish idiom was marked by Neoclassicism, its inspiration derived from antiquity. The punchbowl is shaped like a crater, a form of vessel common in classical times. National-museum [no 230]

The Home Exhibition's interior fittings for small apartments recalled both traditional rural homes and the home Karin and Carl Larsson created for themselves at Sundborn around 1900. The publication of Carl Larsson's watercolor pictures of the interior of their home made it famous as an example of progressive interior design of the period (Fig. 153).[5] Ellen Key, in her 1897 article 'Beauty for Homes', was among those who drew attention to Sundborn as a model example of a beautiful home.[6] Key argued for the aesthetic education of the lower social classes; for her, true beauty was to be found in simple, practical things – any ornament that served no practical purpose was 'false display.' Workers' homes should be furnished with simple objects inspired by rural homes. Ideally, these objects should be made by the people living in the home themselves so as to ensure a stamp of individuality (exactly as the Larssons had done). Key believed that beautiful home surroundings would be sure to make people happier. For her, aesthetic education was a way of tackling social problems and she believed that an accute sense of beauty might even make intoxicating liquor superfluous. Her social-aesthetic vision permeated the rustic furnishings in the 1917 Home Exhibition.

MODERNISM'S CLASSICAL ROOTS

In contrast with the Home Exhibition's everyday artifacts, the major exhibitions of the 1920s concentrated on more exclusive forms of design. A number of lavishly decorated public buildings were erected, among them Stockholm's Town Hall and Concert Hall. In the Swedish pavilion at the Paris Exhibition of 1925 engraved glass by Orrefors and intarsia-marquetry furniture in exotic woods attracted most attention, but simpler practical objects were also shown.[7]

153. Karin and Carl Larsson's furnishings for their home in Sundborn were a source of inspiration for many Swedes during the first decade of the twentieth century. They became widely known through Carl Larsson's watercolors, and links with the interiors of simple rural homes influenced the small modern apartments in the Home Exhibition of 1917. *When the Children have Gone to Bed* was painted *c.*1895. National-museum

154. Edward Hald's fruitbowl for Orrefors Glassworks, 1919, was elegantly decorated with pillars and draped female figures that alluded to motifs from classical antiquity. Hald's motif, decoratively applied to the bowl's simple austere form, has a two-dimensional surface quality.

The 1920s have since often been seen as a historical parenthesis between two exhibitions with strong social purpose: the Home Exhibition of 1917 and the Stockholm Exhibition of 1930. Looking back at the 1920s in 1968 Gregor Paulsson, one of Functionalism's leading advocates, remembered that the Swedish Society of Craft and Design's pavilion at the 1923 Gothenburg Exhibition refused to accept any 'social shit'.[8] The emphasis was on exclusive art handicrafts. Even so, forgetting Modernism's social aims, we can find the roots of its austere idiom in 1920s Swedish Neoclassicism.

Unlike the organic and decorative idiom of the turn of the century, 1920s Neoclassicism was notable for simplification and rationalization. In Sweden the change was less radical than on the continent, but the greater austerity looked forward to Modernism. Surfaces became smoother, forms simpler and bolder. Ornamentation was applied as a virtually two-dimensional image, in contrast with art nouveau where it blended into the object's three-dimensional form.[9]

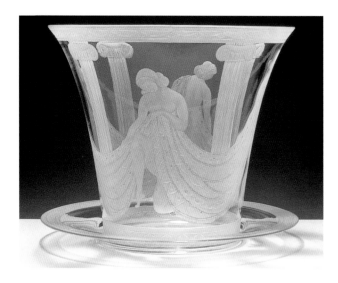

Models were often sought in classical antiquity, from which ornamentation and form could be borrowed and often reinterpreted for modern times. Decorative elements of this kind can be found as engraved ornamentation, for example, on glass pieces by Simon Gate and Edward Hald and in Einar Forseth's ceramics (Figs. 152, 154, 160). Hald, a pupil of Henri Matisse in Paris, put subjects from modern life on glass: a firework display, a cactus exhibition or a hot-air balloon with gondola. Side by side with these exclusive objects, practical pieces were produced which can be seen as a continuation of the Swedish Society of Craft and Design's ambition to create cheap mass-produced artifacts of high aesthetic quality.

During the 1920s new winds blew through the world of European architecture and design. 1919 had seen the foundation of the German Bauhaus school which worked in a pared-down modern idiom. The Bauhaus became one of the leading forces in international Modernism. At the Paris Exhibition of 1925 the French architect Le Corbusier presented his pavilion *L'Ésprit Nouveau* (Fig. 156). This was a Modernist home, both in design and furnishings. This international development influenced those Swedish architects and theorists who disliked the exclusivity of the twenties. Fifty years after the 1925 Paris Exhibition Gregor Paulsson, who had been general superintendent of the Swedish section, remarked that Swedish design in this period was at the time judged modern but not Modernist.[10]

THE DESIGNER IN THE SERVICE OF SOCIETY

As early as 1919 the Swedish Society of Craft and Design took a radical step in its efforts to develop modern industrial art in its manifesto *More Beautiful Objects for Everyday Use*, written by Gregor Paulsson. This argued for a homogenous up-to-date idiom in keeping with the new industrial society. The model for modern design would be the aesthetic of the machine and, with this as his starting point, the designer would design

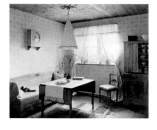
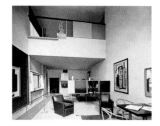

155. The interiors for small apartments shown at the Home Exhibition were reminiscent of rural Swedish homes. Gunnar Asplund equipped one apartment with elaborate decorations in wood stained in the same golden shade as its suite of pine furniture. There were rag rugs on the floor, and Asplund's intention was that the curtains and the textile shade on the central ceiling-lamp should be so simple that 'any worker's wife would be able to make them'

156. Le Corbusier's pavilion *L'Ésprit Nouveau* was the most original contribution to the Paris Exhibition of 1925. This Modernist interior would inspire many Swedish Functionalist architects and theorists, not least Uno Åhrén and Gregor Paulsson

157. Axel Larsson's chair with web seat and back was mass-produced by the Swedish Bodafors furniture factories. It was presented at the 1930 Stockholm Exhibition. A chair made from raw webbing and lacking the usual stuffed seat must have astounded the public of the time. Nationalmuseum [no 204]

158. Bruno Mathsson used ergonomic curves in his laminated bentwood chairs during the 1930s. One of the first was this work-chair from 1934, which was presented in 1936 at Mathsson's first exhibition, at Röhss' Museum for Applied Art and Design in Gothenburg [no 201]

articles that were both beautiful and modern. Objects for modern people would be created through a blending of artistic quality and technical proficiency. Paulsson's manifesto formulated the ideas that characterized Swedish Modernism in the field of industrial art.

The architect Uno Åhrén, who was to become one of Functionalism's foremost advocates in Sweden, argued in 1925 for a modern form of design in line with the contemporary style Gregor Paulsson had advertised in *More Beautiful Objects for Everyday Use*. Åhrén criticized the currently prevailing decorative idiom and pleaded for a logical link between form and function. The designer must restrain his individual creativity and place himself at the service of contemporary society instead. 'How easy it has been for some time to use originality to draw attention to oneself – but what we need now is the ability to efface ourselves. *Artistic form applied to practical artifacts without any "artistry" being visible*: that is the characteristic hallmark of the truly modern.'[11]

The Stockholm Exhibition of 1930 brought the breakthrough of Functionalism, the modern design idiom which Paulsson and Åhrén had publicized; as a trend within Modernism, it was to make great progress in Sweden during the 1930s. The Stockholm Exhibition was organized under the general direction of Gregor Paulsson by the Swedish Design Society. Its pavilions and stands contained not only furniture, textiles, interior fittings, artifacts worked in precious and non-precious metals, glass and ceramics, etc., but also complete home interiors, communications systems, schools, hospitals and hotels suitable for a modern industrial society.

One novelty at the Stockholm Exhibition was tubular steel furniture. Most of the examples made in Sweden had clearly been inspired by 1920s continental tubular steel furniture, one of the few original Swedish specimens being Gunnar Asplund's 1931 armchair for the Swedish Design Society's boardroom (Fig. 150). But on the whole tubular steel furniture had a lukewarm reception in Sweden where bentwood was preferred in furniture manufacturing. Gemla Factories presented a number of pieces at the Stockholm Exhibition, and none have become more famous than Bruno Mathsson's ergonomically designed specimens (Fig. 158).

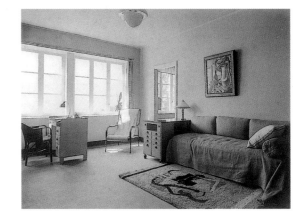

The Stockholm Exhibition had great ambitions. Cramped living conditions in large towns were seen as one of the most pressing problems of the day, and an attempt was made through standardized building and rational design to create good-quality but inexpensive accommodation for less-well-off citizens. A modern home should be equipped with inexpensive factory-made furniture and other articles, designed in the pure and simple idiom of the Functionalist style (Fig. 159). Individual items could be supplemented or exchanged later in line with changes in the family's needs and economic position. Not least, the Functionalists set themselves against 'traditional' furnishing, that is to say suites of furniture manufactured in Renaissance, Rococo or other styles. Young newly married couples often paid for such furniture in installments, which tied them economically to their furniture for many years. 'Fine' furniture of this kind was often heavy and unpractical and, as the Functionalists saw it, ill suited to modern town homes. In 1933 the Swedish Society of Craft and Design and The National Association of Tenants' Savings and Building (HSB) mounted an exhibition which presented, in a sturdily pedagogical manner, two different domestic interiors in a newly-built HSB building in the Gärdet district of Stockholm (Figs. 149, 161). One was a 'horror' apartment with heavy 'fine' furniture and wallpaper decorated with medallions and the

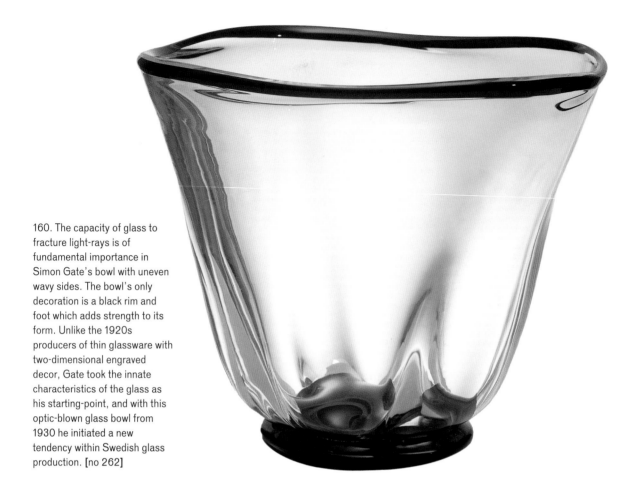

160. The capacity of glass to fracture light-rays is of fundamental importance in Simon Gate's bowl with uneven wavy sides. The bowl's only decoration is a black rim and foot which adds strength to its form. Unlike the 1920s producers of thin glassware with two-dimensional engraved decor, Gate took the innate characteristics of the glass as his starting-point, and with this optic-blown glass bowl from 1930 he initiated a new tendency within Swedish glass production. [no 262]

other an 'ideal' apartment with modern furnishings.[12]

Most of the furnishings at the Stockholm Exhibition had been designed by architects. One of those who took part in the exhibition and one of the first trained 'furniture-architects', was Axel Larsson, whose relatively anonymous work is typical of the Swedish designer in the service of the community during the first half of the twentieth century. Larsson designed a range of mass-produced standard functional furniture which has been used in many Swedish homes (Fig. 157). But both his name and his products were and still are relatively unknown to the public at large.

The modern idiom was intended to comprise all artifacts in the home. Objects should not only be practical and well suited to their purpose but also have a functional appearance. Their technical aspects should not be concealed by ornamentation and decorative detail. Purely decorative objects were viewed with disapproval. Those that would function equally well in everyday use and on special occasions were ideal. People with limited resources should not be expected to spend hard-earned money on a prestigious table-service that would only be used on a few special occasions. Wilhelm Kåge's stackable 'Praktika' service of 1933 had the extra advantage that it would fit into the cramped cupboards of small flats (Fig. 162).

The Stockholm Exhibition's Functionalist program had been criticized even before the exhibition opened. Within the Swedish Design Society a fierce debate, the so-called 'craft war', broke out between 'Traditionalists' anxious to protect individually made handicrafts, and 'Functionalists' who put the emphasis on mass-produced goods. This led to the scope of the exhibition being widened, together with a warning that artifacts should be judged on their quality, not on their style. But the Traditionalists, led by Carl Malmsten, were still not satisfied and insisted that Functionalism did not accord with Swedish tradition and individualism. The Functionalists maintained the opposite.[13]

The Stockholm Exhibition presented not only Functionalist design but home-made

161. From the 'Home' exhibition in a newly built HSB building at Skeppargatan 75 in the Gärdet district of Stockholm, 1933. Two different ways of furnishing the same room are displayed. The 'horror' apartment had heavy, unpractical period furniture while the 'ideal' apartment was furnished with modern furniture, monochrome walls and light curtains

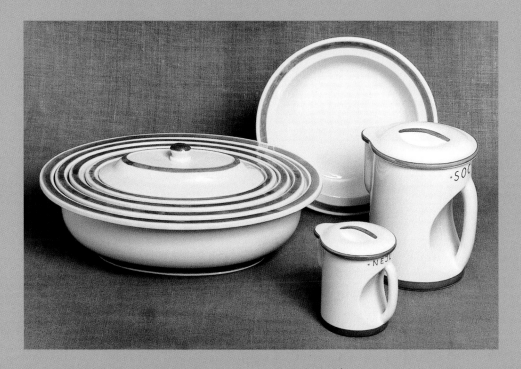

162. The 'Praktika' table service (seen here with 'Weekend' decoration in the upper picture), was to the taste of the Functionalists. The clean lines and simple decoration fitted the rational mind-set of an industrial society. The service was all the more practical for small flats with cramped kitchen cupboards in that its bowls fitted neatly inside one another. 'Praktika' was designed by Wilhelm Kåge for Gustavsberg in 1933. Nationalmuseum [no 233]

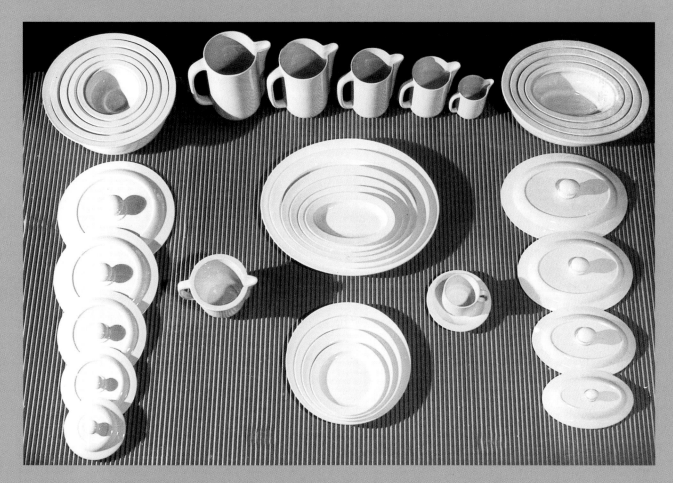

handicrafts, folk costumes and traditional painted wooden horses, the latter being the exhibition's greatest sales success.[14] Exclusive crafted products were also shown, such as furniture in expensive woods with intarsia inlays, embroidery, engraved glass and magnificent ceramic urns. Several of these craft items had been designed by designers like Wilhelm Kåge and Edward Hald who were also active in the field of mass-production for people on low incomes.

When the Nationalmuseum acquired a number of articles from the exhibition it was precisely the relatively exclusive craftwork that was chosen. Even if these exclusive artifacts did not fulfil the social aims of Functionalism, many of them did show signs of a Modernist idiom. One such example was Wiwen Nilsson's severely geometrical teacaddy in silver and ebony (Fig. 163).

All historical writing contains simplification as the historian looks for causal connections to explain a development or course of events. In considering the development of early Swedish industrial art, a relatively straight line has usually been traced from Ellen Key's late nineteenth-century dream of aesthetic education through Gregor Paulsson's 1919 manifesto *Vackrare vardagsvara* (More Beautiful Objects for Everyday Use) to Functionalism as presented at the 1930 Stockholm Exhibition. But this picture needs slight modification.

Both Key and Paulsson believed that a social-aesthetic approach would create a better society. But while Key believed people would be happier in beautiful, comfortable and individually furnished homes, Paulsson's ideal was a homogenous idiom that would reflect the modern industrial community. For him it was a matter of building a modern, rational and civilized society – a greater and more radical concept than Key's pleading for the development of a sense of beauty in the individual.

163. Wiwen Nilsson's exclusive silver and ebony teacaddy was one of the crafted articles which did not conform with the social aims of the 1930 Stockholm Exhibition, though his severely geometrical idiom and undecorated surfaces did conform with the Modernist machine-inspired aesthetic. Yet a simple geometrical idiom can already be found in the design of eighteenth-century Swedish silver. Nationalmuseum [no 299]

Even so, it is easy to understand how traditional historians came to see things the way they did. Ellen Key's pronouncement that anything that suits its purpose is beautiful accorded well with the Functionalist view that the most important thing about any object is its function and that aesthetic quality is achieved when form follows function. The title of Paulsson's manifesto, *More Beautiful Objects for Everyday Use*, may have caused some confusion. It was suggested by a press officer, and Paulsson admits in his memoirs that he was not happy with it but that it became an effective slogan.[15] Perhaps *More Beautiful Objects for Everyday Use* would have been a better title for Key's 'Beauty for Homes', in which she pleaded for beautiful articles for daily use, than for Paulsson's propaganda for a homogenous idiom in tune with modern times.

Ellen Key would hardly have found the interior fittings which realized Paulsson's dream of a suitable idiom for industrial society at the 1930 Stockholm Exhibition either beautiful or comfortable. It seems more likely that she would have joined the exhibition's critics, the Traditionalists. But might she not have appreciated the Swedish variant of Modernism that had yet to make its mark during the 1940s and 1950s?

A SPECIFICALLY SWEDISH FORM OF MODERNISM?

During the 1940s the austere Functionalism presented at the 1930 Exhibition was modified to a more specifically Swedish form of Modernism. Forms became rounder and softer. Furnishings made a warmer and cosier impression. The ideal was light furniture in light-colored Swedish woods, monochrome wallpaper, straight lengths of curtain with tasteful patterns and functionally designed articles equally suitable for everyday use and special events. It was expected that walls be hung with original art or good-quality graphic reproductions and that individual items be subordinated to the overall effect of

164. During the 1940s interior design remained a vital question. The Swedish Design Society arranged courses on which the various functions of the home and the individual needs of members of the family were discussed. Special consultants were employed by the state to help young couples choose furnishings and fittings for their new home

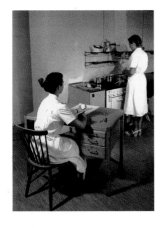

165. An experimental kitchen, 1945. The Home Research Institute made use of such kitchens to study and carefully document the height, position, extent of work surfaces and amount of time required for various kinds of work in the home. These studies often led to standardized measurements and proportions in the construction of Swedish homes

the furnishings as a whole to create a harmonious and comfortable room. We can categorize this Swedish Modernism as a blend of the uncomplicated idiom of Functionalism with the rural folk tradition's feeling for natural materials. This soft look dominated Swedish design during the 1940s and 1950s and came to be known internationally as 'Swedish Modern' or 'Scandinavian Design.'

In the larger towns living space was at a premium after the end of the Second World War in 1945. The lack of available apartments became a vital political question for the ruling Social Democratic party. A state loan for homemakers had been introduced in 1937 to make it easier for newly married couples to buy the furniture and household utensils they needed for their first home. A year later twenty-eight Home Consultants were appointed by the state to advise the general public on questions of housework and household planning. Several organizations applied themselves to the home problem during the 1940s (Figs. 164, 165). In the early forties research was conducted into the ways families responded to living in cramped conditions. Studies showed that despite extremely cramped circumstances many families kept a 'best room' where they stored their most precious possessions. The best room was a legacy of the traditional countryside home in which one room was reserved for formal occasions only. However, it was found that often the best room in a cramped town flat eventually had to be used as a bedroom, necessitating complicated refurnishing, while children were often obliged to use the kitchen and dining-alcove for both play and homework. The dining-alcove would also be used between meals by the housewife for sewing.[16]

In 1944 the Swedish Design Society started a Committee for the Home in conjunction with KF (the Swedish Co-operative Union), HSB, and educational and women's organizations, with economic support from the Swedish Trade Union Confederation (LO) and the Federation of Industry.[17] The Committee for the Home aimed to raise awareness of the importance of interior design through courses and exhibitions. The courses were designed as study circles and often arranged in the

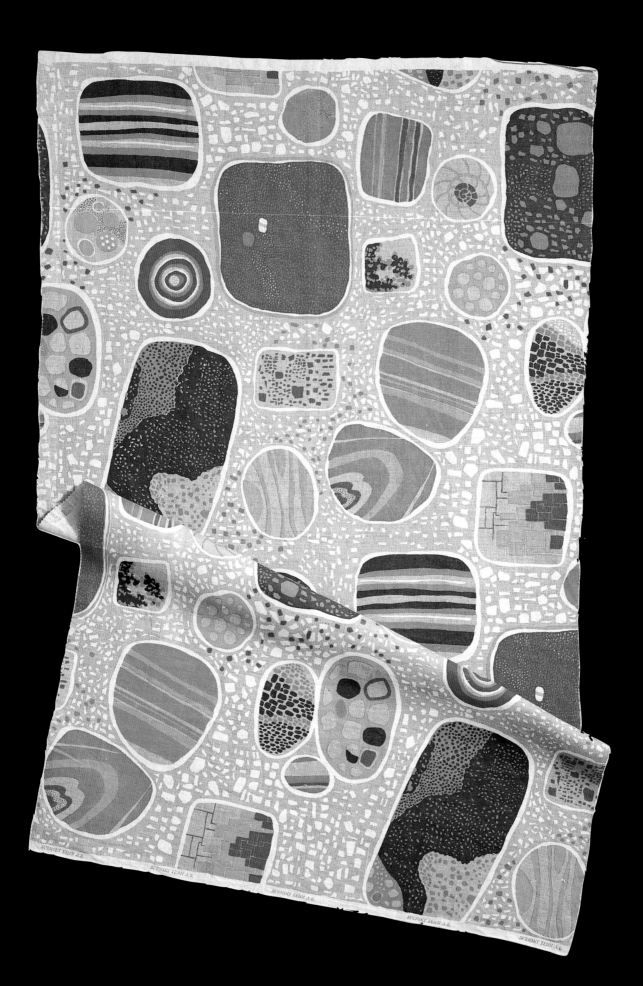

166. Josef Frank designed a
series of printed textiles for
Estrid Ericson's shop Svenskt
Tenn in Stockholm. The
'Terrazzo' pattern from 1943–4
is one of the few in which Frank
did not take his inspiration from
plants or animals. Instead the
abstract design suggests a
mosaic floor made up from
contrasting varieties of stone
[no 281]

smaller industrial centers. Those who took part were mostly young couples. The
purpose of these courses was partly to help people of limited resources who might have
taken a state home-loan to plan their buying, and partly to discuss how a home actually
works, in which areas of the home particular activities can best be performed, and
which equipment might best answer the needs of the family.

An attempt was made to persuade people to replace their 'best room' with a general
living room that could be used for everyday activities. Their furniture ought to be
practical, simple and mass-produced and better suited to a modern lifestyle than the
'fine' furniture of an earlier age, although it was understood that this had high prestige
in the lower-paid strata of society and for this reason often took pride of place in their
homes. The possibility that social prestige in the form of a best room with 'fine'
furniture might fill an important need in the homes of the lowest-paid was never
discussed. Instead, emphasis was laid on children's need of surfaces for play and study.
In fact, a best room could still be found in many Swedish homes until the early 1960s,
when the advent of television caused it to be transformed into a general living room in
which the whole family could watch together.

In 1944 several Swedish women's organizations founded the Home Research
Institute, the purpose of which was to survey the nature and status of women's work in
the home. A series of functional studies suggested conclusions which in many cases led
to the adoption of standard requirements in the building of Swedish homes. These
involved among other things the height of work surfaces, the dimensions and placing of
kitchen cupboards and the design of ergonomic and effective kitchen equipment.[18] The
scientifically developed research methods used in these studies also led to a revaluation
of women's work in the home.

Like the Home Research Institute, the Swedish Design Society and Swedish
National Federation of Architects (SAR) carried out studies and measurements of
various functions and objects in the home. Among other things they examined the
design of bedroom furniture including mattress size and the length of beds' legs, the
latter to facilitate cleaning under the bed. Another study looked into how much room
was needed for four persons to be able to sit comfortably round a table and how large a
table surface a normal dinner setting required. Yet another calculated the quantity of
clothes a normal family was likely to have and how much space would be needed to

167. Sven Palmqvist's 1953
'Fuga' bowls for Orrefors had a
simplicity of form which arose
naturally from industrial
techniques. The bowls were
created by fast-rotating
centrifugal force which caused
the molten glass to cool and set
to a uniform thickness. Orrefors
Kosta Boda AB [no 272]

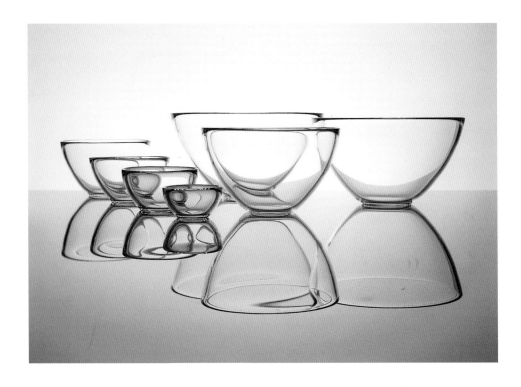

store them.[19] These studies gave results which had general validity and were used to standardize the design of both furniture and the home itself.

Thus the planning and fitting out of the home were an essential element of design in the 1940s and 1950s. The aim was to produce good, user-friendly products which through mass-production would be within everybody's reach. The main furniture manufacturers were NK (the Nordiska Kompaniet department store), Svenska Möbelfabrikerna (Swedish Furniture Factories), KF, HSB and Gemla. The leading producers of ceramics were the Gustavsberg, Rörstrand and Gefle porcelain factories and the leading glassworks Orrefors and Kosta. The most original manufacturers of furnishing fabrics were Elsa Gullberg Textiles and Interiors, NK's textile department under the direction of Astrid Sampe, and Estrid Ericson's Svenskt Tenn (Fig. 166).

Thanks to the co-operation with industry of designers trained as artists it was possible to manufacture many products to a high quality of design and Swedish Modernism became internationally famous. Many industrial designers, especially ceramicists, also worked simultaneously as independent artists and this added inspiration and quality to their industrial work. One can say that the 1910s' dream of 'beautiful objects for everyday use' and 'democratic beauty' became reality during the 1940s and 1950s. The high point was reached in 1955 with the Swedish Design Society's exhibition 'H55' in Helsingborg. But at that very moment it became possible to detect a questioning of the whole concept of aesthetic education and beautiful everyday things.

TASTE AND LIFESTYLE

During the 1950s the Swedish economy grew stronger and the welfare state developed. People were no longer so economically restricted as they had been and there was less need for consumer guidance in the form of such things as courses on planning the home. The idea that such a thing as objective common-sense good taste existed had been prevalent ever since the heyday of Ellen Key at the end of the nineteenth century, but it

169. In 1956 Anders B. Liljefors exhibited ceramic objects which rejected the elegant and harmonious aesthetic prevalent during the fifties. Liljefors' irregularly shaped objects with their thick uneven glaze anticipated the more playful idiom of the 1960s. Nationalmuseum [no 249]

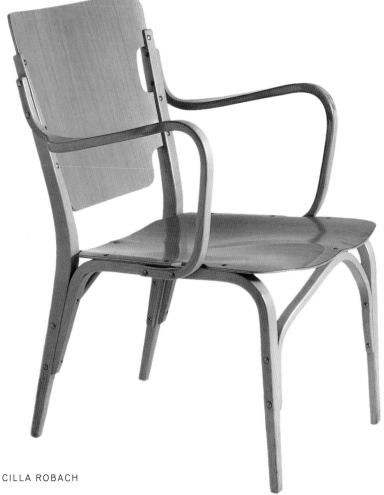

168. Carl-Axel Acking's armchair with laminated bentwood seat and back could be packed in separate pieces and assembled in the shop that sold it. This rational approach to distribution has led to this chair being described from an industrial point of view as the most advanced piece of Swedish furniture of the 1940s. The chair was designed in 1944 and manufactured in mahogany veneer and reddish beechwood by Bodafors Swedish Furniture Factories. Torbjörn Lenskog Twentieth-Century Design Collection [no 213]

began to be challenged during the second half of the 1950s. One of the exhibition notes at H55 asserted that 'we all have different tastes and make different demands on our environment.'[20] In 1956 Gregor Paulsson wrote that 'choice of goods is choice of lifestyle.'[21] People began to be aware that objects might have other characteristics beyond the purely practical at the same moment as they began to question the dream of the same aesthetic values being equally valid for all. Ulf Hård af Segerstad and others maintained that taste was subjective and defined by the values prevalent in the social group to which an individual belonged.[22] Criticism also began to be heard of the idea that it was good to try to teach people how best to equip and live in their own homes. In an article in the Swedish Design Society's journal FORM in 1960 Thomas Paulsson maintained that the social prestige people had once derived from their 'best room' had supplied a human need which its critics had not taken sufficiently into consideration. 'The concept of social prestige is not merely a fragile phenomenon, but one which is often accorded scant respect. It is rather ironic that we dare not face up to it despite the fact that innumerable research projects into the way people live have established its existence – but without accepting it.'[23] Individual needs, such as the desire to create one's personal identity by making one's own choices in matters of taste, artifacts and home furnishings, came into conflict in 1960s Sweden with collective solutions based on ideas of function and quality.

Also called in question in the mid-1950s was the prevailing idiom of elegant lines, harmonious proportions and an almost perfectionist handling of various materials derived from craft skills. This idiom was criticized as much within the craft world as anywhere. Experimental forms using idiomatic brutality came to be accepted as respectable. Among those best known in this connection were the glass designer Erik Höglund and the ceramicists Anders B. Liljefors and Hertha Hillfon, who exhibited expressive artifacts that broke with the cool elegance of the mid-fifties (Fig. 169). This new aesthetic made a breakthrough in 1960s Sweden, much influenced by American pop art, and it can be seen as a first step in the dissolution of Modernism.

NOTES

1. Anders Åman has used the expression 'form follows material' in a discussion of the architecture of wooden churches; this put me in mind of handicrafts. See Anders Åman and Marta Järnefeldt-Carlsson, *Träkyrkor i Sverige* (Wooden Churches in Sweden), 1999, p. 158.
2. The guild system guaranteed a certain standard of craft training throughout the relatively long path from apprentice to master. When professional practice was detached from this it was feared a decline in quality in the production of artifacts would follow, something which the teaching of the Sunday School of Drawing might counteract.
3. 1933 saw the foundation of the pressure-group SIMS (Swedish Association of Interior and Furniture Designers), which has been known since 1953 as SIR (National Swedish Association of Interior Designers). For further information see Sigrid Eklund Nyström, *Möbelarkitekt på 1930-talet: Om inredningsfirman Futurum och hur en ny yrkesgrupp etablerar sig* (Furniture Designers in the 1930s: Concerning the Interior Furnishing Company Futurum and How a New Professional Group Can Establish Itself), 1992, and Agneta Liljedahl, 'Inredninsarkitektur och möbeldesign' (Interior and Furniture Design) in *Tanken och Handen: Konstfack 150 år* (Thought and Hand: 150 Years of Craft and Design), 1994.
4. Kerstin Wickman, 'Hemutställningen på Liljevalchs 1917' (The 1917 Home Exhibition at

Liljevalch's) in *Formens rörelse* (The Movement of Form), ed Kerstin Wickman, 1995, p. 67.
5. Carl Larsson, *Ett hem* (A Home), 1899.
6. Ellen Key, 'Skönhet i hemmen' (Beauty for Homes) in *Skönhet för alla* (Beauty for All), 1913/facsimile edition 1996, p. 16.
7. Gregor Paulsson, 'Stilepok utan morgondag' (A Period of Style with No Tomorrow), in *Fataburen*, yearbook of Nordiska Museet (The Nordic Museum), 1968, p. 112.
8. Ibid., p. 111.
9. Compare for example Simon Gate's and Edward Hald's engraved glass for Orrefors in the 1920s with Alf Wallander's organic ceramics for Rörstrand from the years around 1900.
10. Gregor Paulsson, *Upplevt* (Life Lived), 1974, p. 112.
11. Uno Åhrén, 'Brytningar' (Breaches), *Svenska Slöjdföreningens Årsbok* (Yearbook of the Swedish Design Society), 21st year, 1925, p. 9.
12. Kerstin Thörn, 'Från kök till rum' (From Kitchen to Room) in *Hem* (Home), ed Carl Heideken, Stockholms Stadsmuseum (Stockholm City Museum), 1994, p. 75.
13. Eva Rudberg, *Stockholmutställningen 1930* (The Stockholm Exhibition of 1930), 1999, pp. 197–8.
14. Ibid, p. 108.
15. Gregor Paulsson, *Upplevt* (Life Lived), 1974, p. 100.
16. Brita Åkerman, *Familjen son växte ur sitt hem* (The Family that Grew out of its Home), 1941;

Den okända vardagen – on arbetet i hemmen (The Mysteries of Everyday Life – Work in the Home), 1983, and *Kunskap för vår vardag* (Knowledge for Everyday Use), 1984. See also Lena Larsson, *Vill våra barn ärva våra ljusstakar* (Will our Children Inherit our Candlesticks), 1970.
17. Monica Boman, 'Vardagens Decennium' (Everyday Decade) in *Svenska Möbler 1890–1990* (Swedish Furniture 1890–1990), 1991, p. 231.
18. Britta Lövgren, *Hemarbete som politik. Diskussioner om hemarbete, Sverige 1930-40-talen och tillkomsten av Hemmens Forskningsinstitut* (Housework as Politics. Discussions about Housework, Sweden in the 1930s and 1940s and the Founding of the Home Research Institute), 1993.
19. Erik Berglund, *Tala om kvalitet* (Talk about Quality), 1997, pp. 22–31.
20. Kerstin Wickman, 'På en smal tunga ut i havet' (Out at Sea on a Narrow Tongue of Land), in *Formens rörelse* (The Movement of Form), ed Kerstin Wickman, 1995, p. 196.
21. Gregor Paulsson, *Tingens bruk och prägel* (The Use and Distinguishing Mark of Artifacts), 1956, p. 123.
22. Ulf Hård af Segerstad, *Tingen och vi* (Artifacts and Us), 1957, p. 57.
23. Thomas Paulsson, 'Vi behöver finrummet' (We Need the Best Room), FORM 6/1960, p. 364.

GUSTAF ROSELL

THE LAST MODERNIST

The Rise of Industrial Design as a Profession

Industrial design is one of the youngest creative professions, only a few decades older than computer web design if we take formal training into account. However the type of work and the tasks we associate with industrial design have been practiced for considerably longer by other professional groups and self-taught designers from various backgrounds. This motley growth can still be seen today, for instance in Italy where many industrial designers first trained as architects. So in defining industrial design in the Modernist period, we must for the most part use as our starting point the nature of the objects, ranging from small everyday items like teaspoons to large industrial machinery. What all these objects have in common is that they are mass-produced. As a rule in Sweden furniture or industrial art products such as porcelain are not included.

In many ways the role of the industrial designer sprang from industry's need to design mass-produced wares. In the days before mass production the craftsman was responsible for both design and manufacture. Form was often governed by tradition and development took place through continual small variations between different versions of a product. Industrialization came more and more to separate design from production, bringing about an increasing need for products to be designed by draftsmen. More advanced products and materials together with shorter series of the individual product also reduced the importance of established design models.

THE ENGINEER AS DESIGNER

The first decades of the twentieth century saw considerable technological development, making it natural for engineers to be the first designers of factory-made products. Bridges, machines and vehicles designed by engineers came to serve during the 1910s and 1920s as models especially for architects, but also for artistic movements such as Futurism and Constructivism. Very little of the design done by engineers during this period was as much the result of rationality and science as many theorists have wished to maintain. For example, the design of the cars to which the architect Le Corbusier paid

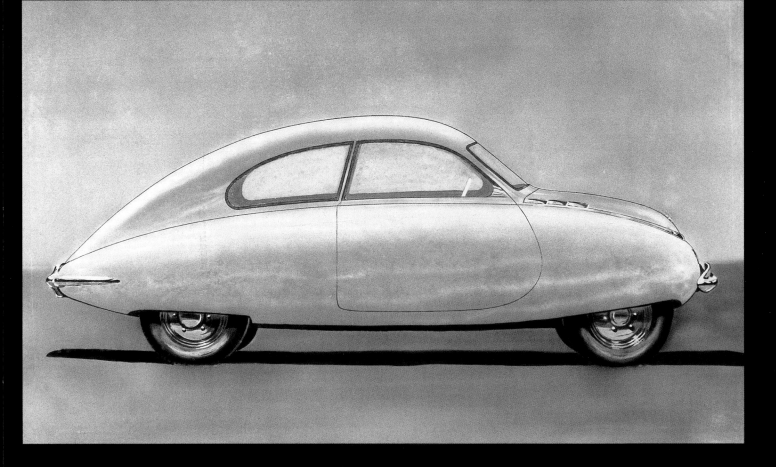

170. Sketch for the Saab 92, the so-called 'Ur-Saab', by Sixten Sason c.1945. Sason developed a specifically Scandinavian variant of streamlined form, hardly surprising in the case of SAAB in view of the firm's history as an airplane manufacturer. Sason designed everything from waffle-irons and cars to a 1939 plan for a bridge across the Öresund to link Sweden and Denmark, but he was also concerned about the possible effects of increased car use on large modern cities. [no 323]

171. Spherical ballbearings by Sven Wingquist for SKF, 1907. The ballbearing is one of the very few objects whose form is almost totally determined by its function, an aspect of the Modernist ideal. Thus it became a symbol for the machine aesthetic and also a source of inspiration to artists like Fernand Léger who used it on his poster for the 1927 'Machine-Age Exposition' in New York. [no 318]

homage in his essay 'Towards a New Architecture'[1] had been developed by the people who manufactured the cars, and it was the same with many other engineering products. Such supposedly rationally thought-out design was really just traditional engineering, in which proportions and other elements of form were built onto classic models.

But a few examples of pure machine aesthetic, of pared-down rational form, did exist. The spherical ballbearing of 1907, which may be seen at the Museum of Modern Art in New York and elsewhere, has a form determined by its function (Fig. 171), as do shapes dictated by the streaming of air or water like propellers and airplane wings. Streamlining as a style became particularly popular in the USA and came to characterize several decades of mass-produced goods, including unmoving objects such as pencil sharpeners and even coffins.

The 1920s also saw a great interest in factory production in itself, seen via Taylorism's systematic way of looking at things. Taylorism was concerned with how time and motion studies could maximize factory work, the very basis for mass production. The faith in the positive influence of machines and engineers which characterized the early part of the century has many interesting parallels with today's faith in information technology and Internet consultants. The engineers whose work as designers attracted most notice were those who were also active as innovators or entrepreneurs. A good example is the Nobel Prize winner Gustaf Dalén, who had very wide technical interests and invented the AGA cooking range in the 1920s. Most remarkable for its ingenious cooking and heating functions, the Aga also came to be seen as a symbol of rational design. That the range had been developed and designed by a physicist appealed to the faith in rational design that characterized the period (Fig. 172).[2]

Further examples of engineering design springing from a wealth of technical invention can be found, for example, in Johan Petter Johansson's long and productive career. He is best known for his adjustable spanner of 1892, but his Triplex hanging lamp of 1919 became a standard article in Functionalist interiors during the 1930s.

Early twentieth-century engineers were often interested in aesthetics. This was partly a matter of handicraft since it involved the technique of drawing, which was fairly formalized early on, but training at the Stockholm Technological Institute (later the Royal College of Technology), also included a little free artistic drawing. The link between technology and aesthetics was given more emphasis in certain training courses such as those at the Stockholm School of Technology, which since 1945 has been known as Konstfack (College of Arts, Crafts and Design). This school was run by the Swedish Society of Craft and Industrial Design and to begin with focused mainly on industrial arts, only later developing the wide general education in art it offers today. Nevertheless, many practicing constructors and designers benefited from an apprenticeship during which they were naturally given instruction in the technique of drawing and the study of form and proportion.[3]

With time, civil engineers gradually began to distance themselves from practical design and engineers in general moved closer to the scientific ideal for which they have

172. Gustaf Dalén's AGA range from 1924, now the Aga-Rayburn. Its ingenious function, so economical in energy, gave the Aga the cult status it enjoys today. As early as the 1930s the British art historian Herbert Read gave it as an example of ideal engineering art in his book *Art and Industry*. [no 319]

173. Gustavsbergs Fabriker (the Gustavsberg Factories) built their business on the concept of the 'caring society.' This involved advertisements which in many cases were more like information for the public on new standards of hygiene than traditional advertising propaganda. This example dates from the introduction of the bidet in 1942. [no 320]

traditionally been celebrated. In the 1940s it became clear that engineers were losing interest in form. At the same time the new professional category of 'industrial designer' emerged and in some firms industrial designers took over responsibility for design.[4]

PRODUCTS FOR A HYGIENIC WELFARE STATE

In many industries design continued to be controlled by craftsmen. For example, in the porcelain industry even today form is partly determined by the pattern-makers who manufacture the moulds for casting. For several decades these very able craftsmen were at the heart of product development in areas where design and manufacture are inseparable, i.e. everything from metal-work to plastics. Today this has been much changed by the advent of CAD/CAM computer-aided design and manufacture.

The Gustavsberg factories' activity in the field of sanitary porcelain can be seen as a happy combination of model-making expertise and strong commercial leadership (Fig. 173). Gustavsberg is a good if rare example of how social ideals can be combined with business interests. When the firm was acquired by the KF Co-operative Union in 1937, the old purely commercial mentality was replaced by the co-operative ideals of a caring society and welfare state. The sanitary ideals of the 1930s found practical expression in such products as bathtubs and bidets. The firm publicized this message effectively in its marketing, and during Hjalmar Olson's long career as head of Gustavsberg a well-balanced mixture of what would later be called 'design management' and social responsibility was developed. Arthur Hald at Gustavsberg may even have been Sweden's first design manager, even if his official title was 'artistic leader'.[5]

It may seem natural that artists and craftsmen should work on industrial products, but in reality this happen only rarely. During the early twentieth century debates on design seldom made any mention of factory-produced goods except those used in the home. Gregor Paulsson's 1919 manifesto *Vackrare vardagsvara* (More Beautiful Objects for Everyday Use) can hardly be said to make direct reference from any practical point of view to what we now call industrial design. But he did take a far-sighted view of coming developments and the future role of industry, and his manifesto became the basis for mediation between artists and industry as promoted by the Swedish Society of Craft and Industrial Design.

Among the more interesting exceptions to the rule that artists did not design for industry was the portrait painter Helmer Mas Olle who worked on Volvo's early models from the very first, the ÖV 4 of 1927. Co-operation with the engineers was not painless and the design of some of Volvo's early models was severely criticized. The not altogether logical consequence of this was that for nearly twenty years Volvo then let engineers take the main responsibility for design, using American cars as models.[6]

It was less unusual for architects to contribute to the development of industrial products. In the lead-up to the 1930 Stockholm Exhibition the Swedish Design Society put pressure on a number of firms to interest themselves in design. The Architects Eskil Sundahl and Sigurd Lewerentz were recruited by the bus manufacturers Tidaholms Bruk and Hägglund & Söner to strikingly good effect. Even so, their frequently neoclassical

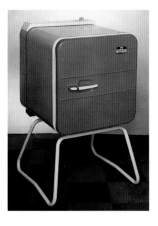

174. Free-standing refrigerator designed for Bolinders by Hugo Lindström in 1952. The design of 'white goods' was early influenced by the design idiom of the car industry, sometimes with very obviously borrowed details. This popular version in red was inspired by the American Studebaker Hawk car

designs contrasted with the more pared-down Functionalism which marked other parts of the exhibition.

A NEW PROFESSION

In Sweden the first real industrial designers emerged at the end of the 1930s. Despite a lack of formal training, many of these early figures stand out even today as having been exceptionally skilled. The influences on them were principally American, as can be seen in their presentation techniques and stream-lined products (Fig. 174).

Perhaps the one who came most under American influence was Ralph Lysell. He had developed a clever graphic technique and was probably the first in Sweden to begin using stream-lined form (Fig. 176). Lysell had worked for some ten years in the USA and Germany before coming to Sweden, where he joined L.M. Ericsson and as early as 1941

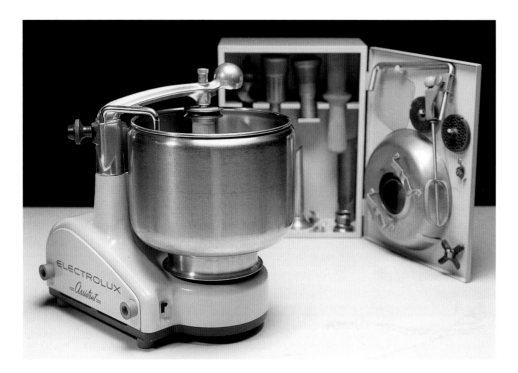

175. Alvar Lenning's 'kitchen assistant' [food processor] for Electrolux was launched in 1940. Lenning was technically oriented in his work as a designer and in his approach to the question of co-operation between industrial designers and engineers. The debate about how these two groups can best work together continues even today, and so far no mature relationship between them has been worked out. [no 311]

produced the first prototype of the Cobra telephone, a considerably stronger design than the mass-produced version (Fig. 178). After working at Ericsson he started the first real design consultancy in Sweden, AB Industriell Formgivning (1944) which, after a turbulent existence during which it invested in its own products, went bankrupt in 1947.

In contrast with the dynamic Ralph Lysell were more technically oriented designers like Alvar Lenning, a civil engineer who worked as a technical and design consultant. Among his achievements were radio sets for AGA, solutions to cooling problems for Bolinder, and his best-known product, the kitchen 'Assistant' (food processer) for Electrolux (1940; Fig. 175).[7] With his background in engineering, Lenning argued that the starting point for design should be the engineer's requirements. Many of his colleagues preferred the designer to have a higher profile – a sensitive question which gives rise to plenty of discussion to this day.

FROM HARMONIOUS WAFFLE-IRONS TO FLYING CARS

Sixten Sason was another colorful post-war industrial designer. He started out as a self-taught technical illustrator and among other activities produced illustrations for motoring periodicals during the later 1930s. He was exceptionally skilled at making 'X-ray' sketches and understanding spatial relationships.

During the Second World War Sason drew illustrations for handbooks and other instruction material for Saab's military planes and afterwards became involved in the development of the firm's return to civil production, which included the small car known as 'Project 92.' It was when Sason showed his sketches in 1944 that this project got off the ground (Figs. 170, 177). His contribution was by no means restricted to external form; he was to a large extent responsible also for the well-planned space for the driver and not least for the model's extremely low wind resistance, which very few of today's cars can approach (coefficient of drag 0.32 for the prototype).

Sason continued to work for Saab as a freelance design consultant up to his death in 1967, but Swedish industry gave him many other commissions at the same time. Three firms which commissioned him were Hasselblad, Electrolux and Husqvarna, for whom he worked on everything from cameras to refrigerators, waffle-irons and power-saws.

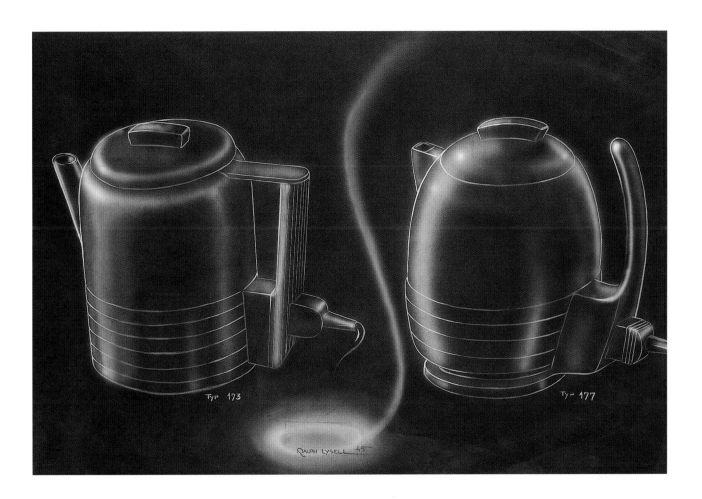

176. Designs for electric kettles by Ralph Lysell, 1945. Nationalmuseum [no 337]

DESIGN DURING THE YEARS OF PROSPERITY OR 'RECORD YEARS'

During the 1950s salaries in Sweden rose twice as fast as the price of consumer goods, creating the essential conditions for an entirely new type of consumer model. It was only then that the effects of mass-production were clearly seen. Many goods were produced in vast quantities, becoming standard products in Swedish homes.[8] Interest in design grew. There were natural reasons for this. As the standard of living rose, Swedish firms found themselves facing increasing international competition. In the field of furniture and household utensils in particular, it was essential that such terms as 'Scandinavian Design' and 'Made in Sweden' should become internationally known slogans.

During the 1950s more and more design studios were established. Perhaps the best known of these was Bernadotte Design, with Sigvard Bernadotte as managing director and active designer for some twenty years from 1950.[9] Bernadotte Design became

known, abroad as well as at home, for simple but refined design and among those who made use of its services were Facit, AGA and SAS. The firm's best known products were the coffee and thermos flasks designed from 1955 onwards for Moderna Kök (Modern Kitchens), which reached a large part of the Swedish population, sometimes under the name 'TV Flask'. In the 1960s Sigvard Bernadotte was chairman of ICSID, the international organization for industrial design; in 1957 he had helped found the corresponding Swedish organization SID.

Bernadotte Design became extremely important as a nursery for young designers, both Swedish and foreign. During the 1960s many of its trainees and assistants were to found some of the most important studios of the future, such as Ergonomi Design Gruppen (The Ergonomic Design Group), Roland Lindhé Design and Carl-Arne Breger; they also included the Dane Jacob Jensen, later internationally famous as chief designer

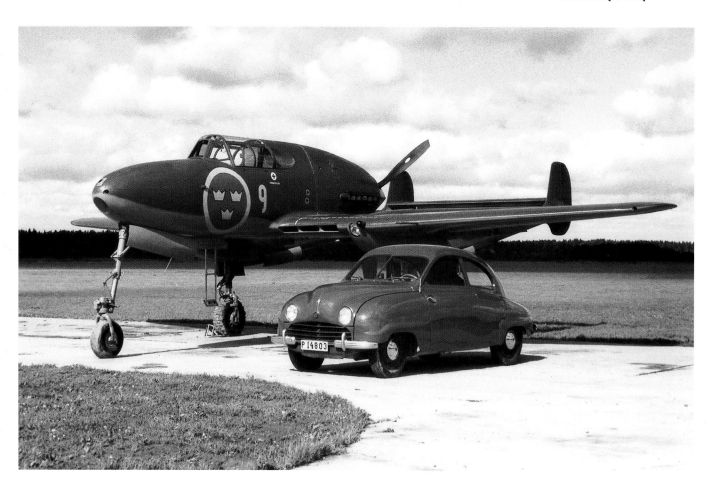

for Bang & Olufsen. It was a distinguishing feature of Bernadotte's studio that working with models formed an important part of the work process and not least of presentations to clients, while the firm even employed an in-house carpenter to construct models. Other designers continued to work with sketches, especially the so-called 'renderings' which are internationally still the most usual form of presentation. But models have come to play a central part in the work of Swedish industrial designers.

Bernadotte had few competitors. The only larger studio was AB Industridesign, established by Rune Monö in 1957. This firm became active in a very wide field, and was one of the first in Sweden to work with the concept of corporate identity, i.e. the design of a complete company image. One such client was SAS, in more recent times particularly well known for its range of corporate identity commissions. Rune Monö has not only put in at least five decades of work as a designer but has been active in SID too,

177. The Saab 92 car in Sixten Sason's 1948 production version together with its inspiration, the Saab J21 plane. The production model of the car differs in certain compromise details from its prototype, as for instance in its wheel-housings and grille

and far from the least of his achievements has been his work for the development of theory in design methodology and systematization of form.

The story of women industrial designers is unfortunately not well documented. In the main, industrial design today is shared equally between the sexes, but for a very long time few women were active in industrial design even though many female designers could be found in the related field of interior design. Those who came closest to industrial design in their work were a number of able textile designers, many of whom attracted notice at the H55 exhibition in Helsingborg. They were close to the industrial designers in that they too worked explicitly for mass-production, and they too came to be active within the designers' association SID. Two of these were Astrid Sampe and Age Faith-Ell. Astrid Sampe produced many fabrics and patterns which have formed the most typical images of 1950s Sweden. Age Faith-Ell was responsible for a large number of textiles for Carl Malmsten and Kinnasand among others; a good many of these are still in production.

The growing interest in design during the 1950s also began to attract the notice of firms specializing in heavy industry. Asea and Alfa Laval started their own design departments, though these were closed down during the 'rationalization' period of the 1960s. Asea's design office, built up by the engineer John Meilink, itself contributed to creating a nursery for young designers. It was also Meilink who together with the silversmith Pierre Forsell in the years from 1957 organized the first training courses for industrial designers in Sweden. This training in fact ran parallel with silver work within the College of Arts, Crafts and Design, and continued to do so until 1968 when Industrial Design became a department of its own.

At the same time, links with the modernistic idiom that stamped other professional creative groups became more obvious. Streamlining was increasingly forced to give way to pared-down forms rooted in Functionalism, something we can see clearly in the designs of the 1960s. Training in industrial design was also affected by the teaching of the German Bauhaus school, as for example in the theory of form and color.

ERGONOMICS AND CONSIDERATIONS OF SAFETY

In recent times Swedish industrial design has become best known for ergonomics and safety considerations. This development came rather late, even if there are interesting links with early research such as that of Hemmens Forskningsinstitut (the Home Research Institute), whose founders in 1944 included Brita Åkerman who was not only active in the Swedish Design Society but also connected with the women's movement.

The Home Research Institute systematized understanding of housework and of how various pieces of equipment actually functioned. Its functional studies laid the groundwork for developing working methods for what later came to be known as user-centered design, which used of the methodology of Taylorism not to increase productivity but to make the home environment more housework-friendly and later also to improve the factory environment. The Home Research Institute's reports were carefully studied by a range of manufacturers, not least the co-operatives, of which the leading example was Gustavsberg.

In the late 1950s Vattenfall showed it is possible for a large organization with a caring philosophy to give impetus to new products. After problems with accidental derailments and collisions during conveyor-belt work in Norrland, this firm used tests and research to develop the 'three-point belt', the type of car seat-belt with three fixed points which we use today. Volvo was

179. Experimental TV broadcasts began in Sweden in 1955, initiating the manufacture of TV sets. The 'Pigtittaren' ('Toilet Glass' TV set) was designed in 1958 for Luma by Stig Lindberg, otherwise best known for his ceramics for Gustavsberg. Television not only symbolized dramatic technical and social change but provided a new piece of 'furniture' to fit into Swedish interior design

one of the first car manufacturers to offer this belt, including it in its 1957 list of accessories and contributing to the final stages of its development. Safety was central to the launch of the Amazon car model on the American market.

Swedish ergonomic design has strong links with research and function studies but contemporary political aims and international impulses have also played an important part in its development. A study trip to the USA fortuitously contributed to a rapid growth of interest in design in Sweden. The trip had been intended for a number of Sweden's most prominent engineers to study production design in the USA, but a translation error referred instead to 'industrial design', in effect giving Swedish industry a unique opportunity to acquire information.[10] The participants had the opportunity to meet Henry Dreyfuss, a pioneer of ergonomics and industrial design in the USA. His systematization of measurements and guidelines round two typical figures, 'Joe' and 'Josephine,' has had a major influence on work involving ergonomic design.

One of the firms mostly strongly influenced by this study trip was Atlas Copco, which started its own design studio in 1956 under Rune Zernell, the manufacturer and former advertising designer (Fig. 180). Zernell's technological background enabled him to make important improvements in the products on offer. This often considerably influenced the technical side of production, evidence of how closely this is bound up with design and ergonomics.

Zernell's work was clearly influenced by Dreyfuss, but he also developed methods of his own appropriate for Atlas Copco's products. He worked with Karolinska Institutet (a major medical school) on relevant aspects of anatomy and practical physical methodology, but also contributed to the later acquisition by Atlas Copco of its own noise-level experts. This led to new products, a great increase in sales, and international interest.

Since then Sweden has developed unique skill in ergonomics and user-oriented design affecting both products and the work-place, and this has not surprisingly influenced the wider Swedish safety tradition as well. The late entry of industrial designers into this field, self-taught at first and only later formally trained, can be said to have completed the development circle of Modernism. At about the same time as Modernism as a style was losing its popularity in the 1960s and 1970s, industrial designers began reverting (if partly for new purposes) to working methods that had come to the fore during its early period. Other aspects of Modernist thinking and theories of social responsibility still survive in what we now call user-centered design. These work-methods have now been introduced in completely new fields such as the development of computer programs and their user demarcation lines.

180. Compressed-air drills from Atlas Copco. During the 1960s the firm built up considerable ergonomic skill under the leadership of the designer and engineer Rune Zernell. In developing compressed-air drills use was made of medical expertise, an example of the step forward taken from the pure engineering design of the thirties to the more ergonomically conscious design of the sixties [no 325]

NOTES
1. Le Corbusier, *Vers une architecture*, 1923.
2. See for example Herbert Read, *Art and Industry – the Principles of Industrial Design*, 1934.
3. An interesting discussion on the subject of construction and aesthetics can be found in Jonas Hesselman, *Teknik och tanke – Hur en motor blir till* (Technique and Thought – How Cars Come into Existence), 1948.
4. On the training and development of engineers, see for example Nils Runeby, *Teknikerna, vetenskapen och kulturen* (Engineers, Science and Culture), 1976, and Gustaf Rosell, *Anteckningar om designprocessen* (Notes on the Design Process), 1990.
5. Arthur Hald, *Gustavsberg, verktyg för en idé*

(Gustavsberg, Instrument for an Idea), 1991.
6. Björn-Eric Lindh, *Volvo – personvagnarna från 20-tal till 80-tal* (Volvo – Private Cars from the 1920s to the 1980s), Gothenburg 1984, gives a broad overview of Volvo's history.
7. A vivid description of both Lysell's and Lenning's careers will be found in Hugo Lindström, 'Min tid med Ralph Lysell och Alvar Lenning' (My Time with Ralph Lysell and Alvar Lenning), in Lasse Brunnström (ed), *Svensk Industridesign – En 1900-talshistoria* (Swedish Industrial Design – A Twentieth-Century Story), 1997.
8. Many of these products and the advertisements that belong to them can be found in Thomas Eriksson, *Älskade pryl!* –

Reklam- och prylhistoria för rekordårens barn, (Beloved Luxury! – The Story of Advertising and Luxury Goods for the Children of the Years of Prosperity), 1999.
9. The studio was originally known as Bernadotte & Bj¢rn, since it was shared by the Danish designer Acton Bj¢rn.
10. See for example Lasse Brunnström, 'Hjälpmedel för ett säkrare och jämlikare liv' (Resources for a Safer and More Equitable Life), in Lasse Brunnström (ed), op. cit. Also recorded in the writings of Mekanförbundet (The Mechanical Association).

MARIE-LOUISE BOWALLIUS

TRADITION AND INNOVATION IN SWEDISH GRAPHIC DESIGN 1910–1950

As commercial designers we do experience difficulties in exhibiting our products in pretentious environments like this exhibition. But even so it gives us a chance to play a part in educating Swedish taste[…]Being a designer or image-maker in advertising is on the whole a very stimulating and interesting job[…]The shaping of the various publicity media – advertisements, brochures, catalogues, packaging, billboards, posters, window-displays, exhibitions, etc – gives us wide scope for variety in our daily work. Sometimes new sales ideas must be visualized; sometimes old well-proven advertising formulae need to be clothed in some new, dramatic, form never seen before. The advertising artist must therefore keep up his morale so as to be able to prove both to those commissioning him and to himself, preferably every day, that he is still up to his job and will continue to be a force to be reckoned with for some time to come.

Stig-Åke Möller, 1949

181. Anders Beckman
Advertising poster for
Aerotransport, 1934
Moderna Museet [no 347]

This quotation comes from Stig-Åke Möller's introduction to the work of advertising designers in the catalogue of Svenska Slöjdföreningen the Swedish Design Society's 1949 exhibition at the Nationalmuseum.[1] Stig-Åke Möller described himself as an 'advertising artist'; at the time, among other things, he taught in the Department of Advertising and Book Craft at Konstfackskolan (the College of Arts, Crafts and Design).

It was not until the 1950s that the professional description 'graphic designer' made any appreciable breakthrough in the graphic industry – at the same time as the description 'art director' began to be used by advertising agencies and the work of industrial designers began to attract attention in Sweden. Thus it has often been assumed that the profession of graphic designer or art director did not exist until after the Second World War. This is true to some extent, since it was not until then that graphic design began to be regarded as a significant and specialized activity in most of the larger business enterprises, presses and publishing houses, and that an increasing number of designers began to be more adequately trained for their job. But the art

flyg
med
AEROTRANSPORT

beckman

director's work had in principle had an equivalent in Sweden in the professional practice of studio and advertising executives as early as the 1920s. If we dig deeper in the archives for information on this virtually unresearched area, we find evidence that many women and men were professionally engaged in various ways in the designing of Swedish printed matter and advertising in various media long before the appearance of the graphic designer. Among these were advertisement and fashion draftsmen and women, illustrators, book and poster artists, lettering artists, layout designers, decorators, advertisement typesetters, heads of printing firms, etc.

Many of these technically or artistically trained people united several of these roles in their professional work. This makes it difficult to determine exactly when the profession of graphic designer came into existence. But, in their work for a variety of clients, designers in the fields of advertising and graphic production developed in the interwar period an expertise which laid the foundations of modern graphic design, while at the same time setting their mark on the visual culture of their time. Inspired by continental traditions and aesthetic developments they gave the modern era, with all its intrinsic contradictions, a graphic face.

ART ENTERS THE GRAPHIC INDUSTRY

Art and advertising – these words should harmonize even more sweetly for the professional than for the man in the street. Many still ask what advertising has to do with art. Alas! If advertising is to achieve its aim, it must be an art, an art that touches us all[...]A pictorial advertisement, naturally of artistic quality, to the point and well-balanced, is capable of achieving the result desired[...]And to achieve this, businessmen, industrialists and artists must work together[...]Simplicity and relevance – those must be your passwords.[2]

It was in the decade between 1910 and 1920 that the aesthetics of advertising began to be seriously discussed in Sweden and the 'artistic' poster and advertisement began to make their definitive breakthrough.[3] The quotation above from 1914 comes from a contribution on 'the ever more topical question of the use of art in the service of commerce' by a young artist who had specialized in creating advertisements of artistic quality, and it is at this time that we find the first signs of advertising departments and agencies beginning to employ artistically trained individuals to take over responsibility for the design of advertisements and printed material. As a rule German originals were used as models, especially those found in the German journal *Das Plakat* (The Poster), which reproduced the work of German advertisement and poster illustrators. In Sweden at this time there were only a handful of poster artists, many of them also active in other fields. One of the best known of these was Wilhelm Kåge, later art director at Gustavsberg.[4]

The first known visual survey of Swedish advertising art was arranged by a small advertising agency called Halcks in Stockholm in 1918. The next year, on the initiative of the Gumaelius advertising agency, an exhibition was organized at the Academy of Art, also in Stockholm. Both the posters exhibited and the choice of venue bear witness to an early attempt by one of Sweden's oldest producers of advertisements to raise advertising to the dignity of art (Fig. 182).[5]

At this time it was still normal for advertisers to put together their advertisements themselves, while responsibility for the layout of printed material generally lay in the hands of the printer's employees. Foremen and printing directors discussed the planning of the job with the customer before passing it on to typographers and typesetters. Some of these by assiduous practice had acquired considerable skill at their job and many contributed to raising the standard of typographical and printing technique in Swedish graphic production.

By the beginning of the second decade of the twentieth century these efforts had created a typographical parallel to the turn-of-the-century national romantic style found in painting and to the rediscovery by architects of natural building materials. This style was characterized by simplicity and absence of ornament. Composition was well-

balanced and built on symmetry as a fundamental principle of form, while text was set in heavy, renaissance-inspired lettering, all of which, taken together, gave monumental dignity to the printed page.

The first book illustrator to be employed on a permanent basis in industry was Akke Kumlien, whose name continued to be synonymous with Swedish book art for several decades to come (Fig. 183). It was the mediation agency set up by the Svenska Slöjdföreningen, *Swedish Design Society*, that introduced him to the publishers Norstedts in 1916 as an 'artistic adviser'; this made him a member of the 'first generation of artists in industry.' Kumlien's book-jackets and titlepages were greatly refined during the 1920s to achieve a typographical parallel with Neoclassicism in Swedish architecture and industrial art. His importance for book-design in Sweden has been compared with that of Edward Hald and Simon Gate for Swedish glass and Wilhelm Kåge for ceramics.

EXPERIMENT AND RENEWAL IN THE TWENTIES

While neo-classical book-design was being developed in Sweden, busy experimentation in typography and photography was proceeding simultaneously in Europe. Towards the end of the 1920s this resulted in what came to be called 'new' or 'elementary' typography. An early Swedish example of the influence of a more experimental approach was the artist Georg Pauli's journal *flamman* (the flame), published from 1917 to 1921. With the exception of a couple of other journal projects which had their origins in the intellectual sphere of high culture,[6] it was in advertisements above all that the new typography was first used in Sweden.

During this decade the United States took the lead in the world of advertising. Slogans and catchwords were the thing and market research became popular. Up to this point advertising agencies had functioned mainly as links between newspapers and advertisers, but now they added more and more services to what they already had to offer, while at the same time an increasing number of firms set up special publicity

182. Exhibition poster for Swedish Advertising Week at the Royal Academy of Art, 1919, designed by Richard Bergman. The figure is Hermes, god of businessmen, inventor of language and writing and super-fast Olympic messenger on winged feet – a suitable protective patron for those who produce advertisements. [no 329]

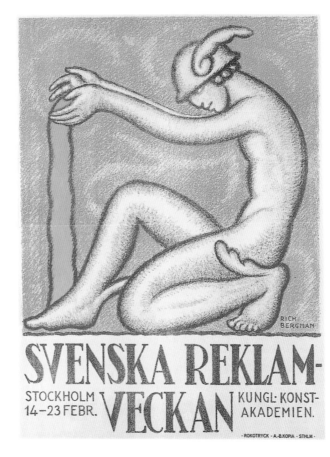

183. *Dikter av Vitalis* (Poems by Vitalis), book jacket design by Akke Kumlien, P. A. Norstedt & Sons Publishers, 1929. Kumlien's jackets were often based on simple, clean capitals and a light and elegant italic script. As decoration a second color could be added and sometimes a vignette or decorative line. [no 330]

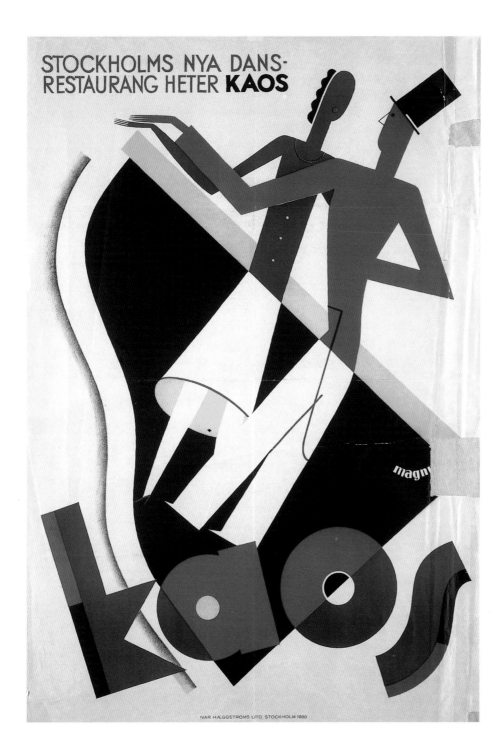

STOCKHOLMS NYA DANS-
RESTAURANG HETER **KAOS**

184. Advertisement poster for
the Kaos dance restaurant in
Stockholm, 1929
Design Georg Magnusson
Kungliga biblioteket
(Royal Library) [no 331]

departments. According to *Svensk Reklam* (the yearbook of the Swedish Advertising Federation) Asea was the first Swedish company to have a special department for publicity and the printing of catalogues, brochures, etc.[7] The Swedish Ballbearing Factory (SKF) and P. A. Norstedt & Sons were also quick to create special advertising departments and during the postwar boom this became an ever more common phenomenon. Even the Co-operative Union (KF) soon took an interest in the new opportunities offered by advertising and from the end of the 1920s worked closely with the Svea advertising agency on planning posters, advertisements, shop-material and window-displays. The 1920s also saw the establishment of a whole range of miscellaneous publicity-oriented organizations which worked to raise the creative level of Swedish advertising art. There was a marked increase in the demand for qualified advertising artists, who made sure that Modernist idiom with its characteristic use of

color and form was applied in an ever more sophisticated manner for the purposes of commerce and publicity (Fig. 184).

However most 1920s advertising artists and illustrators worked in a more naturalistic and sometimes American-influenced style, something they could study in American trade journals and the weekly press. Advertising personnel who had visited America were certainly often inspired by the new commercial aesthetic which had developed there, and kept a watchful eye on freelance advertisement illustrators and studio staff.[8]

From a technical point of view Swedish advertisement and poster art was still dominated by painted or drawn illustrations but towards the end of the 1920s photographs began to be used too. A glance at the advertisements in the 1929 edition of *Svensk Reklam* reveals that at that point Swedish advertising sometimes attempted to be 'Modernist' in its use of the new typographic style. The distinguishing features of this style were wide use of photography and photomontage, asymmetrical layout, and pictures breaking out of their frames, together with geometrical forms and bars which guided the eye across the surface. It was a dynamic and 'purpose-stamped' typography built on contrasts, which treated the unprinted white areas of the paper as an active part of the composition and characteristically preferred *sans-serif* lettering.[9]

The raison-d'être for this new typography – sometimes classified as 'Functionalism' – can be found partly in the ever-increasing pace of contemporary life, in which a miscellany of sales offers jostled for attention on trams and the façades of buildings, in shop windows and cinemas, in newspapers and in the ever-increasing flood of printed material of all kinds. In this environment traditional book-typography was unable to satisfy the needs of publicity; the problem needed new typographical and image-based solutions able to convey their message more quickly and effectively. It was recognized that the old methods could not respond adequately to all the demands of the new age which *Svensk Reklam*'s 1929 edition summed up as: 'to communicate to the recipient of the printed product the greatest possible content while making the least possible demands on his or her capacity for comprehension.'

Advertising was very soon perceived as a distinguishing characteristic of this new age and advertising executives came to see themselves – as did their American colleagues – as leading apostles of modernity. Full of their own importance, they prophesied that advertising typography was bound to become the most important typography of all. In 1932 the yearbook of the Swedish Advertising Union was so bold as to claim that 'the name of the creator of modern typography is Advertising' while maintaining that the 'advertising artist' was altogether freer and more up-to-date than the traditional book-artist. 'During the short time he has been active he has done more for development and creativity within the graphic professions than was previously achieved in more than 500 years of hard work.'[10] By this time 'Functionalist' typography had also made some inroads into Swedish book design via some book-artists and architects who had been strongly influenced by the new outlook on the continent. One of the most radical examples of this was *acceptera* (to accept), the Functionalist architects' manifesto, first published in 1931 (Fig. 185).

The new basic typography was partly a development of typographical and photographic experiments at the Bauhaus School in Germany, but also derived from Russian Constructivism and Modernist attempts at reform within scattered groups of German, Dutch and central European designers during the 1920s. It received its earliest formulation in Germany and reached Sweden through foreign trade journals and visits made by Swedish advertising executives and people active in the book industry to exhibitions on the continent. Hugo Lagerström – the leading representative of National Renaissance typography in Sweden – reported on the new manifestations in a succession of articles in *Nordisk Boktryckarekonst* (The Art of Nordic Book Printing) from 1927 onwards, never failing to point a warning finger at the new style's excesses and 'artificial' methods.[11] In the years that followed there was sometimes severe conflict

between the defenders of tradition and advocates of the new approach in Swedish book design.

THE 1930 STOCKHOLM EXHIBITION

The Stockholm Exhibition of 1930 was an important event for the graphic industry and for advertising art (Fig. 187). Advertising played a vital part in the marketing and arrangement of the exhibition and was planned in the Functionalist spirit. Shop windows and advertising displays took the place of old-fashioned ornament and formed an ensemble with the exhibition's Functionalist buildings. Architects involved themselves in the design and character of the displays. Even the exhibition's official posters were designed by an architect – Sigurd Lewerentz, who was also responsible for the illuminated sign-boards on the tall advertising mast at the exhibition site (Fig. 113).

According to the Advertising Union's 1930 yearbook the particular merit of the exhibition was that it consistently applied Functionalism to exhibition technique. Among those who assisted in this was the MEA department store's advertising executive Harald Rosenberg. The professionals engaged in lively discussions of advertising and its various media, often finding themselves right in the midst of what was happening during the planning and construction of the exhibition. Subsequently Rosenberg applied the experience he gained from working at the Stockholm Exhibition to many window-displays during the early 1930s (Fig. 188).

The exhibition's graphic section revealed a blend of Functionalism with both German and American advertising style, but in the opinion of many judges the new influences had not been fully assimilated. They wrote about dilettantism and fashionable excesses and of an 'attempted Swedish version' of the newly imported basic typography. One authority on Swedish book design maintained that it was not by its *example* that the Stockholm Exhibition enriched the field of graphics, but that it initiated a period when the book was once more seen not as an art or craft product but as a 'reading device', 'which should sometimes be beautiful, could sometimes be ugly, sometimes large, often little,[...]but always *easy to read*.'[12] A combination of readability and sober neoclassical typography became the basic criterion for functional and aesthetically pleasing books in Sweden for a long time to come.[13]

However there was one Swedish book-designer who was strongly influenced by the exhibition. His name was Anders Billow, and he devoted himself throughout the summer of 1930 to the displays in the book-hall as a guide. As he put it, he was trying to interest the public in 'book culture' in the most general sense while giving full recognition to the many 'sterling' items on show. He dismissed the fashionable photomontages as ephemeral eccentricities and warned the professionals against this kind of playing around with cut-up photographs. But by the end of the summer he was convinced that Functionalism in the true meaning of the term should not be restricted to the architecture. In 1940 he summarized the reason for this himself in the following words:

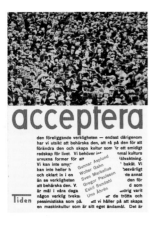

185. Cover for *acceptera*, a major manifesto for modern architecture, 1931. The design includes typical stylistic features of the new typography: a bleeding photograph, asymmetrical placing of the text and the use of *sans-serif* lettering. In this radical example of Swedish book design capital letters have been abolished, in line with the Bauhaus school's reductionistic approach to typography. [no 455]

186. Cover for *Årets bilder* (The Year in Pictures) Swedish Tourist Board, 1933, designed by Anders Billow [no 334]

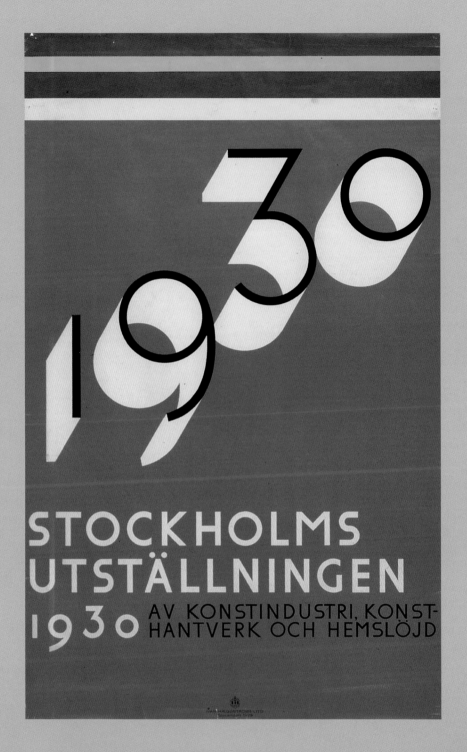

STOCKHOLMS
UTSTÄLLNINGEN
1930 AV KONSTINDUSTRI, KONST-
HANTVERK OCH HEMSLÖJD

187. Left: An official poster for the Stockholm Exhibition, 1930. Designed by the architect Sigurd Lewerentz using lettering specially created by himself. [no 332]

188. Below: Window display featuring shirts that claimed to be 'Swedish from start to finish.' MEA department store in Norrmalmstorg, Stockholm, early 1930s

LÖRDAG
14
September

till

SÖNDAG
29
September

UTSTÄLLNING

NATIONALMUSEUM

**svensk
reklam
i svenskt
tryck**

beckman

ESSELTE AKTIEBOLAG
STOCKHOLM 1935

Now that books were being built up with pictures and methods of reproduction not yet invented in Gutenberg's day, and with technical aids which he never even dreamed of, there was every reason to add this program to the housing department's list, something only [Gregor] Paulsson grasped: new forms needed to be created.[14]

In his work at Nordisk Rotogravyr (Nordic Rotogravure) during the 1930s, Billow came to develop some of the foremost expressions of the Functionalist approach to Swedish book design (Fig. 186). He was no slave to orthodoxy, however, but developed a pragmatic approach involving among other things asymmetrically placed headings, narrow margins and bleeding photographs. But this was enough to challenge received opinion among professionals as forcefully as the Functionalists were challenging architects with their flat roofs and large windows.

At the beginning of the 1930s Traditionalism broke with Functionalism as decisively in Swedish book design as in other fields of industrial art. The Traditionalists borrowed features from as far back as William Morris and Art nouveau and reflected the Neoclassicism which had dominated Swedish industrial art during the 1920s. In book-designing circles the battle between Traditionalists and Functionalists culminated in 1932 around *Svenska Turistföreningens Årsskrift* (The Swedish Tourist Board Yearbook). The 1933 edition of this publication, designed by Anders Billow, was chosen as a Swedish Book Art special selection in 1937, which represented a decisive victory for the Functionalist camp in Swedish book design though a more traditional look continued to predominate.[15]

ADVERTISING – SWEDEN'S GREATEST FORM OF INDUSTRIAL ART

In the field of printed advertisements many trained artists were now involved, which increased the pressure for renewal. In 1932 Oskar Dahlström wrote in *Svensk Reklam*: 'At the very moment the concept of advertising came into existence it became impossible to stand still and unthinkable to go backwards. There was only one thing to do: go forwards.'[16] Dahlström also noted how closely this drew the advertising artist and the printer together, which not only assisted technical development but the 'planned design of printed matter.' The designer was described as an 'artist' but in practice did the same work as modern graphic designers in the postwar period. Normally trained as an artist, he tested the boundaries of what was technically possible in co-operation with the typesetter and other printing-house personnel. According to Dahlström virtually all the larger printers of the time employed full-time or consultant 'artists.' But for the time being the great majority of these worked anonymously without status or financial advantage or any opportunity to influence project planning. The studio staff of advertising agencies and publicity departments found themselves in the same position. The situation has been described by Erik Heffer, who joined the printhouse Esselte's publicity department in 1931 and worked at the Swedish Telegram Bureau from 1935 to 1974:

> We who did the actual work were slaves. The directors who sold our ideas were kings and brought home fat commissions. Deals were usually struck in bars without us having any chance to influence the proceedings.[17]

One advertisement artist who nonetheless managed to create a significant reputation for himself in the 1930s was Anders Beckman. Trained at the School of Technology, he began his career in the year of the Stockholm Exhibition, 1930, and from the start enjoyed a close relationship with the Svenska Slöjdföreningen, *Swedish Design Society*. Beckman's first employer was the Swedish airline company AB Aerotransport (ABA; Fig. 181), for which he created a number of posters in a modern simplified style in the early 1930s. Characteristic of his early work was a naturalistic portrayal of objects and milieus using modern poster technique. Airbrush and photography were often combined with hand-painted images to compose an effective message in which the text was integrated with the image in an artistic manner (Fig.

189). During the later 1930s the symbolic and idea based character of his work became increasingly marked.

Anders Beckman ran his own advertising studio in central Stockholm and was one of those who began to work consciously in the mid-1930s towards raising the status of the advertisement artist. 1935 found him working on the first exhibition of Swedish advertisement art at the Nationalmuseum, Stockholm. This exhibition was arranged by the Advertising Federation and Swedish Printed Book Association, and parts of it came in for severe criticism. The most highly praised item was Beckman's poster to advertise the exhibition, which was considered to exemplify the best in the Swedish advertising art of the day (Fig. 189).

In 1936 Anders Beckman and some ten other designers working in advertising founded SAFFT – The Swedish Poster Artists' Association. SAFFT was the first association of this kind and in 1937 its members presented their work in an exhibition at the Galerie Moderne in Stockholm (Fig. 190). The aim was to demonstrate what the advertising artist did and give a concentrated picture of contemporary Swedish advertising art. It was the first time the initiative for such an event had come from the practitioners themselves and it aroused great interest among critics and writers on design, who now began to be aware that a new profession had developed as a result of the rapid advance made by advertising. That on top of this it was happening within something the catalogue described as 'our greatest field of industrial art' astonished the world of Swedish design which had mainly concerned itself hitherto with furniture, textiles, glass and ceramics.

The members of SAFFT tended to look to contemporary English and French advertising art for their models. The French poster and advertisement artist A. M. Cassandre was an acknowledged source of inspiration as was Surrealism, whose symbolic idiom was considered specially well suited to advertising. English advertising art was valued more for its humor.

Further types of expression were developed in Swedish poster art during the 1930s in the advertisements of the Co-operative Union through the work of the Svea advertising agency, which sometimes built on the influences mentioned above, but also gave the very earliest graphic expression to the idea of a Swedish 'folkhem' (welfare state) and social structure which came to the fore during the Social Democrats' first years in power.[18] In poster art as in other areas, Functionalist simplified form and new industrial techniques seem to have suited Social Democratic aspirations as well as co-operative ideals did (Figs. 191, 192).

There were great variations in idiom, but there were corresponding variations in clients' interests and in intended target groups. With their exhibition at the Galerie Moderne, the members of SAFFT wanted to display the best in the field and create greater understanding of what the profession of advertising art could offer. The exhibitors formed a small elite within Swedish advertising art – eighteen men and four women – of whom many were also involved in the activities of the Swedish Society of

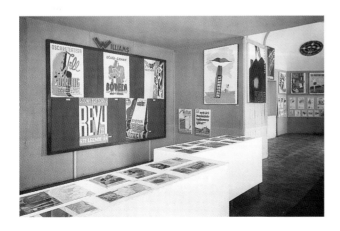

190. Interior view of the SAFFT exhibition at the Galerie Moderne in Stockholm September 1937

191. 'THE EFFECTS OF 10 YEARS OF WORKERS' RULE,' election poster for the Social Democratic Workers' Party in Stockholm, used before local elections in 1931. Design anonymous. Photomontage represented a new technique of graphic composition in the spirit of the new typography and was used in this case to bring together a raft of social reforms in the building of homes, transport, health care and education. Archive of the Workers' Movement. [no 343]

192. 'make the most of your money – buy at the co-op,' advertising poster from 1931. Designed by Harry Bernmark and Knut Krantz at Svea advertising agency. Krantz was the Co-operative Union's (KF) advertising boss from the end of the 1920s and worked mainly as an 'ideas man' while Bernmark, influenced by Functionalism, simplified the idiom of the Co-op's advertisements during the 1930s. This poster was nominated the best for the second quarter of 1931 by the newspaper *Affärsekonomi* (Business Economics) and reappeared in a new version in 1954. KF archive

Craft and Industrial Design. The women included Karin Ageman, who was commissioned in 1939 to design the catalogue for the Swedish section at the New York World's Fair.[19]

SAFFT's own publication for the World's Fair was an unassuming little booklet in a lemon-yellow cover which among other things contained the articles 'Our Greatest Art Industry' by the cultural critic Gotthard Johansson and 'Is it Beautiful or Is it Going to Sell?' by Stig Arbman, head of Esselte's advertising department at the time. Gotthard Johansson had this to say about the advertising artist's professional role:

> The advertising artist is still a new type in society, a little mistrusted both by 'real' artists and by hands-on advertising executives. His profession is not glorified by the halo of tradition which shines round the ancient crafts. But if he is truly talented and has the right conception of his task he is one of the foremost creators of form in our time, one of those with the capacity to open our eyes to the fact that when it comes to beauty even our modern environment has its values.[20]

Things had come a long way from the time when advertisements and posters were regarded as nothing more than commercial messages in which artists sometimes made guest appearances for decorative reasons. Now they could be better described as posing technical, psychological and communicative problems of form, in which choice of lettering, image and composition often required careful professional attention.

THE EXPANSION OF TRAINING

The ever more complex work expected of the graphic designer highlighted the need for better training than that available in the 1930s. The decade ended with the founding of two new vocational schools in Stockholm. In 1939 the School for Book and Advertising Art[21] was founded on the initiative of the Swedish Design Society and the Swedish Book-Printers' Association, and at the same time Anders Beckman and the fashion illustrator Göta Trägårdh started Beckman's school of Advertising, Illustration and Fashion.[22]

193. *The First Swedish Style Foundry* by Nils G. Wollin. Book jacket drawn by Karl-Erik Forsberg, 1943. Forsberg succeeded Akke Kumlien in 1949 at Norstedts Publishers and became the foremost exponent of the classical heritage in Swedish book design in the postwar period. The cover is an early example of the refined lettering developed by Forsberg and other Swedish book artists during the 1940s. [no 335]

The war years saw further training opportunities with the opening of the School of Advertising Technique (now RMI Berghs) in 1941 and the Graphic Institute in 1944. When the School of Technology was reorganized as the College of Arts, Crafts and Design in 1945 a special department of Advertising and Book-Craft was established with the stated aim of creating a more clearly defined professional direction for these areas of Swedish industrial art. This improved training situation went a long way towards meeting the increasing demand within trade and industry in the postwar period for professional graphic designers (Figs 194–6). The groundwork had been laid for the continued development of the profession.

THE POSTWAR FORWARD MARCH OF MODERN GRAPHIC DESIGN

During the first postwar years graphic means of expression, rhetoric and professional design practice, were still very different in the field of book production on the one hand and advertising on the other. It would be another ten years or more before they began to come closer together in any real sense. A revolutionary decade that would see an explosion in consumption, the production of printed matter, and advertising.

When the first self-service shops appeared in the late 1940s graphic design began to take over the role of sales personnel to an ever greater extent. In bookshops books had to convey their content and sell themselves by means of seductive jackets, which increasingly borrowed their design from the traditions of advertising typography, a typography which needed not only to be readable but to accord with the book's contents. The same was true of periodicals. Articles in the 1959 Catalogue of Swedish Book Art expressed the opinion that 'Functionalism' in the correct meaning of the word had finally been achieved. Interest in shaping the book as object had gradually shifted from conventional means of expression to how to create a form of expression adequate to the particular book's nature and content.[23] The book industry was now attaching more importance to creative versatility and the ability to put across a message by visual means.

The advertiser now expanded his focus from straightforward advertising matters to comprise the whole distribution chain and widely conceived campaigns that laid ever more complex tasks on the designer who was working at the frontiers of advertising. Self-service shops, frozen food and new eating habits increasingly demanded packaging able to give information and sell. At the same time the 'design program' became an ever more common concept, changing the graphic designer's field of activity. By the end of the 1950s the expression 'graphic design' was being used ever more frequently to describe the work of those who designed books and advertisements.

IS ADVERTISING GOOD OR BAD?

In the 1950s Anders Beckman still attached great importance to the significance and value of advertising in society. To him advertising was an indispensable link in selling, maintaining good-will and promoting ideas, and there were no definite boundaries to

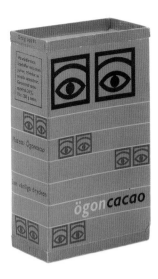

194–6. Packaging with Olle Eksell's new logotype for Mazetti, 1956. Olle Eksell's far-reaching work for Mazetti is usually regarded as the first modern design program for a Swedish firm. It included everything from creating a logo and applying it to the firm's vehicles, packaging and stationary to designing advertisements, shop material and in some cases the shape of the firm's products

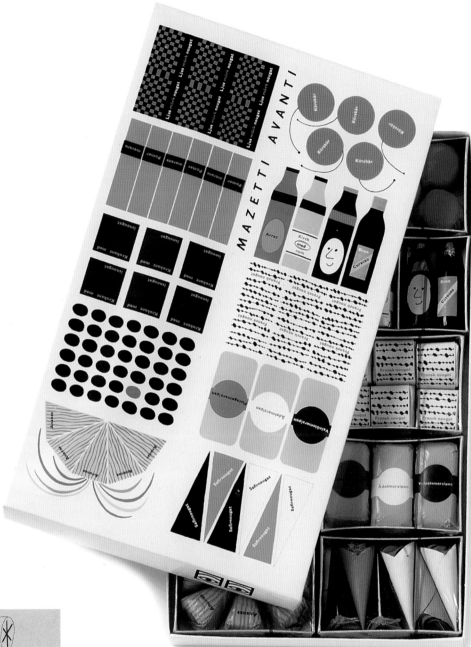

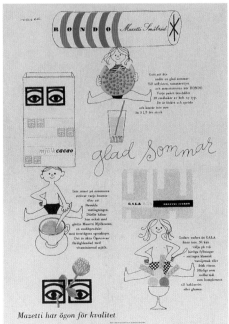

197. *Advertising is Life-Threatening – a Polemic* by Sven Lindqvist, 1957 – one of the first books to join in the debate on the harmful effects of advertising. The cover design by Vidar Forsberg shows characteristics of international advertising typography rather than restricting itself to traditional jacket typography. [no 345]

its scope. 'Advertising' was often understood to include non-commercial propaganda on behalf of non-profit-making organizations and institutions within cultural and social life. As Gotthard Johansson put it, modern society had 'a use for the true advertising artist's expert knowledge, even outside commercial advertising.'

Owing to the steadily increasing scope of commercial publicity, the term 'advertising' came in the postwar period to be more and more exclusively associated with commercial interests. The development of the modern welfare state and its affluence brought with it among many other things a sharp questioning of the methods and effects of advertising which influenced attitudes to the work of the graphic designer.

In the 'modern life' Gotthard Johansson was talking about in 1937, the design work that advertising had set in action was a distinctive feature bound up to a high degree with the whole modern project. Criticism of the effects of advertising had not yet begun, even if a certain weariness could be discerned in some commentaries:

> We live, they tell us, in a new age. And one of the new things in this age is advertising – the whip that cracks and the smile that seduces once we have collected our weekly pay packet or drawn our monthly salary and are looking around us for what we need and want. We cannot move freely like those who lived in earlier times. If we open a newspaper, magazine or book, step out into the street or sit down in a theatre, tram or bus; in fact, wherever we go a poster or an advertisement rises up in front of us promising at the very least value for our money, and sometimes gold and green forests as well.[24]

Criticism hardened during the 1950s (Fig. 197)and in the middle of the decade silence once more enveloped the work of the advertising artist and designer. The Nationalmuseum had been presenting exhibitions of Swedish and international book and advertising art since the middle of the 1930s but did so no more after 1955. Book design found a new home at Kungliga biblioteket (The Royal Library) in Stockholm, while design dedicated to the service of publicity remained in limbo and was obliged to resort to commercial and industrial institutions. Always visible, of course, but never critically assessed or discussed outside professional circles.

Today the time seems ripe to place this forgotten category of Swedish design alongside art, photography, architecture, arts and crafts, industrial art and industrial design and have a new look at it. It is to be hoped that this will not only create a new interest in the branch of Swedish design which perhaps more clearly than any other reflected the economic, social and cultural transformation of Swedish society during the twentieth century, but that it may also contribute to a new perspective on other categories of creative image and form in Sweden. By doing this we would complete our picture of utopia and reality in the last century.

NOTES

1. Stig-Åke Möller, 'Att utforma reklam' (Shaping Advertisements) in *Nyttokonstärerna* (Useful Artists) 1949, catalogue to the professional section of the Swedish Design Society's exhibition, Nationalmuseum 1949.

2. 'Konsten i reklamen, Konstnärlig utöfning' (Art in Advertising, Artistic Practice), (signed 'Nireber'), in *Stockholms Dagblad* May 6, 1914.

3. An attempt to launch 'artistic' advertising posters on the French model had already been made in 1895 but was not successful. On the other hand 1913, when *Svenska Dagbladet* arranged a poster competition which attracted a lot of attention, is usually seen as a breakthrough year. See for example Lisbet Svengren (ed), *Svenska Reklamaffischer, en bilderbok om den svenska reklamaffischens historia* (Swedish Advertising Posters, an Illustrated History of the Advertising Poster in Sweden), 1986.

4. Others were Eigil Schwab, trained at the School of Technology and the Academy of Art 1901–10, best known as a draftsman and illustrator, and Einar Nerman, theatre designer and draftsman specializing in caricature, who studied at the School of the Society of Artists and with Matisse.

5. For a more detailed description of this exhibition, parts of which came in for severe criticism, see Yngve Hedvall in *Svensk Reklam*, 1944.

6. See the radical journal *Fönstret* (The Window) 1928 and *Spektrum*, started in 1926 by the Riwkin brothers, Russian émigrés living in Sweden.

7. Initially the department was known as the Literary Department, but changed its name to the Advertising Agency in 1912.

8. On the transformation of American culture and related advertising aesthetic from the late nineteenth century onwards see William Leach, *Land of Desire: Merchants, Power, and the Rise of a New American Culture* 1993 and Roland Marchand, *Advertising the American Dream: Making Way for Modernity 1920–1940* 1986.

9. Futura, the typeface which so strongly influenced the 'new typography,' did not appear in the yearbook of the Swedish Advertising Federation until 1931. The first advertisement set in this typeface was carried in *Dagens Nyheter* (another daily paper) in 1929. The client was Twilfit and the designer Valter Falk.

10. Oskar Dahlström, 'Den nya typografiens skapare' (The Creator of the New Typography), in *Svensk Reklam 1932*.

11. The articles were printed in 1933 in Hugo Lagerström's publication *Den nya stilens genombrott* (The Breakthrough of the New Style).

12. Bror Zachrisson in 'Tio år efteråt' (Ten Years Afterwards) in *Form* no 5, 1940.

13. See for example the exhibition catalogues of Svensk Bokkonst (Swedish Book Art) from 1933 onwards. The force behind this institution, which every year arranged a selective and prestigious display at the Nationalmuseum was Bror Zachrisson, who in 1940 wrote the commentary on the 1930 Stockholm Exhibition mentioned in note 12 above. He was himself a book designer, son of the book-printer W. Zachrisson and later Principal of the Graphic Institute, and a trend-setting figure in debates on Swedish book design from the 1930s to the 1950s.

14. Anders Billow, in 'Tio år efteråt' (Ten Years Afterwards) in *Form* no 5, 1940.

15. Explanations for this can be sought on many levels, but one very important factor was the technique of printing. With the intaglio technique used at Nordisk Rotogravyr it was easy to place pictures and text in the margin. In traditional book-printing the same thing required a great deal of complicated additional work. Thus, in book-printing, typography that presented margin-breaking images appeared conspicuously unnatural, unfunctional and uneconomic to practical and economy-conscious typographers and printing-house directors. Besides, book-printers did not have the same positive attitude towards modernity and innovation as the makers of advertisements.

16. Oskar Dahlström, 'Den nya typografiens ansikte' (The Face of the New Typography) in *Svensk Reklam* 1932, pp. 77ff.

17. Lisbeth Svengren (ed), *op. cit.*, p. 19.

18. On Co-operative advertising see *Co-op reklam – Reklam i Sverige under ett kvarts sekel* (Co-op Advertising – Advertising in Sweden during a Quarter Century), Svea Advertising Agency, 1955.

19. *Swedish Modern: A Movement Towards Sanity in Design*, The Royal Swedish Commission, New York World's Fair, Uppsala 1939. Those responsible for the theory and practice of the layout in the Swedish pavilion were Anders Beckman and the artist Bibi Lindström.

20. Gotthard Johansson, 'Vår största konstindustri' (Our Greatest Form of Industrial Art) in *Safft – Svenska affischtecknare* (Safft – Swedish Poster Artists), exhibition catalogue, Galerie Moderne, Stockholm 1937.

21. One who worked here during its first two years was Professor Hugo Steiner from Prague, a Czech in exile who had been a member of the exhibition committee at the Leipzig Book Fair of 1927. Then Akke Kumlien took over the teaching till 1946, when the school was closed. Despite its short existence, the school is considered to have played an important part in the raising the quality of Swedish book and advertising art and it counts many of the postwar period's leading designers among its pupils, including Olle Eksell and Hubert Johansson.

22. Among other things, Göta Trägårdh made drawings for advertisements for Sidenhuset (The Silk House) from the late 1920s onwards and exhibited at the Galerie Moderne in 1937.

23. Karl-Erik Forsberg, Georg Svensson and Bror Zachrisson, *Svensk Bokkonst under 25 år* (25 Years of Swedish Book Art), Royal Library, Stockholm, 1959.

24. Nils Palmgren, 'Reklam för reklamens män – Glad Safft-färg på Galerie Moderne' (Advertising for Advertising Men – Cheerful Safft-Colours at the Galerie Moderne)' in *Aftonbladet*, September 18, 1937.

LEIF WIGH

'YOU'VE GOT TO BE MODERNISTIC'[1]

Photographers' Way to a Modernist Attitude

PHOTOGRAPHY – A MODERN PHENOMENON

It was in the 1890s that modern photography really caught on in Sweden, one important cause being increased industrial production of photographic material both at home and abroad. The invention of negative roll film[2] was even more important. This innovation led to a growth in amateur photography, at least among the higher social classes. People could now buy a camera loaded with enough film for a hundred separate exposures. After use the whole camera would be sent to the Kodak factory for the developing and printing of positive pictures. The new negative material did not require immediate exposure and developing unlike earlier material but could be kept for a time before use. The new technology made taking photographs easier since the new smaller mass-produced cameras were intended to be hand-held and without tripods it was easier both to transport them and to use them. So the snapshot was born, bringing with it a significantly lower quality of picture. Professional photographers in Sweden were interested in these innovations but some missed the older technique with its wet collodion negatives and albumen silver paper.[3]

Unlike other artistic groups at the time, photographers at first saw themselves less as artists than as practitioners of a modern profession, this attitude was reinforced by artistic distaste for the camera: art was thought of as something that should be produced manually, not with mechanical apparatus. Despite their occupation being so up-to-date, professional photographers in many respects still clung to an old fashioned guild-mentality. In Sweden they lived in a very closed world and their work consisted almost exclusively of portrait photography. The amateur Fotografiska Föreningen (Photographic Society) was founded in 1888, followed in 1895 by the professional Svenska Fotografernas Förbund (Swedish Photographers' Association). Technical advances were made public at several industrial exhibitions and discussed in the periodicals *Fotografisk Tidskrift*, *Svenska Fotografen* and *Nordisk Tidskrift för Fotografi* which appeared successively over the next few decades. The photographers were anxious to protect their separateness

198. Harry Jonasson *From south Kungstornet Tower, c.* 1938 Moderna Museet [no 581]

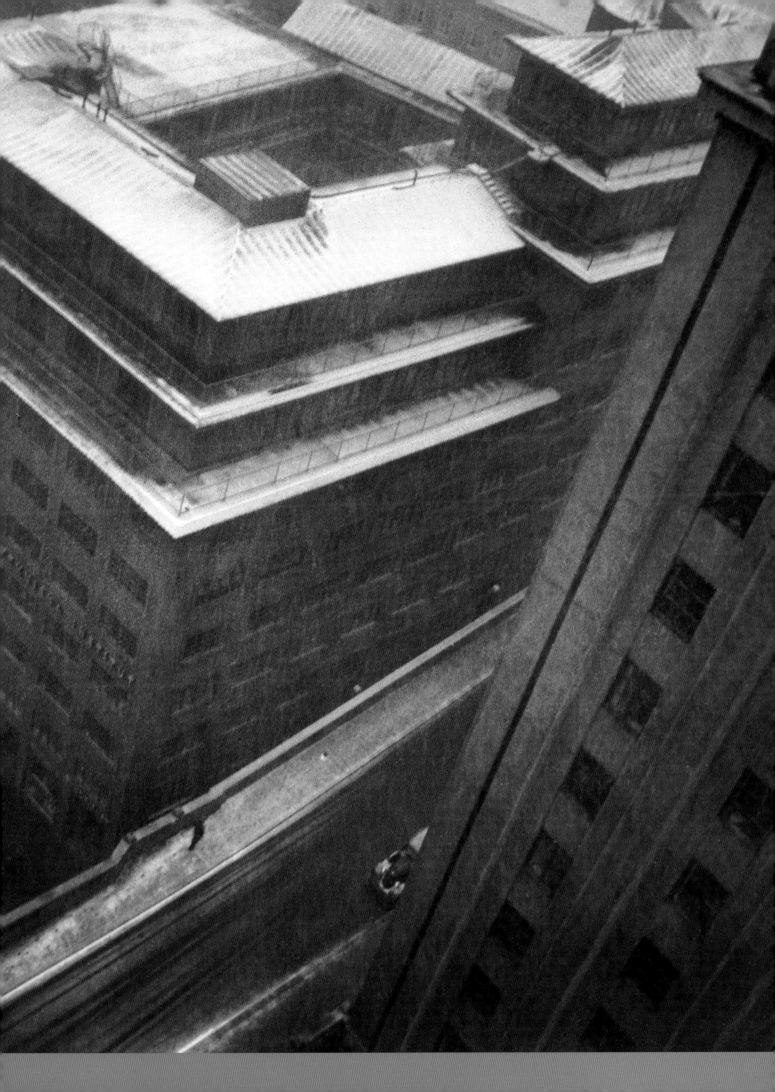

Mitt första försök i
Gummitryck
26 febr. 99.
Gunnar Malmberg

as a profession and were often suspicious of foreign establishments and newfangled ideas. As far as training was concerned, there were no schools of photography at all; it was different in other countries, but in Sweden you had to become a paying apprentice with an established photographer if you wanted to acquire the necessary practical knowledge. After a certain number of years an enterprising apprentice could set himself up by taking over an established business or by opening a new portrait photography studio. The subjects most discussed in professional circles were technique, competition and prices; less often photography as a means of expression or form of visual art.

'EVERYWHERE FREE!' THE COMING OF MODERN TIMES

During the 1890s a number of able photographers searching for a modern visual idiom appeared on the photographic scene in Sweden, forerunners of a new attitude which would later become generally noticeable. Several made study trips abroad. John Hertzberg studied in Vienna, Leipzig and Dresden and, for a time, with the most famous photographer in Paris, the Swedish-born portraitist Otto Wegener.[4] The amateur photographer Gunnar Malmberg introduced new Continental trends in the articles he wrote for *Fotografisk Tidskrift* at the turn of the century. Another of the new school was Oscar Halldin, who took off in a balloon (for the second time) in 1898 with the aeronaut Captain Cetti (Fig. 199). Not long afterwards he wrote an account of the flight: 'In the morning it was blowing very hard – so hard that I was afraid the trip would be cancelled[...]Naturally I wasn't able to take up a tripod for my 24 x 30 (cm!) camera. I readjusted the camera for every third plate (glass negative) while Captain Cetti calculated our height. The procedure for these readjustments was extremely laborious. Captain Cetti would move to the side opposite to me. He had to lean out as far as possible over the opposite side of the basket to prevent the whole thing capsizing altogether while at the same time holding on to my legs to prevent my too rapid return to planet Earth.' What Halldin was describing so dramatically was really the launch of a new modern age, a leap into the air and straight out over the agrarian world of the Swedish countryside. 'Everywhere free', wrote Halldin optimistically and went on: 'The third plate was taken at 800 metres right over Vasastaden, where Odengatan cuts across Norrtullsgatan (today Odenplan in Stockholm)[...]At 800 to 1000 metres we sat with one leg out of the gondola; when after a while we began to descend we were greeted by incessant waving from the country people, who rushed out of their cottages, their attention attracted by blasts from our horn[...]At Gnesta the people received us with wonder and curiosity as though we belonged to a diplomatic mission from some great power.'[5] It was not a great foreign power arriving but modern man with balloon and camera bringing a new age and making a symbolic landing in the consciousness of the people.

While Oscar Halldin inspected Sweden from the air Gunnar Malmberg was looking for ways to use photography to make creative and expressive pictures (Fig. 200). If Halldin personified the professional role that would be known twenty years later as that of the photo-journalist, Malmberg personified the conscious artist as photographer, working within the movement that later became known as Pictorialism and would dominate Swedish photography until the end of the 1920s.

Pictorialism was an international movement that came into being during the 1910s and whose ideals were reflected in the annual British publication *Photograms of the Year* and the annual exhibition of the London Salon of Photography. In Sweden the pioneers of Pictorialism included Herman Hamnqvist, Ferdinand Flodin, Uno Falkengren, John Hertzberg and Henry B. Goodwin (Figs. 201, 202). The photographs they exhibited were of uncommonly fine quality but looked more like paintings, etchings, and graphic prints, rejecting the sharp definition made possible by the latest technology in favor of effects that suggested manual art. Tonal range was restricted, a limitation reinforced by a preference for closed surfaces in black and chiaroscuro. Most Pictorialists were amateurs, but professional photographers too were known to wrap artistic scarves round their necks and abandoned down-to-earth representation. Malmberg discussed the subject in an article entitled 'Photography – an Art?'[6] and in 1897 wrote about gum

201. Henry B. Goodwin
Jenny Hasselquist, c. 1917
Moderna Museet [no 504]

202. Henry B. Goodwin
Cushion of Saxifrage in Bloom
1930
Moderna Museet

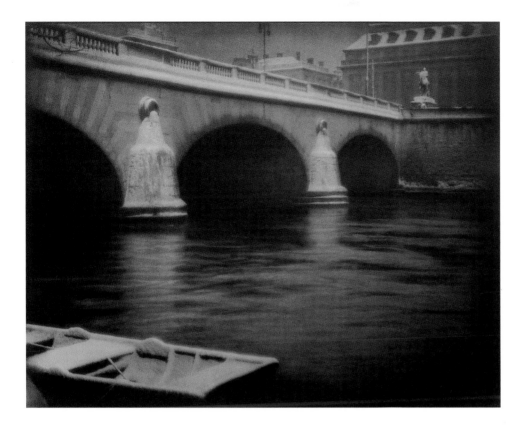

203. Ture Sellman
Norrbro Bridge, Stockholm
c. 1920
Moderna Museet

printing, a process in which developing on pigmented drawing-paper gave the photograph a more painterly appearance.[7] A year earlier, in 1896, he had discussed a really old-fashioned method, photography with a pinhole camera, and had given his opinion that 'there is resistance [among artistically inclined photographers] to the new industrially-developed technique of the camera-objective and the camera's newly refined mechanism. [...] now that the objective lens has reached such a high degree of perfection, we see people today clinging more and more to the simplest methods: monocle and pinhole camera.' Malmberg himself gives the reason for this new attitude: 'We must look for the explanation in the fact that since the desire for the sharpest possible pictures has now been satisfied this has lost its charm and must give way to the attempt to provide the photographic image with the most artistic appearance possible. This new movement [Pictorialism], which rejects sharp definition, or rather would restrict it to purely scientific purposes, and which much prefers soft-focus images for their painterly effect, has won a large number of followers in virtually every country.'[8]

PHOTOGRAPHERS ON THEIR OWN TERRITORY

The relationship of those modern phenomena, photography and the camera, to contemporary society were described by Albin Roosval, editor of *Fotografisk Tidskrift*, in a report on a meeting on April 25, 1896 of the education and hygiene committee of the General Exhibition of Art and Industry: 'In our day photography has come to be so important and widely used in so many fields that it has earned the right to demand not to be thrust aside in major exhibitions as if it were a relatively unimportant branch of industry.' The reason for this comment was that photography had laid claim to a place in a major exhibition in Stockholm the same year but, as Roosval pointed out unhappily, had been placed in a group under the general title 'aids to science.' 'But photography does not merely have value as an aid to science,' he went on, 'it is also a branch of industry of not insignificant scope, seeing that portrait photographs have become a

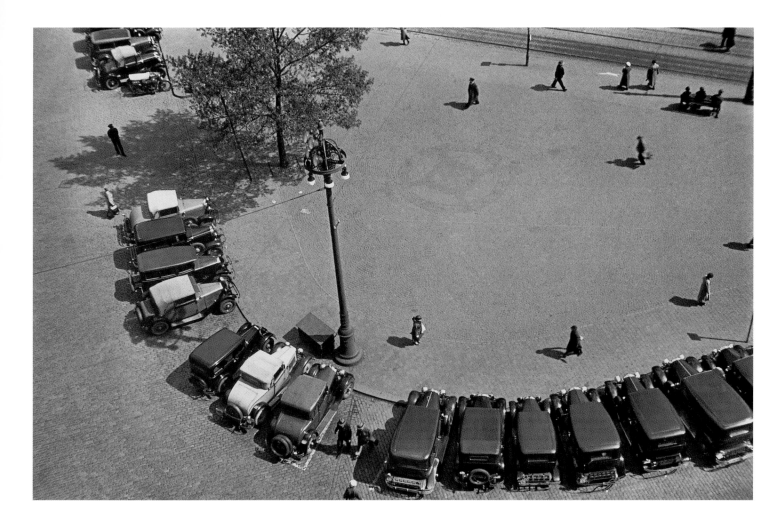

consumer product of use to virtually all members of civilized society from the highest to the lowest. Photography has now become a major hobby, a branch of art in fact, which has been enthusiastically welcomed in all civilized countries.'[9]

It is perhaps debatable whether art and hobbies should be lumped together, but much more significant is the fact that Roosval's pleading for photography to be considered a branch of art attracted attention. Halldin's and Malmberg's pictures and Roosval's commitment reinforced those trends in Swedish photographic art which, along with traditional professional photography, were to dominate the field until the end of the 1920s, but also gave rise to a new awareness of the medium's distinctive qualities. Malmberg's aim was a more pictorial quality, while the documentary nature of Halldin's work emphasized the pure untreated image – a foretaste of modern photography.

PROS AND AMATEURS

Many photographers followed Halldin's example, but it was Malmberg's artistic ideal that dominated debates and exhibitions during the first two decades of the twentieth century. An important event in the history of photography in Sweden occurred in October 1913 when the German portrait-photographer Nicola Perscheid visited Stockholm.[10] He had been invited by the professional Swedish Photographers' Association on the initiative of Henry B. Goodwin, and he proved an inspiration to Swedish, Danish and Norwegian photographers alike. Perscheid was far from being an isolated Pictorialist; he belonged rather to the late Jugendstil period though his heavy, muffled style of portraiture fitted the contemporary pictorial ideal equally well. In his lectures Perscheid dealt among other things with such questions as how models should

pose and how they should place their hands. The men in his portraits are heavy, stern and responsible in the manner of Bismarck and the Kaiser while the women, in contrast, are presented as cool, chaste, bourgeois and domestically self-important, with a very occasional hint of sensuality. Perscheid's dominating position in Sweden was further strengthened in 1914 by his pupil Goodwin who at a photographic meeting at the Baltic Exhibition in Malmö made a speech on Pictorialism, a word he rendered as 'pictorial quality:'[11] 'Laymen may of course amuse themselves by taking photographs by the hundred and showing them at club meetings – all equally fine but at the same time equally impossible as pictures. But we must be sufficiently ambitious to recognize that playing games and hunting with a camera are utterly unworthy of a professional. When it comes down to it, it is picture quality and how fully fledged Pictorialists can achieve it that must be the absolute ideal of our journal.' Goodwin's denigration of amateur holiday photographers attracted the attention of other professionals who regarded him as in some sense their spokesman. He also maintained contact with Perscheid's portrait studio and was thus able to help many young Swedish photographers to go there to gain practical experience, among them Uno Falkengren, Curt Götlin and the sisters Ebba-Lisa and Ulla Roberg. A year later, on Goodwin's initiative, *Photograms of the Year* published a number of photographs from Sweden and other Nordic countries, and an exhibition including Swedish Pictorialists was mounted in London in 1915.[12]

THE BATTLE FOR A PURE OBJECTIVE IMAGE

During the 1920s the younger generation began in earnest to turn away from the ideals of their elders and instead plan their pictures in full awareness of the medium's distinctive qualities. But many photographers were still using a soft-focus objective to create soft, diffuse pictures while the youngest generation increasingly favored sharp, well-defined pictures with a rich tonal range. One standard-bearer for this 'pure photography' was the photographer, writer and architect Ture Sellman (Fig. 203). Sellman had given up his earlier Pictorialist credo. Reviewing the First International Salon in Stockholm in 1926 he stated that 'manual methods, with the work of the hand very much to the fore, are rapidly disappearing in favor of purely photographic work in which camera and intellect can work together.'[13] As a theorist Sellman maintained that photographs were made not by manual editing but inside the camera, and that the dark room should be restricted to developing negatives and transferring pictures from negative to paper without Pictorialist interference.

In Germany such photographers as Werner Mantz, Otto Umbehr (Umbo) and not least Albert Renger-Patzsch presented this new attitude in pure unedited photographs. The new style was clearly announced in Stuttgart in 1929 at the *Film und Foto* exhibition[14] which featured German and American photographers. Professional photographers still preferred tripod cameras though the number of hand-held ones was increasing. In 1920s' Germany the new Leica camera enabled the use of 24 x 36 mm film or cinefilm, scornfully dismissed in professional circles as 'postage stamp format.' The somewhat larger format used in the Rolleiflex camera was more respectfully received, but even this was still being rejected as too small in Swedish photographic studios in the late 1940s. Younger photographers like Arne Wahlberg and Gunnar Lundh went to Germany for information and training in the years before the Nazi regime established itself. Wahlberg was one of the first in Sweden to photograph objects (Fig. 205), often for advertisements, and also one of the first to disseminate information about 'New Objectivity' photography. He was commissioned to produce photographs for advertising brochures, folders and financial statements for a number of building firms and for the Swedish glass industry, and was active at a time when the market was becoming increasingly dominated by mass-produced consumer goods. He introduced a new technique for photographing objects and had an exceptional talent for lighting them (Fig. 205). Arne Wahlberg was the outstanding modern studio photographer during the period of expansion of advertisement photography, while the inquisitive Gunnar Lundh walked the streets and squares in search of the Picture with a capital 'P'. Lundh, best

known for his collaboration with the writer Ivar Lo-Johansson, attracted attention in Stockholm press-photography circles at the beginning of the 1930s for using a little Leica camera while his colleagues were still busy with large-format cameras and glass negatives (Fig. 204). Together with somewhat older colleagues such as Theodor Modin, Axel and Victor Malmström, Gustaf Rydén and Kalle Ransell, Lundh now worked beside Oscar Halldin as a supplier of pictures to the Swedish dailies, which were increasingly anxious to have photographs with a story to tell for their columns.

HERE COME THE NEW PHOTOGRAPHERS!

A young press-photographer with a totally new approach now appeared on the scene; this was Karl Sandels. Up to this time press photographs tended to be nothing more than a simple shot of the subject, but the sports-mad Sandels would work his subjects into visual compositions unlike anything previously known, using bold angles and geometrical figures and recognizing no obstacles in his path (Fig. 207). At sports meetings in Stockholm stadium he ran up inside the clocktower to capture events from above. At hurdle races he lay flat on the ground to highlight the drama of the moment at a thrilling angle from below. His grandfather and father and an uncle had all been photographers, and he himself is representative of the first generation of working Modernist photographers in Sweden. Most of all, he had a feeling for picture composition that few other Swedes of his time could match and he would even dress in such a manner as to be able to work inconspicuously in a variety of milieus. It was very probably Sandels – a 'mere' press photographer – who as early as the 1920s became the first in Sweden to incorporate geometrical form in his style. In 1930 he was one of the founders of the Press Photographers' Club. But the nature of his job supplying pictures to the daily press meant that his work had a relatively short life in the public consciousness, and it was not until 1977 that his photographs were (re-)discovered in an exhibition arranged by the Photography Museum at Moderna Museet in Stockholm. This treasure-trove revealed not only a series of masterpieces in the Modernist spirit executed by a conscious visual artist, but the scoops of an unusual press photographer. Sandels pulled off what was perhaps his most highly acclaimed scoop for the press in 1926 when he waylaid the Belgian Crown Prince Leopold en route to Stockholm to marry the Swedish princess Astrid. With the Crown Prince expected daily, press photographers flocked every morning to the arrivals hall at Stockholm's Central Railway Station to get the earliest possible shot of him. Meanwhile Sandels each morning would surreptitiously take the milk-train to the nearby branch-line station at Södertälje South and wait there for the night-train from the Continent to come in. Sure enough, eventually one morning a car from the Swedish court drove up at Södertälje to meet the train. Sandels surreptitiously followed the chauffeur on to the platform. Leopold duly appeared and Sandels used a number of glass negatives to photograph him on his way to the waiting court car (Fig. 208). Running backwards before the prince, he kept himself at a predetermined distance to which he had already adjusted his camera objective. When the train began to move away from the platform he jumped on board and soon afterwards glided into the Central Station to greet his assembled colleagues in place of the prince. Within two hours the daily *Stockholms Dagblad* had brought out a special edition to commemorate Leopold's arrival in Sweden. This exploit perfectly fitted Sandels to personify the expression *Es kommt der neue Fotograf* (Here Comes the New Photographer), minted in 1929 by Werner Gräff as the title of a book.[15]

Soon Sandels was joined by many other photographers interested in depicting modern life, often with political overtones (Fig. 209). Anna Riwkin-Brick, some years younger, had planned a career as a ballet dancer, but instead came to devote herself to ballet and dance as a photographer. She later became known for her work with the writer Ivar Lo-Johansson on the gypsies of Sweden.[16] She also produced a number of well-known portraits of Swedish writers and artists connected with the circle round the radical journal *Spektrum* (Fig. 210). In the early 1940s she traveled within Sweden and among other things photographed the Sami (Lapps) in the north of the country. Her

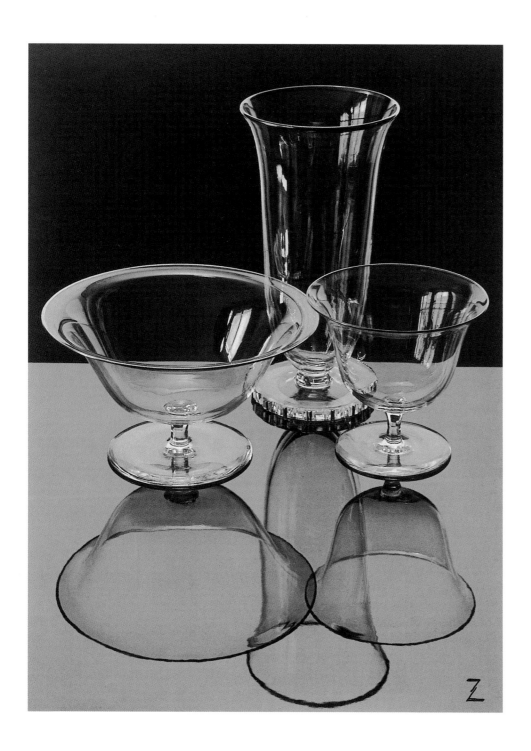

205. Arne Wahlberg
Glass, *c.* 1931
Moderna Museet [no 533]

206. Emil Heilborn
Advertisement for Läkerol
Pastilles, 1934
Moderna Museet [no 554]

207. Karl Sandels
Moreau, USA
Stockholm Stadium, 1934
Moderna Museet [no 553]

photoreportage was often published in the magazine Vi. She was also interested in the situation of children in different cultures, and after the Second World War made a series of journeys abroad during which she mostly photographed children; she also published a series of books for children which excited international interest and were published in many editions. Agnes Hansson was a nurse whose photographs taken at work and on holiday attracted attention in the Photographic Society's competitions during the 1930s (Fig. 211).[17] Sven Järlås specialized in photographing architecture (Fig. 213), and was also a representative of the 'New Objectivity'; later he too worked as a documentary photographer with Ivar Lo-Johansson. Emil Heilborn, originally an engineer by profession, was a world archery champion and active in the car industry both in the USA and Sweden before becoming a full-time industrial photographer. The photographs he took in Swedish industrial settings contain elements of both the poetry of machinery and Modernistic austerity. In his 1934 photograph 'Dog Show', a row of young people hanging over a wire fence provide the diagonal in a severe composition (Fig. 214). Gustaf W:son Cronqvist produced color photographs by the autochrome method as early as 1907.[18] He was captivated by the images offered by the modern city and early became aware of the possibilities of the industrial environment as a subject. Carl Gustaf Rosenberg, son of the painter Edward Rosenberg, was engaged by the Swedish Tourist Board to portray Sweden in accordance with the slogan 'Get to Know Your Country'. He spent several decades travelling through Sweden and producing pure unsentimental pictures of the countryside. His photographs are well composed and show sensitivity to the beauty and drama of nature despite the fact that he seldom moved very far from his car (Fig. 212).

THE NEW OBJECTIVITY – MODERNISM MOVES IN

Even if, looking back from the present, we can now describe many photographs of the period as Modernist in both technique and composition, most photographers of the

208. Karl Sandels
*Crown Prince Leopold of
Belgium Arrives in Sweden*
1926
Moderna Museet [no 512]

209. Karl Sandels
*Press Photographers at Work –
When Per Albin Resigned
Stockholm June 1936*, 1936
Moderna Museet [no 573]

210. Anna Riwkin
Karin Boye, 1939
Moderna Museet

211. Agnes Hansson
Poppies, c. 1940
Moderna Museet

213. Sven Järlås
Under Skurubron Bridge, 1933
Moderna Museet [no 546]

214. Emil Heilborn
Dog Show, 1934
Moderna Museet [no 552]

inter-war period never used the word 'Modernism', even if they described some pictures as 'modern' simply to distinguish them from older pictures. The terms the photographers themselves used to describe the two opposite tendencies were 'Pictorialism' and 'New Objectivity'. One or two photographers did use the word 'Modernism', but only in a derogatory sense. One such was the leading Pictorialist Ferdinand Flodin, who in 1930 expressed his distaste for the modern photographs exhibited in the international exhibition at the Gallery 'Skånska mine': '[Albert] Renger Patzsch is completely occupied paying tribute to the 'New Objectivity', but since I am not a believer, it is quite impossible for me to assess a picture like 'Stocking Warehouse'. This particular item, technically poor in any case, can be found in the the room reserved for Modernism or, as one newspaper calls it, the chamber of horrors.' Flodin asked himself why a picture should be 'considered more of a picture because taken from a bird's-eye or frog's-eye point of view'.[19] Despite Flodin's disapproval the exhibition did not contain very much modern photography, and though the term 'modern' was used, it was applied to everything produced more recently than the nineteenth century!

It was not until 1934 that Gotthard Johansson felt able to write that the large international photographic exhibition at Liljevalch's art gallery gave 'an overview of the development of modern photography from false artistic pretension to an objectivity which revealed genuine, not merely sham, artistic values; in fact a new photographic art.[...] Through this attitude to reality, modern photography has also freed itself from the other vices of "artistic" photography.[...] But the most remarkable thing of all is that this photographic renaissance has come about as a consequence not of purely artistic speculation but of the orientation of photography towards new practical tasks.'[20] With 'new practical tasks' Johansson was stating his belief that the art of photography had now returned to its natural function. The most basic purpose of photographic art was to see, and its strength lay in this new unconventional way of looking at reality. Johansson's words make clear the opposition between Pictorialism and New Objectivity, between the outlook of the older generation of photographers and that of the younger.

As has already been pointed out, Germany has had considerable influence on Swedish photography from time to time. In addition to the new photographic techniques and chemical preparations developed in Germany, the annual publication *Das Deutsche Lichtbild*, edited by Bruno Schultz, played an important role. The photographs in New Objectivity spirit that it published greatly influenced the style of young Swedish photographers. Reviewing this publication in 1929, John Hertzberg drew attention to Renger-Patzsch's picture of a baboon.[21] 'That this is, and can be, and must be a question of the most faultless, most absolute photographic as well as inventive talent operating through technical artistry is obvious! But we may easily forget something even more important: only a trained feeling for nature and a critical faculty developed through study could have sufficient control over this subject to be capable of such documentary artistry in reproducing it.' But *Das Deutsche Lichtbild* gradually changed. By 1934 its preface was being written and its content dictated by Adolf Hitler.

PHOTOGRAPHERS IN SWEDEN

Although some photographers sought new knowledge abroad and in foreign material, there was also an independent course of development within Sweden, especially through such figures as Arne Wahlberg, Karl Sandels and Gunnar Lundh who inspired other photographers all over the country. Harald Lönnqvist's photograph of a little goldfish in a cylindrical glass of water is an accurate image of the situation of Swedish photographers during the interwar period (Fig. 215). It is also the self-portrait of a photographer who for more than a decade was the Swedish photographer best known outside Sweden. Lönnqvist himself had no opportunity to travel: his profits as a portrait-photographer in Gävle went on postage. So he had to be content with viewing the world from inside a glass. Another who found himself inside the glass was Helmer Bäckström, appointed Professor of Photography at the Royal College of Technology in the 1940s. Bäckström took the initiative in organizing both exhibitions and competitions, and wrote among other things a series of articles on the history and development of photography in Sweden based on his own original research. Bäckström was internationally respected as one of the most important collectors of photographica of his day, and in 1965 the Swedish state bought his collection as the basis for the Swedish Museum of Photography, founded in 1971 (now part of Moderna Museet).[22]

THE BOUNDARIES ARE STRENGTHENED

During the 1930s foreign artists made their way to Sweden in the hope that the Social Democratic ideal would protect them from the brown- and black-shirted forces of Nazism and Fascism spreading across Europe. Among those who spent time in Sweden was the German-born photographer Andreas Feininger.[23] Bringing radical ideas from the Bauhaus school he attracted attention with a large number of photographs which he published in such books as *Stockholm*, *Boken om HSB* (The Book on The National

215. Harald Lönnqvist
Still Life, 1928
Moderna Museet [no 516]

Association of Tenants' Saving and building HSB) and others. He also took part in the 1934 exhibition at Liljevalch's. Commenting on this exhibition Ernest Florman, chairman of the Swedish Photographers' Association, wrote: 'Fortunately Andreas Feininger's pictures were not shown in the Swedish room, but they should never have been [in the exhibition] at all.'[24] Without naming anyone in particular, Helmer Bäckström also wrote in 1934: 'Recently interest in the newer trends in photographic taste has increased – trends often brought together under the general term 'New Objectivity', which however doesn't entirely cover everything involved. For instance, we have noticed within the Photographic Society, where in recent years there has been a boom so far as interest in aesthetic questions is concerned, that this new current has been extremely fertile. If we go through the Swedish pictures in this annual, we shall find good representatives of modern picture-making here too. Gratifyingly enough, in this country we seem to have managed to stay reasonably free of the exaggerations and absurdities which extremists in other countries have been perpetrating during the last couple of years.'[25] The cultural climate of the time made it difficult for Feininger to settle permanently in Sweden. In connection with which we can add today that it is a pity that Bäckström took pleasure in something which later revealed itself to be a deficiency on the part of Swedish photographers. As for Feininger, in the USA during the 1940s he became one of the major photographers on *Life* magazine and also wrote a series of outstanding educational books, on the technique of photography among other things.

Nevertheless it is reasonable to maintain that despite everything Modernism, allied in its photographic context with 'New Objectivity', did make a definite impact on the Swedish art scene. Yet the signs of creativity shown by the above-mentioned photographers and some of their colleagues in the early 1930s died away in the later part of the decade. A pallid form of National Romanticism arose that insensitively smoothed away rough corners. Photographs published at this time in *Nordisk Tidskrift för Fotografi* and in the newly-started *FOTO* concentrated on what was considered specifically Swedish: blond children, light portraits of women, harmonious landscapes under billowing cumulus clouds – all conjured up with yellow and green filters, the most important photographic aids of the time. It was no longer a case of 'Get to know your country' so much as an image of Sweden during a time of unrest.

At the end of the 1930s an attempt was made to persuade the Nationalmuseum to take an interest in photography and mount exhibitions. But despite its concern with art the Nationalmuseum was little inclined to include photographs in its collections, and its then head Axel Gauffin considered photography to have little of value to offer beyond photographs of paintings and sculpture. However in 1944 a new director, Erik Wettergren, did exhibit over 300 photographs under the title 'Swedish Photographic Art Today', and the Nationalmuseum accepted a donation of 38 pictures by 35 photographers from this exhibition – a first step towards Swedish museums recognizing photography as a form of art.

MODERNISM FOSSILIZED
Before the Second World War international impulses took a long time to reach Sweden, but after the war they increased markedly, especially from the USA. 'The American way of life' spread across Europe in such magazines as *Look, Life, Vogue, Saturday Evening Post* and *Harper's Bazaar*, and the pictures in them were an inspiration to local professional photographers – *Life* featured W Eugene Smith's social reportage and *Vogue* was dominated by Irving Penn's fashion and advertising photography. During the 1950s it became easier for Swedish photographers to travel abroad, and the fashion shows of Paris provided young photographers with work for such Swedish magazines as *Veckojournalen, Se* and *Vi*. In Paris it was also possible to come into contact with French photographers like Edouard Boubat, Willy Ronis, Henri Cartier-Bresson and Robert Doisneau who looked after reportage and news for *Réalités* and *Paris Match*. When Tore Johnson visited Paris he was inspired by Cartier-Bresson and 1930s Modernists such as Brassaï (Fig. 217). Swedish photographers were also attracting attention abroad. Hans

Hammarskiöld was contracted to the large Condé-Nast organization which controlled the British edition of *Vogue*, and worked in London for a time as a fashion photographer.

But it was not until the late 1940s that Swedish photographic art discovered enthusiastic young visual artists to equal the painters who had made their name in the early 1910s. New postwar work reached the public via the 'Young Photographers' exhibition of 1949 which altered both professional and amateur attitudes to photography, bringing in USA idealism, the influence of American magazines and new French Humanism alongside Surrealism and some surviving aspects of early 1930s Modernism. This exhibition was held in the late winter of 1949 in the Rotorhallen Gallery in Sveavägen, Stockholm.[26] The eleven young photographers who took part rejected the superficiality that had come into Swedish photography at the beginning of the 1940s. One exhibitor, Sten Didrik Bellander, had worked in Richard Avedon's studio in New York in 1947 and brought home new ideas from the United States. Bellander minted the expression 'the new pictorial eye' together with, among others, Rune Hassner, Tore Johnson, Hans Hammarskiöld, Lennart Olson and a little later Georg Oddner plus the editors of FOTO (Lars Wickman) and of the daily *Svenska Dagbladet* (Ulf Hård af Segerstad). These young photographers were intent on capturing the dynamic in modern life, on bringing movement into the system (Figs. 216, 219, 220).

Their clean, sometimes surrealistically colored photos and provocative titles impressed younger photographers but antagonized older ones. The generation gap naturally formed part of the background to what was later described as a conflict.

'Young Photographers' became one of the postwar period's most discussed photographic exhibitions. A few months later, in the fall of 1949, the gallery known as De Ungas Salong mounted a counter-exhibition arranged by Stockholm Camera Club.[27] This club had been formed by a number of older professional and amateur photographers, among them Arne Wahlberg and Rudolf Ekström. All were unhappy with the ideals proclaimed by the Photographic Society, Sweden's leading photographic

217. Tore Johnson
Rue de Rivoli, Paris, c. 1951
Moderna Museet

216. Hans Hammarskiöld
Steps, c. 1953
Moderna Museet

218. Lennart af Petersens
Wormeaten Façade. Chimneys,
Malmskillnadsgatan 34, c. 1955
Moderna Museet [no 615]

219. Hans Hammarskiöld
Cross-section of Log, 1950
Moderna Museet

220. Lennart Olson
Slussen, Stockholm 1950
Moderna Museet [no 611]

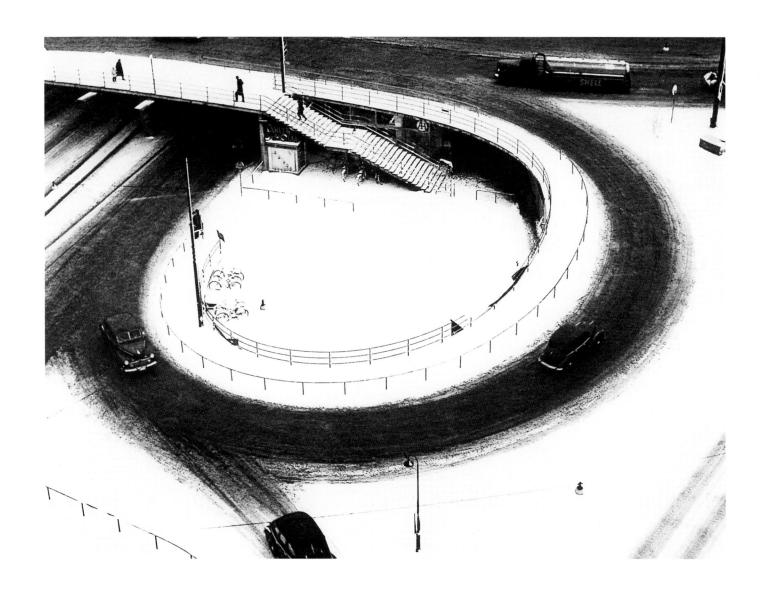

club. Stockholm Camera Club remained committed to early thirties Modernism with its emphasis on the photography of objects and architecture, and their exhibition was a swipe at the pictorial concepts of the 'Young Photographers'.

Lennart af Petersens worked with the Stockholm Camera Club but would have fitted in equally well with the 'Young Photographers'. He was interested in their work and interest in the debate about their new ideas. During the 1950s he became Stockholm's foremost documentary photographer;[28] today his socially and structurally aware images of Östermalm and of old buildings being pulled down in the Klara quarter in the center of Stockholm are classics (Fig. 218). Af Petersen kept one step ahead of the bulldozers as he recorded for posterity whole districts being swept away during a drastic Modernist restructuring of the heart of the city.

By the time Sune Jonsson's photographs became known to the general public in the late 1950s Modernism had fossilized in both form and content. Jonsson avoided intellectual and aesthetic photographic styles. His 1959 book *Byn med det blå huset* (The Village with the Blue House) is a meditation on another aspect of Sweden that was about to disappear. His unsentimental studies of the village community life of those who owned and worked small farms in Västerbotten were ground-breaking (Fig. 221). Pre-eminently a photographer but also a writer, film maker and ethnologist, Jonsson came to personify in Sweden the socially conscious photographer. He brought his subjects and their environment into focus in a way not previously seen in Swedish photography, and his pictures encouraged the young photographers of the sixties to move away from formal Modernism and towards social realism, taking a serious new interest in conditions in the world around them.

Sune Jonsson's photographs bring our narrative to an end but they also provide an introduction to the 1960s when photographers began to question the ideals of New Objectivity and Modernism from several points of view. During the late 1930s and the 1940s photography had been a plaything for the middle classes, but during the 1960s it became a popular hobby open to all. More and more people were now able to record their nearest and dearest with their own cameras, which meant the virtual end of portrait photography as a profession. When television sets moved into Swedish homes and began to show troubled parts of the world on news film, the status of press photographers was also drastically affected, and many now exchanged their still cameras for cine-cameras. Others gave up and left the profession altogether.

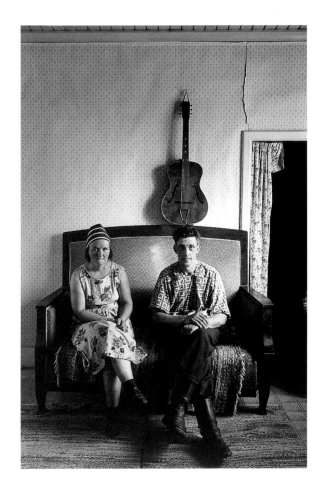

221. Sune Jonsson
Elsa and Evert Bygdell, 1961
Moderna Museet

NOTES

1. 'You've Got To Be Modernistic' is the title of a piano composition performed in 1930 by James P. Johnson, who wrote it when disturbed by the realization that his recording company was more interested in increased sales than in music.

2. Roll film was made of celluloid and factory-produced to give 24 exposures. It was manufactured in various sizes, such as for example 60 x 90 x 120 mm. Coming into use during the late 1880s, it became very popular among middle- and upper-class people for holiday snaps.

3. The older type of wet collodion negative, popularly but wrongly known as 'wet plate,' was in use from the late 1850s to the mid-1880s. The negative was prepared by the photographer on the spot: he or she needed a dark place in which to pour viscous collodion over a glass plate. This privately prepared negative needed to be exposed while still wet and then developed immediately before it lost its sensitivity to light. Albumen silver paper consisted of a thin paper base coated first with white of egg (albumen) and then with light-sensitive silver nitrate. This paper was used in conjunction with the wet collodion negative.

4. Åke Sidwall and Leif Wigh, *Bäckströms bilder!* (Bäckström's Pictures!) 1980, p. 144.

5. Oscar Halldin in *Fotografisk Tidskrift* no. 178, 1899, pp. 277–89.

6. 'Fotografien som konst' (Photography as an Art) *Fotografisk Tidskrift* 1899, p. 213.

7. Gunnar Malmberg's article on gum printing in *Fotografisk Tidskrift* 1897, p. 97 contains a description of the method, but in fact this has nothing to do with printing technique. Malmberg has misunderstood the English word 'print' ('tryck' in Swedish), using it in error for the phrase 'pigment photography.' 'Drawing-paper with a rough surface is prepared with a solution of gum arabic, watercolor and bichromats,' he writes. 'When the paper has dried it is exposed to bright light with a negative over it.[...]The resulting picture does not at all give the impression of being a 'photograph' and[...]this process seems to be superior to all others.'

8. On the pinhole camera, see *Fotografisk Tidskrift* 1896, p. 183.

9. Stockholm Exhibition 1897. *Fotografisk Tidskrift* 1896, p. 116.

10. Ernest Florman, 'Nicola Perscheids föreläsningskurs' (N. P.'s Lecture Course) in *Svenska Fotografen* 1913, p. 168.

11. Henry Buergel Goodwin, 'Om begreppet "Bildmässig"' (On the Expression 'Pictorial') in *Svenska Fotografen* 1914, 123.

12. Anthony Guest, 'Scandinavian Photography at the A. P. Little Gallery,' *The Amateur Photographer*, Nov. 1915, p. 412.

13. Ture Sellman, 'Första Internationella Fotografiska Salongen i Stockholm' (The First International Photographic Salon in Stockholm) in *Nordisk Tidskrift för Fotografi* 1926, no. 6, p. 101.

14. The 1929 'Film and Photo' exhibition in Stuttgart organized by the Deutsche Werkbund was a ground-breaking event with photographs by among others the Europeans László Moholy-Nagy, Piet Zwart and El Lissitzky and the Americans Edward Weston and Edward Steichen. See *Fotografía Pública, Photography in Print 1919–1939*, p. 101.

15. Werner Gräff, *Es kommt der neue Fotograf!* Berlin, 1929.

16. Ivar Lo-Johansson, *Zigenarväg* (Gypsy Road), photographs by Anna Riwkin, 1955.

17. Sophie Andersson, 'Agnes Hansson – fotograf under Rosenlundepoken' (A. H. – The Photographer During Her Rosenlund Period), diss. Uppsala, 1996.

18. Richard Anderberg, 'Bröderna Lumières färgfotografi' (The Color Photography of the Lumière Brothers), *Fotografisk Tidskrift* 1907, p. 103.

19. Ferdinand Flodin, 'Internationella fotografiutställningen i Skånska gruvan, Skansen 1930' (The International Photographic Exhibition at the Gallery Skånska Mine, Skansen 1930) in *Nordisk Tidskrift för Fotografi* 1930, no. 6, p. 87.

20. Gotthard Johansson, 'En ny bildkonst' (A New Form of Pictorial Art), in *Kritik*, 1941, p. 260.

21. John Hertzberg, 'Das Deutsche Lichtbild. Jaresshau 1930' (German Photography. Jaresshau 1930) in *Nordisk Tidskrift för Fotografi*, 1929, p. 195.

22. Åke Sidwall, 'Bäckströms Bilder! Introduktion till professor Helmer Bäckströms fotografihistoriska samling i *Bäckströms Bilder!*' (Bäckström's Pictures! An Introduction to Professor Helmer Bäckström's Collection on the History of Photography in *Bäckström's Pictures!*), 1980.

23. Gösta Flemming and Andreas Feininger, *Stockholm 1933–1939*. Stockholm City Museum, 1991.

24. Ernest Florman, 'Internationella Fotografiutställningen i Liljevalchs Konsthall i Stockholm' (The International Photographic Exhibition at Liljevalch's Art Gallery in Stockholm) in *Nordisk Tidskrift för Fotografi* 1934, no. 2, p. 18.

25. Helmer Bäckström, 'Fotografien år 1934 i Sverige' (Photography in Sweden During the Year 1934), in *Nordisk Fotografi* 1934, 1934 Yearbook.

26. For a deeper study of 'Tio fotografer' see Anna Tellgren, *Tio fotografer. Självsyn och bildsyn* (Ten Photographers, Personal Vision and Pictorial Vision), dissertation, Stockholm 1997.

27. SKK. *Stockholms Kameraklubb*. Catalogue for exhibition at De Ungas Salong, Stockholm 1949.

28. Leif Wigh, *Genom landet in i staden. Lennart af Petersens retrospektivt.* (Through the Countryside and Into the City: L. af P. Retrospective). Exhibition catalogue, Museum of Photography, Stockholm 1983.

NICLAS ÖSTLIND

FINE GRAIN AND BOLD ANGLES

Modernism in Swedish Photography as Reflected in the Photographic Press of the Time

MODERNISM, MODERNITY AND PHOTOGRAPHY

There are several good reasons for quoting Ivar Lo-Johansson's description of the 1930 Stockholm Exhibition, when as a young novice writer he walked down its straight paths that hot summer when Modernism made its official entrée into architecture and social life. In Sweden the Functionalist movement became a part of progressive Social Democracy and its ideals came literally to be built into people's lives and consciousness.

222. Karl Sandels
Swedish Flag Day at the Stadium, 1936
Moderna Museet [no 516]

> I walked down the main street to the great 1930 Stockholm Exhibition. It was summer and dazzling hot. The sun of the new decade was shining on my head. A whole new steel, glass and concrete city had risen where previously had been open space[...]All round people were discussing the new architecture and how it would give birth to a new sensibility[...]The tall steel mast on the exhibition site stood like a signal, like a thrill of happiness in the stark blue sky. The age of Functionalism had arrived. The style of the new era was in reality a detritus of styles. There was a name for its naked language: Facts.[1]

This description is so clear that we can easily imagine we were there ourselves, and it is also interesting to see how the writer manages to capture several of Modernism's most important themes in so few lines. 'New' is a key term. Humanity, sensibility and the world were about to be born again and it would not be long before a happier, healthier and more vigorous existence would follow. The world would be populated by modern people who had broken with the conventions of the past. The Modernist movement was marked by a strongly optimistic view of development and an almost luminous faith in the ability of technology and science to shape this better world. 'Facts,' mentioned at the end of the quotation, is also a central concept, something reason declares to be self-evident, since it has nothing to do with personal opinion but with analysis of the actual condition of things. Reduction or, as Lo-Johansson puts it, a 'detritus of styles,' is one of the principal stylistic characteristics of Modernism. Another related feature of Modernist strategy is the separate cultivation of the distinctive character of each means of expression or, to put it another way, concentration on

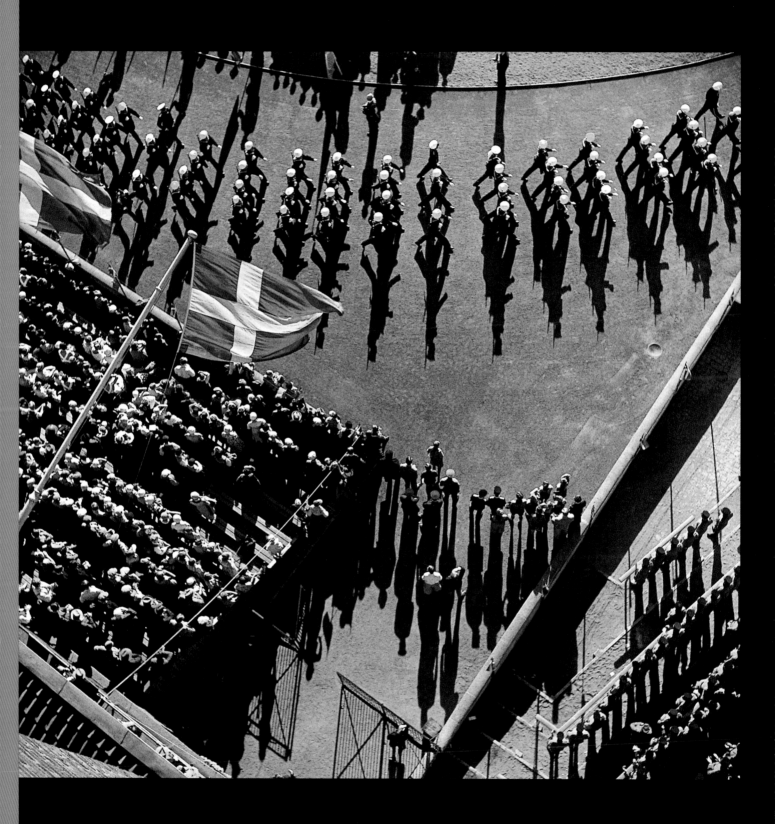

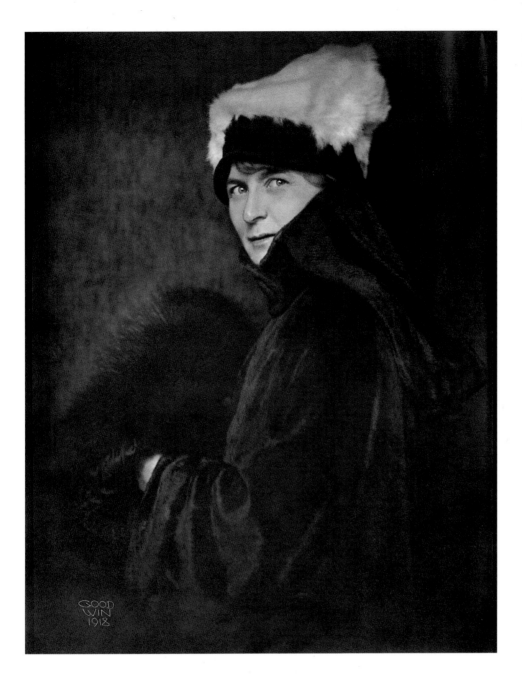

223. Henry B. Goodwin
Portrait of Ida Goodwin, 1912
Moderna Museet

224. Helmer Bäckström
The Hubertus Chapel, Munich 1923
Moderna Museet

bringing out what is specific to each artistic medium and not mixing the different media together. Clearly Lo-Johansson's text points to the central aspects of Modernism, but it is important to remember that Modernism is a composite phenomenon. It embraces a number of different styles, figures of thought and methods of expression that can be difficult to bring together: it can comprehend both an insistence on rationality and an interest in dark mysterious instincts; both enthusiasm for development, speed and technology and a longing for the prehistoric world; both dreams of universality and dreams of individuality. In a nutshell: Modernism can manifest itself in vastly different ways depending on where one chooses to place its center of gravity.

But where do photography and Modernism meet? Before we study the relationship between the two it may be interesting to have a closer look at the relations between photography and modernity, i.e. the technological and societal assumptions for artistic creation within Modernism. There are obvious links between photography and modernity. Indeed, one might go so far as to say that it is impossible to imagine modern society without the photographic image. Photography is not only found in the mass media and advertising but is also a widely practiced private activity. Photographing one's family and friends and collecting the pictures in an album is something people do all over the world. Family photos play an important part in forming our life-stories, but a large part of our 'memories' of events in world history are also stamped on our minds by photographs. The photographic image, and during recent decades television, go a long way towards providing the basis for our understanding of places and events of which we often have no first-hand experience. Photography operates on many levels in the construction both of our own identity and of our view of history. Photography has played a vital part in a whole series of the contexts that make up modern life, not least for sciences that came into existence in the late nineteenth century like ethnology, anthropology and criminology. Photography has made possible the construction of archives and records that have been instrumental in laying the foundations of research into what human beings are and how they behave. Photographs have often been used to distinguish one race from another, determine personality types and tell the sick from the well – all in an attempt to find out and establish what we may define as normal.[2] But photography has also proved of vital significance in less controversial areas such as the study of art. Thanks to photographic reproductions in books, art has become accessible to a much larger public than formerly when few had the chance to travel and see the original works that photography can now reproduce. Nowadays thousands of students all round the world sit in dark lecture halls learning to know art through transparencies. Many art-lovers have even been disappointed later when they have stood in front of the original: shouldn't it be bigger? Should its colors really be so strong?

PHOTOGRAPHY AS ART

Ever since photography came to the fore in the mid-nineteenth century it has had a complicated relationship with art. Photographers have often believed strongly that photography should be accepted as one of the fine arts. This view has often been opposed on the grounds of photography's prominent technical and chemical aspects. The visible work of the hand, so highly valued as evidence of artistic creativity and artistic spirit in painting, drawing and graphic work, is absent in photography. Soon, with its convincing naturalism, photography conquered a number of pictorial territories which painters and graphic artists had previously considered their own, such as illustrations of every conceivable kind, topographical depictions, and portraits. It quickly achieved a practical function, which hardly improved its status in relation to art. In the decades immediately before and after 1900, the movement which tried the hardest to make photography into a form of art was called Pictorialism. This operated mainly by laying emphasis on photography's so-called pictorial aspects, which in this context most often involved its resemblance to painting and graphic art. Pictorialism preceded the currents of Modernism and was strongly criticized by advocates of the new approach. But within Pictorialism too there was a desire for synthesis and simplification within large-scale

interrelated designs – ideas we also come across within the aesthetics of Modernism. Photography's place within the artistic hierarchy continued to be an almost inexhaustible subject for debate during the Modernist period.[3]

PURE, PURER, PUREST

Modernism first touched the visual arts around 1900. But it was not until the 1920s that its new currents affected photography on the Continent and in the Soviet Union, particularly within Constructivist, Futurist and Surrealist circles. In Sweden it took another ten years, more or less. This kind of photography was variously called modern, new or avant-garde, but also 'the new way of seeing'. A whole series of theoretical and stylistic factors characterize Modernist photography: the world as seen through new eyes should be reproduced by means of bold cutting and angles, montage and photogram; thematically, it should show a clear interest in the new world of fast accelerating speed, Functionalist architecture, goods and production, technology and physical development – all visible aspects of modern life. Surrealistically oriented photography worked together with dream-vision, in which unexpected conjunctions create images that are simultaneously poetic and terrifying. To some extent, new perspectives were introduced on the old question of whether photography is an art. Modernism saw photography as part of a developing technological culture, and the opportunity to mass-produce images and distribute them among a large number of people was considered of central importance.[4] Photography must no longer be distorted by manual editing to resemble painting, but should be respected by photographers themselves as a pictorial form in its own right.

This brings us to one of the most important questions within Modernism: the cultivation of a medium's distinctive character. During the 1920s two separate concepts of photography formed, one tending to the experimental and the other to the naturalistic. One of the most important advocates of experimental photography was László Moholy-Nagy (1895–1946), who was associated with the Bauhaus school. He produced a large number of publications in which he formulated ideas on how the technical and chemical processes necessary to photography could be the basis for a form of visual art which could test out and develop new creative forms. In his article 'Unprecedented Photography' (1927), Moholy-Nagy writes that it is important for pictorial art to create what is new and indicated the qualities unique to photography that it should keep hold of: 'In today's photographic work, the first and foremost issue is to develop an integrally photographic approach that is derived purely from the means of photography itself';[5] this was to include among other things a unique capacity to reproduce values and startling points of view and to experiment with various methods of thematic cutting together with shifts and shortenings of perspective. On the other hand, the naturalistic tendency found a powerful advocate in the German photographer Albert Renger-Patzsch (1897–1966). The ideas on the characteristic qualities of photography that he and others formulated within the 'New Objectivity' movement were intended mostly as a refutation of the Pictorialist approach, but also as an attack on contemporary experimental photography. In his article 'Aims' (1927) Renger-Patzsch writes: 'Photography has its *own* technique and its *own* means. Trying to use these means to obtain painterly effects brings the photographer into conflict with the truthfulness and unequivocalness of his own medium, his material, his technique';[6] and he ends by insisting that art should be left to the artists and that photographers must 'use the medium of photography to create photographs that can endure thanks to their photographic qualities – without borrowing from art.'[7] In a 1928 article Renger-Patzsch claims that photography's most important advantages compared to other visual media are speed, objectivity and the ability to arrest movement, and that its characteristic qualities are an ideal basis for naturalistic creativity, the form most suited to it. And if the photographer makes the right use of his medium he is able to create images that reveal the beauty in the world and present aspects of existence never seen before.[8] Furthermore what have been pointed out as the characteristic features of the medium are not so different from what has been stated as the purpose of photography: either creating new visual worlds or making visible as yet unportrayed beauty in the real world around us.

225. Emil Heilborn
Montage, 1936
Moderna Museet

226. Olle Nyman
Still Life, 1931
Stockholm City Museum

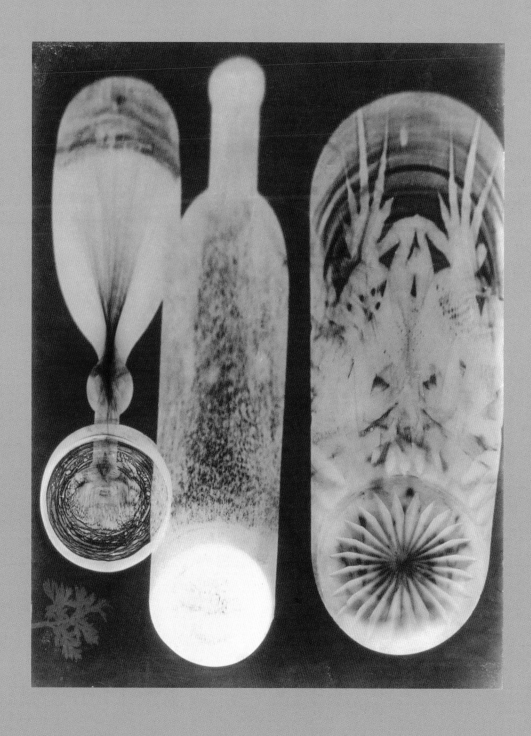

MODERNISM IN SWEDISH PHOTOGRAPHY

In studying the development of the photographic scene during the first half of the twentieth century we can state that the questions discussed in Sweden were the same as elsewhere: cultivation of the characteristic qualities of photography and the relationship between photography and art. The latter is a virtually inexhaustible subject. I have studied three of the leading Swedish photographic organs of the time: *Nordisk Tidskrift för Fotografi* (NTFF, The Nordic Journal of Photography), *Foto* and *Fotografisk Årsbok* (FÅ, The Photographic Yearbook) to discover how the Modernist way of seeing things made itself felt. All three, if with slightly different centers of gravity, addressed a mixed readership of professional and amateur photographers. NTFF first came out in 1917 and continued throughout the whole period in which we are interested. *Foto*, which first appeared in 1939, targeted amateurs and professionals within both photography and small-format cine-film. FÅ was published from 1945 to 1957 and was intended as an up-to-date reference book within the field.

FROM PICTORIALISM TO NEW OBJECTIVITY

Discussions in NTFF at the end of the 1910s and the beginning of the 1920s were strongly marked with the artistic ideals of Pictorialism even if the question of the cultivation of the distinctive qualities of photography was handled in various ways. Various statements on and evaluations of the degree of sharpness in the photographic image were made, and from having earlier been a problem, sharpness came to be considered one of the medium's foremost qualities. For example, S. Schiöler writes: 'This is the camera's greatest restriction, this being bound fast to reality. And it is a restriction which must be recognized and respected without reservation or compromise. Altering what is most important in the subject by combining different negatives or by retouching and interfering manually in various ways so as to change the character of the photograph – this is pure forgery and can never result in anything but a sham from an artistic point of view. The result is not photography. Nor is it drawing, etching or any other form of art. It is scrambled egg.'[9] A more permissive attitude is taken by the photographer and hist-orian Helmer Bäckström in his article 'At the Frontiers of Photography' (1925), where he discusses the battle raging between the champions of pure photography and those who argue that photography in its purest form is altogether too naturalistic and mechanical in character. For Bäckström what matters is not the procedure but the result and he has no problem with such hybrid forms as, for example, combinations of photography and drawing.[10] NTFF published the writings of foreign photographers and critics particularly from England who advocated the Pictorialist point of view, but the future belonged to pure photography.

In his report on the First International Photographic Salon in Stockholm in 1926, the architect and amateur photographer Ture Sellman writes that manual methods are in retreat and that pure photography has made a definitive breakthrough in Sweden.[11] International Modernist photography is dealt with in a 1928 article by Helmer Bäckström entitled 'Ultramodern Camera Art'. This makes reference to new trends in painting and highlights Moholy-Nagy's photographic experiments with non-figurative composition. Bäckström describes these as 'attempts' to give impulse to a new photographic art but he is not entirely convinced of their value: 'What you get in this way is a strange photogram full of bizarre drawings and singular light-effects.'[12] A more extensive critique of international Modernist photography is made by the court photographer Ferdinand Flodin in his lecture 'Inferior Variants of Pictorial Photography' printed in NTFF 3/1929. Flodin reflects on avant-garde work by, among others, Alvin Langdon Coburn, Hugo Erfurth, Franticek Drtikol and Moholy-Nagy and distances himself firmly from the avant-garde trend it represents, dismissing it as a 'transitory disease' and stating explicitly that he will do his best to combat it. The two great international photographic exhibitions held in 1928 in Stockholm and 1929 in Gothenburg which brought the twenties to a close further smoothed the path that had already been clearly marked out towards pure photography. Henry B. Goodwin, a judge on the Gothenburg prize committee, wrote: 'Special recognition has been given to those photographers who with confidence and original creative initiative have known how

to choose those distinctive effects which only photography is in a position to give: the camera's own particular way of seeing and depicting.'[13]

The 1930s began with the big Stockholm Exhibition mentioned at the beginning of this chapter, but as this contained no section for photography, a special international exhibition was arranged on the initiative of the Nordic Museum. The material was divided into six separate sections, one of them headed 'Modernism'.[14] Ferdinand Flodin reviewed this exhibition in NTFF 6/1930. His response was mixed, but as before he shows a complete lack of understanding of the New Objective and Modernist contributions, and makes no comment at all on Renger-Patzsch's pictures which were hung in the modern section – dubbed by the press the 'chamber of horrors'. The expression 'bildmässig' ('pictorial') was often used in the photographic debate, but without ever being clearly defined. But in 1931 Arne Wahlberg developed his view of 'pictorial' photography in 'Something on "Pictorialism",' a lecture published in NTFF. Wahlberg's argument circles

round personal expression and the laws of aesthetics, which lie beyond subjective thought. At the same time he commented that modern photography has gone in for various kinds of deviation from the rules and that happily this had yielded sensational results; it was necessary both to work within the aesthetic laws and to develop beyond them. Wahlberg also wrote that if one did not keep within the distinctive nature of the medium one's work was wasted: 'And likewise, no matter how brilliant one may be at creating and composing subjects, if one is not capable of executing them in terms of any of the means of expression characteristic of this particular form of art, then one can never expect results of any value either.'[15] The greatest photographic exhibition to date in the northern countries was mounted at Liljevalch's in Stockholm and reviewed by Flodin in NTFF 2/1934, where he stated very clearly that pure photography was his aesthetic ideal and he praised it whenever it raised its head. He also mentioned 'Modernist things' and 'Modernist compositions', but without going into any detail about what he might mean by these terms apart from the technique of such works not always being equal to their originality. Of the exhibition's Swedish room he said: 'One must welcome it as a good sign that not one picture in the whole room was produced using any manual process.' The cultivation of the distinctive characteristics of photography is also a theme of many other articles on 'pictorial' photography in the late thirties and often constitutes the hub of the argument. In an article from 1936 entitled 'Truth, art and photography' Harald Ranson voiced an opinion held by many: 'But truth makes certain demands on all real art. The first of these is: Be true to your medium.'[16]

THE BREAKTHROUGH OF DOCUMENTARY PHOTOGRAPHY AND OF THE 'NEW PICTORIAL EYE'

The journal *Foto* started publication in 1939 and in one of its first numbers the pioneers of Modernist painting – no longer in their first youth – were invited to join a discussion on art and photography. It emerged as clearly as anyone could wish that painting and color photography had little in common. The Swedish painter Isaac Grünewald declared

Emil Heilborn

that they were separated by 'the greatest state of opposition it would be possible to imagine'; he saw two possibilities for color photography: either strive for an exact reflection of reality or, as far as beauty is concerned, create totally new values.[17] In *Foto* in 1946 no less a figure than Pablo Picasso pronounced on photography and his reasoning runs on the same lines: photography is not art, but must develop its own specific characteristics, which are documentary.[18]

In 1944 photography conquered significant new territory when the Nationalmuseum in Stockholm mounted the exhibition 'Modern Swedish Photographic Art'. In NTFF 12/1944 the press photographer Karl Sandels wrote that what photography does best is exactly mirror reality. Sandels noticed in the exhibition that two 'styles' had dominated the last fifteen to twenty years: New Objectivity and photo-reportage. New Objectivity, Sandels maintained, flourished briefly but disappeared because it was an end in itself, whereas reportage can unite stories from life with good photography. The critic Ulf Hård af Segerstad reviewed the exhibition in *Foto* 12/1944; he too highlighted the photograph which makes the moment eternal and illustrates everyday life. For Hård af Segerstad a photograph was 'a document which shows how an external reality in a given relatively short fragment of time assumes form through the objective eye of the camera as distinct from the subjective eye of a human being.' During the 1940s photography's ability to depict reality became ever more synonymous with its distinctive character, as stated by Arne Wahlberg in his address '"Artistic" Photography' in NTFF 3/1940: 'Photography must preserve its distinctive character as a truthful depicter of the present moment, an invaluable preserver of documentary values.' But some, notably Ture Sellman, took a different view. In NTFF 2/1945 Sellman wrote that photo-reportage is the opposite of pictorial photography since it is so dependent on having a story to tell; in other words, its values are literary rather than photographic. He summed up: 'Picture journalism – a literary "artform" – really has no place in the Nationalmuseum. It would be more at home in the Swedish Academy!'

1949 saw a breakthrough for Modernism in Swedish photography in the form of the 'Young Photographers' exhibition in Stockholm.[19] This left its imprint on photographic debate throughout the 1950s and by the end of the decade the Modernist viewpoint, or as it was called at the time, the 'new pictorial eye', had won general acceptance. This had a strikingly experimental character, but at the same time its expression varied markedly from one photograph to another. One constantly recurring question about this 'new pictorial eye' was whether it really was new or merely plagiarized from international trends. In NTFF 7/1949 the photographer Yngve Hand speculated on its origin: 'The fact is there are two things at the heart of "the new" – the atomic age and worship of the USA.' He offers no unambiguous explanation of this but appeals to readers to help him interpret what is happening. The art historian Bo Lindwall, in his review of the 'Young Photographers' exhibition, divides the photographers of the day into 'effect-seekers' and 'impressionists': the 'effect-seekers' create effects in a Surrealistic spirit while the 'impressionists' capture moments of reality. Lindwall's response is both positive and negative, and he particularly disapproves of anything too artfully contrived, but also of the artlessness of some photoreportage. He also takes up the question of whether photography can be art, deciding that it can so long as the photographer keeps within the limits of his genre. In 'A Necessary Shift of Style' (*Foto* 1/1950), Ulf Hård af Segerstad states his belief that the 'Young Photographers' are filling a space left empty for abstract photography in Sweden, and that they have turned towards the USA in the first instance as a way of breaking out from national isolation, which he considers the most important factor in this connection. However, only a few years later Hård af Segerstad and Lindwall both warn that the 'new pictorial eye' risks becoming a new academicism.[20] By the end of the decade many considered this prophecy had come true.

The relationship between photography and art continued to be discussed during the 1950s; for instance, *Foto* 12/1950 conducted an inquiry among leading museum staff and

connoisseurs on the subject of whether photography can be art. It is clear from the replies that cultivation of the distinctive character of photography was still considered the most important thing, but that personal expression mattered too, and the total freedom of the picture, i.e. the freedom of the photographer to employ the whole expressive register of the medium unhampered by technical or aesthetic rules. In *Foto* 1/1957 Hård af Segerstad, under the title 'A Look Back at the Future II,' discusses the implications of changes in photography over the last few years: 'if this (freedom) is not the greatest gain that one can make in this context, then I don't know what scale of values should be applied.' The word Modernism appeared more often in the discussions of the 1950s than it had earlier; for example, in NTFF 4/1952 Dr Bertil Walldén reflects on photography's relationship with Modernist currents in the visual arts. He gives several examples of Concrete and Surrealist photography in Sweden and concludes with the hope that in future many examples of Modernist experimental photography will be seen. This attitude is entirely different from the 1930s when Modernist trends were condemned as unfruitful mutations.

In the mid 1950s, amid discussions about the artistic status of photography, a gulf opens between 'pictorial' photography and photo-reportage, evidence of different concepts of photography's distinctive characteristics and aims. In a contribution to this debate NTFF's editor, Carl Adam Nycop, asks why the term art should ever be used at all in connection with photography. As far as he is concerned, the word 'art' is utterly superfluous, and he states that his own ideal is documentary photographs depicting everyday things.[21] In 1957 the photographer Sune Jonsson published a manifesto attacking the 'Young Ones' and their photographer followers. He maintained that their work was marked by 'intellectualism and aestheticism' while he himself would rather put the emphasis on 'ardent content' and 'a broadly based emotional life'. The manifesto is permeated by a conviction that photography has a greater task to perform than merely being art. For Jonsson as for many others, the ground-breaking exhibition *The Family of Man* was a guiding star to what photography can achieve. This exhibition was assembled by Edward Steichen at the Museum of Modern Art in New York and contained hundreds of photographs depicting the everyday experiences of human life: love, birth, work, struggle, friendship and death. It toured the world during the 1950s and was shown at Liljevalchs in Stockholm in 1956.[22] 'The pictures in *The Family of Man* preached a sort of photographic Sermon on the Mount, not through sensation and extremes but through the habitual, through the dominant motif of human life – greyness.'[23]

SUMMARY AND REFLECTIONS FROM A POSTMODERNIST STANDPOINT

The material we have studied shows that the principal issues during the first half of the twentieth century were photography's relationship with art and the distinctive characteristics of photography itself. A large proportion of this debate coincides with the main vein in Modernist aesthetics in which considerations of the media-specific play a central part. From a pictorialist point of view the value of the cultivation of distinctive characteristics was held in doubt at the beginning of the century, but thereafter came to be generally accepted. However, in Sweden as on the Continent, views differ slightly on what photography's distinctive characteristics really are and on what its purpose should be. The term 'Modernism' itself was rarely used before the 1940s, but later occurs much more frequently. In the first instance the term refers to non-figurative photography and experiments with photogram, bold cutting and perspective. This did not catch on in Sweden until the 1950s, and even then took a less radical form than on the Continent. What was held up as a model was if anything a restrained version of this new means of expression: 'moderate Modernism' might be a better way to describe it. But once it had broken through it soon became normative.

Since the 1950s much has happened in photography and it may be worthwhile to say something about this. In the Postmodernist period, that is to say from the 1980s

229. Ture E:son
Milk Makes Prime Males, c. 1940
Moderna Museet

230. Gunnar Lundh
First Holiday, 1938
Nordic Museum

231. Tore Johnson
By the Canal St Martin, Paris
c. 1951
Moderna Museet

232. Caroline Hebbe
Venini, 1951
Moderna Museet

onwards, it has become one of the most popular of the visual media and this has decisively extended its field, not only in the increasing number of photographs shown in exhibitions and the way photography is now assessed in criticism, but also in the integration of photography into the advanced teaching of art and into museum collections. In many areas the old boundaries separating the different media have weakened or been completely abolished. Teaching and collecting today start from a broader concept of art, and photography is taken for granted as an aspect of art no less than painting and sculpture. The reason it became (and still is) such a useful form of expression was that several of its unique characteristics related to issues of interest to many artists and theorists, not least problems of authenticity and originality. During the last few decades many artists have analyzed and criticized the media society and the hidden power structures that surround us. Power strategies are now very different from what they were in the politically conscious seventies. Avoiding direct confrontation and documentary presentation, Postmodern art has infiltrated the enemy camp and caused confusion by becoming similar to what it aims to expose.[24] Among popular objects of research have been women's roles in film, advertising and pornography, and the gender constructions of academic discourse. This has undoubtedly owed something to the increasing number of female photographers. Modernist documentary photography depicted the world from a universal humanist viewpoint. Postmodernist critics and artists working from Feminist, postcolonial or gay and lesbian standpoints deconstructed this, rejecting 'universality' as the fraudulent generalization of a dominant group: white, heterosexual, western, middle-class men. Thus the picture of reality presented in major pictorial narratives such as *The Family of Man* was replaced by other pictures in which various minority groups presented themselves and the world from points of view that differed completely from the blinkered humanism characteristic of Modernism. But that's quite another story...

NOTES

1. Ivar Lo-Johansson, *Författaren* (The Writer), 1957.
2. Allan Sekula, 'The Body and the Archive', *The Contest of Meaning. Critical Histories of Photography*, Richard Bolton (ed), 1989.
3. Rolf Söderberg and Pär Rittsel, *Den svenska fotografins historia 1840–1940* (The History of Photography in Sweden 1840–1940), 1983.
4. Christopher Phillips, *Photography in the Modern Era, European Documents and Critical Writings, 1913–1940*, 1989, p. xiii.
5. Ibid, p. 84.
6. Ibid, p. 105.
7. Ibid, p. 105.
8. Ibid, p. 108f.
9. S. Schiöler, 'Några reflektioner rörande fotografisk konst' (Some Reflections on Photographic Art), NTFF 6/1924.
10. NTFF 10/1925.
11. NTFF 6/1926.
12. NTFF 'Fotografi för alla' (Photography for All) 6/1928.
13. NTFF 10/1929.
14. Flodin suggests that a more accurate name would have been 'Modern Photography.'
15. NTFF 3/1931.
16. NTFF 2/1936. The text is that of a lecture originally delivered to the Royal Photographic Society in London in 1935.
17. Foto 8/1940.
18. Foto 2/1946.
19. Among the 11 participants in the 'Young Photographers' exhibition were Rune Hassner, Sten Didrik Bellander, Lennart Nilsson and Astrid Bergman.
20. Foto 1/1951, Foto 9/1952.
21. NTFF 8/1954.
22. Anna Tellgren, 'Tio fotografer. Självsyn och bildsyn. Svensk fotografi under 1950-talet i ett internationellt perspektiv' (Ten photographers. The Personal Eye and The Pictorial Eye. Swedish Photography of the 1950s Seen in an International Perspective), 1997 (dissertation).
23. FÅ 1957.
24. Lars Nittve (ed), *Implosion, ett postmodernt perspektiv* (Implosion, a Postmodern Perspective), exhibition catalogue, Moderna Museet, 1987.

BO FLORIN

'THIS MODERN ESTABLISHMENT KNOWN AS THE MOVIE HOUSE'

Modernity and Modernism in Swedish Feature Film

233. The Flamman Cinema in Stockholm, 1930 designed by Uno Åhrén. [nr 425]

Anyone referring to the standard literature on Modernism and film, will encounter a group as limited as it is exclusive – a handful of great filmic artists: Ingmar Bergman, Luis Buñuel, Michelangelo Antonioni, Federico Fellini, Orson Welles.[1] Their most productive period was between the 1950s and the 1970s; hence these decades are appropriately recognized as a high-water mark of Modernism in western film-making, or more simply, the era in which Modernism completed its conquest of the cinema.[2]

However, this rather conventional rendering of history is far from clear. It introduces an odd time lag between film and other art forms, creating the impression that film was lagging behind: that its modernist expression was late to evolve, and only did so in the wake of dominant, established art forms. But unlike the extended history of painting, sculpture and architecture, in which various stylistic periods have followed one after the other, film and Modernism are children born in the same time. It took a few decades for the emerging new medium to solidify as an art form, so that film-makers could identify and be identified by the modernist artistic vision – based on ideas such as the romantic heritage, individualism and subjectivity as a creative principle. In the mean time, all the attention lavished on individual film-makers has added to a distinctly narrow definition of Modernism based on the role of the artist.

This narrow focus is also indicative of a blind spot in many classical definitions of Modernism, which are based on purely aesthetic criteria. Modernism in this context has readily been seen as something opposed to, or at least separated from, technical development. As a consequence of this, the fact that Modernism was contemporaneous not only with cinematography, but also with phonography, telephony or high velocity technology, has for long been ignored. In real terms, Modernism and modernity are inextricably linked, and new research has emphasized the importance of fast-evolving technology during early modernity in establishing the aesthetics of Modernism.[3]

Film, for its part, has often been viewed as both a symptom and an expression of the

crisis precipitated by Modernism. It is intimately related to the inferno of communication that characterizes the modern city, the quickening tempo of the ephemeral moment, and the liberation of 'perception' from its immediate context of the 'here and now' – for instance, through photography, world exhibitions or forays into other worlds in what might be dubbed 'department store culture'.[4] Early cinematic forms such as newsreel footage or travelogues where the camera either transports the viewer to known urban or rural locations, or explores distant, unknown places – the 'sensation' film was perhaps the most fought-over genre of the decade from 1910 – are all expressions of the same modern culture.

When August Strindberg commented in a 1908 theater brochure on the contemporary crisis in the theater, he attributed it to the breakthrough of film: 'This modern establishment known as the Movie House captured the *zeitgeist* and took off at a fearful pace...'

Varied programming – 'a little bit of distraction, a touch of chronicling or lusting pure and simple' – in combination with low ticket prices and choice in terms of the screening times of the shows, made it difficult for the theater to compete with this latest form of entertainment. However, ironically enough, modernity did not saturate every part of the new medium. For example, not until the breakthrough of Functionalism in Sweden did the architectural design of cinemas begin to correlate with Strindberg's comments. The norms of theatre architecture proved tenacious; and the picture palaces of the 1920s were still being constructed on baroque principles. However, in Uno Åhrén's Functionalist cinema *Flamman* (The Flame) built in 1930, film's indebtedness to theatre had become a thing of the past. This was not just a question of architectural renewal, but also a matter of a newly won independence. Only now was film able to exist as an art form in its own right, rather than having to justify its existence by making references to more established art forms.

Of course, modern films were also being screened in the early, traditional cinemas. Swedish cinema in the decade from 1910 to the 1920s has never been given much attention, perhaps because a great deal of footage has been lost. The period is often summarized as one in which nature and pastoral romance predominated – each, apparently, wholly antithetical to Modernism. But these thematic materials may also be seen as precursors of the rapid advance of industrialization and modernity. The cinemas turned popular culture, which had only recently been made into history, into a modern entertainment for an emerging urban audience. In this way, film also portrayed the continuing process of modernization in society.

Of course, it was not all pastoral romance on the screens. Among the directors of the silent era, Mauritz Stiller was pre-eminent as a representative of 'the modern.' His modernity was expressed not only in the films themselves, but also in the culture that surrounded them, Einar Nerman's famous film poster for Stiller's *Erotikon* is typical of the new directions in poster design which set in around 1917, when the film companies began to abandon earlier clichés – stills from the picture and decorative ornamentation – in favor of modern design with its own artistic style.[5]

Stiller's vigorous stories (not least *Erotikon*, Figs. 234, 235) of city and street life, with all the attributes of modern life – consumerism, automobiles, aeroplanes – were already being seen by the critics as quintessentially urban and modern, a cinema reflecting the world at large. But tension in *Erotikon* is conveyed by means of a problem that is often

234. Still from *Erotikon* (1920) by Mauritz Stiller

235. Poster for *Erotikon*, designed by Einar Nerman in 1920

236. Still from *Miss Julie* (1951)
by Alf Sjöberg

considered a mainstay of Modernism – perception. The protagonists of the film, Preben and Irene, go to the theatre to see a play which, as they soon realize, bears striking similarities to their own lives. In this instance, their perceptions help them achieve an insight. Preben is obsessed with looking at Irene: in the street, through binoculars, in a mirror. The idea of subjectivity is introduced, with various possible ways of interpreting events, but no truth revealed at the end: has Preben really seen Irene in the company of an unknown gentleman, or is he mistaken? Thus the film expresses what Paul Adams Sitney has called 'autonomy of vision' in Modernism: perception is impeded and fundamentally questioned.[6]

Victor Sjöström's *Körkarlen* (1921; Fig. 237), based on the writings of Selma Lagerlöf, seems at first sight the absolute opposite of *Erotikon*. Unlike Stiller, Sjöström has long been viewed as a master of character, more a timeless teller of the human drama than a modern film-maker. There is good cause to revise such an assessment. Even the structure of *Körkarlen* places its creator in the modernist camp, in a similar context to other great modernist storytellers. The film is constructed as a series of systematically aligned Chinese boxes. The protagonist David Holm exists in the present. However, through a flashback his good friend and drinking partner George tells the legend of the 'driver of death.' The film then 'takes over' his tale and abruptly develops its own images and story of the driver. The techniques employed in the film, primarily the renowned double exposures, also place it squarely in the front line of modern film-making. The double exposures were praised not least by the avant-garde in France, where directors such as Louis Delluc and Jean Epstein were influenced by Sjöström's films and commented on them in their writings; hence, *Körkarlen* became a reference for other pioneers within the modern cinematic art.

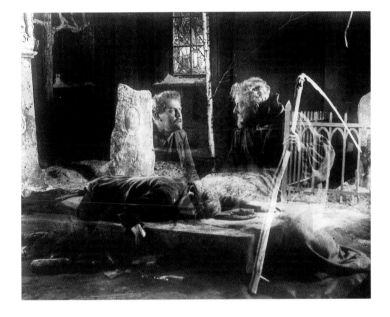

Meanwhile, the dividing line between Sweden and France was growing clearer in terms of divergent paths chosen to develop modernist ideas in the cinema. Those working within the cinema in France, who sought to develop and define both its form and unique power of expression as well as a precise and modern film-making ethic, are often collectively known as 'the avant-garde.' This 'avant-garde' was not a small, exclusive clique alongside the mainstream of cinematic narration. The output of the avant-garde, quite simply, *was* contemporary French film. However, in Sweden, film-makers with evolved modernist credentials were far more restricted in their movements. Generally, cinema in Sweden for several decades as from the 1920s, was strongly influenced by 'Americanization' and, obviously, American films – although this may be an excessively schematic view. If the 1930s are dominated by the much-maligned slapstick and melodrama (indigenous by theme but internationalised in narrative style) the 1940s are characterized by an emerging 'youth film' responding to a growing 'youth culture.'

Only at the end of the 1940s, as a new decade was beckoning, does a clear tendency away from the prevailing broad, popular narratives become apparent; films began to appear that quite clearly paid homage to Sjöström and Stiller while also looking ahead and striving to integrate creative currents from other countries, thereby creating a Swedish cinematic Modernism. Alf Sjöberg's films are often viewed as landmarks in this new orientation. As an example one might quote Leif Furhammar, writing on the screen adaptation of Strindberg's *Fröken Julie* (Miss Julie) (1950; Fig. 236), that it 'opened up a new cinema language, and became the chief exponent for a cinematographic Modernism.'[7] *Miss Julie* had already been adapted for the screen with Strindberg's

concurrence. It was filmed in 1912 by Anna Hofman-Uddgren – who with Pauline Brunius, was one of the few women pioneers in the silent era. (Film-making was otherwise predominantly a male bastion; not until Mai Zetterling's Modernist-influenced feature film debut in 1964, was another woman to take the director's chair).

As a rule, Strindberg's drama has been regarded as naturalistic rather than modernist. However, in his preface to the play, Strindberg described *Miss Julie* as being influenced by modern impulses: 'As modern characters, living in a transitional time more hurriedly hysterical than its predecessor, I have depicted my figures as tottering, worn out, a mixture of new and old...'[8] It is also doubtless the case that the close-structured identities in the play exceed the simplicity of the naturalistic. Hence, Sjöberg had a good foundation of complexity to build upon when he took the decision to break up the original unity of the drama in terms of time, space and action into what was described (rather decorously) by Rune Waldekranz as 'mosaic-like fragments of deep psychology, so that the shards could be reassembled into an intensified view of the whole.'[9] In certain sequences, Sjöberg superimposes both past and present – people and events from different times – in the same image. It is a forceful display of dream-like narration, where camera movements take the place of editing, and the only unifying factors are derived from the actual images: subjective experience uniting what might otherwise be viewed as irreconcilable.

In other words, *Miss Julie* is a sort of meeting between the turn-of-the-century modernity and the much later cinematic high Modernism, with the Modernist tendencies of the silent era also much in evidence. It may therefore serve as a reminder of the proliferation of cinematic Modernism in all directions, both thematically and historically: a series of overlapping, modern pictures, brought together by technology with a loosely woven, associative logic.

NOTES
1. See Roy Armes, *The Ambiguous Image*, 1976.
2. John Orr, *Cinema and Modernity*, 1993, pp.2ff.
3. For a discussion of this argument see Sara Danius 'The Senses of Modernism, Technology, Perception and Modernist Aesthetics, (diss.), 1998.
4. *Cinema and the Invention of Modern Life*, anthology, ed. Leo Charney & Vanessa R. Schwartz, 1995.
5. See Jan Olsson (ed.), *I offentlighetens ljus*, (In the Light of Publicity) 1990, p.9f.
6. P. Adams Sitney, *Modernist Montage*, 1990, pp.2ff.
7. Leif Furhammar, *Filmen i Sverige*, (Film in Sweden) 1991, p.241.
8. August Strindberg, *Fröken Julie* (Miss Julie) [1888].
9. Rune Waldekranz, *Filmens historia*, (The History of Film) vol. 3, 1995, p.876.

HENRIK ORRJE

FILM AS ART –
A MODERNIST MOVEMENT

When film was launched on the world at the beginning of the twentieth century, it was seen as a trailblazing innovation in which motion and time could be depicted in a way that seemed impossible in either reality or dream. Technological and industrial innovations such as the telephone, electricity, railways, cars and airplanes were already radically changing the human environment. With its remarkable ability to portray all these new things, film became a symbol of what modern society might achieve.

In Europe and the USA contemporary artists were pioneering new forms of pictorial art that reflected the aesthetic values of their own time more those of an earlier age. In Cubism and Futurism they abandoned central perspective and linear chronology to depict movement and the new dimensions of modern life. But such static media as painting and sculpture have obvious limitations when it comes to depicting time, and in Europe artists were becoming aware of the potential of film in this respect.

During the 1910s and 1920s many artists made films themselves in the shadow of the commercial feature film. In Germany Walther Ruttman, Hans Richter and Oskar Fischinger created short films based on abstract picture-sequences. In France the avant-garde film reached its highpoint in the 1920s in such outstanding works as Fernand Léger's *Ballet mécanique* (1924), Germaine Dulac's *La coquille et le clergyman* (The Seashell and the Clergyman, 1927) and Marcel Duchamp's *Anemic cinéma* (1927). In the USA Charles Sheeler based his *Manhattan* (1921) on a poem by Walt Whitman, while Ralph Steiner in H_2O (1929) was a poetic study in film of the reflection of light on the surface of water. But the most discussed work from this avant-garde period is Luis Buñuel's *Un chien andalou* (An Andalusian Dog, 1929), in which the concept of psychological automatism is perhaps presented more clearly than in any other Surrealist work. The film can be characterized as 'visual shock' and is basically anti-aesthetic since it breaks every rule of classical aesthetic harmony.

One of the most important pioneers in the field of avant-garde film was the Swede Viking Eggeling. Born in 1880 in Lund, he left Sweden in 1897 to study in Europe and

Picture sequence from
Diagonal Symphony (1924)
by Viking Eggeling
Moderna Museet [no 83]

lived in Germany, Switzerland and Italy during the early years of the century. In about 1911 he moved to Paris where he came in contact with Amedeo Modigliani, Hans Arp and Tristan Tzara. Eggeling became increasingly obsessed with the idea of creating a sort of optical symphony and bringing time into visual art as a fourth dimension. At this time many painters in Europe were occupied with similar ideas of film as art, but it was perhaps Eggeling who had the clearest vision of the unique potential of film to make reality of these ideas. In 1918 he came in contact with the Dada group in Zürich, and from 1918 to 1921 he worked with the artist Hans Richter who was also deeply interested in film as a medium. After a series of severe setbacks and a quarrel with Richter, Eggeling managed in the summer of 1922 to borrow enough money to acquire a studio in Berlin equipped with what he needed for film-making.

He had already worked with Richter around 1920 on animated abstract pictures and made several film sequences. In his new studio he continued work on his first film *Horisontal-vertikal orkester* (Horizontal-vertical Orchestra). But he was never satisfied with this and instead in the summer of 1923 started on his second film *Diagonalsymphoni* (Diagonal Symphony). A student from the Bauhaus school in Weimar, Ré (Erna) Niemeyer, helped him in the time-consuming work of constructing the film, which ran for 7 minutes 40 seconds. The models he used were manufactured from metal foil and animated from single frames. It took more than a year before *Diagonal Symphony* had its premiere on 5 November 1924 in Berlin, before a private audience which included László Moholy-Nagy and El Lissitzky. Six months later, on 3 May 1925, it had a public showing at a cinema in the Kurfurstendamm in Berlin. Eggeling deliberately shaped his material by analogy with music and contrapuntal theory, and the resulting flux of abstract images does have something in common with musical composition.

He used an abstract geometric idiom in which discrete constructions in light open themselves in a deep black space. Geometric shapes contrast with soft organic elements that move slowly before vanishing in the darkness. Straight lines at angles to one another, curved lines and points of reflected light form a symphonic whole. Eggeling died suddenly in Berlin in May 1925, but *Diagonal Symphony* has made his name as one of the genuinely creative figures in modern art. In Moscow in September the same year, writing in the periodical *Asnova*, the Russian Constructivist Lissitzky asserted that the importance of Eggeling's contribution to the history of plastic art was beyond dispute, because he had transformed two-dimensional studio composition into an illusorily three-dimensional image on the screen and had added a fourth dimension to visual art: time.

During the 1920s and 1930s the ideas of the continental avant-garde did not directly penetrate Sweden. But while Eggeling was working on *Diagonal Symphony* in Berlin, Otto G. Carlsund was helping Fernand Léger with his film *Ballet mécanique* (1924) by making drawings and patterns for its vignette figure which was animated by cut-out technique. But after this Carlsund made no films of his own. On the other hand, Reinhold Holterman became the first artist resident in Sweden to explore for himself the possibilities of cinematography. In 1928 he made the two films *Arabesk I och II* (Arabesque I and II). These were shown on various occasions, and in 1956 a sound-track was added by Hans Eklund and Ulf Linde. *Arabesque I and II* were distributed in the 1950s in Stockholm through Artfilm but subsequently disappeared.

Influenced by the European avant-garde, the firm Svensk Filmindustri (SF) produced a couple of films with experimental features during the 1930s. One was *Gamla Stan* (Old Town, 1931) by Eyvind Johnson, Artur Lundkvist, Erik Asklund and the film critic Stig Almqvist. SF gave them a free hand to explore the film camera's possibilities. Artur Lundkvist had spent time in Paris the year before and was entirely familiar with the state of the art in Europe and the USA. SF also produced another film with experimental ambitions the same year - *Tango*, by the young director Gösta Hellström. Hellström had gone to Moscow at the age of twenty-one to study Russian montage-film and now, influenced by Russian theory, he excluded all dialogue from his work, taking the view that dialogue interfered with a film's rhythm and tempo as well as the viewer's

Still from *...and after dusk comes darkness* (1947) by Rune Hagberg

imagination. His solution in *Tango* was to exclude totally all speaking characters from the film. Hellström died of tuberculosis in Stockholm in 1932. Neither *Tango* nor *Gamla Stan* had any great success with the public but they are interesting as examples of original creative films produced with financial support. Unfortunately SF did not have the funds to finance any more experimental films during the 1930s and the Swedish film industry in general had very little interest in encouraging contemporary artists and writers to turn to film as a means of individual expression.

Outside Sweden the situation was to some extent different. A number of directors managed to create successful films rooted in the avant-garde within the confines of the commercial cinema. From France came Jean Cocteau's *Le sang d'un poète* (The Blood of a Poet, 1930) and Jean Vigo's *Zéro de conduite* (No Marks for Conduct, 1933). Both these films have continued to inspire film-makers over several decades. In the USA *Lot in Sodom* (1933–34) featured a memorable philosophical world, while artists like Joseph Cornell and Maya Deren began to research the medium of film in the late 1930s. Hans Richter's *Dreams that Money can Buy* may be considered the culmination of the European avant-garde film. In Sweden it is not until about 1945 that occasional articles and reviews point to an increasing interest in experimental and original creative films, a phenomenon which coincided with greater attention being paid to Russian montage-film and to the European avant-garde, and with an increased international interest in experimental film.

In her article 'The Unfortunate Experimental Film,' published in *Biografbladet* in 1945, the film director Gerd Osten writes about the cultural difficulties of launching original creative films in Sweden during the 1930s. She points out that the general run of films produced in Sweden during the 1930s and early 1940s offer almost nothing but superficial entertainment without artistic depth. But she also draws attention to a few new films with original creative tendencies, one of which was Alf Sjöberg's *Hets* (Persecution) from 1944.

Also in *Biografbladet* in 1945 is a piece by the painter Lennart Rodhe about the

stagnation of contemporary film. Rodhe contrasts the feature film and its conventional structure with modern painting, which at the beginning of the twentieth century had already abandoned naturalism and through abstraction and other methods had discovered new routes to creativity, and he makes a series of comparisons between feature films and paintings by Picasso, Juan Gris and Georges Braque. The next year Rodhe collaborated with Gösta Werner on a film project entitled *Förvandling* (Transformation) and based on a script by Lars Ahlin, producing a large number of designs for various scenes. The film was never made but many sketches survive. The same year he prepared the scenario for Werner's film *Tåget* (The Train, 1946). Werner edited *Biografbladet* during 1945-47 giving the periodical new impetus through his interest in the theoretical and aesthetic aspects of film. His film *Midvinterblot* (Midwinter Sacrifice, 1945), which was shown at the Cannes Film Festival in 1946, had already attracted a good deal of attention. It depicts an ecstatic heathen ritual with subversive touches and can be seen as the introduction to a new epoch in Sweden in which artists and writers would explore the medium of film alongside poetry and painting.

Up to now film-making had been restricted to those few able to finance their projects through a film company, which made it difficult for anyone to put into practice ideas which did not accord with the accepted relationship of the traditional feature film to public taste and demand. But after the Second World War the new technology of narrow-gauge film made it economically possible for individuals to realize their ideas

independently of the big producers. An increasing interest in early avant-garde films and contemporary experimental films combined with the introduction of narrow-gauge film brought on the beginnings of a Swedish experimental film movement around 1945.

Rune Hagberg is undoubtedly the great pioneer of postwar Swedish experimental film with his *...och efter skymning kommer mörker* (...and after dusk comes darkness, 1947). Leif Furhammar writes in *Filmen i Sverige* (Film in Sweden) that 'it was now that Sweden got her first feature-length avant-garde film.'[1] Hagberg made the film over three years on his own initiative, shooting much of it in his apartment and on the roof of Kammakargatan 19 in Stockholm. The Swedish premiere was beset by problems. Since the film establishment considered the film too difficult for the average cinema-goer, the premiere was planned at first for Stockholm's Sture cinema which had been used earlier for showing several films classed as experimental. But eventually it was premiered at the Terrassen cinema where it ran for a week. It did better in Paris when shown at the Studio Montparnasse, and the French company Terrafilm financed some ten copies with French text for showing in film clubs. Even if *...and after dusk comes darkness* made little impression on the Swedish public, its visionary complexity made it a forerunner of the work of the new generation of artists and film-makers who were to give experimental film in Sweden a more prominent position as an art form during the 1950s.

It was at the end of the 1940s that Sweden's first real experimental film groups on continental lines came into being. The most important of these was Svensk Experimentärfilmstudio (SEFS, Swedish Experimental Film Studio), founded in 1950 and now known as Stiftelsen Filmform (The Filmform Institute). Among its members were Mihail Livada and Rut Hillarp who together made the noted short film *De vita händerna* (The White Hands, 1950). Hillarp tried to create a poetic effect by keeping the film's naturalistic content to a minimum and it won First Prize for 1950 in Sweden's annual competition for short films. Taking part in *The White Hands* were Hillarp herself, Puppi Grimberg and the poet Jean Clarence Lambert who was closely connected with

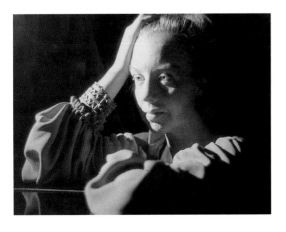

Still from *The White Hands* (1950) by Rut Hillarp

the Cobra group, that had been formed in Paris in 1948. Lambert had started the Swedish–French Film Club in Stockholm to show and discuss experimental films but people were also growing more and more interested in making films themselves. This led to the amalgamation in March 1950 of the Swedish–French Film Club and the Swedish Experimental Film Studio under the latter name, which in 1954 was changed to Arbetsgruppen för Film (AFF, Working Group for Film). This became a meeting place for the production and dissemination of experimental films in Sweden. Among its members in the 1950s and 1960s were Eivor Burbeck, Öyvind Fahlström, Carl Gyllenberg, Pontus Hultén, Carl Fredrik Reuterswärd, P. O. Ultvedt and Peter Weiss. Many of AFF's members were active if only for short periods and it sometimes assisted them in making an individual film.

Parallel with AFF, Moderna Museet in Stockholm became an important forum for new experimental film. As early as 1950 Carl Nordenfalk, the National Museum's director-elect, met Hans Richter in the USA, and the National Museum arranged the showing of a series of films including avant-garde work and an exhibition that included paintings and drawings by Viking Eggeling under the title '30 years of experimental film'. To celebrate the opening of Moderna Museet a special event, 'Apropos Eggeling', was arranged there in May 1958. This featured a series of showings of avant-garde films and contemporary experimental films under the slogan 'films related to modern visual art – film as a form of artistic expression'. This was the only international event

Stills from *A Day in Town* (1955) by Pontus Hultén, Hans Nordenström and Gösta Winberg. (The Swedish word REALISATION means SALE.)

arranged for the opening of the museum. For several years before the opening, the Moderna Museet Film Club, with over a thousand members, had been arranging revivals of non-commercial films in Stockholm and the club's members now provided the basis of the new museum's public. During the 1960s film became an important part of the museum's activities and the film series 'The New American Cinema – New York Film' of 1962 is still considered to have been a major event in late-Modernist Swedish artistic life.

For Pontus Hultén, who became director of Moderna Museet in 1959, film was a part of contemporary art. He had been interested in film as a form of artistic expression since the late 1940s and in 1949, together with Hans Nordenström, he had produced *Det tryckta ordet 500 år* (500 Years of the Printed Word) in connection with that year's Gutenberg celebrations. This was no traditional documentary: it featured the letters of the alphabet in an illegible animated stream. During the 1950s Hultén lived on and off in Paris where he met the artist Robert Breer. Both saw new possibilities for film and

made *Ett mirakel* (A Miracle, 1954) a short satirical portrayal of the Pope. In *En dag i staden* (A Day in Town, 1955) by Pontus Hultén, Hans Nordenström and Gösta Winberg, the anarchic tendency is driven to an extreme and the idea of the artist as a contemporary provocateur becomes a significant feature of Swedish Modernism.

Shots of a peaceful Stockholm are mixed with humorous elements from bomb explosions, car-chases and Swedish bureaucracy. Among those who worked on this film were Jean Tinguely, Oscar Reuterswärd and P. O. Ultvedt. *A Day in Town* was made for the twenty-fifth birthday celebrations of the Europafilm company, and despite its deviation from the firm's traditional image which was built on comedies featuring such actors as Edvard Persson, it was shown in Europafilm's cinemas before the main film and was fairly successful with the public. Stylistically, *A Day in Town* has roots in classic Modernist avant-garde films like René Clair's *Entr'acte* (1924) and Russian montage-films like Dziga Vertov's *The Man with the Movie Camera* (1928–29).

Stills from *Hägringen* (Mirage) (1959) by Peter Weiss.

A good many short films influenced by Modernist art and poetry were made in Sweden during the 1950s. Many of these were individually produced and financed, adding to the conventional image of the modern artist as an individualist whose work stands in opposition to commercial industrialized mass-culture. Short films were often shown to private audiences at film clubs, museums and galleries and their world was a very long way from the world of mainstream cinema.

In 1950 Carl Gyllenberg began creating experimental narrow-gauge films including *Nonfig-Live* (1950) and *Nonfig Telefilmen Oscilloscope Movements* (1951). These short films were shown in a wide variety of connections and in 1953 several of them were toured by La Cinématèque Française. That year Gyllenberg was also given the opportunity to make a feature film for the producer Lars Burman at Metronome. This was *Som i drömmar* (As in Dreams, 1954). The writer and translator Lasse Söderberg wrote the script and the film was shot in summertime on Grönskär off Sandhamn in the Stockholm archipelago, using a silent-film camera. *As in Dreams* is based on the classic Greek myth of Prometheus, with the story developed in relation to music by Jean Sibelius and Bela Bartók, among others. The film's choreographic course is shaped through so-called form-tone circles, perception circles and emotion circles presented through drawings and schematic movement. There is no synchronized dialogue or synchronous sound but

image and music play against one another in a contrapuntal relationship. *As in Dreams* had its premiere in Stockholm in March 1954 and was also shown the same year at the Venice Film Festival. Gyllenberg got good reviews and was compared to Maya Deren and Jean Cocteau, but this was to be his only feature-length film.

The artist and writer Peter Weiss is considered the key figure in 1950s Swedish experimental film. His five films *Studie I* (1952), *Studie II/Hallucinationer* (Hallucinations, 1952), *Studie III* (1953), *Studie IV/Frigörelse* (Liberation, 1954) and *Studie V/Växelspel* (Interaction, 1955) attracted a great deal of attention. They are built up from an existential and psychological set of problems shaped through symbols and metaphors. Weiss believed strongly that large numbers of people could be reached more directly through film than through painting. But he also looked on generally accepted film structures with skepticism and preferred free subjective film. This is reminiscent of 1920s avant-garde and individualism, but it was not in modern art's formalistic use of color and form that he considered the big challenge lay.

For Weiss, art and film were a powerful force for influencing society. His *Hägringen* (Mirage, 1959) is one of the very few Swedish experimental feature-length films of any kind ever made; the only other one produced in the 1950s being Gyllenberg's *As in Dreams*. The starting point for *Mirage* was a sketch that appeared in *Biografbladet* in 1949. The same year Weiss produced *Dokument I*, which formed the basis of *Mirage*. *Mirage* is partly a subjective study, partly a critical depiction of the development of modern society. The action revolves round an alienated young man who can't find his place in the city. In an associative sequence we see the new city of Stockholm with its Hötorget skyscrapers that is gradually replacing the old city. This symbolizes the shrinking of the mental and physical space available for individual people and individual expression.

Mirage was shot during 1958–9 on raw film stock Weiss obtained from the New York periodical *Film Culture*. Altogether it cost him 30,000 kronor to make, which hit his finances hard. Critical reception was mixed and the film ran in the cinema for only a week and a half. It can be seen as a synthesis of Weiss's development as an artist and film-maker. The socially critical eye of the camera surveys the Modernist city, bringing together the poetic film-maker and the existential thinker.

Interest in film as an individual art-form is characteristic of the Modernist movement. Modernist artists, poets and composers believed in film as a self-sufficient independent art-form, 'cinéma pur,' free of theatre, filmstars and banal narrative; this belief was founded on the struggle of early modern artists to break away from outdated nineteenth-century academicism. When in the 1960s art moved in new directions and the conventional boundaries between the various art-forms became ever more relaxed, film was no longer seen as an independent self-sufficient artistic medium. It became increasingly integrated with other forms of artistic expression within new trends such as pop-art, performance-art and action art.

NOTE
1. Leif Furhammar, *Filmen i Sverige; en historia i tio kapitel* (Film in Sweden, a History in Ten Chapters), 1991, p 201.

FURTHER READING
Biografbladet (Swedish film periodical), 1945-50.
Leif Furhammar, op. cit.
Filmfront, 1953-57, Stockholm.
El Lissitzky, *Life Letters Texts*, 1968.
Louise O'Konor, *Viking Eggeling 1880-1925, Artist and Filmmaker, Life and Work*, 1971.
Henrik Orrje, *Svensk experimentell film 1945-1990* (Swedish Experimental Film), licentiate essay for Stockholm University Institute for Theatre and Film, 1994.
Peter Schifferli, *Als Dada Begann* (When Dada Began), 1957.
Philippe Soupault, *Vingt mille et un jours* (Twenty Thousand and One Days), 1980.
Peter Weiss, *Avantgardefilm*, 1956.

SÖREN ENGBLOM

HAPPY TRANSITIONS

On the Encounters between Art, Music, Dance, Poetry, and Stage in the Era of Modernism

The encounter between different genres, combined in universal works of art or as a speculation about the inner connection of the forms of art, through varied expressions, is a story that is quite unique. It may concern the origins of theatre in the Dionysian feasts of antiquity or the history of opera, but may also be about recurring, more or less artistically successful events in the era of modernism. In the best instance, a kind of happy transition in which poetry and poets, ideas, and the work of translation become the driving force behind international contacts; in which music and rhythm solder the structure together; in which the inventions of painting become scenic reality and in which wordless dance, with movement and form, sometimes sculpts and sometimes narrates a drama composed as a united whole or as a lyrical-fragmentary abstraction.

Speculations, dreams and sketches around these connections were in the air at the turn of the nineteenth century, in the Parisian symbolist theater of the 1890s, in the work of the original theoretician of stage lighting technique, Adolphe Appia, in the Russian composer Scriabin's experiments with optical color accompaniment and in that of the English solitary A. Wallace Rimmington, whose home-built light-organ was demonstrated in London in 1895. Vasily Kandinsky dreamed of a pure color drama in his text 'Über Bühnenkomposition' (on scenic composition) at the time of the German Expressionist group Der Blaue Reiter (1909). Perhaps the most vital realization was Sergei Diaghilev's Ballets Russes in Paris, with Vaslav Nijinsky's choreography (inspired by the rhythmical gymnastics of Jacques Dalcroze) for Igor Stravinsky's *Rite of Spring* (1913) as the most famous scandal. Not to mention the 1917 teamwork between Pablo Picasso, Erik Satie, Jean Cocteau and Diaghilev in *Parade*, a Dadaist ballet-varieté with dancers dressed as cubist buildings, an almost surrealist – *avant la lettre* – plot and collage-like music complete with pistol shots and the chatter of typewriters.

Then followed the period of the Ballet Suédois at the Théâtre des Champs-Elysées in Paris from 1920 until 1925. Here there was collaboration between artists: Fernand Léger,

245. *Rites* at the Royal Swedish Opera, 1960, with Björn Holmgren and Yvonne Brosset. Set designs and costumes: Lennart Rodhe, music: Ingvar Lidholm, choreography: Birgit Åkesson and Kåre Gundersen

Nils Dardel, Francis Picabia and Giorgio de Chirico; composers: Darius Milhaud, Georges Auric and Erik Satie, Gösta Nystroem and Viking Dahl; and choreographers and dancers: Jean Börlin and Carina Ari. Artistic delight in invention and a broad repertoire were the hallmarks of the ensemble, as was a mixture of avant-garde and populism in both choreography and music. The whole enterprise was led and financed by the theatre director, art collector and enthusiast Rolf de Maré.[1] One unique pioneering work in which abstract art and musical composition meet in the form of film is Viking Eggeling's *Diagonal Symphony* of 1924.

Returning home to Sweden after studying with Léger in Paris, Otto G. Carlsund – a warm admirer of Diaghilev, and deeply musical – tried to introduce the new abstract art at the Stockholm Exhibition of 1930, in a selection of neo-cubist and neo-plasticist works by both international and Swedish artists. Unfortunately it was a fiasco, which came as a bitter blow to Carlsund. However, the contacts made with figures such as the poet Gunnar Ekelöf meant that discussion of the new art was carried forward in the slowly growing welfare state in Sweden during the 1930s – in the Europe of the dictatorships a silent and gloomy decade for all radical art, including abstract modernism.[2]

Not until after the Second World War was modern art given a real chance to achieve a wider breakthrough in Sweden, and this eventually came about through a combination of strength and strategy. The breakthrough came with an exhibition at the Färg och Form gallery in 1947, showing works by artists Lennart Rodhe, Olle Bonniér, Karl-Axel Pehrson, Randi Fisher, Olle Gill, Lage Lindell, Armand Rossander, Uno Vallman, Knut-Erik Lindberg and Liss Eriksson. They eventually came to embody the concept of 'the men of 1947,' in spite of the fact that one of them was a woman. Journals like *Konstrevy, Utsikt, Fönstret, Ord och Bild, 40-tal*, and especially *Prisma* gave them space and room to develop. The Bach fantasist Carlsund – who in 1933–4 produced paintings that took the musical form of the fugue as their starting-point, but never realized a direct collaboration between artists and composers – died in 1948. He never lived to see how during the 1950s new art conquered public spaces in the new, beautiful, modern incipient welfare state. Art, music, poetry and dance met again in the late 1940s, a collaboration that bore fruit above all towards the end of the next decade. In the text that follows, the connections with non-representational abstract, so-called 'concrete' painting and modern music are set in focus. The 1950s were also a period of intense development in jazz music, whose 'natural' partner in painting is informal art – especially in its so-called 'spontaneous' form – where in both cases improvisation is the leading principle and also the uniting method. In particular, Olle Bonniér, as a practicing musician, established contact between the art and modern music of the time, especially New Orleans jazz. In a central text from 1948 he describes his pictorial compositions as 'part surface, part space – multi-space – but all these spaces are completely relative and force the eye to move on: they contain no fixed point.'[3] 'This means that the factor of time is given form in the picture.'[4] And of course, music is always extended in time. From the point of view of composition, this forms a criterion that is fundamental to the fusion of art and music. In the field of modern music Bonniér was particularly interested in the

246. Olle Bonniér's painting *Progressive Well-Tempering*, 1948, was shown at the Konkret exhibition at Galerie Blanche in Stockholm, 1949. Moderna Museet [no.167]

work of Schönberg and Edgar Varèse. As early as 1945 he wrote 'Piece of Music for the Imagination,' a work 'that can almost be described as a phonic sculpture or aleatoric sound composition.'[5]

A conversation with Professor Karin Lindegren[6] stimulated investigations concerning the cross-genre contacts between the arts during the 1950s, which she experienced at close quarters. These encounters have their origin in the circle that gathered around the journal *Prisma*, which appeared between 1948 and 1950. It was not a purely literary or art journal, but it had, as the poet and writer Erik Lindegren (Fig. 247) expressed it, 'a cultural-synthetic program.' This was evident even from the editorial committee, which consisted of the artists Eric Grate, Pierre Olofsson, Ragnar Sandberg, Egon Möller-Nielsen, and Endre Nemes; poets and authors like Lindegren, Hjalmar Gullberg, Stig Dagerman; the philosopher Ingemar Hedenius, the theatre director Alf Sjöberg and the architect Paul Hedqvist. Everything tended to favor a meeting of artistic genres, and *Prisma* became legendary, though it was short-lived. Here, in 1948, Olle Bonnniér wrote his radical conceptual analysis 'Natural Representation – Abstraction – Concretion', which came to be viewed as the manifesto of the 1947 group. Here there were meetings of texts by Igor Stravinsky and by the choreographer Birgit Åkesson; in 1949 a whole issue was devoted to contemporary free-form dance. There were articles on experimental film, and a sonata for solo flute by Sven-Erik Bäck was published as a supplement to the first issue of the journal's final year.

During this period contacts between composers belonging to the so-called Monday Group – with Karl-Birger Blomdahl pre-eminent among a group including Sven-Erik Bäck, Ingvar Lidholm, Klas-Ture Allgén (later Claude Loyola Allgén), Göte Carlid and musical historians like Ingmar Bengtsson, Bo Wallner, Magnus Enhörning and others – and the 'Forties' poets were a fact.

Originally, these groups of artists and composers had worked quite separately. In music there was a turning away from all kinds of allusions and programs, from images, narratives and tone pictures to pure, 'absolute' music, and in pictorial art there was a development of geometrical abstraction towards 'concrete art.' But with the obvious analogies between the genres that are represented by 'absolute music' and 'concrete art', the contact between visual art and music was hardly unexpected. For other reasons, too, it seems probable that they would encounter one another. Stockholm was not very large, and its cultural circles were even smaller. Furthermore, it is inevitable that those who are working in new methods and media find their way to one another; this had also been true of the first breakthrough of Modernism at the turn of the century, and around 1910. A small number of groups formed an avant-garde in a rather hostile surrounding world. One meeting-place was the Chamber Music Association, founded in 1948, which was led by the composers Carlid, Blomdahl and Bäck, and the painter Pierre Olofsson, and to whose inner circle Olle Bonniér, Karl-Axel Pehrson and Arne Jones belonged.

In April 1949 an exhibition was held at Galerie Blanche for which the composers wrote music to paintings by the concretists among the 1947 group. The young composers had each composed a section of a string quartet, the titles of whose movements referred directly to certain works by the exhibiting artists. Allgén wrote 'Concretion I,' Blomdahl 'Progressive Movement,' Bäck 'Dynamic Constellation,' Carlid wrote 'Loop Game,' and Sven-Eric Johanson 'Dancing Dot,' each of which shared its title with a work of art. At the same event a 'Dedication Suite' was given its first performance: Bäck wrote 'Préambule pour Pierre'; Blomdahl 'Ostinato for Olle'; Carlid 'Kvartander for Karl-Axel' and Sven-Eric Johanson 'Jig for Jones.' The event was unique, but came to form the beginning of collaboration during the 1950s.

The contact between the poet Erik Lindegren and the composer Karl-Birger Blomdahl grew into a collaboration that came to occupy the central focus of what was to follow. Blomdahl had studied with Hilding Rosenberg before the war and with Tor Mann after it. The music of Bach, and Paul Hindemith's contrapuntal style were of crucial importance. All of this pointed in the direction of a completely instrumental, absolute music. Thus,

the contact with Erik Lindegren's poetry involved a radical and sudden change in Blomdahl, who now began to take an interest in the role of the human voice in music. His reading of the 40 'broken sonnets' in Lindegren's first official collection *the man without a path (mannen utan väg)*[7] resulted in the oratorio *In the Hall of Mirrors*, which included nine of the sonnets. Blomdahl and Lindegren later undertook frequent collaborations, among them the opera *Aniara*, based on poems by Harry Martinson, for which Lindegren wrote the libretto, and *Herr von Hancken*, after Hjalmar Bergman's novel of 1920.

These collaborations in the field of opera were, however, preceded by the ballets with choreography by Birgit Åkesson, who had earlier produced dance without music and without narrative choreography – a kind of 'absolute dance'. The first collaboration took place as early as the summer of 1951. Lindegren and his wife were in Österlen on the south-east coast with Birgit Åkesson and the sculptor Egon Möller-Nielsen. A good deal of the choreography had already been devised, and during the autumn the rest of it grew into place in parallel with Karl-Birger Blomdahl's music and Lindegren's poem. The work came to be called *Eye: Sleep in Dream*. Birgit Åkesson writes in a memoir: 'The contrasting sections of the dance are embedded in light and darkness, the illumined and the darkened. The music flares up in the darkness and the dance responds in light[...] *Eye: Sleep in Dream* has a taut, dialogic form that emphasizes the special nature of both music and dance[...]The poem is printed in the program. The dance does not illustrate the poem. The poem shadows the dance. Poem, dance and music are woven together on their own terms.'[8]

There now followed a series of dance events: *Sisyphus* (1957) and *Minotaur* (1958), both with music by Blomdahl and librettos by Lindegren. In 1960 came *Rites*, with music by Ingvar Lidholm, libretto by Lindegren and costumes and choreography by Lennart Rodhe (Fig. 245). This was followed two years later by *Game for Eight* (Fig. 249), and here as in the next ballets the choreography was created with Kåre Gundersen; the music was by Blomdahl, and the set design and costumes by Olle Bonniér. In 1963 came *Icarus*, to music by Sven-Erik Bäck and costumes and set design by Lage Lindell (Fig. 248), and finally, in 1966, *Nausicaa Alone*, after an episode in Eyvind Johnson's *Odyssey*-paraphrase *Strändernas svall* (The Surge of the Shores), with music by Ingvar Lidholm and photographic projections by Pål-Nils Nilsson.

At this time it was common for artists to design backdrops for the performances of the Opera and the Royal Dramatic Theater. This, too, was part of what Karin Lindegren calls the 'collapse of barriers' in the 1950s, stressing that the 50s were by no means as conservative as people seem to think today. The Chamber Music Association Fylkingen – with the aim of performing and promoting contemporary music – had been started as early as 1933. In 1946 members of the Monday Group took over the running of the association. Karl-Birger Blomdahl was chairman between 1949 and 1954. The association grew in importance during the 1950s. From 1959 onwards, performances were given at Moderna Museet. The 1960s were perhaps its heyday, including appearances by the composer John Cage and the dancer Merce Cunningham, and the famous event in March 1964 when the pianist Karl-Erik Welin – by mistake, it should be noted – injured his leg when he attacked the grand piano with a chain-saw. While this is a different story from the collaboration between the Monday Group, the Forties poets and the Concretists, it was none the less a continuation of the postwar universal artistic work, with music at the center.[9]

These contacts, these happy transitions, seem to exist only in times of peace and confidence in the future, or at any rate in times when art is not being required to have a political function by a strong central power. With the strong dictatorships of the 1930s, the vital cultural life disappeared from an affected metropolis like Berlin as pioneering artists fled, if they were able to. Many ended up in the United States. In Moscow, experimental, innovative, Constructivism was killed by Stalin's cultural policies.

In Sweden, the century's great manifestation of Modernism in architecture took place with the Stockholm Exhibition of 1930. Functionalism slowly began its march to

248. Björn Holmgren in *Icarus* at the Royal Swedish Opera, 1963. Set designs and costumes: Lage Lindell, music: Sven-Erik Bäck, choreography: Birgit Åkesson and Kåre Gundersen

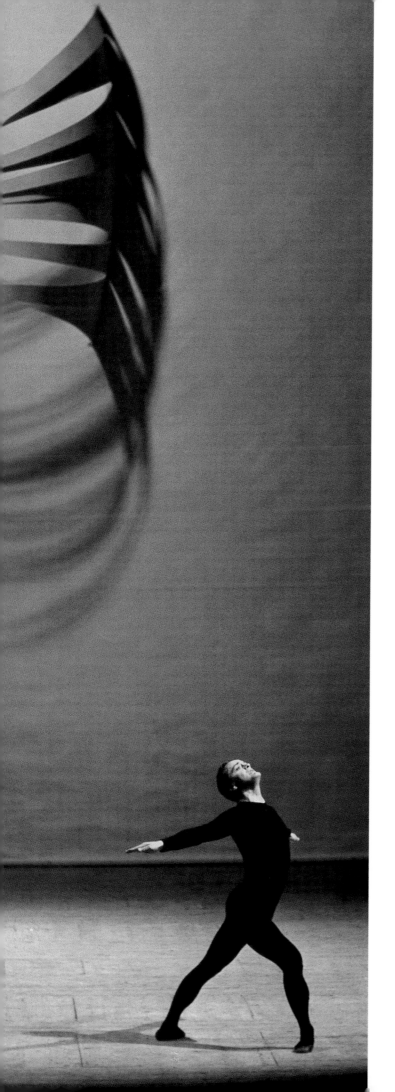

249. *Play For Eight* at the Royal
Swedish Opera, 1962. Set
designs and costumes: Olle
Bonniér, music: Karl-Birger
Blomdahl, choreography: Birgit
Åkesson and Kåre Gundersen

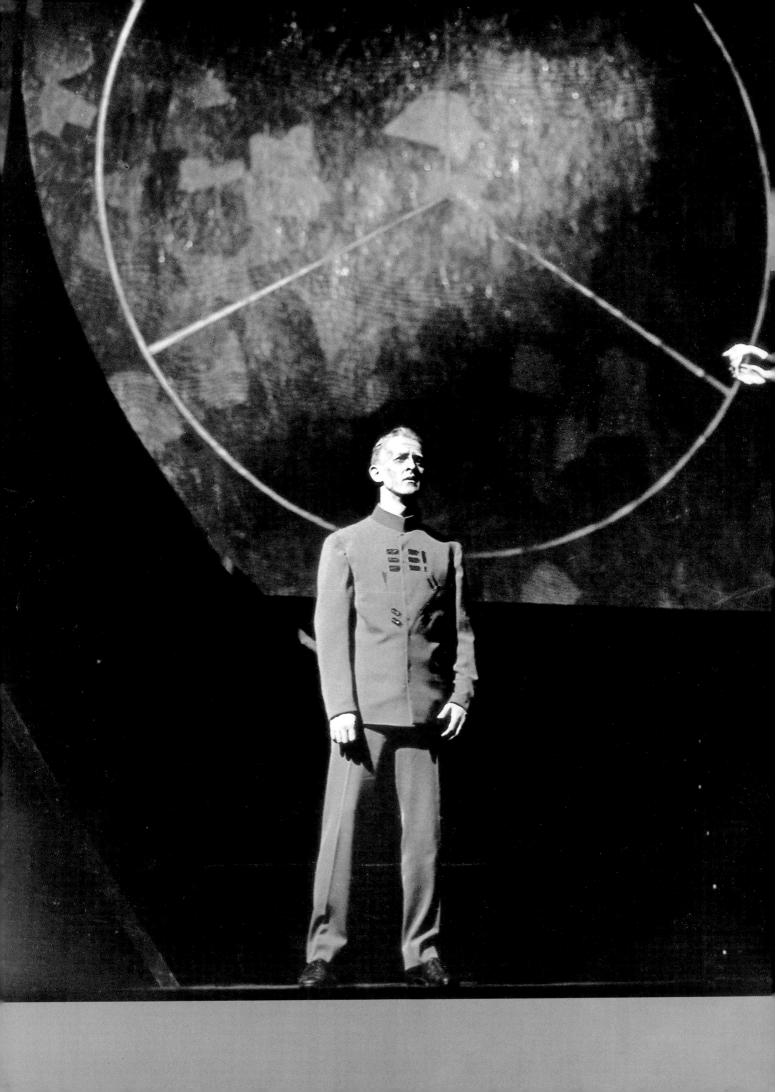

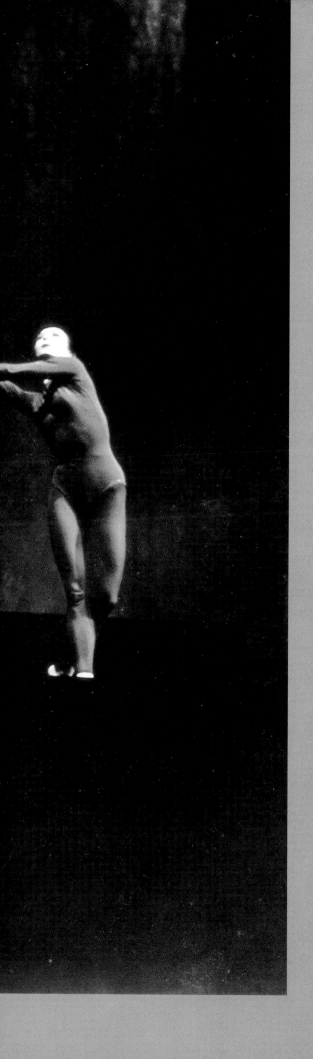

250–3. *Aniara* at the Royal
Swedish Opera, 1959. Set designs
and costumes: Sven X:et Erixson,
music: Karl-Birger Blomdahl, text:
Erik Lindegren after Harry
Martinson's verse epic. Main
picture, left: Erik Sædén as
Mimaroben; right: Loulou Portefaix
as Isagel

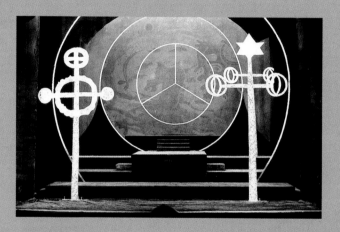

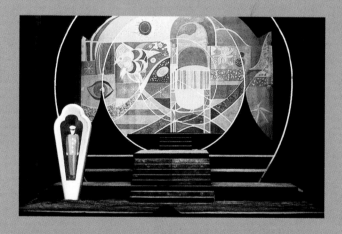

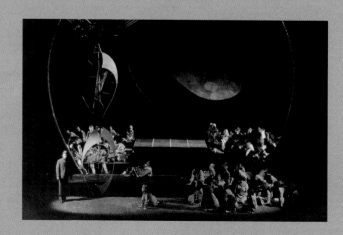

victory, but in the field of art abstract, formally strict and reduced modernism had a shaky start. It may have been that Swedes were more prepared to accept the new forms if they could be incorporated into a functional, everyday context, such as architecture or design. Abstract art had to wait until the end of the 1940s. Not until then did peace and faith in the future seem to create a more relaxed cultural climate, though the era was overshadowed by the growing threat from the Cold War. It was also a breakthrough for an international attitude – and here 'international' also means 'intellectual' – in contrast to the naivism of the inter-war years, or the patriotic poetry of wartime. But the modernity of this period is paradoxical. One who sought the balance between lived experience of darkness and marginality on the one hand, and of light, confidence in science and optimism about the future on the other – between 'Lort-Sverige' (Dirt-Sweden) and Sport-Sverige' (Sport-Sweden') – was Gunnar Ekelöf.[10] Perhaps it was mainly within music and abstract painting (rather than in architecture and design) that formal Modernism was cultivated in its pure form.

One source of cross-genre experiments in Sweden came from French poetry.[11] The translation work of poets kept open a door on the international scene even in the provincial 1930s, and a volume such as 19 franska poeter (19 French Poets), with translations by Erik Lindegren and Ilmar Laaban, published in the 'Panache' series in 1947, was widely read. It contained work by many of the French modernists: André Breton, René Char, Jean Cocteau, Paul Éluard, Michel Leiris, Henri Michaux, Saint-John Perse, François Ponge, Tristan Tzara, etc.

Important sources of cross-genre contacts may in general be sought in the Parisian theatre of the 1890s, with their many encounters on the stage between the play of shadow and light, poetry, mime and dance. But in Vienna, too, there was a meeting of visual art, literature and theatre – here were the theosophical, and later anthroposophical, movements that perhaps constituted the first interchange of artistic genres. The new, free-form dance was a particular focus of interest. What differentiates the scorned avant-garde of the turn of the century from that of the 1950s is its – for its time – strongly erotic expression, which was viewed as grossly improper, something that was also true in the 1920s. Isadora Duncan and Loie Fuller were considered not only 'liberated,' but also indecent. This is hardly something one associates with the 1950s, which in retrospect can seem overdressed, even chaste. Perhaps this factor has contributed to the decade's 'bourgeois' reputation.

Opera became the object of a lively avant-garde aesthetic during the 1950s. Its history – from the camerata in Florence to the elaborate stage designs of the Baroque, the reforming works of C. W. Gluck and the Gesamtkunstwerk dreams of Richard Wagner – came to form a source of inspiration for followers in our own time. Perhaps a little paradoxically in view of the prevalent stylistic purism, music's great Modernists have all exploited this hybrid form of art. Igor Stravinsky, possibly the most important Modernist composer, wrote The Rake's Progress (1951) and Alban Berg's Wozzeck (1925) is considered the most convincing opera of the twentieth century. Even the strict contrapuntalist Hindemith wrote an opera, Mathis der Maler (1934), the protagonist of which is the sixteenth-century painter Mathias Grünewald.

In the Swedish context – or better: on the Swedish stage – the opera Aniara is a high point probably unsurpassed in the history of the modern universal artwork (Figs 250–3). Yet it does not involve a direct analogy between image, music, poetry and stage, but is simply a high point of modern opera. Erik Lindegren based the libretto on Harry Martinson's verse epic, which had been inspired, among other things, by a meeting with the Danish nuclear physicist Niels Bohr. The work came to be called a 'revue about man in time and space.' The earth has become uninhabitable and human beings are instructed to flee. The spaceship Aniara is to take them to Mars, but a collision knocks the ship badly off course and we follow the doomed travelers who have nothing ahead of them but a slow death. Harry Martinson's original has no plot to speak of, and neither does the opera. But Lindegren's adaptation has given the work 'a clear line of action

which observer and listener can follow, and above all it possesses an arc of symphonic tension that gives the composer room for his expressive needs.'[12] On board there is an instrument, Miman, 'which captures images, language and smells from other worlds.'[13] Blomdahl's inventions in *Aniara* include tapes with both concrete and electronic material, which constitute Miman's song before it breaks down after it has reported the end of the Earth. The female pilot, Isagel, is a dance role, in choreography by Birgit Åkesson. The stage design for Stockholm Opera's premiere in 1959 was done by the painter Sven X:et Erixson. Thus, from a formal standpoint, this was not a pure modernistic solution, but the work also contains a deeply felt ambivalence towards the brave new world, in parallel with – or as a part of – the overriding apocalyptic theme. The fact that the premiere was staged in the final year of the 1950s might also be construed as significant. During the decade that followed, established Modernism would encounter a critique that in extrapolation was to throw us into our current Postmodern position.

Where the spreading of new musical expression was concerned, the Swedish Broadcasting Corporation (Sveriges Radio) came to play a central role. The composers of the Monday Group were immediately able to disseminate their music by means of radio broadcasts, and gradually a number of them came to occupy positions at Sveriges Radio. Writers had the journals at their disposal, but artists only had a small number of galleries that were interested in the new art, and possibly Liljevalchs Konsthall. It was partly in response to this that Moderna Museet took shape. When the professor and artist Otte Sköld took up the position of curator at the Nationalmuseum in 1950, there was already a plan to house modern art in a separate building, and in 1953 the Friends of Moderna Museet association was formed. When the museum was finally opened in 1958, it did so in the context of the increasingly lively art world of the late 1950s. There was as yet no House of Dance, or Swedish Film Institute or Cultural House in Stockholm. Fylkingen had no premises of its own, as it does today. Consequently, the new museum on Skeppsholmen became a focus for all of the arts, and by the early 1960s the flow of new expressions and contacts between the arts were established in a way that had not been known before. Another chapter, happenings and pop art, took up where the cross-genre works of the 1950s had left off. This continued until 1968, when politics, student revolt and the Vietnam War produced a different attitude in the arts. Thus, the era we have discussed here embraces a period of twenty years: from 1948, when *Prisma* was started, until 1968. Then art was once again required to put itself at the service of political slogans. And, for the moment, the time of happy transitions was over.

NOTES

1. The survey presented in the introduction is based on Gösta M. Bergman, *Den moderna teaterns genombrott* (The Advent of Modern Theatre), 1966.

2. For further reading, see Teddy Brunius, Ulf Thomas Moberg (ed.) *Om och av Otto G. Carlsund* (About and By Otto G. Carlsund), 1989.

3. 'Naturavbildning, abstraktion, konkretion – en begreppsutredning' (Natural Representation, Abstraction, Concretion – a Conceptual Analysis), *Prisma* no.2, 1948.

4. Thomas Millroth, *Rum utan filial?* (Room Without Branch?), 1977.

5. Thomas Millroth, *Olle Bonniér. Och varför inte dansa?* (Olle Bonniér. And Why Not Dance?) SAK publ. 104, 1995.

6. Karin Lindegren studied art history at Lund with Professor Ragnar Josephson; married to the poet Erik Lindegren (d. 1968); curator at Moderna Museet during the 1960s and early 70s; editor of *Konstrevy* 1960–5; Swedish Cultural Attaché in Bonn 1970s; Director of Moderna Museet 1978–80; secretary of the Royal Academy of Art 1980s; and recently, chairperson of the Friends of the Architectural Museum association.

7. Lindegren had published *Posthum ungdom* (Posthumous Youth) in 1935, but later disowned it.

8. Birgit Åkesson, *Den skapande akten* (The Creative Act), *Artes*, no. 3, 1992.

9. For a more detailed account of the 1960s at Moderna Museet, see Leif Nylén, *Den öppna konsten* (Open Art), SAK publ. 1998.

10. Gunnar Ekelöf, 'Styggsvensken' (The Stubborn Swede), from *Utflykter* (Excursions), 1941.

11. See Charles Baudelaire, *Correspondances* for examples of words being transformed into images: 'luxe, calme et volupté' from *Invitation au voyage* became Matisse's motto; Stéphane Mallarmé's 'L'après-midi d'un faune' became a symphonic poem by Debussy, as well as a work of the Russian Ballet. Or Rimbaud, whose poetry might be seen as pointing towards surrealism in film and painting, but possibly also towards instrumental poetry, abstract art and music.

12. Rabe, Hellqvist, Estrén, *Opera*, 1966.

13. Ibid.

SELECT BIOGRAPHIES

Jenny Håkansson Hedberg

Abbreviations that appear frequently in the biographies:

GAN initials by which Gösta Adrian-Nilsson was known as a painter; see his entry below.

HSB (Hyresgästernas sparkasse och byggnadsföreningarnas riksförbund) – National Association of Tenants' Savings and Building Societies (i.e. national housing co-operative)

KF (Kooperativa förbundet) – Co-operative Union and Wholesale Society.

KTH (Kungliga tekniska högskolan) – Royal College of Technology.

NK (Nordiska Kompaniet) – a leading department store.

CARL-AXEL ACKING (1910–2001)

Architect and interior designer. Trained as a furniture designer at College of Industrial Art Stockholm 1934. Professor at College of Technology in Lund 1964–76, cathedral architect in Lund 1970–77. Extensive experience as a designer of furniture and interior fittings for both public buildings and homes. Interior designer for KF and Gunnar Asplund's architectural studio; designed standard furniture for the Bodafors Swedish Furniture Factories, NK and KF.

GÖSTA ADRIAN-NILSSON (1884–1965)

Signature GAN. Trained in Copenhagen, Berlin and Paris. At first strongly influenced by Futurism, but later adopted a more Cubist style. His late paintings are entirely non-figurative. From 1912 spent a considerable period in Berlin in the avant-garde circle round Herwarth Walden and 'Der Sturm.' Exhibited at gallery of the same name 1915. Conducted showings of Bruno Taut's Glashaus at the Werkbund Exhibition, Cologne 1914. Resident in Paris 1920–25. Wrote *Den Gudomliga Geometrien* (Divine Geometry) 1921. Contributed five plane-geometry works to 'Art Concret' Exhibition in Stockholm 1930.

HAKON AHLBERG (1891–1984)

Ran own architectural studio 1917–73. Taught at KTH 1918–28. Force behind foundation of SAR (National Federation of Swedish Architects) 1936, chairman till 1945. Editor of journals *Arkitektur* 1921–2 and *Byggmästaren* (Masterbuilder) 1922–4. Important works: Brännkyrka vicarage and parish hall 1917–20, Mälarhöjden chapel 1928, Hjorthagen residential estate 1934–40 and Masonic orphanage in Blackeberg 1928–31, all of these in Stockholm; Industrial Art pavilion at Gothenburg Exhibition 1923, Brunnsvik primary school 1928–50, Sidsjö mental hospital in Sundsvall 1939 and main building with sifting works and administrative office for LKAB company in Kiruna 1953–60.

ERIK AHLSÉN (1901–88) & TORE AHLSÉN (1906–91)

Associated with KF architecture studio from 1926 and 1929 respectively. Freelance from 1936, though Erik continued with KF parallel with his freelance work till 1946. Homes, large central buildings, meeting halls. Often worked with artists. Great influence on postwar architecture. Important works: Årsta centre 1944–54 and PUB department store 1948–60, both in Stockholm; bishop's residence in Gothenburg 1954–7, Krämaren department store etc in Örebro 1955–63 and Örebro civic centre 1957–65.

NILS AHRBOM (1905–97)

Professor of Architecture at KTH 1942–63. Shared architectural studio with Helge Zimdal 1932–50, after which ran own studio 1950–80. Editor of *Byggmästaren* 1934–6. Important works: Sveaplan gymnasium (i.e. upper school) 1935, Eriksdal school 1937 and Skanstull gymnasium 1943 all in Stockholm; Linköping museum 1939, KTH extension 1944–61, plus Swedish embassy buildings in Tokyo 1959, Ankara 1961, Peking 1971 and Cairo 1976.

UNO ÅHRÉN (1897–1977)

One of Modernism's most important advocates, debaters and theorists in Sweden. Driving force behind the Stockholm Exhibition 1930 and the manifesto *acceptera* (accept, 1931). Edited journal *Byggmästaren* (The Master Builder) 1929–32. Director of Town Planning Gothenburg 1932–43, Director of Swedish National Construction 1943–5. Member of several national committees of inquiry including Housing Social Inquiry 1933–47 and General and Regional Planning Commission 1948–68. Professor at KTH 1947–63. Important works: Flamman cinema 1930 and College of Technology union building (with Markelius, 1930). As Director of Swedish National Construction responsible for Sweden's first planned community center at Årsta.

OSVALD ALMQVIST (1884–1950)

Wide-ranging activity including furniture, street furniture, town planning and research. Developed standard Swedish kitchen 1922–34. His power station buildings broke new ground. Planner of public gardens in Stockholm 1936–8, town planning architect in Södertälje 1940–48. Important works: Town plan and workers' homes for Bergslagsby in Borlänge (1915), Hammarfors and Krångfors power stations (1925–8) and vocational school in Domnarvet (1931–2).

Published *Praktiska och Hygieniska Bostäder* (Practical and Hygienic Homes) 1921.

ALBIN AMELIN (1902–75)
Studied at School of Technology 1918–21. His paintings often had social and agitprop content. First exhibited 1929 at Swedish-French Gallery in Stockholm. Joined Communist party same year. Helped found artists' association 'Färg och Form' (Color and Form) 1932. Editor of journal *Mänsklighet* (Humanity) 1934. Exhibited in Moscow 1937 at the Museum of West-European Art.

ANCKER GATE LINDEGREN ARKITEKTER
Stig Ancker (1908–92), Bengt Gate (1909–88) and Sten Lindegren (1906–89) worked together from 1936, designing housing estates, offices and public buildings. Important works: homes at Torsvikshöjden in Lidingö 1943, Anckerbyn in Haverdal 1954, Gröna gatan in Uppsala 1955 and Norra Kvarngärdet in Uppsala 1963.

FOLKE ARSTRÖM (1907–97)
Industrial designer and painter. Design consultant for a series of Swedish companies. From 1940s to 1960s designed stainless cutlery for Gense, including 'Focus' 1955.

ERIK ASMUSSEN (1913–98)
Born in Copenhagen, moved to Sweden 1939. Employed by David Helldén and Nils Tesch. Own architectural studio from 1960. Principal Swedish anthroposophical architect, designing a series of Waldorf schools in Sweden and elsewhere. Important works: Kristofferskolan (Christopher School) in Bromma 1965–7; followed by Kulturhuset (arts center) 1992, college buildings 1973 – and Vidar clinic 1985–92, all in Järna.

GUNNAR ASPLUND (1885–1940)
One of those who protested against the conservatism of the Academy of Art by joining the Klara School in 1910–11. Editor of *Arkitektur* 1917–20, Professor of Architecture at KTH from 1931. During 1920s achieved a special position in Scandinavian architecture, becoming a principal source of inspiration for twenties Neoclassicism and the breakthrough of Functionalism. Principal architect for the Stockholm Exhibition of 1930. Important works: Stockholm City Library 1920–27, Villa Snellman in Djursholm 1917–18, Skandia cinema in Stockholm 1922–3, Town Hall extension in Gothenburg 1913 and 1934–7 and Skogskyrkogården (Forest Cemetery) in Stockholm 1935–40.

SVEN BACKSTRÖM (1903–92)
Employed in KF architectural department 1929–32. Briefly with Le Corbusier 1932–3 and Hakon Ahlberg 1934–5. Assistant to Gunnar Asplund at KTH during 1930s. Editor of *Fyrtiotalets svenska bostad* (Swedish Homes of the 1940s) 1950. Shared architectural studio with Leif Reinius 1936–92 (see under Reinius for important works).

OLLE BAERTLING (1911–81)
Painter and sculptor, originally banker. Studied with André Lhote and Fernand Léger in Paris. Geometrical non-figurative painting and sculpture. Horizontal-vertical compositions, later working towards so-called 'open form'. Exhibited 1954 at Galerie Denise René, Paris. Represented Sweden at São Paulo Biennial 1963. In 1959–60 produced mural composition for entrance hall of first high-rise building in Stockholm's new 'City' center.

ELIS BENCKERT (1881–1913)
Gained experience in Ragnar Östberg's studio. Despite the brevity of his career achieved one of the most consistent expressions of the early twentieth-century urge for simplification. Forerunner of the Neoclassical tendencies of the second decade of the century. Important works in the Stockholm district: Villa Lagercrantz in Djursholm 1910, Villa Thiel in Saltsjö-Duvnäs 1912.

GUSTAF ADOLF BERG (1891–1971)
Furniture and industrial designer. Designed refrigerator for Electrolux and furniture for the Harald Westerberg company. Self-employed 1933–44 with studio, workshop and shop in Stockholm. Developed ergonomically designed chairs.

CHRISTIAN BERG (1893–1976)
Sculptor and until 1924 painter. One of the pioneers of abstract sculpture in Sweden, producing figures in burnished metal and marble, etc. Studied at Althin's painting school 1911–13 and Academy of Art 1915–19. Lived in Paris 1924–30. In 1925 came in contact with the 'Halmstad Group' which led him to Post-cubism. Took part in 1930 'Art Concret' exhibition in which he was described as Post-cubist.

CARL BERGSTEN (1879–1935)
Architect and designer. Graduated from KTH 1901 and completed architecture course at the Academy of Art 1903. Taught at Klara School 1910–11. Edited journal *Arkitektur*, for which he also wrote many articles, 1912–15. Head of furniture department at NK 1917–21 and Professor at Academy of Art from 1931. Important works: exhibition building in Norrköping 1906, Hjorthagen church in Stockholm 1904–9, Liljevalch's art gallery 1913–16 and Gothenburg municipal theater 1927–35.

SIGVARD BERNADOTTE (b. 1907)
Silversmith, industrial and graphic designer. Employed by Georg Jensen in Copenhagen from 1930. From 1950 to 1964 ran Bernadotte and Bjørn design agency (with the Danish architect Acton Bjørn). Designed products for a series of Swedish and international firms. Founded Bernadotte Design 1964.

HOLGER BLOM (1906–96)
Town planner; head of park planning for Stockholm city 1938–71. Effected a comprehensive expansion of Stockholm's parks, especially in the suburbs. This resulted in a new style of park and the so-called 'Stockholm school,' which regenerated Swedish landscape design and gave it an international reputation. Also a committed debater on the subject of city buildings.

FERDINAND BOBERG (1860–1946)
One of Sweden's most highly regarded architects around the turn of the century. Possessed great decorative talent, also prolific designer of furniture and objects for practical use. Important works: several buildings for the Stockholm Exhibition of 1897, fire stations in Gävle 1889–91 and Rosenbad 1899–1902, Thiel Gallery in Stockholm 1904–5, Church of the Revelation in Saltsjöbaden 1910–13 and Nordiska Kompaniet department store in Stockholm 1912–15.

OLLE BONNIÉR (b. 1925)
Trained at School of Technology and Isaac Grünewald's school of painting in Stockholm. Study trips to Denmark, Switzerland, Italy and France 1946–8. A 'Concretist' member of the 'Men of 1947.' His early style is plane-geometric and his color-range often black, white and gray; his 'Concrete' compositions derive from mathematics and geometry. Exhibition at Galerie Denise René, Paris 1953. At present active in New York and Mexico.

HELMER BÄCKSTRÖM (1891–1964)
Amateur photographer and historian of photography. Sweden's first Professor of Photography (at the Royal College of Technology 1948–58). His collection (now in Moderna Museet) comprises photographs from the earliest days of photography to the 1940s. Bäckström was one of the first to research the history of photography in Sweden. Member of Fotografiska Föreningen (Photographic Association). Editor of comprehensive three-volume work *Fotografisk Handbok* (Handbook of Photography). Main organizer of the photographic exhibition 'Det nya ögat – Fotografien 100 år' (The New Eye – A Hundred Years of Photography) at Liljevalch's Art Gallery, 1939. Photographed in both pictorial and new objective styles.

OTTO G. CARLSUND (1897–1948)
Studied in Paris from 1924 with Fernand Legér and Amédée Ozenfant. Inspired by Cubism and later by Purism. In contact with Piet Mondrian 1927, when he began to paint according to the rules of Neoplasticism. In 1929 in Paris among those who founded the 'Art Concret' group, which advocated non-figurative plane-geometric painting. Arranged the 'Art Concret' section at the 1930 Stockholm Exhibition. Member of 'Abstraction–Création' group, in Paris 1932.

PETER CELSING (1920–74)

Practical experience with Ivar Tengbom and others. Employed by Stockholms Spårvägar (Stockholm Rail Transport) as architect for underground stations 1948–52. Worked with Lewerentz on restoration project at Uppsala Cathedral 1951–5. Professor at KTH 1960–69. Best known for church-building and the reconstruction of Stockholm city center. Important works: Stockholm Kulturhus (Cultural House) 1965–76, Stockholm Film Centre 1964–70, Härlanda church in Gothenburg 1952–9, St Thomas's church in Vällingby 1953–9, Riksbank (National Bank of Sweden) in Stockholm 1965–76.

ERIK CHAMBERT (1902–88)

Furniture designer and painter. Artistic director of Chambert family firm (furniture factory) in Norrköping. Worked in craft tradition. Inspired by austere idiom of Functionalism. Began painting in the 1940s.

AGNES CLEVE (1876–1951)

Studied with Carl Wilhelmson at Valand school of painting in Gothenburg around the turn of century and with Henri Le Fauconnier in 1914 at Académie de la Palette, where she adopted a Cubist idiom. After contact with Vassily Kandinsky and his wife Gabriele Münter, who came to Sweden during the First World War, her work became more overtly Expressionist. Unlike the pupils of Matisse, she seldom exhibited. Married to the artist John Jon-And.

GUSTAF W:SON CRONQUIST (1878–1967)

Civil engineer. A pioneer of color photography, he produced Sweden's first example of this in 1907 by the autochrome process, after experiments conducted with the photographer John Hertzberg. Undertook long lecture-tour of USA 1947–8. During a trip to Germany in 1930 was influenced by 'New Objectivity' (Neue Sachlichkeit).

EWALD DAHLSKOG (1894–1950)

Ceramicist, glass designer and painter. Best known for models for intarsia decoration. Worked at Kosta glassworks 1926–9 and Boberg's Faïence factory 1929–50.

NILS DARDEL (1888–1943)

Studied at College of Art 1908–10. From 1910 mainly active in Paris. Attended Matisse's academy but only for a short time, preferring private study. In Paris influenced by Cubism. Associated with the circle round the Germans Wilhelm Uhde and Alfred Flechtheim at Senlis, north-east of Paris. Exhibited with 'De Åtta' (The Eight) in Stockholm 1912. Study trips in the 1920s and 1930s included North Africa, Mexico and Sicily. Artistic consultant to Swedish Ballet in Paris 1920–25. Characteristic of Dardel's naive painting are his dandy motif and an imaginative fantastic idiom.

SIRI DERKERT (1888–1973)

Painter and sculptor. Studied at Althin's school of painting 1908 and at Academy of Art 1911–13. 1913–14 in Paris, where she quickly took up Cubism. Derkert's major breakthrough did not come till 1944, at Stenman's gallery in Stockholm. From 1916 to 1925 she worked intermittently as a fashion designer. Created the Feminism and Peace wall for Östermalmstorg underground station in 1963–5 and the 'Women's Pillar' for T-centralen (Stockholm's central underground station) in 1957–8.

INGRID DESSAU (1923–2000)

Textile artist and industrial designer. Employed by Kasthall carpet factory 1954–78 and Kinnasand 1970–84. Created textiles for many public interiors.

VIKING EGGELING (1880–1925)

Pioneer of abstract film and Cubist painting and drawing. Active principally in Paris, Switzerland and Germany. Studied art in his free time while working as accountant and later as a teacher and librarian. Influenced by Cubism in Paris 1911–15. Came in contact with Dada in Switzerland 1915–21. Took part in Dada exhibition at Cabaret Voltaire in Zurich 1916. Worked with Hans Richter, moved to Berlin 1921. *Vertikal-horisontal-mässa* (Vertical-Horizontal-Mass, 1919) and *Diagonalsymfoni* (Diagonal Symphony, 1924) were the first non-figurative works in the history of film.

YNGVE EKSTRÖM (1913–88)

Furniture designer. Together with brother Jerker Ekström founded in 1945 the firm Ese Möbler (Ese Furniture), which in 1960 became Swedese Möbler AB, Vaggeryd. Best known for 'Lamino' easy chair 1956.

OLLE ENGKVIST (1889–1969)

Major building contractor, active from 1922. Long Sweden's leading building entrepreneur through his company 'Bygg Oleba.' Member of state commission investigating social aspects of housing 1933–47. Worked with architects Backström and Reinius. Important works: Terraced houses in Ålsten 1932, 'Slender' houses in Hjorthagen 1934–7, Hässelby 'family hotel' 1955; also Smaragden (Emerald, collective residential building for women) 1938, Elfingegården in Alvik 1940 and star-shaped and terraced residential buildings and tower blocks in Gröndal 1945–52.

LEANDER ENGSTRÖM (1886–1927)

Studied at Artists' Association's school 1907 and with Matisse in Paris 1908–9. Member of groups 'De Unga' (The Young) together with other Swedish pupils of Matisse, and 'De Åtta' (The Eight). Best known for Norrland scenes painted in strong colors. Breakthrough at Baltic exhibition 1914 in Malmö. Took part in 'Yngre svenska konstnärer' (Young Swedish Artists) exhibition at Liljevalch's 1918.

NILS EINAR ERIKSSON (1899–1978)

Employed by Gunnar Asplund, among others. Freelance Stockholm 1930–32 and then in Gothenburg. Worked with Asplund at Stockholm Exhibition 1930. Important works: Gothenburg concert hall 1935, Community center in Gothenburg 1949, Skansen music pavilion 1938, Torpa housing estate 1948, Tiden publishing house in Stockholm 1929.

SVEN 'X' ERIXSON (1889–1970)

Studied at Academy of Art 1922–3. Co-founder of and a driving force in 'Färg och Form' (Color and Form) group. Combined influences from primitive folk art with a naïve style, often bordering on the fantasy of folksong and fairytale. His work also shows influence of German Expressionism and depicts social reality with a strong social conscience. In his painting, 'X' aimed for a more 'genuinely Swedish' form of expression than that offered by the Swedish pupils of Matisse. Professor at Academy of Art 1943–53.

RALPH ERSKINE (b. 1914)

Studied architecture in London 1931–7. Freelance architect in Sweden from 1942. Many international commissions. Many Swedish and international awards including RIBA Gold Medal for Architecture 1987. Important works: Library, main building and Law building for Stockholm University at Frescati 1974–90, Luleå shopping center 1954, residential blocks etc in Gryttorp 1945–55, Tappström on Ekerö 1983–9, tourist hotel in Borgafjäll 1948.

TURE E:SON (ERIKSSON) (1903–79)

Advertising and portrait photographer. Employed 1924–37 by Åhlén & Åkerlund. Set up Studio E:son in Stockholm 1937. Portraits of actors from film and theatre and artists in 'new objective' style. Active in USA 1949–58. Younger brother of artist Sven 'X' Erixson.

UNO FALKENGREN (1889–1964)

After apprentice years with Werner Lindhe in Linköping moved in 1910 to Stockholm where he gained experience with John Hertzberg. Worked with portrait-photographer Nicola Perscheid in Berlin 1913. Active in Sweden as a portrait-photographer in 1910s and 1920s, with own studio from 1918. First photographer to work for Nordiska Kompaniet department store. Pictorialist in style.

ANDREAS FEININGER (1906–99)

Born in Paris and grew up in Germany. Studied architecture at Bauhaus school of arts and crafts. Resident in Sweden 1933–9 rapidly becoming a leading photographer of architecture together with C. G. Rosenberg and Sune Sundahl. Feininger photographed the developing welfare state in 'new objective' style. His work was reproduced in the book *Stockholm, 1936.* Left for USA on last ship before the outbreak of war. In the USA he worked for the Black Star picture agency and joined *Life Magazine* in 1943.

RANDI FISHER (1920–97)

Born in Australia. Studied at College of Art, Crafts and Design 1937–8 and Academy of Art 1939–44. Only woman to exhibit at 1947 'Ung konst' (Young Art) exhibition at 'Färg och Form' (Color and Form). Regarded as a member of the Concretist group 'Men of 1947.' Did both figurative and abstract work, often for public places.

FERDINAND FLODIN (1863–1935)

Best known as a portrait-photographer. Inspired by early English and Scottish photography and by pictorialist idiom. Worked in USA 1885–9, first as assistant to William Notman, then in his own studio outside Boston. Returned to Sweden in 1889, establishing himself in Stockholm where his studio was exceptionally successful.

FRED FORBAT (1897–1972)

Born in Hungary, studied at Bauhaus 1920–22. Architect in Berlin 1925–32 and Hungary 1934–8. General planning work in Soviet Union 1932–3. Fled to Sweden in 1938 with help of Swedish colleagues. Town planning architect in Lund 1938–42. Employed by Egler's town planning agency in Stockholm 1945–69. Also active as an artist. Important works in Sweden: town–planning of Borgmästaregården housing development in Lund, town-planning of HSB housing estate on Reimersholme 1942–6, general town plan for Skövde 1949.

EINAR FORSETH (1892–1988)

Painter and ceramic designer. Studied at Swedish Society of Craft and Industrial Design school and Academy of Art. Professor 1962. Worked with glass-painting and mosaics. Designed ceramics for Rörstrand during the 1920s.

ARVID FOUGSTEDT (1888–1949)

Studied at School of Technology in Stockholm 1906–7. In Paris 1911–17; spent a short time at Matisse's academy, but deciding on a more classical approach adopted a more naturalistic form of painting. First exhibited 1919, becoming a standard-bearer for 'New Objectivity' in the 1920s. Professor at Academy of Art 1937–47.

JOSEF FRANK (1885–1967)

Architect and designer. Studied at College of Technology, Vienna, 1908. Proprietor with Oskar Wlach of interior design firm Haus und Garten (House and Garden) 1925–33. Played a leading part in Central-European Modernism till forced to emigrate in 1933. Living in Stockholm from 1933, working principally with furniture, textiles and interior decoration for Svenskt Tenn. Contributed to 'Weissenhofsiedlung' housing exhibition in Stuttgart 1927 and principally responsible for 'Werkbundsiedlung' housing exhibition in Vienna 1932. Designed five villas in Falsterbo 1924–36.

ERIK FRIBERGER (1889–1968)

Town planning architect in Gothenburg 1921–6. Freelance in Gothenburg from 1927. Chairman of Association of Provincial Architects 1933–8. Designed prefabricated holiday cottages for Fritiden (Leisure Time) exhibition, Ystad 1936. Important works (all in Gothenburg): HSB building in Betel district 1934, Munkebäcksgatan terraced housing 1934 and Villa Lange 1938.

SIMON GATE (1883–1945)

Artist in glass and painter. Studied at College of Arts, Crafts and Design and Academy of Art. Began work as designer at Orrefors glassworks 1916, where with Edward Hald he initiated modern Swedish glass design. Developed 'graal' technique and engraved glass.

LÉONIE GEISENDORF (b. 1914)

Born in Switzerland and studied at ETH in Zurich. Employed by Le Corbusier. Came to Sweden 1938, employed by Sven Ivar Lind, Paul Hedqvist and KF architecture department. From 1950 freelance together with her husband Charles Edouard Geisendorf. Worked in the spirit of Le Corbusier. Important works: Villa at Ranängen in Djursholm 1951, terraced housing in Bagarmossen 1956 and St Göran Upper School, Stockholm 1961.

ERIK GLEMME (1905–59)

Landscape-architect and architect. Worked full-time at Stockholm Park Administration department 1936–56. One of the principal figures of the so-called Stockholm School, whose aim was to interpret and stylize the local Mälaren landscape in an artistic manner for the city's park areas. Worked on parks, squares, kiosks and other features of Stockholm city environment.

HENRY BUERGEL GOODWIN (1878–1931)

Born in Germany. Active mainly as a portrait-photographer. Pioneer pictorialist, opened Kamerabild studio in Strandvägen, Stockholm, 1914. His portrait photographs often appeared in the weekly press. Some were also published in the books *Konstnärsporträtt* (Portraits of Artists) 1917 and *Anders de Wahl* 1919. Contributed illustrations to *Nordisk Tidskrift för Fotografi* (Nordic Journal of Photography), 1916.

ERIC GRATE (1896–1983)

Sculptor and painter. Studied at Althin's school of painting 1916 and from 1917 on the sculpture course at the Academy of Art. Study trips to Denmark, Germany, France and Greece. Lived in Paris 1922–33. Teacher and Professor of Sculpture at Academy of Art 1941–51. His prolific output was influenced by Surrealism, Classicism and Expressionism. He was often inspired by nature and made use of so-called 'objets trouvés.'

ISAAC GRÜNEWALD (1889–1946)

Studied at Artists' Association school 1905–8 and with Matisse in Paris 1908–11. Member of the 'De Unga' (The Young) group of artists who first exhibited in 1909 and later of 'De Åtta' (The Eight) who exhibited in 1912. Aimed to create a 'feast for the eyes' with two-dimensional decorative Expressionism in powerful colours. In 1913 submitted a design for decorating the Wedding Room in Stockholm Town Hall, but this was never used. Exhibited at Der Sturm gallery in Berlin 1915. Principal Designer at Swedish Opera 1920s. Teacher and Professor at Academy of Art 1938–42. Ran his own school of painting in Stockholm 1942–6. Married to the artist Sigrid Hjertén.

TORBEN GRUT (1871–1945)

Employed by I. G. Clason 1893 and 1896. Edited journal *Arkitektur* 1904–7. Designed Stockholm Stadium for the 1912 Olympic Games in a spirit of National Romanticism, using as his model the town walls of Visby. Subsequently specialized in sports structures.

VIOLA GRÅSTEN (1910–94)

Textile artist and designer. Worked for Friends of Finnish Handicrafts 1944–5 and for NK's textile department 1945–55. Art director for fashion textiles with Mölnlycke 1965–73. Known for hooked rugs strong in color and design and printed textile designs.

ELSA GULLBERG (1886–1984)

Textile artist. Trained at College of Industrial Art. Head of Swedish Society of Craft and Industrial Design intermediary agency for establishing contacts between artists and industry 1917–24. In 1927 founded Elsa Gullberg Textiles and Interiors and worked with the artists Märta Afzelius, Vicke Lindstrand, Carl Malmsten, Alf Munthe and Arthur Percy.

CURT GÖTLIN (1900–93)

Practical experience with photographer K. L. Lindelöw in Norrköping and later with Petrus Pramm in Karlstad. Went to Berlin 1925 to study with portrait-photographer Nicola Perscheid. Own studio in Örebro from 1927. Worked mainly as a portrait-photographer. For many years active within Swedish Photographers' Federation as chairman, teacher and course leader. Photographed in both pictorialist and 'new objective' styles.

ERIK HAHR (1869–1944)

Own architectural business in Stockholm from 1897. Town architect in Västerås 1909–35. Known as an industrial architect for the buildings he designed for ASEA and workers' housing. Important works: ASEA head office 1916–19 and Gothenburg College (with Torulf) 1907; also Mimer works 1911–15, workers' apartment blocks Kåre, Julius and Oscaria 1917 and other apartment blocks, villas, schools, etc, all in Västerås.

EDWARD HALD (1883–1980)

Painter and designer of glass and ceramics. Active at Orrefors glassworks from 1917; director 1933–44. Professor 1954. Studied painting in Paris with Matisse. Hald's greatest achievements were in industrial art through his work for Orrefors, Rörstrand and Karlskrona Porcelain. Best known for having created with Simon Gate a modern Swedish idiom in glass which achieved international fame.

OSCAR HALLDIN (1873–1948)

Pioneer press-photographer, active at the 1906 Olympic Games in Athens and the Stockholm Exhibition of 1930. His balloon-trips with a large camera over Stockholm and Gothenburg are legendary. Director of Axel Lindahl's photographic business in Stockholm from 1898. An active member of Swedish Photographers' Federation for twenty-five years.

PER OLOF HALLMAN (1869–1941)

Taught town planning at KTH 1897–1932. Together with Fredrik Sundbärg won first prize in town-planning competition for Gothenburg 1901; this represented the breakthrough in Sweden of the new town-planning ideas introduced by the Austrian Camillo Sitte. Director of town planning, Stockholm, 1922–7. Important works: Town plans for Lärkstaden, Enskede, Blecktorn Park, Rödabergenlen district and Helgalund in Stockholm plus various town planning projects throughout Sweden.

ERIC HALLSTRÖM (1893–1946)

Pioneer naive painter together with Gideon Börje, Hilding Linnqvist and Axel Nilsson. Studied at Carl Wilhelmson's school of painting 1912. Study trips in the 1920s included Italy and Paris. His paintings, characterized by strong colors and narrative features, often portray small-town life. First exhibited at Ciacelli's new gallery in Stockholm, 1918. One of the forces behind the 'Color and Form' group, 1932.

AGNES HANSSON (1888–1961)

By profession a nurse, employed at the 'Mjölkdroppen' (Milkdrop) child welfare clinic in Adolf Fredrik parish, Stockholm. An amateur photographer, she was active in the Photographic Association. Interested in social questions; photographed children but also took photographs on walking tours in the hills. Her work attracted considerable interest in photographic circles during the 1930s. Documentary, 'new objective' style.

PAUL HEDQVIST (1895–1977)

Employed by Ragnar Östberg and Cyrillus Johansson. Own architectural studio from 1921. A leading designer of schools. Professor of Architecture at College of Art 1938–48, chairman of Stockholms Skönhetsråd (Stockholm Aesthetic Advisory Board) 1948–60. Important works in Stockholm: Katarina Secondary School 1928–31, Västerbron (Western Bridge) 1931–5, terraced housing in Ålstensgatan 1932, waterworks on Lovö 1932, Traneberg bridge 1933–5, Vanadis baths 1936, Bromma aerodrome 1936, and office premises for *Dagens Nyheter* newspaper 1960–64.

BJÖRN HEDVALL (1889–1982)

Self-employed from 1921. Chief architect at Navy headquarters 1939–43. Mostly active in Stockholm, but also in Linköping, Eskilstuna and Karlstad. Important works in Stockholm: Metropol Restaurant 1926, Eden Hotel 1928–30, housing at Norr Mälarstrand 20 1931, Paraden Cinema 1932, club and restaurant premises inside Konstnärshuset (Artists' Centre) 1932, Ängby Church at Blackeberg 1959.

EMIL HEILBORN (b. 1900)

Photographer principally active within industry and advertising. Some forty major Swedish firms commissioned work from him. Used dramatic perspectives and diagonals in 'new objective' style. Towards the end of the 1930s began working more with film, making many films connected with industry and the archipelago. Ended his career as photographer for Nordiska museet (Nordic Museum).

DAVID HELLDÉN (1905–90)

Employed by Erik Lallerstedt 1927–35, then self-employed. Functionalist in the spirit of international Modernism. Participated in Stockholm town planning by contributing the first tower block and indoor market for Hötorg Centre 1951–60 and Sergels Torg 1958–60. Other important works: multi-family buildings at Ribershus in Malmö in 1937–42 and at Hökarängen in Stockholm 1944–51, and Malmö municipal theatre (together with E. Lallerstedt and S. Lewerentz). Also Stockholm University at Frescati 1961–73.

ELLI HEMBERG (1896–1994)

Painter and sculptor. She studied at Carl Wilhelmson's school of painting in Stockholm 1918–22. Study trips included Italy and Paris. First solo exhibition at Galerie Moderne, Stockholm 1942. As a sculptor mainly interested in architectural composition. A number of her works were executed for public places.

JOHN HERTZBERG (1871–1935)

Studied with Alfred J:son Dahllöf and at the Graphische Lehr- und Versuchsanstalt (Institute for Graphic Teaching and Research) in Vienna 1890–96. Set up as a photographer in Stockholm 1899. Teacher at Stockholm College of Technology from 1907; Senior Fellow in Photography 1921. Committee member of Swedish Photographers' Federation from 1899. Edited *Svenska Fotografen* (The Swedish Photographer) 1911–16. Founded *Nordisk Tidskrift för Fotografi* (Nordic Journal of Photography) 1917.

SIGRID HJERTÉN (1885–1948)

Trained as textile artist 1906–10 at College of Industrial Art. Studied with Matisse in Paris 1910–11. During the 1910s she painted in Fauvist style, later becoming more Expressionist and favoring strong colors. Only woman member of 'De Åtta' (The Eight) 1912, a group which took part in many national and international exhibitions. Exhibited at Der Sturm gallery in Berlin 1915. Diagnosed schizophrenic in 1932, she spent periods in mental hospital and stopped painting altogether in 1938. Married to the artist Isaac Grünewald.

BROR HJORTH (1894–1968)

Sculptor and painter. Studied at Copenhagen Art Academy and with Bourdelle in Paris 1921. Cubism, naive art and Swedish folk art were important influences on his work. His painting favors clear pure colors, his sculpture rugged naturalism. Founder-member of the 'Färg och Form' (Color and Form) group in 1932. Ran his own school of sculpture in Stockholm 1931–4. Professor of Drawing at Academy of Art 1949–59.

TORA VEGA HOLMSTRÖM (1880–1967)

Studied with Carl Wilhelmson at Valand school of art 1900–2. Study trips to France, Finland, England, Italy, etc. Took part in Baltic Exhibition in Malmö 1914. Painted in a personal Expressionist style with radical use of colour. Her composition was austere and simple, with clear opposition between warm and cold colors.

ERIK HÖGLUND (1932–98)

Studied at College of Arts, Crafts and Design 1948–53. Produced works for public places in various materials, made greatest impact as an artist in glass. Employed by Boda glassworks 1953–73; thereafter freelance.

KERSTIN HÖRLIN HOLMQUIST (b 1925)

Furniture designer; designed for NK, including shell-shaped wicker chairs 1952.

KARL ISAKSON (1878–1922)

Studied at Academy of Art, 1897–1901. Several periods of residence in Denmark. Studied at various times during 1910s in Paris, where the main influences on him were Cézanne and Cubism; studied with Le Fauconnier at Académie de la Palette. Clear pure colors in the spirit of Cubism. About 1920 his use of color intensified in a series of works with religious and Biblical motifs. Memorial exhibition in Stockholm, 1922.

CYRILLUS JOHANSSON (1884–1959)

Own studio in Stockholm from 1906. His architecture is personal in style, timeless in character. Versatile town planner and designer of industrial buildings, water-towers and residential housing. Important works: Årsta bridge 1923–24, Vaxholm and other water-towers, church and parish center on Stora Essingen; also War Archive and Centrum building, Kungsgatan 1929–31 in Stockholm.

EINAR JOLIN (1890–1976)

Studied at Artists' Association's school 1907 and with Matisse in Paris 1908. To Copenhagen 1914, after exhibiting with 'De Unga' (The Young) in 1909 and 'De Åtta' (The Eight) in 1912. Naive, two-dimensional style, often brightly colored. Best known for panoramic views of Stockholm. Exhibited 1915 at Der Sturm gallery in Berlin and 1918 at Liljevalch's in 'Yngre svenska konstnärer' (Young Swedish Artists) exhibition.

ARNE JONES (1914–74)

Sculptor, draftsman and graphic artist. Studied under Eric Grate at Academy of Art 1941–7. Study trips to Italy, France and England. He worked with the Concretist painters known as the 'Men of 1947' and often exhibited with them. Professor at Academy of Art 1961–71.

SUNE JONSSON (b 1930)

Ethnologist, writer, film-maker and photographer. Active mainly at Västerbottens läns museum (West Bothnia Provincial Museum). Has depicted in a series of books the small farmers and conditions of life in inland Västerbotten. Inspired by such photographers as Dorothea Lange, Walker Evans, Russell Lee and August Sander, he has himself inspired a generation of Swedish photographers with his documentary style.

SVEN JONSON (1902–81)

Studied at Carl Wilhelmson's school of painting in Stockholm 1925 and for Otte Sköld at Maison Watteau in Paris 1926–7. Returning to Sweden, he opened an advertising studio with Esaias Thorén. Member of the Halmstad group, with whom he exhibited. One-man show at Färg och Form (Color and Form) in 1938. Started in a Post-Cubist non-figurative style, his idiom becoming more Surrealist during the 1930s.

TORSTEN JOVINGE (1898–1936)

Studied at Althin's and Wilhelmson's schools of painting in Stockholm and in 1925 with André Lhote in Paris. Influenced by Post-Cubist painting, as represented by Ozenfant, Le Corbusier and Fernand Léger. About 1930 his painting developed a more Purist style with clean surfaces and bright clear colours. Panoramic town views featuring Functionalist housing estates a typical motif. Died in Seville during the Spanish Civil War.

SVEN JÄRLÅS (1913–70)

Own studio specializing in portrait- and advertising photography. Noted for collaboration with writer Ivar Lo-Johansson on book Ålderdom (Old Age) 1949; on a fact-finding mission throughout Sweden they visited 400 old people's homes which Järlås photographed. A pioneer of 'New Objectivity' in Sweden. Known also as a theatre photographer, employed in Stockholm by Dramaten Theatre and Opera, etc.

GRETA KNUTSON-TZARA (1899–1983)

Studied at Carl Wilhelmson's school of painting 1918–19 and at College of Art 1919–20, also with André Lhote in Paris 1922. Founder-member of the group known as 'Optimisterna' (The Optimists) 1924. Married to the French poet and writer Tristan Tzara 1925–38. Worked most of her life in Paris. Associated with French avant-garde circles and the Dada movement. Exhibited with the Surrealists. Took part in Stockholm 'Art Concret' exhibition 1930.

CARL KYLBERG (1878–1952)

Gave up architecture studies to study at Valand art College under Carl Wilhelmson 1901. Traveled to Paris and Italy 1914. First exhibited with 'Februarigruppen' (the February Group) at Liljevalch's in Stockholm 1919. Painted in fluid style, motifs often of a religious nature.

WILHELM KÅGE (1889–1960)

Ceramicist and painter. Artistic director at Gustavsberg 1917–49. Professor 1951. Engaged in 1917 by Gustavsberg to modernize the firm's range for the Home Exhibition at Liljevalch's the same year. Kåge designed a series of table services for Gustavsberg and developed many new ceramic techniques. Also designed posters.

ERIK LALLERSTEDT (1864–1955)

Worked in Stockholm 1890–1944. Professor at KTH 1905–29. Important works in Stockholm: reconstruction of Academy of Art building 1892–97; College of Technology 1911–40, Stockholm University building 1918–27 and a number of buildings for the Post Office. Also Malmö municipal theatre (together with Lewerentz and Helldén) 1933–44.

NILS LANDBERG (1907–91)

Glass designer and engraver. Worked at Orrefors glassworks 1925–72. Best known for thin, gracefully formed glass from the 1950s.

AXEL LARSSON (1898–1975)

Studied furniture design at School of Technology in Stockholm. Designed a series of mass-produced standard furniture for Swedish Bodafors Furniture Factories 1925–56, the first from 1928.

LENA LARSSON (1919–2000)

Interior designer, teacher, journalist and adult educator. Head of the progressive interiors shop 'NK-bo' (NK-Nest) 1947–56. Active in Swedish Design Society's 'Nest Circle' program during 1940s and 1950s. Known to a wider public from the 'köp – slit – släng' (buy – wear out – throw away) debate on Swedish television 1961.

GUNNAR LECHE (1891–1954)

Employed by Gothenburg city engineering office before becoming Uppsala town architect 1920–54. Residential housing and various communal buildings in Uppsala, all in traditional idiom. Member of Committee of Swedish Town Architects. Important works in Uppsala: Vaksala school 1925 and Sala Backar (Sala Slopes) 1950–53.

ALVAR LENNING (1897–1980)

Industrial designer. Studied in USA, employed by Electrolux.

SIGURD LEWERENTZ (1885–1975)

After studies at Chalmers gained practical experience in Germany 1907–10. One of the 1910–11 group of students at Klara school. Shared architectural studio with Torsten Stubelius 1911–17, thereafter freelance. Long collaboration with Gunnar Asplund on Skogskyrkogården (Forest Cemetery) in Stockholm, where he was responsible for the Resurrection Chapel 1921–5 etc. Participated in Stockholm Exhibition 1930. Other important works: Eastern Cemetery in Malmö 1916–76, Church of St Mark at Björkhagen in Stockholm, National Insurance building in Stockholm 1931, Malmö municipal theatre (with Lallerstedt and Helldén) 1944, Klippan Church 1962–6.

ALBERT LILIENBERG (1879–1967)

Chief city engineer Gothenburg 1907–27, making significant contributions. Teacher at Chalmers 1916–27. Head of Town Planning Stockholm 1927–44. Important works in Gothenburg: Bagaregården 1908, Landala owner-occupied housing 1908, Kungsladugård 1916. General plan for Stockholm 1928.

ANDERS B. LILJEFORS (1923–70)

Ceramicist and painter, grandson of Bruno Liljefors. Active many years with Gustavsberg. From 1956 began to develop a personal idiom which deviated from ceramic tradition.

SVEN IVAR LIND (1902–80)

Employed by Gunnar Asplund 1925–8, freelance in Paris 1928–30. Edited journal Byggmästaren (The Master Builder) 1932–3. Completed some of Asplund's work after his death. Professor at University College of Art 1948–58. His architecture is simple, austere and thorough. Important works: Råsunda football stadium 1937, block of service flats at Marieberg in Stockholm 1943, Treasury and Armoury at Royal Palace in Stockholm 1967–76, Swedish pavilion at Paris World Exhibition 1937, Byttan Restaurant in Kalmar 1939.

STIG LINDBERG (1916–82)

Artist and ceramicist. Artistic director at Gustavsberg 1949–57 and 1972–80. Senior lecturer at College of Arts, Crafts and Design 1957–70. Professor 1970. Designed a series of table services for Gustavsberg. Also produced industrial design for glass, textile patterns and illustrated books as well as decorative material for public places.

LAGE LINDELL (1920–80)

Studied at Academy of Art 1941–6 under Isaac Grünewald and Sven 'X' Erixson. Debut 1947 in 'Young Art' exhibition arranged by 'Color and Form'. Executed a number of official projects. Elected to the Royal Academy of Art 1960.

VICKE LINDSTRAND (1904–83)

Glass designer and ceramicist. Designer at Orrefors 1928–40. Artistic director at Upsala-Ekeby 1942–50 and Kosta 1950–73. During the 1960s constructed monumental sculptures by sticking together thousands of plates of window-glass.

SUNE LINDSTRÖM (1906–89)

Studied at Bauhaus 1928, graduated from KTH 1931. Head of HSB town-planning department 1937–9. Taught Town Construction at KTH 1938–47. From 1944 employed by VBB (Water Construction Department). Professor of Town Construction at Chalmers 1956–69. Edited Byggmästaren (The Master Builder) 1936–40. Important works: Town Hall and town hotel in Karlskoga 1939, Swedish Radio premises in Stockholm 1956 and Wennergren Center in Stockholm 1959; also water towers and a good many general projects both in Sweden and abroad.

HILDING LINNQVIST (1891–1984)

Studied at Academy of Art 1910–12, but left because dissatisfied with the teaching. His naive painting was inspired by folk art, myths and fairytales. Contact with artists in Smedsudden community, the so-called 'Intimists.' Took part in the 'Young Swedish Artists' exhibition at Liljevalch's 1918. Member of 'Color and Form' 1934, Professor at Academy of Art 1939–41.

WALDEMAR LORENTZON (1899–1984)

Studied at Wilhelmson's school of painting 1919–20, at Althin's school of painting 1920–21 and with Fernand Léger in Paris 1924. In the 1920s his style was modified Cubist, but assumed a Surrealist character in the 1930s. Member of the 'Halmstad group.'

GUNNAR LUNDH (1898–1960)

Pioneer of reportage photography, which became possible in the 1920s with the introduction of the small Leica camera. Visited Germany several times during the 1910s and 1920s. Freelance photographer from 1929. Worked with Gunnar Sträng and Ivar Lo-Johansson on a series of reports on the lives of 'statare' farm labourers (seasonal workers paid partly in kind) which were a major contribution to the abolition of the unfair 'statare' system in 1944. Their reportage was published in book form in 1948 under the title Statarna i bild (Statare Workers in Pictures). 'New objective' idiom.

TYRA LUNDGREN (1897–1979)

Ceramicist, sculptor, painter and textile designer. She studied at Althin's school of painting, the Academy of Art 1917, and in Paris at André Lhote's school of painting 1920–21. From 1930 resident in Paris with her own studio. Artistic director of Arabia, Helsinki 1924–37. Worked with Gustavsberg and Kosta. In late 1920s in Rome where she joined the 'Valori Plastici' group of artists which included among others De Chirico and Morandi.

INGEBORG LUNDIN (1921–92)

Designer of glassware, employed by Orrefors 1947–71. Best known for elegant and graceful objects in thin glass, including 'Äpplet' (The Apple) 1955.

KNUT LUNDSTRÖM (1892–1945)

Studied at Carl Wilhelmson's school of painting 1912–15 and with André Lhote in Paris 1919–20. Active in Paris 1919–33. In 1924 began producing abstract musical compositions in which a particular color represented a particular note. Contributed five works to 'Art Concret' exhibition in Stockholm 1930. In Paris helped found 'Les Artistes Musicalistes.'

RALPH LYSELL (1907–87)

Head of AB Industriell Formgivning (Industrial Design Ltd) 1945–7. Designed a prototype upright telephone in collaboration with Hugo Blomberg 1941. Also designed refrigerators for Electrolux.

GUNNAR MALMBERG (1877–1958)

Amateur photographer, also chemist and writer. Variously employed as a chemist in Stockholm around the turn of the century and in 1907 started his own company for the production of photogravure. Secretary of Photographic Association 1905–7 and editor of Fotografisk Tidskrift (Photographic Journal) 1907–9. At the end of the nineteenth century introduced Swedish photographers to new trends in photography from Austria, Germany and France. One of the first in Sweden to produce monochrome pictures. His first successful attempt dates from 1899.

CARL MALMSTEN (1888–1972)

Interior designer, furniture designer and teacher. Noted for his furniture at the Home Exhibition 1917. Designed interior for Stockholm Concert Hall 1928, and also for High Court 1947–9 and People's Assembly 1956–60, both also in Stockholm. Designed standard furnishings for KF 1944. Started Carl Malmsten's Workshop School 1933 and Capellagården on Öland 1958. Honorary Professor 1936. In 1955 brought together a number of small factories which, under the name of Nyckelverkstäderna (The Key Workshops), manufactured his furniture. Member of Swedish Society of Craft and Industrial Design's managing committee. Traditionalist and opponent of Functionalism.

SVEN MARKELIUS (1889–1972)

Architect, head of standardizing committee's design office for carpentry in building 1920, building consultant and head of Building Council's Research office 1938–44. Director of town planning for Stockholm 1944–54, own studio from 1910s till his death. One of Sweden's leading Functionalists. Important works: town plan and villas on Lidingö for 'Bygge och bo' (Build and Live) exhibition 1925, homes and interiors for Stockholm Exhibition 1930, Helsingborg Concert Hall 1932 and Students' Union building for Royal College of Technology (with Uno Åhrén) 1930. Service flats in Stockholm 1935, Builders' Association building in Stockholm 1937, 'Eco-soc' hall in United Nations building in New York 1952, Community center with municipal theatre, Stockholm 1960.

BRUNO MATTHSON (1907–88)

Architect and furniture designer. Internationally known for ergonomic furniture in shaped and laminated pressed wood. Designed his first chair for Värnamo hospital 1931. Also designed prefabricated homes with glass walls. Made his breakthrough at Paris Exhibition 1937.

SIRI MEYER (1898–1985)

Studied at Design Society's school in Gothenburg, and at College of Industrial Art (now College of Arts, Crafts and Design) and College of Art in Stockholm. Studied with Léger at Académie Moderne in Paris 1923–5. Took part in several collective exhibitions in Stockholm, Paris and Munich, etc.

VERA MEYERSON (1903–81)

Studied at Althin's school of painting in Stockholm 1919–20 and then for a couple of years at Workshop School for textile craftwork run by the Association of Friends of Handicraft. Contributed several decorative works to the 1923 World Exhibition in Gothenburg. 1925 studied with Léger in Paris at Académie Moderne where she developed a mechanical element-alphabet for her non-figurative painting. Around 1926 worked for a while also with advertising and decoration in Stockholm. Studied in Finland with Gallen-Kallela 1928.

MÄRTA MÅÅS-FJETTERSTRÖM (1873–1941)

Textile artist. Teacher at Kulturen school of weaving in Lund 1902–5, head of Malmöhus Province home craft association 1905–11. Started her own workshop in Båstad 1919, which after her death became a company as Märta Måås–Fjetterström AB. Here her work was continued and developed by the artists Barbro Nilsson, Ann-Mari Forsberg and Marianne Richter, among others.

ENDRE NEMES (1909–85)

Born in Hungary, active in Sweden from 1940. Studied at Academy of Art in Prague in 1930s. Breakthrough at 'Color and Form' 1947. Teacher and head of Valand College of art 1947–55. Paintings full of symbolism and literary allusion with roots in Central-European Modernism.

AXEL NILSSON (1889–1981)

Studied at Academy of Art 1910. Naive painter. Studio in 'Sjövillan' (Lake Villa) at Smedsudden together with the so-called 'Intimists.' Motifs to a large extent derived from the view from the villa plus portraits, still lifes and figures. In his later work he developed a more naturalistic style. Founder member of 'Color and Form' group 1932.

BARBRO NILSSON (1899–1983)

Textile artist. Principal teacher of Textiles at College of Arts, Crafts and Design 1947–57. Artistic director of the Märta Måås-Fjetterström weaving workshop 1942–70. Executed large-scale public works.

GEORG A NILSSON (1871–1949)

Ran architectural studio with Ivar Nyqvist 1904–12. Head of administrative office at Building Council 1922–37. Inspired with a firmly rational attitude by the Wagner School in Vienna. Active mostly as a school architect. Important works: Matteus primary school (a forerunner of Functionalism) 1899–1901, the building he himself lived in at Regerinsgatan 88 1906–7, Adolf Fredrik primary school 1910 and a series of other schools in Stockholm.

VERA NILSSON (1888–1979)

Studied with Carl Wilhelmson at Valand College of Art in Gothenburg 1910, with Henri Le Fauconnier at Académie de la Palette 1911, and also at several Russian schools in Paris. Lived in Copenhagen 1916–19. Painted in intense colours, her style rooted in Expressionism and Cubism. First exhibited Copenhagen 1917 with Mollie Faustman. Took part in 'Young Swedish Artists' exhibition at Liljevalch's 1918. Member of Academy of Art 1954. One of those responsible for shaping the character of the Stockholm T-bana (underground railway system).

WIWEN NILSSON (1897–1974)

Silversmith and sculptor. Studied in Germany 1913–14. Went to Paris 1924 where he met GAN and was strongly influenced by his abstract painting. His work as a silversmith is geometric and abstract with clean form, influenced by Cubism. Took part in 'Art Concret' exhibition in Stockholm 1930.

GUNNAR NYLUND (1904–97)

Ceramicist and glass designer. Artistic director at Rörstrand 1931–49, designed both unique and mass-produced stoneware. Artistic director and artist in glass at Strömbergshyttan 1954–68.

EDVIN ÖHRSTRÖM (1906–94)

Sculptor and artist in glass. Studied at Academy of Art in Stockholm and in Paris. Worked for Orrefors 1936–57. From the 1960s Öhrström created abstract sculptures in glass, including the great glass monolith in Sergels torg square in Stockholm 1964–74.

PIERRE OLOFSON (1921–96)

Studied at Otte Sköld's school of painting in Stockholm 1937–38 and at Academy of Art 1938–43. Study trips to Denmark, Italy and France, etc. Member of the group of Concretists known as the 'Men of 1947.' Produced many works for public places and also design commissions.

AXEL OLSON (1899–1986)

Born in Halmstad. Elder brother of Erik Olson, cousin of Waldemar Lorentzon. Studied at Archipenko's art school in Berlin. In 1919 met GAN who came to have a strong influence on his work. In 1929 founded 'Halmstad group' together with Erik Olson, Waldemar Lorentzon, Sven Jonson, Stellan Mörner and Esaias Thorén.

ERIK OLSON (19 01–86)

Born in Halmstad, younger brother of Axel Olson and cousin of Waldemar Lorentzon with whom he helped found the 'Halmstad group' in 1929. During the 1920s studied in Paris with Fernand Léger. Influenced by his teacher's Cubism, but around 1930 his painting became more Neoplastic. His later work was Surrealist, often with religious motifs.

ERIC H. OLSON (1909–95)

Painter and sculptor. Studied at various schools of painting in Paris 1937. Abstract geometrical paintings. During the late 1950s began making glass objects with light-refracting lamination, so-called 'optochromes.' Much of his work was public decoration.

RAGNAR ÖSTBERG (1866–1945)

Began his career by designing a series of villas. Central figure in the world of early twentieth-century Swedish architecture. Professor of Architecture at College of Art 1922–32. Strong opponent of

Functionalism. Important works: summer villa for Eva Bonnier in Dalarö 1904; Villa Pauli in Djursholm 1904–5; Stockholm Town Hall 1909–23 and Östermalm upper school 1906–10.

BENGT O. ÖSTERBLOM (1903–76)

Studied in 1920s at Schule Reimann in Berlin and with André Lhote and Fernand Léger in Paris. Pioneered abstract art in Sweden with public projects, etc. Early interest in abstract trends in art, influenced partly by journal flamman (the flame) in which Georg Pauli argued for Cubism, but also by GAN's painting. Contributed four non-figurative works to 'Art Concret' exhibition in Stockholm 1930. After 1930 more oriented towards Surrealism.

SVEN PALMQVIST (1906–84)

Glass designer and painter. Active at Orrefors glassworks 1928–72. Developed centrifugal glass style in 'Fuga' series during 1950s. Produced public decorations from blocks of glass.

GREGOR PAULSSON (1889–1977)

Art historian, writer and Curator of Nationalmuseum 1916–20. Crucial to the breakthrough of Functionalism in Sweden. PhD 1915. Art critic for Stockholms Dagblad, etc. Managing director of Swedish Society of Craft and Industrial Design and editor of its journal 1920–34. Professor of Art History at Uppsala University 1934–56. Swedish general superintendent at 1925 industrial art exhibition in Paris and also at 1930 Stockholm Exhibition. Important writings: Den nya arkitekturen (The New Architecture, 1916), Vackrare vardagsvara (More Beautiful Objects for Everyday Use, 1919) and acceptera ('accept', together with Asplund, Markelius, Gahn, Sundahl and Åhrén). Also Konstens världshistoria 1–4 (World History of Art, 4 vols, 1942–52) and Svensk stad 1–2 (Swedish Towns, 2 vols, 1950–52).

ARTHUR C:SON PERCY (1886–1976)

Painter and designer of ceramics and glass. Worked 1923–60 at Gefle Porcelain Factory, 1942–51 at Karlskrona Porcelain Factory and 1951–65 at Gullaskruf glassworks. Designed textile patterns for Elsa Gullberg. Textiles and interior fittings during 1930s and 1940s.

KARL-AXEL PEHRSON (b 1921)

Studied at Otte Sköld's school of painting 1938–40 and at Academy of Art 1940–46. One of the 'Men of 1947.' Severe Concretist style; his later paintings more representational, with plant and animal motifs. Decorated Karlaplan underground station in Stockholm.

SIGURD PERSSON (b 1914)

Silver, industrial, glass and graphic designer. Had own workshop and design studio in Stockholm 1942–80. 1967–81 artistic collaboration with Kosta glassworks. Best known for secular and church silverware and for jewelry.

SIGNE PERSSON MELIN (b 1925)

Ceramicist and glass designer. Professor 1985. She ran her own workshop in Malmö 1951–66 and worked for Kosta Boda, Höganäs Keramik and Rörstrand.

ERIC SIGFRID PERSSON (1898–1983)

Innovative and productive building contractor, active mostly in Skåne. Introduced the large plate-glass panoramic window to Sweden in the 1930s. Creator of many outstanding housing estates. Important works: Malmgården 1935, Ribershus 1938 and Friluftsstaden 1944–48, all in Malmö.

LEIF REINIUS (1907–95)

Employed by Hakon Ahlberg 1929–35. Shared studio with Sven Backström 1936–92. Backström and Reinius are among Sweden's foremost designers of homes. Edited Byggmästaren (The Master Builder) 1944–50. Important work: 'Slender' houses in Hjorthagen (1934–40, with Hakon Ahlberg), 'Women's House' 1938, Elfvingegården 1940, Nockeby family hotel 1952, Rosta housing estate in Örebro 1947–52, Danviksklippan 1945; also star-shaped building(s), tower blocks and terraced housing in Gröndal 1944–62; Vällingby center 1948–54, Farsta center 1956–60 and Åhlén's department store 1964.

ANNA RIWKIN (1908–70)

Born in Russia, came to Sweden 1914. Own studio in Stockholm from 1928 with special interest in portrait and dance photography. From late 1930s concentrated on reportage photography, which was published in book form, including a comprehensive series of children's books about children in other lands which appeared in large editions. She also worked with such writers as Ivar Lo-Johansson and Astrid Lindgren. Photographed in 'new objective' style.

LENNART RODHE (b 1916)

Studied at Academy of Art 1938–44. Study trips abroad included Norway, France, Italy and Spain. Professor at Academy of Art 1958–68. Elected member of Academy of Art 1956. Concretist and one of the 'Men of 1947.' Produced a number of works in late 1940s and in 1950s for public places, including decoration for Östersund post office and Ängby secondary school.

CARL GUSTAF ROSENBERG (1883–1957)

Studied photography and chemistry in New York 1904–5. During 1910s worked for periodicals *Hvar 8 Dag* (Every 8 Days) and *Veckojournalen* (The Weekly Journal). Best known for his photographs for the Swedish Tourist Association yearbook. In 1947 won newly established photographic prize awarded by the daily newspaper *Svenska Dagbladet*. Pioneer of the 'new objective' style, typical of which are his 'objective' architectural photographs.

ASTRID SAMPE (b 1909)

Textile designer. Professor 1989. Attached to NK's 'Textilkammare' (textile department). During her period as head of this in 1937–71 she created a revolution in Swedish industrially produced textiles.

GÖSTA SANDELS (1887–1919)

Studied at Althin's school of painting 1904 and Artists' Federation school 1905. Took part in Stockholm exhibitions of 'The Young' 1909 and 'The Eight' 1912. His creative career was short (1906–19) but intensive. Influenced by Munch, Van Gogh and French Fauvism. Motifs from Sweden's west coast. Regarded as one of the precursors of so-called 'Gothenburg Colorism.' In 1919 went to Spain, where he died of typhus at the early age of thirty-two.

KARL SANDELS (1906–86)

In his work for the press he introduced in Sweden a new photographic style which tempered traditional journalistic pictorialism with 'new objective' trends. Shortly after the daily newspaper *Dagens Nyheter* published one of his sports photographs in 1924 he set up as a freelance photographer in Stockholm. He worked for *Stockholms Dagblad* in 1926, and in 1934 started his own picture agency, Sandels Illustrationsbyrå, which he ran till 1942. Director and agent for Swedish Photographers' Federation 1942–60.

SIXTEN SASON (1912–67)

Industrial designer and technical draftsman, key figure in Swedish industrial design. Produced several car models for Saab, including the Saab 92 (1947) and Saab 99 (1967). Also designed 1948 Hasselblad camera, 1957 Electrolux vacuum cleaner, and household machines and motor cycles for Husqvarna.

ARTUR VON SCHMALENSEE (1900–72)

A leading architect in KF's architecture department. Modernist with a penchant for the Swedish eighteenth century. Employed for short periods by Lewerentz, Asplund, Markelius and others. Freelance from 1937. Important work for KF in Stockholm: Mill for oats and housing on Kvarnholmen 1928–34, Luma factory 1930 and annexe to head office in Gamla Stan 1945–50; also student residential complex in Uppsala 1945–53, laboratory for Marabou chocolate factory in Sundbyberg 1942–63 and Kiruna Town Hall 1958–62.

KURT VON SCHMALENSEE (1896–1972)

Architect in KF's architectural department 1925–9 and town architect in Norrköping 1929–61. Notable works: model homes for 1930 Stockholm Exhibition, Norrköping Crematorium 1938 and restoration of Växjö Cathedral 1956–60 and many other churches and church restorations.

TURE SELLMAN (1880–1969)

Architect and amateur photographer. Member of Photographic Federation in Stockholm 1913. Own architect's studio in Stockholm from 1917. In 1931 started Sellmanfilm which produced color films, etc. Photographed in pictorialist style but with elements of late 1920s 'New Objectivity'.

OTTE SKÖLD (1894–1958)

Grew up partly in China where his parents were missionaries. Studied in Stockholm at Althin's and Wilhelmson's schools of painting. Active in Copenhagen 1914–19. Resident in Paris 1919–28. Early work in Cubist style, but his work from the 1920s has been linked with 'New Objectivity'. Took part in 'Young Swedish Artists' exhibition at Liljevalch's 1918. Ran his own school of painting in Stockholm 1928–50. Professor at Academy of Art 1932–42 and Chief Curator of Nationalmuseum 1950–58. Worked for the establishment of Moderna Museet which opened in 1958.

JOHN STEN (1879–1922)

Worked as a professional painter from the beginning and began signing his paintings in 1905. Resident in France 1910–18. Studied with Henri Le Fauconnier at Académie de la Palette 1913 adopting a Cubist idiom, though the figurative was never absent from his Cubism. From 1917 his painting became more naturalistic. Participated in the 'Young Swedish Artists' exhibition at Liljevalch's in Stockholm 1918. In 1922 went to paint in Bali and died there of a tropical disease.

NISSE STRINNING (b 1917)

Furniture designer. work includes 'Stringhyllan' (The String Shelf) with his wife Kajsa Strinning 1949. Founded the firm String Design AB in 1952.

CARL HARRY STÅLHANE (1920–90)

Ceramicist. Worked at Rörstrand 1939–73 where he was a pupil of Isaac Grünewald 1942–6. Started his own workshop in 1973. Created both objects for practical use and unique stoneware plus monumental decorative outdoor items.

ESKIL SUNDAHL (1890–1974)

Head of KF's architecture department 1924–58. Member of Committee for Standardization of Building Materials 1923–6. Professor of Building at KTH 1936–57. Important works in Stockholm: Sandström school in Danderydsgatan 1923, bus garage at Hornsberg 1933 and 1939, and Konsum building at Södermalm 1930–33.

GUNNAR SUNDGREN (1901–70)

Studied with Ferdinand Flodin. Active as photographer with own studio in Uppsala from 1928. Best known as a portrait photographer but also made many photographic environmental studies of Uppsala and district. Worked with others for the establishment of a special museum of photography. Used both pictorialist and 'new objective' styles.

ELIAS SVEDBERG (1913–87)

Interior and furniture designer. Pupil of Carl Malmsten 1931–2. Ran his own design business 1935–44. From 1944 active with NK, where among other things he headed NK Interiors 1952–61. Created the first prefabricated self-assembly furniture with his 'Triva' series for NK 1944.

IVAR TENGBOM (1878–1968)

Edited journal *Arkitektur* 1908–11. Taught at Klara School 1910–11. Freelance from 1912. Professor of Architecture at College of Art 1916–20. Important works: Borås Town Hall (with Torulf) 1909–10, Stockholms Enskilda Bank 1912–15, Högalid Church 1917–23, Stockholm Concert Hall 1923–6, College of Commerce 1925–6, Swedish Match building 1928 and 'City' building in Norrmalmstorg 1930–32; all except the first of these buildings in Stockholm.

NILS TESCH (1907–75)

Employed by Paul Hedqvist 1934–6. Architecture studio with L. M. Giertz from 1936. Important works: Villa Wehtje in Djursholm (Stockholm) 1940, Solna upper school, Villa Smith on Lidingö 1959, Mölna terraced-housing estate 1954–60, Umeå College of Domestic Science 1951–60, Civil Service department building in Loen block (Stockholm) 1970.

GÖSTA THAMES (b 1916)
Industrial designer, employed by L. M. Ericsson. Best known for developing the design of the 'Ericofon' telephone also known as the 'Cobra,' 1953.

ESAIAS THORÉN (1901–81)
Studied at Wilhelmson's school of painting and at Maison Watteau in Paris 1926–27. Shared advertising studio with Sven Jonson. Exhibited at Stockholm Exhibition 1930. Purist compositions, becoming Surrealist from 1933. Member of 'Halmstad group.'

OLOF THUNSTRÖM (1896–1962)
Employed by KF's architecture department 1925–62. Important work for KF: terraced building at Kvarnholmen in Nacka 1929, prize-winning entry 'One Day the Earth shall be Ours' for Stockholm City design competition for inexpensive housing 1932, Katarina Lift and KF offices at Slussen in Stockholm 1935, and accommodation and office buildings at Gustavsberg 1937 to 1950s.

INGEGERD TORHAMN (1898–1994)
Sculptor, painter and textile designer. Designed rugs with abstract motifs inspired by Russian avant-garde and French Purism for Stockholm Exhibition 1930.

AXEL TÖRNEMAN (1880–1925)
Studied at Valand College of art 1899 and at Munich College of Art 1900. Went on to Dachau 1901. In Paris 1902–6 where he was strongly influenced by Impressionist painting. Munch's work was a great source of inspiration and an important influence on his development. One of the first to break with the nationalistic tradition which dominated painting at the turn of the century. Breakthrough at the Paris Salon 1906 with his painting 'Nattcaféet' (Café at Night).

PER-OLOF ULTVEDT (b 1927)
Taught at Academy of Art 1945–50 by Sven Erixson, among others. Built his first mobile construction in 1954 as decor for the ballet 'Spiralen' (The Spiral) performed at Stockholm Concert Hall. Member of editorial board of *Blandaren* (The Mixer) with Gösta Winberg, Pontus Hultén, Hans Nordenström and others in the 1950s, the period when his first 'machines' came into existence. During the 1960s took part in such exhibitions at Moderna Museet as 'Movement in Art' and 'She', the latter together with Niki de St Phalle and Jean Tinguely. In 1963 joined the 'New Realists' at the Sidney Janis Gallery in New York and worked with Carolyn Brown and Robert Rauschenberg on the dance-show 'Pelican.'

ARNE WAHLBERG (1905–87)
Leading object and advertising photographer using 'new objective' style. Studio in Stockholm from 1929. Work included photographic portraits, glass and general ware plus photographs for industrial and publicity purposes. Worked for many years on commissions from Swedish Society of Craft and Industrial Design. Active in Swedish Photographers' Federation and Photographic Association. Responsible together with others for exhibition 'The New Eye – A Hundred Years of Photography' at Liljevalch's in 1939.

NELL WALDEN (1887–1975)
Painter from Landskrona. Married 1912–24 to German gallery-owner and editor Herwarth Walden. Played an active part in work connected with 'Der Sturm.' First one-woman show 1917 in Der Sturm gallery, after which her work was seen regularly in the gallery's exhibitions. Style often non-figurative. Best known for painting on glass.

SVEN WALLANDER (1890–1968)
Worked on Kungsgatan and designed north Kungstornet when employed by Stockholm Town Planning Commission 1916–17. Freelance from 1917. Founded HSB 1923 and served as its director and head of architects' office 1923–58. Member of committee investigating social aspects of housing 1933–47. Important housing projects for HSB in Stockholm: Metern 1926, Färjan 1929, Marmorn 1932 & 1939 and Kungsklippan 1936 'quarters' (i.e. city blocks bordered by four streets) and Reimersholme housing estate 1942–6.

INGRID WALLBERG (1890–1965)
One of Sweden's first female architects, mainly active in Gothenburg. Practical experience with Le Corbusier 1928. Shared studio with international Modernist architect Alfred Roth 1928–30. Important works, all in Gothenburg: new building for HSB 1929–30, villa in Örgryte 1932, terraced housing in Brödragatan 1935.

JAN WALLINDER (b 1915)
Employed by Gunnar Asplund 1938–40. Active in Gothenburg 1948–54 with Sven Brolid. Professor at Chalmers 1959–80. New Functionalist developments in the construction of housing. Important works: housing in Södra Gullheden 1950, Doktor Fries Torg (square) in Gothenburg 1955, Kortedala housing in Gothenburg 1956, Karlskrona Library 1959.

PETER WEISS (1916–82)
Writer and artist. Grew up in Berlin and Bremen but emigrated to Britain in 1935 and later to Prague. After studying at Prague Academy of Art moved to Sweden in 1939. Today Weiss is regarded as a leading postwar writer in German but he was an active painter too. Also produced experimental short films such as *Hägringen* (The Mirage) 1958, and published the book *Avantgardefilm* 1956.

HANS WESTMAN (1905–91)
Functionalist rooted in Skåne regional architecture. Town planning architect Malmö 1932–36. Freelance in Malmö and Lund 1936–83. Important works: 'Fritiden' (Leisure Time) exhibition in Ystad 1936; also public baths 1938, Linnéstaden 1945–8 and Museum of Sketches 1947–59, all three in Lund.

TAGE WILLIAM OLSSON (1888–1960)
Trained and worked as a mining engineer. Retrained as architect 1925. Mainly active as a town planner. Head of Town Planning Gothenburg 1943–53. Important works: Slussen traffic system in Stockholm 1931–5 and Järnbrott experimental building in Gothenburg 1950–53.

HELGE ZIMDAHL (1903–2001)
Studied at KTH and College of Art. Professor of Architecture at Chalmers 1951–70. Shared architectural studio with Nils Ahrbom 1932–50, thereafter had own studio. Important works: Sveaplan upper school for Girls 1935, Eriksdal school 1937 and Skanstull upper school 1943, all with Nils Ahrbom in Stockholm.

BIBLIOGRAPHY

ARCHITECTURE

Ahlin, Janne: Sigurd Lewerentz arkitekt, 1985.
Arkitektur 6/1982 (Backström & Reinius).
Arkitektur 6/1983 (Carl Nyrén).
Arkitektur 5/1991 (Nils Tesch).
Arkitektur 4/1994 (Sven Ivar Lind).
Arkitektur 6/1998 (Jan Wallinder).
Asplund, Gunnar et al.: acceptera, 1931.
Aufbruch und Krise des Funktionalismus 1930–80, Bauen und Wohnen in Schweden 1930–80, (Arkitekturmuseet 1976.)
Backström, Sven & Ålund, Stig (ed.): Fyrtiotalets svenska bostad, 1950.
Bergkvist, Michael & Michelsen, Olof (ed.): Josef Frank, arkitektur, 1994.
Brunius, August: 'Kolorism och kubism i svensk arkitektur,' in Färg och Form, 1913.
Brunnberg, Hans et al. (ed.): Trettiotalets byggnadskonst i Sverige, 1943.
Brunnström, Lisa: Den rationella fabriken, om funktionalismens rötter, 1990.
Caldenby, Claes & Walldén, Åsa: Kollektivhus, 1979.
Caldenby, Claes & Hultin, Olof (ed.): Asplund, 1985.
Caldenby, Claes (ed.): Att bygga ett land, 1998.
Caldenby, Claes & Hultin, Olof (eds.): Asplund, 1985.
Caldenby, Claes (ed.): Sweden – 20th Century Architecture, 1998.
Childs, Marquis: Sweden – the Middle Way, 1937.
Coates, Gary G: Erik Asmussen, Architect, 1997.
Collymore, Peter: The Architecture of Ralph Erskine, 1982.
Constant, Caroline: The Woodland Cemetery: Toward a Spiritual Landscape, 1994.
Cornell, Elias: Ny svensk byggnadskonst, 1950.
Curman, Jöran & Zimdal, Helge: 'Gruppsamhällen,' in Inför framtidens demokrati, 1944.
Curman, Jöran: Industriens arbetarebostäder, 1944.
Dymling, Claes (ed.): Architect Sigurd Lewerentz. Vol 1. Photographs of the work. Vol 2. Drawings, 1997.
Egelius, Mats: Ralph Erskine, arkitekt, 1988.
Engfors, Christina (ed.): Folkhemmets bostäder 1940–60, 1987.
Engfors, Christina: E. G. Asplund. Arkitekt, vän och kollega, 1990.
Engfors, Christina: E G. Asplund. Architect, friend and colleague, 1990.
Eriksson, Eva: Den moderna stadens födelse, 1990.
Femtiotalet. Arkitekturmuseets årsbok 1995, 1995.
Findal, Wenche (ed.): Nordisk funktionalism, 1995.
Forsman, Per: Det gamla och det nya bygget. Bilder och betraktelser kring en metafor, 1993.
Fred Forbat (Arkitekturmuseet 1970.)
Funktionalismens genombrott och kris. Svenskt bostadsbyggande 1930–80, (Arkitekturmuseet 1976.)
Fyrtiotalets svenska bostad/Swedish Housing of the Forties, 1950.
Gullström, Charlie (ed.): Léonie Geisendorf Arkitektur, 1990.
Hitchcock, Henry-Russell & Johnson, Philip: The International Style, 1932.
Holm, Lennart (ed.): HSB, 1954.
Holm, Lennart: 'Bostadens form som ideologisk spegel,' in Bostadspolitik och samhällsplanering, 1968.
Holm, Lennart (ed.): Från bostadsnöd till önskehem. Stockholms kooperativa bostadsförening 1916–91, 1991.
Holmdahl, Gustav m fl (ed.): Gunnar Asplund arkitekt 1885–1940, 1943.
Holmdahl, Gustav et al. (eds.): Gunnar Asplund, Architect, 1950.
Hårde, Ulla: Eric Sigfrid Persson, 1986.
Johansson, Bengt O. H.: Carl Bergsten och svensk arkitekturpolitik under 1900-talets första hälft, 1965.
Johansson, Bengt O. H.: Tallum, 1996.
Kidder Smith, G. E.: Sweden builds, 1950, 1954.
Kooperativa förbundets arkitektkontor 1925–35, 1935.
Kooperativa förbundets arkitektkontor 1935–49, vol. 1–2, 1949.
Larsson, Lars-Olof (ed.): Peter Celsing. En bok om en arkitekt och hans verk, 1980.
Larsson, Mårten (ed.): Ny arkitektur i Sverige/New Architecture in Sweden, 1961.

Lectures and Briefings from the International Symposium on the Architecture of Erik Gunnar Asplund, 1986.
Lindvall, Jöran (ed.): Den svenska byggnadskonsten, 1992.
Lindvall, Jöran (ed.): The Swedish Art of Building, 1992.
Linn, Björn: Osvald Almqvist. En arkitekt och hans arbete, 1960.
Linn, Björn: Storgårdskvarteret, 1974.
Linn, Björn: 'Ivar Tengbom och arkitektyrket,' in Hall, Thomas (ed.): Stenstadens arkitekter, 1981.
Linn, Björn: 'Arkitektyrket i Sverige,' in Hall, Thomas & Dunér, Katarina (ed.): Den svenska staden, 1997.
Lund, Nils-Ole: Nordisk arkitektur, 1991.
Lundahl, Gunilla (ed.): Nordisk funktionalism, 1980.
Lundahl, Gunilla: Recent Developments in Swedish Architecture, 1983.
Lundahl, Gunilla (ed.): Kvinnor som banade väg, (Byggforskningsrådet T6: 1992.)
Markelius, Sven: 'Uppståndelsekapellet,' in Byggmästaren 20/1996.
'Modernismens byggnader,' Kulturmiljövård 1–2/1996.
Museet och 30-talet, 1985.
Nordisk klassicism/Nordic Classicism 1910–30, 1982.
Ny svensk arkitektur/New Architecture in Sweden, 1961.
Olle Engkvist Byggmästare, 1949.
Paulsson, Gregor: Den nya arkitekturen, 1916.
Paulsson, Gregor: Svensk stad 1–2, 1950–53.
Praktiska och hygieniska bostäder, SOU 1920: 3–12.
Rudberg, Eva: Uno Åhrén, 1981.
Rudberg, Eva: 'Kvinnor blir arkitekter,' in Arkitektur 2–3/1983.
Rudberg, Eva: 'Sverige provins i Europa,' in Arkitektur 10/ 1987.
Rudberg, Eva: Sven Markelius, arkitekt, 1989.
Rudberg, Eva (ed.): Funktionalismen värd att vårda, 1992.
Rudberg, Eva: Folkhemmets byggande, 1992.
Rudberg, Eva: Stockholmsutställningen 1930, 1999.
Rudberg, Eva & Paulsson, Eva (ed.): Hakon Ahlberg, arkitekt och humanist, 1994.
Rudberg, Eva: Sven Markelius, Architect, 1989.
Rudberg, Eva: 'Schweden – eine europäische Provinz/Sweden – a province of Europe,' in Raumdenken/Thinking Space, Bauart 4/ 1996.
Rudberg, Eva: The Stockholm Exhibition 1930, 1999.
Råberg, P G: Funktionalistiskt genombrott, 1972.
Rådberg, Johan: Den svenska trädgårdsstaden, 1994.
Rådberg, Johan: Drömmen om Atlantångaren, 1997.
Rörby, Martin m fl: Georg A. Nilsson, arkitekt, 1989.
Sandström, Ulf: Arkitektur och social ingenjörskonst, 1989.
Sax, Ulrika: Den vita staden. Hammarbyhöjden under femtio år, 1989.
Sax, Ulrika: Vällingby – ett levande drama, 1998.
Sidenbladh, Göran: Planering för Stockholm 1923–58, 1981.
Stavenow-Hidemark, Elisabet: Villabebyggelse i Sverige 1900–1925, 1971.
Sveaplan, en skola i tidlös funktionalism, (SISAB) 1997.
Sörenson, Ulf: Ferdinand Boberg. Arkitekten som konstnär, 1992.
Tengboms. Ett arkitektkontors utveckling sedan 1905, 1991.
Thörn, Kerstin: En bostad för hemmet. Idéhistoriska studier i bostadsfrågan 1889–1929, 1997.
Tägil, Thomas: Arkitekten Hans Westman, funktionalismen och den regionala särarten, 1996.
Waern, Rasmus: Tävlingarnas tid, 1996.
Wickman, Kerstin (ed.): Formens rörelse, 1995.
Wrede, Stuart: The Architecture of Erik Gunnar Asplund, 1980.
Yerbury, F. R. (ed.): Swedish Architecture of the Twentieth Century, 1925.
Zimdal, Helge: En arkitekt minns, 1981.
Åhrén, Uno: 'Betraktelse över enkelheten,' i Svenska slöjdföreningens tidskrift, 1926.
Åhrén, Uno: Arkitektur och demokrati, 1942.
Åhrén, Uno: Ett planmässigt samhällsbyggande, SOU 1945:63.
Åkerman, Brita m fl: Den okända vardagen, 1983.

DESIGN

Affischen i Sverige. 230 affischer från 100 år. Paul Lipschutz samling, Sveriges Radios förlag, 2000.
Berglund, Erik: Tala om kvalitet: Om möbelmarknaden och brukarorienterad produktutveckling, 1997.

Brunnström, Lasse (ed.): Svensk Industridesign, 1997.
Dahlbäck Lutteman, Helena: Svensk 1900-talskeramik, 1985.
Eklund Nyström, Sigrid: Möbelarkitekt på 1930-talet: Om inredningsfirman Futurum och hur en ny yrkesgrupp etablerar sig, 1992.
Form, 1917–1960.
Heideken, Carl: Hem, 1994.
Hård af Segerstad, Ulf: Tingen och vi, 1957.
Key, Ellen: 'Skönhet i hemmen,' in Key, Ellen: Skönhet för alla, 1899.
Larsson, Carl: Ett hem, 1899.
Larsson, Lena: Vill våra barn ärva våra ljusstakar, 1970.
Lövgren, Britta: Hemarbete som politik. Diskussioner om hemarbete, Sverige 1930–40-talen och tillkomsten av Hemmens Forskningsinstitut, 1993.
Paulsson, Gregor: Vackrare vardagsvara. 1919. (facsimile edition), 1995.
Paulsson, Gregor, et al.: acceptera, 1931.
Paulsson, Gregor: Tingens bruk och prägel, 1957.
Paulsson, Gregor: 'Stilepok utan morgondag,' in Fataburen, Nordiska museets årsbok, 1968.
Paulsson, Gregor: Upplevt, 1974.
Reternity. Torbjörn Lenskrogs designsamling kommenterad av sju konstnärer (Nationalmuseum 1996.)
Svenska möbler 1890–1990, 1991.
Svenska slöjdföreningens årsbok, 1925.
Svenska textilier 1890–1990, 1994.
Svenskt glas, 1995.
Wickman, Kerstin (ed.): Formens rörelse, 1995.
Åkerman, Brita: Familjen som växte ur sitt hem, 1941.
Åkerman, Brita: Den okända vardagen – om arbetet i hemmen, 1983.
Åkerman, Brita: Kunskap för vår vardag, 1984.

PHOTOGRAPHY

Bäckström, Helmer: 'Ett halvsekels fotografi,' in Fotografisk årsbok 1949, 1948.
Feininger, Andreas: Stockholm, 1936.
Feininger, Andreas: HSB, 1937.
Flemming, Gösta: Andreas Feininger, Stockholm 1933–1939, 1991.
Foto, 1939–59.
Fotografer Curt Götlin, Anna Riwkin, Karl Sandels, (Moderna Museet 1977).
Fotografer Emil Heilborn, Sven Järlås, Gunnar Sundgren, Arne Wahlberg, (Moderna Museet 1977).
Fotografi 55. Jubileumsutställning 1954–55, (Svenska Fotografernas Förbund 1954.)
Fotografisk tidskrift, 1893–1910.
Fotografisk årsbok, 1945–69.
Goodwin, Henry B: Kamerabilden. En orientering för envar med ett hundratal praktiska vinkar, 1929.
Hammarskiöld, Hans: Objektivt sett. Med foto i fokus, 1955.
Hammarskiöld, Hans & Wigh, Leif: Subjektivt sett (Moderna Museet 1993).
Heideken, Carl (ed.): Xposeptember (Stockholm Photography Festival 1998).
Hård af Segerstad, Ulf: Bildkomposition, 1952.
Internationell fotografiutställning (Liljevalchs Konsthall 1930).
Internationell fotografiutställning (Liljevalchs Konsthall 1934).
Internationella fotografiutställningen i Göteborg (Göteborgs Konstmuseum 1929).
Internationella fotografiutställningen i Skånska gruvan, (Skansen 1930).
Johansson, Gotthard: Kritik, 1941.
Jonsson, Sune & Sörlin, Sverker: Hemmavid. Bilder av Sune Jonsson, 1986.
Nordisk fotografi, 1934-1939.
Nordisk tidskrift för fotografi, 1916-1959.
Det nya ögat. Fotografien 100 år (Liljevalchs Konsthall 1939).
Sidwall, Åke & Wigh, Leif: Bäckströms Bilder!, 1980.
Sidwall, Åke & Wigh, Leif: Lennart af Petersens retrospektivt, 1983.
Svartvitt, svensk fotografi av idag (Nationalmuseum 1954).
Svensk fotografisk tidskrift, 1916–59.
Svenska fotografen, 1911–15.
Söderberg, Rolf & Rittsel, Pär: Den svenska fotografins historia, 1983.
Tellgren, Anna: Tio Fotografer. Självsyn och bildsyn, svensk fotografi under 1950-talet i ett internationellt perspektiv, Stockholm 1997.
Wigh, Leif: Fotograferna och det svenska landskapet, 1982.
Wigh, Leif: Uno Falkengren. Fragment från en epok (Moderna Museet 1982).
Wigh, Leif: Sten Didrik Bellander (Moderna Museet 2000).

PAINTING, SCULPTURE, PRINTS AND DRAWINGS

Adrian-Nilsson, Gösta: Den gudomliga geometrin, 1984.
Aspekter på modernismen (Kulturen i Lund 1997).
Barnett, Vivian Endicott: Kandinsky och Sverige, (Moderna Museet 1989).
Behr, Shulamith: Women Expressionists, 1988.
Behr, Shulamith (ed.): Expressionism Reassessed, 1993.
Bergmark, Torsten: Den åldrade modernismen, 1977.
Bild och verklighet. Studier i 1900-talets konst, 1972.
Bosson, Viveca (ed.): Halmstad – Berlin – Paris. Målarresa genom 20-talet, 1984.
Bosson, Viveca: Lhotes tre döttrar. Solvig Olson, Ragnhild Keyser, Vera Meyerson (Mjällby konstgård 1997).
Brunius, August: 'Svensk och norsk expressionism,' in Kunst og kultur, 1911.
Brunius, August: Färg och form. Studier af den nya konsten, 1913.
Brytningstider, (Norrköpings konstmuseum 1998).
Carlsund, Otto G.: Otto G. Carlsund skriver om konst, 1988.
Chambert, Inga: Carlsundstudier. Otto G. Carlsund 1924–1930, 1982.
Claustrat, Frank: Les artistes suédois à Paris 1908–1935, 1994.
Cornell, Peter et al.: Innanför och utanför modernismen, 1979.
Cornell, Peter: Den hemliga källan, 1988.
Danius, Sara: The senses of modernism. Technology, perception and modernist aesthetics, 1998.
Den otroliga verkligheten. 13 kvinnliga pionjärer, (Prins Eugens Waldemarsudde 1994).
Den unga expressionismen. Svenskt måleri 1909–1920, (Nationalmuseum 1944).
Edwards, Folke: Den barbariska modernismen, 1987.
Ekbom, Torsten: Bildstorm, 1995.
Ekström, Anders: Den utställda världen. Stockholmsutställningen 1897 och 1800-talets världsutställningar, 1994.
Ellenius, Allan: Konstsamlingarna och arbetarrörelsen, 1967.
Elsner, Catharina: Expressionismens framväxt. August Brunius skriver om konst, 1993.
Ettrup, Lise: Det modernes gjennombrudd i Norden, 1993.
Facos, Michelle: Nationalism and the Nordic Imagination. Swedish Art of the 1890s, 1998.
Florin, Bo: Den nationella stilen. Studier i den svenska filmens guldålder, 1997.
Frykman, Jonas: Moderna tider. Vision och vardag i folkhemmet, 1985.
Gabriele Münters svenska vänner, (Liljevalchs konsthall 1993).
Grünberger, Tulla: Svenskt måleri under andra världskriget. Speglat genom dagspressens konstrecensioner av utställningsverksamheten i Stockholm 1939–45, 1984.
Grünewald, Isaac: Isaac har ordet, 1959.
Halmstadgruppen 60 år. Halmstad – Berlin – Paris – Halmstad, (Liljevalchs konsthall 1989).
Hedrén, Thomas: Modernism på svenska. Tendenser i svensk konst från sekelskiftet till ca 1950, 1996.
Holten, Ragnar von: Svenska teckningar. 1900-talet, 1985.
Holten, Ragnar von: Surrealismen i svensk konst, 1969.
I Légers ateljé (Mjällby konstgård 1994).
Johansson, Gotthard: Kritik, 1941.
Josephson Ragnar (ed.): Svensk Konstkrönika under 100 år, 1944.
Konstfrämjandet 50 år, (Nationalmuseum 1997).
Konstnärsförbundet efter 1890, (Riksförbundet för bildande konst 1948).
Källström, Staffan & Sellberg, Erland (ed.): Motströms. Kritiken av det moderna, 1991.
Lagerkvist, Pär: Ordkonst och bildkonst, 1913.
Léger och Norden, (Moderna Museet 1992.)
Lengborn, Thorbjörn: Ellen Key – Gerda och Richard Bergh, 1997.
Lidén, Elisabeth: Expressionismen och Sverige. Expressionistiska element i svenskt måleri 1916–47, 1970.
Lidén, Elisabeth: Expressionismen och Sverige. Expressionistiska drag i svenskt måleri från 1910-talet till 40-talet, 1974.
Lidén, Elisabeth & Sandström, Sven: Konsten i Sverige. 1900-talets bildkonst, 1981.
Lilja, Gösta: Det moderna måleriet i svensk kritik 1905–1914, 1955.
Lilja, Gösta: Svenskt måleri under 1900-talet, 1968.
Lilja, Gösta: Den första svenska modernismen, 1986.
Lindberg, Anna-Lena: André Lhote och hans svenska elever efter 1918, 1967.

Lundkvist, Arthur: *Arthur Lundkvist skriver om surrealism och annan konst*, 1989.

Lärkner, Bengt: *Det internationella avantgardet och Sverige*, 1984.

Melin, Emmy: *Föreningen svenska konstnärinnor. 1910–1960*, 1960.

Millroth, Thomas & Stackman, Pelle: *Svenska konstnärer i Paris*, 1989.

Moberg, Ulf Thomas (ed.): *Nordisk konst i 1920-talets avantgarde*, 1995.

Moderna tider 1884-1984 (Malmö Museum 1984).

Modernismens genombrott (Moderna Museet 1989).

Pauli, Georg: *Konstens socialisering*, 1915.

Paulsson, Gregor: *Vackrare vardagsvara*, 1919 (facsimile edition), 1995.

Pettersson, Hans: *Gregor Paulsson och den konsthistoriska tolkningens problem*, 1997.

Qvarnström, Gunnar (ed.): *Moderna manifest*, 4 vol. 1973.

Rolf de Marés samling. Franska kubister. Nils Dardel, (Föreningen för nutida konst 1947).

Sandqvist, Tom: *Han finns förstår du. Siri Derkert och Valle Rosenberg*, 1986.

Scandinavian modernism, 1989.

Schaffer, Barbro: *Analys och värdering. En studie i svensk konstkritik 1930–35*, 1982.

Schwedische avantgarde und Der Sturm in Berlin/Svenskt avantgarde och Der Sturm i Berlin, (Kulturgeschichtlichen Museums Osnabrück/ Felix-Nussbaum-Haus. Kulturen i Lund 2000).

Sjölin, Jan-Gunnar (ed.): *Konst och bildning*, 1994.

Strömbom, Sixten: *Nationalromantik och radikalism. Konstnärsförbundets historia 1891–1920*, 1965.

Svensk modernism. Viljan framåt 1905–1940, 1997. (CD-ROM).

Svenska baletten i Paris 1920–1925, (Dansmuseet 1995).

Svenskt 10-tal, (Norrköpings konstmuseum 1987).

Sverige i tiden 1900–1920, (Kulturhuset, 1977).

Svenskt avantgarde. Kubism futurism purism nonfiguration från 10-talets genombrott till tiden efter andra världskriget, (Norrköpings museum 1979).

Söderberg, Rolf: *Den svenska konsten under 1900-talet*, 1970.

10-talets bilder, (Moderna Museet 1972).

Ursvenskt. Naivister och realister 1916–1946, (Norrköpings konstmuseum 1992).

Vergine, Lea: *Andra hälften av avantgardet 1910–1940. Kvinnliga målare och skulptörer inom de tidiga avantgardistiska rörelserna*, (Kulturhuset 1981).

Werenskiold, Marit: *The concept of expressionism*, 1984.

CHECKLIST

* indicates items exhibited in Stockholm and New York
† indicates items exhibited in New York but not Stockholm
Measurements are given in centimeters, height before width
Reference numbers relate to the Stockholm exhibition

PAINTING, SCULPTURE AND DRAWING

Gösta Adrian-Nilsson (1884–1965)
Abstract III, 1919
oil on canvas, 40 x 55
Private collection [56]

Gösta Adrian-Nilsson
High Jumper, c. 1913, 45 x 40
Private collection [172]

Gösta Adrian-Nilsson
Apparatus for Storage of Sunlight (marine), c. 1922
collage, watercolor and Indian ink, 31 x 23.5
Kulturen i Lund [57]

Gösta Adrian-Nilsson
Bloody Boxing Debut, c. 1922
collage and watercolor, 31.5 x 23
Kulturen i Lund [58]

Gösta Adrian-Nilsson
The Architecture of the Heart, 1921
collage, watercolor, and ink, 28.5 x 22
Kulturen i Lund [59]

Gösta Adrian-Nilsson
Picture Factory, 1921–3
collage, watercolor and chalk, 26 x 19.5
Kulturen i Lund [60]

Gösta Adrian-Nilsson
The Architecture of Boxing, 1923
pencil and wash with collage, 33.5 x 27.5
Kulturen i Lund [61]

Gösta Adrian-Nilsson
Footballers in Motion, 1915
oil on canvas, 53 x 50
Private collection [62]

Gösta Adrian-Nilsson
The Steps of Life, 1920
oil on paper, 62 x 53.5
Private collection [65]

Gösta Adrian-Nilsson
The Industrial Worker (The Machine Worker), 1918
oil on canvas, 136 x 130
Norrköping Art Museum [66]

Gösta Adrian-Nilsson
Plane Geometry 2, 1930
oil on pasteboard, 54 x 49
Moderna Museet [67]

Gösta Adrian-Nilsson
Composition I, 1930
oil on pasteboard, 50 x 42
Private collection [189]

Gösta Adrian-Nilsson
Sketches for the Arctic Sea Ballet, music by Gösta Nystroem, 1923
gouache, Indian ink, pen drawing, c. 35 x 24
Nationalmuseum [106-108]

Gösta Adrian-Nilsson
Sketches for the South Pacific, 1923
watercolor, pencil, pen drawing, c. 35 x 25
Nationalmuseum [109-112]

*Gösta Adrian-Nilsson
The Loudspeaker, c. 1920
painted wood and metal, height 56
Moderna Museet [125]

Gösta Adrian-Nilsson
Negro King, c. 1920
painted wood and metal, 29 x 16 x 16
Private collection [126]

Gösta Adrian-Nilsson
The Divine Geometry, 1922
Moderna Museet, Art Library [157]

*Gösta Adrian-Nilsson
Der Sturm, 1922
collage
Private collection [169]

†Gösta Adrian-Nilsson
The Express Train II 1916
Oil on board, 39 x 45
Malmö Konstmuseum

Carl Alexandersson (1897–1941)
Demonstration at the Prison, 1936
120 x 105
Stockholm Art Bureau[186]

Carl Alexandersson
Unemployed, 1933
oil on canvas, 104 x 116
Per Ekström Museum [199]

Albin Amelin (1902–75)
Racial Hygiene, 1934
mixed media on pasteboard, 58 x 70
Private collection [150]

*Albin Amelin
Racial Hygiene, 1935
gouache, 65 x 72
Gothenburg Art Museum [197]

*Amelin et al.
The journal *Mänsklighet* (*Humanity*), 1933
Moderna Museet, Art Library [156]

†Olle Baertling
Spiro 1954
Metal, lacquered iron plate, H. 88
Moderna Museet

†Olle Baertling
Kereb 1956
Metal, lacquered iron plate
plate 21.5 x 34
Moderna Museet

† Olle Baertling
Agra, 1959
Oil on canvas, 97 x 195
Baertling Foundation, Stockholm

Christian Berg (1893–1976)
Shadows, 1928
oil on canvas, 114.5 x 56
Private collection [68]

Christian Berg
Composition for an Observatory, 1929
oil on canvas, 115 x 80
Private collection [69]

Christian Berg
Torpedo Figure I, 1927
bronze, height c. 46
Private collection [190]

Christian Berg
Flower Form I, 1929–30
bronze, height 30
Private collection [192]

Christian Berg
Bonnet Mark, 1928
bronze, height 14
Private collection [193]

Christian Berg
Monumental Figure, 1927
granite concrete, height 250
Moderna Museet [127]

Bo Beskow
*Sketch for Sveaplan Girls' Grammar
School*
Stockholm, 1939
pencil and Indian ink, 13.5 x 21.5
Sketch Museum [178]

Olle Bonniér (b. 1925)
Vibrations, 1948
plexiglass
Private collection [183]

Olle Bonniér
The Solitary/The Listener, 1948
plexiglass, height c. 50
Private collection [184]

Olle Bonniér
Fugue, 1948
collage, lithograph, 69 x 106
Private collection [122]

*Olle Bonniér
*Sketches for AB Svenska
Bostäder, Vällingby*, 1955
Moderna Museet [175]

Olle Bonniér
Progressive Well-Tempering, 1948
oil on canvas, 78.5 x 51
Moderna Museet [167]

*August Brunius (1879–1926)
Color and Form (Färg och Form), 1913
Moderna Museet, Art Library [152]

Gideon Börje (1891–1965)
From Vaxholm, 1918
oil on canvas, 55.7 x 69
Moderna Museet [99]

*Otto G. Carlsund (1897–1948)
*The Cinema Series, decoration for a
cinema in Paris*,
architect: Le Corbusier, 1926
oil on wood and panel, c. 125 x 59
Moderna Museet and private collection
[48]

Otto G. Carlsund
Le musicien construit, project for
Stockholm's Regina Theatre, 1935
ripolin, 310 x 100
Norrköping Art Gallery [49]

Otto G. Carlsund
The Locomobile, 1924
oil on panel, 35 x 27
Private collection [50]

*Otto G. Carlsund
The Chair, 1926
oil on canvas, 125 x 58
Moderna Museet [51]

Otto G. Carlsund
The Note's Vibration, 1929
oil on canvas, 27 x 27
Private collection [52]

Otto G. Carlsund
Sequence of Notes, 1929
oil on canvas, 78 x 78.5
Private collection [53]

Otto G. Carlsund
Six Announcements for Art Concret,
1930, oil on panel, 33 x 33/54 x 18
Eskilstuna Museum and Private
collection [54]

Otto G. Carlsund
*Sketch for the Einstein Observatory in
Potsdam*, 1925
oil on canvas, 141 x 75.5
Sketch Museum [160]

Agnes Cleve (1876–1951)
Vision II, 1915
oil on canvas, 85 x 60.5
Per Ekström Museum [4]

*Agnes Cleve
Fire in New York, 1916
oil on canvas, 85 x 60.5
Per Ekström Museum [28]

Nils Dardel (1888–1943)
Jean Börlin in Siamese Dance, 1919
oil on canvas, 116 x 82
Moderna Museet [20]

Nils Dardel
Rue Ville de Paris in Senlis, 1912
oil on canvas, 91 x 68.5
Moderna Museet [21]

Nils Dardel
The Girl with the Iron Ball, 1912
oil on canvas, 81 x 65
Moderna Museet [23]

*Nils Dardel
*Set Design for La Maison de Fous,
Ballet Suédois*, 1920
Dance Museum [114]

*Siri Derkert (1888–1973)
Still Life with Teapot, 1915
oil on canvas, 61 x 47
Moderna Museet [26]

Siri Derkert
Self-Portrait with Parasol, 1916
oil on canvas
Private collection [27]

Siri Derkert
Children around Table, 1927
oil on canvas, 80 x 60
Private collection [115]

Siri Derkert
Factory Landscape, 1918
watercolor
Private collection [137]

Siri Derkert
*Sketches for the Woman Pillar in the
T-central subway station, Stockholm*,
1956–8
charcoal and Indian ink, 70/73 x 27
Sketch Museum [180]

*Siri Derkert
Fashion Designs, 1917–21
Private collection [168]

*Viking Eggeling (1880–1925)
Diagonal Symphony, 1924
film; 16mm, silent, 7.40 min
Moderna Museet [83]

Sven Erixson (1899–1970)
Sketch for the Forest Cemetery,
1937–40
oil tempera, 73 x 102
Sketch Museum [179]

*Sven Erixson
Picture of the Times, 1937
oil on canvas, 137 x 136
Moderna Museet [170]

Sven Erixson
Travelling Painters, 1941
oil on canvas, 66 x 73
Stockholm Art Bureau [185]

† Sven Erixson
I don't believe in sport either 1931
Oil on canvas, 61.2 x 61.2. ABF

Randi Fisher (1920–97)
Climbing Tree, 1955
tempera, 121 x 30
Stockholm Art Bureau [187]

Arvid Fougstedt (1888–1949)
Still Life, 1920
oil on canvas, 62.5 x 47.5
Per Ekström Museum [33]

Arvid Fougstedt
Mauritz Stiller, c. 1920
oil on glass, 48 x 60
Sandrew AB [34]

Arvid Fougstedt
Matisse teaching in Paris, 1912
Indian ink, 49.5 x 30.5
Borås Art Museum [146]

Eric Grate (1896–1983)
Crystals and Facets, 1922–3
oil on canvas, 55 x 67
Per Ekströmmuseet [89]

Eric Grate
Shore Finds, c. 1930
wood, roots, stone, terracotta, shell,
30.5 x 21 x 15
Private collection [118]

*Eric Grate
Dido and Aeneas, 1930
terracotta, height 29.5
Moderna Museet [130]

Eric Grate
TU-TU-E, TU-TU-HOI, 1928
Indian ink and colored chalk, 36 x 50
Private collection [181]

Eric Grate
Negro King, 1923
watercolor, 31 x 22
Private collection [182]

Isaac Grünewald (1889–1946)
The Authoress Ulla Bjerne, 1916
oil on canvas, 200 x 100
Moderna Museet [9]

Isaac Grünewald
The Violinist (The Fiddler), 1918
oil on canvas, 64 x 54
Malmö Art Museum [10]

*Isaac Grünewald
The Crane, 1915
oil on canvas, 150 x 98
Moderna Museet [11]

Isaac Grünewald
The Temptation of St Antony
watercolor, 37.7 x 26.8
Moderna Museet [135]

Isaac Grünewald
*Exhibition Poster 'The Eight – Swedish
Expressionists,'* 1912
Moderna Museet [136]

Isaac Grünewald
*Sketch for the Wedding Chamber in
Stockholm Town Hall*, 1913
oil on paper, 100.5 x 114
Sketch Museum [159]

Eric Hallström (1893–1946)
Rörstrand's Porcelain Factory, 1918
oil on canvas, 110 x 162
Stockholm City Museum [90]

Eric Hallström
Funeral in Solna, 1918
oil on panel, 22 x 55
Moderna Museet [91]

Eric Hallström
Summer Day in Haga, 1918–19
oil on canvas, 63 x 115
Moderna Museet [92]

Eric Hallström
New Year's Eve at Skansen, 1918
oil on wood panel, 90 x 105
Moderna Museet [93]

*Sigrid Hjertén (1885–1948)
The Red Blind, 1916
oil on canvas, 116 x 89
Moderna Museet [2]

Sigrid Hjertén
From Kornhamnstorg, 1912
oil on canvas, 81 x 65
Malmö Art Museum [3]

Sigrid Hjertén
The Blue Balcony, 1915
oil on canvas, 116 x 89
Private collection [5]

Sigrid Hjertén
Woman in Red Interior, 1915
oil on canvas, 159 x 151
Private collection [6]

Sigrid Hjertén
Boy with Toy Boat (Iván with Toy Boat),
1916
oil on canvas, 65 x 54
Private collection [7]

*Sigrid Hjertén
Harvesting Machines, 1915
oil on canvas, 74 x 100
Moderna Museet [8]

Sigrid Hjertén
Self Portrait
watercolor and pen, 35.5 x 25.5
Moderna Museet [138]

Sigrid Hjertén
Mother and Child, 1916–18
linocut, 42.5 x 30.5
Private collection [139]

Sigrid Hjertén
Family: Sigrid, Isaac and Iván, 1916–18
linocut, 43 x 30.5
Private collection [140]

Sigrid Hjertén
Artist and Model, 1916–18
linocut, 40.5 x 32
Private collection [141]

Sigrid Hjertén
*Sketch for the Wedding Chamber in
Stockholm Town Hall*, 1913
oil on paper, 99 x 119
Sketch Museum [158]

Bror Hjorth (1894–1968)
The Racing Sleigh, 1922
oil on canvas, 82 x 66
Moderna Museet [85]

*Bror Hjorth
Fröding, 1923
alder wood, height 60
Bror Hjorth's House, Uppsala [128]

Bror Hjorth
Giacometti, 1922
pencil, 20 x 17
Bror Hjorth's House, Uppsala [188]

Bror Hjorth
Portrait of Ernst Josephson, 1920s
pencil
Bror Hjorth's House, Uppsala [189]

*Bror Hjorth
Love Group, 1932
alabaster, height 35
Moderna Museet [129]

Tora Vega Holmström (1880–1967)
Negroes listening to music, 1929
oil on canvas, 63.5 x 54
Norrköping Art Museum[97]

John Jon-And (1889–1941)
The Painter, 1914
oil on canvas, 42 x 50.3
Moderna Museet [31]

†Arne Jones
Cathedral 1950
Bronze, H. 110
Moderna Museet

Sven Jonsson (1902–81)
The Bandy Player, 1930
oil on canvas, 60 x 80
Halmstad kommun [77]

†Sven Jonsson
Hurdle-racer 1929
Oil on canvas
65 x 54
Private collection

*Torsten Jovinge (1898–1936)
The Bergsund Quarter, 1931–33
oil on canvas, 61 x 50
Norrköping Art Museum [101]

Torsten Jovinge
The Marmorn Quarter, 1933
oil on canvas, 61 x 50
Private collection [102]

Torsten Jovinge
Flamman Cinema, 1932
oil on canvas, 65 x 53
Stockholm City Museum [104]

Hilma af Klint (1862–1944)
Group 9 The Swan no. 18, 1914–15
oil on canvas, 155 x 152
Hilma af Klint Foundation [12]

Hilma af Klint
Group 1 Primordial Chaos no. 2, 1906
oil on canvas, 50 x 38
Hilma af Klint Foundation [37]

Carl Kylberg (1878–1952)
The New Start, 1935
oil on canvas, 106 x 124
Moderna Museet [171]

Pär Lagerkvist (1891–1974)
*Verbal Art and Visual Art (Ordkonst och
Bildkonst)*, 1913
Moderna Museet, Art Library [153]

Fernand Léger (1881–1955)
*Sketch for the Cover of Ballet Suédois
Programme*, 1923
Dance Museum [116]

†Birgitta Liljebladh
Marilyn Monroe 1951
Oil on masonite, 63 x 59
Moderna Museet

Lage Lindell (1920–80)
*Sketch for Decoration of Västerås Town
Hall*, 1958–9
pencil, gouache, 18 x 39.5
Moderna Museet (98)

Hilding Linnqvist (1891–1984)
The Heart's Song, 1920
oil on panel, 37.5 x 24
Moderna Museet [94]

Hilding Linnqvist
Klara sjö, 1916
oil on canvas, 44 x 106
Moderna Museet [95]

Hilding Linnqvist
Military Funeral, 1918
oil on canvas, 67 x 95
Moderna Museet [96]

Sture Lundberg (1900–30)
Sardine Fishermen, Positano, 1923–5
oil on canvas, 90.5 x 54
Moderna Museet [32]

Sture Lundberg (1900–30)
Still Life with Calf's Head, 1923
oil on canvas, 35.5 x 45.5
Private collection [43]

Knut Lundström (1892–1945)
Still Life, 1922
oil on panel, 61 x 49.5
Norrköping Art Museum [87]

Knut Lundström
Chords, Paris, 1924
oil on canvas, 73 x 54
Per Ekström Museum [88]

Gunnar Löberg (1893–1950)
My Models/Inconsequence III, 1932
oil on canvas, 77 x 112
Norrköping Art Gallery [121]

Vera Meyerson (1903–81)
Composition mécanique, 1925
oil on canvas, 100 x 65
Private collection [79]

Axel Nilsson (1889–1981)
Still Life with White Jug, 1922
oil on panel, 55 x 38
Moderna Museet [46]

Axel Nilsson
Rocks at Roslagstull, c. 1915
oil on wood, 62 x 46.9
Moderna Museet [47]

Vera Nilsson (1888–1979)
The Master Joiner, Copenhagen, 1916
oil on canvas, 68.5 x 66.5
Norrköping Art Museum [15]

*Vera Nilsson
Street in Malaga II, 1920
oil on canvas, 106.5 x 71.5
Norrköping Art Museum [16]

Vera Nilsson
Boy in Blue Cap, 1918
oil on canvas, 70 x 62
Private collection [17]

Vera Nilsson
Öland Landscape, 1917
oil on canvas, 86 x 77
Småland Art Archive [18]

Vera Nilsson
Grandmother and Little Girl, 1925
oil on canvas, 92 x 78
Moderna Museet [19]

*Vera Nilsson
German Mothers, 1939
oil on canvas, 83 x 105
Skövde Art Museum [195]

Vera Nilsson (1888–1979)
Drawings, 1910s
Moderna Museet [131]

Wiven Nilsson (1897–1974)
Moon over Paris, 1925
plaster
Private collection [70]

†Hans Nordenström, et al
Journal 'Blandaren' 1955
Paper, card
3.5 x 45 x 31
Moderna Museet

*Erik Olson (1901–86)
The Constructor, 1925
oil on canvas, 51.5 x 79.5
Moderna Museet [71]

Erik Olson
The Gauntlet is Thrown, 1930–1
oil on canvas, 60 x 92
Halmstad kommun [72]

Erik Olson
The Ox Driver, 1924
oil on canvas, 73.5 x 60.3
Halmstad County Museum[73]

Erik Olson
The Daily Press, 1940
oil on canvas, 66 x 66
Halmstad kommun [149]

Erik Olson
The Balloon, 1924
oil on canvas, 51 x 42
Halmstad County Museum [74]

Erik Olson
Composition with Strong Contrasts,
1930
Private collection [75]

Axel Olson (1899–1986)
8-Hour Evening, 1923
watercolor, 34.5 x 18
Halmstad County Museum [148]

Olle Olsson Hagalund (1904–72)
Jewish Funeral, c. 1945
oil on canvas, 80 x 85
Moderna Museet [166]

Karin Parrow (1900–86)
The Harbor in Winter Weather, 1939
oil on canvas, 41.5 x 54.5
Gothenburg Art Museum[196]

*Georg Pauli (1855–1935)
The Socialization of Art – A Program,
1915
Moderna Museet, Art Library [154]

Gregor Paulsson (1889–1977)
The New Architecture, 1916
Moderna Museet, Art Library [155]

*Karl-Axel Pehrson (b. 1921)
Delphinic Movement, 1952
oil on masonite, 100 x 72
Moferna Museet

†Carl Fredrik Reuterswärd
Kilroyalty 1963
Crayon on paper. Advertisement in *New
York Herald Tribune* 19–20 January
1963, 58 x 43
Moderna Museet

Lennart Rodhe (b. 1916)
Sketch For Ängby Grammar School,
1948–53
black pasteboard, 33 x 36
Sketch Museum [176]

Lennart Rodhe
Spiral Track, 1948
oil on canvas, 67 x 83
Private collection [164]

Lennart Rodhe, Karl-Axel Pehrson,
Pierre Olofsson, Lage Lindell
*Sketches for Decoration at Astra in
Södertälje*, 1955–6
various techniques, 45 x 100
Sketch Museum, Lund [177]

*Ragnar Sandberg (1902–72)
Lilla Bommen Café, 1938
oil on canvas, 73 x 90
Moderna Museet [173]

Gösta Sandels (1887–1919)
Self Portrait, 1915
oil on canvas, 40 x 32
Gothenburg Art Museum[13]

Inge Schiöler (1908–71)
Winter, Bohuslän, 1932/3
oil on canvas, 73 x 92.5
Gothenburg Art Museum[188]

Otte Sköld (1894–1958)
White Star, 1917
oil on oilcloth, 100 x 125
Norrköping Art Museum[35]

Otte Sköld
Iron and Starched Collar, 1919
oil and collage on canvas, 50 x 50
Västerås Art Museum [38]

Otte Sköld
Lady with Cat, 1918
oil on canvas, 73 x 59
Malmö Konstmuseum [39]

Otte Sköld
*Sans Souci, The Cyclist, The
Horsewoman*, 1916
colored woodcuts
Moderna Museet [142–144]

John Sten (1879–1922)
Sketch for the Wedding Chamber, 1913
oil on canvas, 59 x 60
Sketch Museum [174]

John Sten
Self Portrait, 1914
gouache, 62 x 46
Hälsingland Museum [25]

*August Strindberg (1849–1912)
Wonderland, 1894
oil on pasteboard, 72.5 x 52
Nationalmuseum [1]

Esaias Thorén (1901–81)
The Game Has Begun, 1938
oil on canvas
Halmstad kommun [76]

Axel Törneman (1880–1925)
Youth, 1919
oil on canvas, 80 x 63.5
Per Ekström Museum [14]

Axel Törneman
The Fool, 1919
oil on canvas, 81 x 64.5
Moderna Museet [36]

P. O. Ultvedt (b. 1927)
Housework Machine, 1959
mobile sculpture in wood
Private collection [105]

†P. O. Ultvedt
Spinning Object 1959
Mixed media, electric motor
40 x 40 x 15
Private collection

Nell Walden (1887–1975)
Glass Picture no. 10 (Fliessendes), 1916
oil on glass, 22.5 x 16
Landskrona Museum [29]

Nell Walden
Glass Picture no. 19/18, 1917
oil on glass
Landskrona Museum [45, 63]

*Nell Walden
Glass Picture, 1915
oil on glass, 30 x 24
Moderna Museet [30]

†Nell Walden
The Red Village 1915
Oil on glass, 21.5 x 19
Moderna Museet

Nils Wedel (1897–1967)
Banjo Player, 1924
oil on canvas, 128 x 87
Norrköping Art Museum[198]

*Nils Wedel
Jury (Censorship), 1938
nawax, 204 x 300
Moderna Museet [103]

Bo von Zweigbergk (1897–1940)
Self Portrait, 1921
oil on canvas, 48 x 38
Per Ekströmmuseet [42]

*Martin Åberg (1888–1946)
Karlberg, 1921
oil on canvas, 66.5 x 73
Per Ekström Museum [41]

*Bengt O. Österblom (1903–76)
Radio Tower, 1926
pencil, 27 x 21
Norrköping Art Museum[80]

*Bengt O. Österblom
Rum – tid i svart cirkel, 1923
gouache, 17 x 29
Norrköping Art Museum[81]

Bengt O. Österblom
*Costume sketches for The Fingerprint
Ballet*, 1927–30
gouache, 29 x 23
Norrköping Art Museum[82]

*Bengt O. Österblom
The Pitcher's Projection, 1926
gouache, 37 x 30
Norrköping Art Museum[162]

†Bengt O. Österblom
Radio Tower, Paris 1926
Reconstruction, cardboard, H. 76
Norrköping Art Museum

*The journal *Flamman*, 1917–21
Moderna Museet, Art Library [151]

*The journal *Der Sturm*, July, 1915
Moderna Museet, Art Library [163]

DESIGN

*Carl-Axel Acking (1910–2001)
Armchair, Swedish Furniture Factories,
1944
laminated mahogany veneer
Torbjörn Lenskog 20th Century Design
Collection [213]

Louise Adelborg (1885–1971)
The National Service (Nationalservisen),
Rörstrand, 1930

feldspar porcelain
Apollo Antiques, Stockholm [250]

Gösta Adrian-Nilsson (1884–1965)
Tobacco Tin, Astrid Aagesen, 1930
pewter
Nationalmuseum [304]

Karin Ageman (1899–1993)
*Binding for Färg och Form (Color and
Form)* by August Brunius, F. Beck &
Son, 1930
leather binding
Nationalmuseum [306]

Karin Ageman
*Binding for Stänk och flikar (Rags and
Patches)* by Gustaf Fröding,
F. Beck & Son, 1930
morocco leather
Nationalmuseum [307]

*Folke Arström (1907–97)
Fokus Cutlery Set, Gense, 1955
stainless steel
Private collection [303]

*Gunnar Asplund (1885–1940)
Armchair for the Paris Exhibition 1925,
David Blomberg Inc
mahogany, leather
Nordic Museum [202]

Gunnar Asplund
Chair for the Stockholm Exhibition 1930
lacquered tubular steel, leather
Architecture Museum [206]

*Gunnar Asplund
Armchair for the Boardroom of the
Swedish Design Society, 1931
Tubular steel, leather
Swedish Architects' Pension Fund [211]

*Olle Baertling (1911–81)
Margot and Denise textile print, NK:s
Textilkammare, 1954, velvet
Archive for Swedish Design, Kalmar Art
Museum [292]

*Anders Beckman (1907–67)
*Exhibition Poster 'Svensk reklam i
svenskt tryck'* (Swedish Publicity in
Swedish Print) 1935, lithograph
Moderna Museet [336]

*Anders Beckman
Advertising Poster for Aerotransport,
1934, lithograph
Moderna Museet [347]

*Hertha Bengtsson (1917–93)
Blue Fire (Blå Eld) Service, Rörstrand,
1951, flintware
Rörstrands Museum [245]

Elis Bergh (1881–1954)
Glass Service, Kosta, 1930
Private collection [264]

Richard Bergman
Poster for Swedish Advertising Week,
1919 [329]

Carl Bergsten (1879–1935)
Chair for Strömsholmen Restaurant in
Norrköping, 1906, painted birch
Nationalmuseum [200]

Sigvard Bernadotte (b. 1907)
Candlestick, Jörgen Jensen, 1930
silver
Nationalmuseum [301]

Sigvard Bernadotte
Ice Water Jug, Georg Jensen, 1952
silver
Nationalmuseum [302]

Bernadotte & Björn
Thermos Flask, Moderna Kök, 1959
stainless steel
Private collection [317]

*Bernadotte & Björn
Facit T1 Typewriter, 1957
Torbjörn Lenskog 20th Century Design
Collection [327]

†Bernadotte & Björn
Tableware for Camping 1950s
Plastic, 31.5 x c.25
Private collection

†Bernadotte & Björn
'Margrethe' Bowl designed by Jacob
Jensen 1954
Plastic. 4 parts, 12.5 x 16.5
Private Collection

Harry Bernmark/Knut Krantz
*Advertising poster 'Gör pengarna dryga
– köp i Konsum'* (Make Your Money Last
– Shop At Konsum)
lithograph
Cooperative Union [342]

Anders Billow (1890–1964)
Cover for 'Årets bilder' (Pictures of the
Year) Swedish Tourist Board, 1933
[334]

*Carl-Arne Breger (b.1923)
Water Jug, Gustavsberg, 1957
plastic
Private collection [326]

†Torun Bülow-Hybe
Bracelet with glass by Edward Hald,
1961, silver, glass, 2 x 5 x 3.5
Nationalmuseum

† Torun Bülow-Hybe
Necklace 1948
Silver and mediterranean stones
Nationalmuseum

Erik Chambert (1902–88)
Easy Chair for the Stockholm Exhibition
1930, Chambert's Furniture Factory,
remade 1980
lacquered tubular steel and wood
Architecture Museum [207]

Erik Chambert
Scales Of Life (Livets vågskål)
Cupboard, Chamberts Möbelfabrik,
1950, inlaid wood
Nationalmuseum [221]

*Ewald Dahlskog (1894–1950)
Vase, Boberg's Earthenware Factory,
1930, earthenware
Nationalmuseum [231]

Ingrid Dessau (1923–2000)
Manhattan Curtain, 1953
Russia weave, flax, wool
Nationalmuseum [293]

*Erik Ekeberg (1898–1960)
Cutlery Set, K Andersson, 1929
silver
Nationalmuseum [298]

*Olle Eksell (b.1918)
Graphic Design for Mazetti, 1956
Private collection [344]

*Yngve Ekström (1913–88)
Lamino Armchair, Swedese Furniture,
1955, beech, teak, sheepskin
Private collection [220]

Märta Måås Fjetterström (1873–41)
Perugia Curtain, Märta Måås
Fjetterström's workshop, 1927
röllakan, wool
Nationalmuseum [274]

Karl-Erik Forsberg (1914–95)
*Book jacket for 'Det första svenska
stilgjuteriet' (The First Swedish Style
Foundry) by Nils G. Wollin*, 1943 [335]

*Vidar Forsberg (1921–92)
*Book jacket for 'Reklamen är livsfarlig
' (Advertising is Dangerous – A Polemic)
by Sven Lindqvist*, 1957 [345]

Einar Forseth (1892–1988)
Crater Punchbowl, Lidköpings Porcelain
Factory, 1922, porcelain
Nationalmuseum [230]

Josef Frank (1885–1967)
The Nationalmuseum Cupboard, 1938
amboina root and walnut, veneer
Swedish Pewter [212]

*Josef Frank
Terrazzo fabric, Svenskt Tenn, 1943
linen [281]
Nationalmuseum

*Berndt Friberg (1899–1981)
Vase, Gustavsberg, 1954
flintware
Nationalmuseum [251]

Simon Gate (1883–1945)
Triton Vase, Orrefors, 1917
glass, ground
Nationalmuseum [254]

Simon Gate
Glass Service, Sandvik Glassworks,
1917, soda glass
Nationalmuseum [261]

*Simon Gate
Vase, Orrefors, 1930
glass, handblown
Agnes Hellner Collection of Orrefors
glass [262]

*Edward Hald (1883–1980)
'Turbine' Service, Rörstrand, 1917
flintware
Nationalmuseum [227]

*Edward Hald
Service, Karlskrona Porcelain Factory,
1930
feldspar porcelain
Nationalmuseum [244]

*Edward Hald
Bowl – Girls Playing Ball, Orrefors, 1919
glass, engraved
Nationalmuseum [255]

Edward Hald
Balloon Goblet with gondola, Orrefors,
1925, glass, engraved
Nationalmuseum [256]

Edward Hald
The Fireworks Bowl (Fyrverkeriskålen),
Orrefors, 1923
glass, engraved
Agnes Hellner's Collection of Orrefors
Glass [259]

Edward Hald
Service, Sandvik Glassworks, 1931
glass, pressed
Orrefors [260]

Edward Hald
Carafe, Orrefors, 1942
soda glass
Nationalmuseum [266]

Edward Hald
The Curtain Bowl (Draperiskålen),
Orrefors, 1919
glass, engraved
Nationalmuseum [296]

*Jean Heiberg (1884–1976)
Telephone, L. M. Ericsson, 1931
bakelite
Technology Museum [310]

*Erik Höglund (1932–98)
Vase, Boda, 1954
glass with stamped decoration
Nationalmuseum [273]

*Kerstin Hörlin Holmquist (b. 1925)
Great Kraal (Stora Kraal) Chair,
Nordiska Kompaniet, 1952
lacquered iron, rattan
Nationalmuseum [218]

*Folke Jansson (b. 1920)
Arabesk Armchair, Wincrantz
Möbelindustri, 1955
birch, saddle-girth
Wigerdals Värld [219]

Gocken Jobs (1914-1995)
Trollslända textile print, NK:s
Textilkammare, 1945
linen [285]

Johan Petter Johansson
Triplex Fitting, Triplex i Enköping,
c. 1928
lacquered steel
Torbjörn Lenskog 20th Century Design
Collection [208]

Akke Kumlien (1884–1949)
*Book jacket for 'Dikter av Vitalis' (Poems
by Vitalis)* 1929 [330]

*Wilhelm Kåge (1889–1960)
*The 'Worker' Service (Arbetarservisen)
with Liljeblå decoration*, Gustavsberg,
1917, stoneware
Nationalmuseum [228]

Wilhelm Kåge
Reklam Toilet Service, Gustavsberg,
1917, stoneware
Nationalmuseum [229]

Wilhelm Kåge
Vase, Gustavsberg, 1930, silver
Nationalmuseum [232]

*Wilhelm Kåge
Praktika Service, Gustavsberg, 1933
stoneware
Gustavsberg Porcelain Museum [233]

*Wilhelm Kåge
*The Gentle Forms (De mjuka formernas)
Service*,
Gustavsberg, 1938
flintware
Gustavsberg Porcelain Museum [239]

*Wilhelm Kåge
Surrea Vase, Gustavsberg, 1940
flintware
Gustavsberg Porcelain Museum [240]

*Nils Landberg (1907–91)
Tulip Glass, 1955
hand blown glass
Orrefors [269]

Axel Larsson (1898–1975)
Chair, Swedish Furniture Factories,
1930, painted birch, saddle-girth
Nationalmuseum [204]

*Alvar Lenning (1897–1980)
Kitchen Assistant, Electrolux, 1940
Torbjörn Lenskog 20th Century Design
Collection [311]

*Sigurd Lewerentz (1885–1975)
Poster for the Stockholm Exhibition,
1930
Architecture Museum [332]

*Anders B Liljefors (1923–70)
Object, Gustavsberg, 1956
flintware
Nationalmuseum [249]

*Stig Lindberg (1916–82)
Teapot and water jug, Gustavsberg,
1940s
earthenware, painted decor
Gustavsberg Porcelain Museum [238]

Stig Lindberg
Vase, Gustavsberg, 1942
earthenware, painted decor
Nationalmuseum [241]

*Stig Lindberg
Terma Serving Dish, Gustavsberg, 1955
Nationalmuseum [242]

*Stig Lindberg
Spisa Ribb Service, Gustavsberg, 1955
bone china
Gustavsberg Porcelain Museum

*Stig Lindberg
Domino Ashtray, Gustavsberg, 1955
flintware
Gustavsberg Porcelain Museum [247]

*Stig Lindberg
TV 'Cosmetic Mirror', Luxor, designed
1959, in production 1964
Jönköping Radio Museum [316]

*Ingeborg Lundin (1921–92)
The Apple, 1955
glass
Orrefors [270]

*Ralph Lysell (1907–87)
Elektro-Helios Tea Urn, early 1940s
stainless steel
Nationalmuseum [312]

Ralph Lysell
Designs for Electric Kettles, 1945
gouache
Nationalmuseum [337]

Ralph Lysell
Design for a refrigerator, 1940s
gouache
Nationalmuseum [338-339]

*Ralph Lysell and Hugo Blomberg
Prototype for the Cobra telephone, 1941
Telemuseum [322]

Georg Magnusson (1907–70)
*Poster for the KAOS Dance Restaurant
in Stockholm*, 1930 [331]

*Carl Malmsten (1888–1972)
Little Åland Chair, 1940
björk
Carl Malmsten AB [224]

Sven Markelius (1889–1972)
Chair for Epa-bar in Stockholm,
Nordiska Kompaniet, 1930s
tubular steel and red lacquered wood,
red PVC coating
Torbjörn Lenskog 20th Century Design
Collection [216]

Sven Markelius
Markeliusrutan textile print, NK:s
Textilkammare, 1943
linen
Nationalmuseum [286]

Sven Markelius
Set Square textile print, NK:s
Textilkammare, 1954
linen
Nationalmuseum [287]

*Bruno Mathsson (1907–88)
Work-chair, Karl Mathsson and
Company, 1934
Bentwood and webbing
Bruno Mathsson International [201]

†Einar Nerman
Poster for the film 'Erotikon'
Director: Mauritz Stiller.
Design: Einar Nerman 1920
Moderna Museet

*Wiwen Nilsson (1897–1974)
Teacaddy, 1930
silver and ebony
Nationalmuseum [299]

*Gunnar Nylund (1904–97)
'Frigi' storage container, Rörstrand,
1941
flintware
Nationalmuseum [237]

Edvin Ollers (1889–1959)
Glass Service, Kosta, 1917
Nationalmuseum [253]

Edvin Ollers
Binding for Poems of Viktor Rydberg,
Nordiska Bokhandeln, 1930
leather binding
Nationalmuseum [308]

*Sven Palmqvist (1906–84)
Fuga Bowl, Orrefors, 1953, glass
Orrefors [272]

Karl-Axel Pehrson (b. 1921)
Delphinic movement (Delfinisk rörelse)
textile print, NK:s Textilkammare, 1952
linen [291]

Arthur C:son Percy (1886–1976)
Kiruna Vase, Gefle Porcelain Factory, 1931
flintware
Nationalmuseum [235]

*Sigurd Persson (b.1914)
Global Deep Dish, AB Silver & Stål, 1954
stainless steel
Galleri Sigurd Persson [305]

*Sigurd Persson
Servus Cutlery Set, Cooperative Union/AB Silver & Stål, 1953
stainless steel
Galleri Sigurd Persson [349]

Signe Persson Melin (b. 1925)
Jug, 1954
flintware
Nationalmuseum [252]

Dag Ribbing (1898–1980)
Radiogram for the Stockholm Exhibition 1930, C A V Lundholm AB
Architecture Museum [226]

*Astrid Sampe (b. 1904)
Spontanism textile print, Stigen's Factories, 1954
cotton, photoprint
Nationalmuseum [288]

Astrid Sampe
Granite Rug, Svängsta Rug Weavers, 1954
linen, wool
Nationalmuseum [289]

Astrid Sampe
Linen line (Linnelijnen) Household Towel, NK:s Textilkammare, 1955
linen
Nationalmuseum [290]

†Astrid Sampe
'Negroni' Napkin 1955
Linen, 29.2 x 47.2
Nationalmuseum

*Sixten Sason (1912–67)
Prototype for Saab 92001, 1945–6
Saab Automobile AB, Trollhättan [319]

Sixten Sason
Design for floor polisher, 1948
gouache
Nationalmuseum [340]

Sixten Sason
Design for vacuum cleaner, 1943
gouache
Nationalmuseum [297]

*Sixten Sason
Floor polisher, Electrolux, 1956
Torbjörn Lenskog 20th Century Design Collection [315]

Nisse Strinning (b. 1917)
String Floor Rack , String Design, 1953
plastic-covered metal
Torbjörn Lenskog 20th Century Design Collection [217]

Gerda Strömberg (1879–1960)
Bowl, Strömbergshyttan, 1943
glass
Nationalmuseum [267]

Carl-Harry Stålhane (1920–90)
Abstrakt Pie Dish, Gustavsberg, 1952
flintware
Nationalmuseum [248]

Elias Svedberg (1913–87)
Stol Triva 31, Nordiska Kompaniet, 1944
birch, woollen material
Nationalmuseum [214]

Elias Svedberg
Triva Safari Chair, Nordiska Kompaniet, 1944, birch, leather, linen
Torbjörn Lenskog 20th Century Design Collection [215]

New York Exhibition 'Design Towards Sanity', 1939
Organizer: Svenska Slöjdföreningen (Swedish Handicraft Association)
Svensk Form [463]

*Gösta Thames (b. 1916)
Ericofon (Cobra) Telephone, LM Ericsson, 1954
Private collection [314]

*Ingegerd Torhamn (1898–1994)
Rug, 1930
wool, hand-knotted pile
Stockholm City Museum [276]

†Ingegerd Torhamn
Carpet, 1930 (for the Stockholm Exhibition 1930)
napped wool
Stockholm Stadsmuseum

Nils & Alice Wedel
The Knitter (Strumpstickerskan) Wall Hanging, 1937
textile, batik
Nationalmuseum [279]

*Marianne Westman (b. 1928)
Picnic Serving Vessel, Rörstrand, 1955
earthenware
Rörstrands Museum [246]

*Sven Wingquist (1876–1953)
Spherical Ballbearings, 1907
SKF [318]

Edvin Öhrström (1906–94)
Ariel Vase, Orrefors, 1937, glass
Orrefors [265]

*Edvin Öhrström (1906–94)
Carafe, Orrefors, 1954
engraved glass
Nationalmuseum [271]

ARCHITECTURE

Hakon Ahlberg (1891–1984)
Art Handicraft Pavilion, Gothenburg Jubilee Exhibition, 1923
Architectural Museum [409]

Hakon Ahlberg and Leif Reinius
Hjorthagen housing project, 1934
designs
Architecture Museum [434]

*Nils Ahrbom (1905–97) and Helge Zimdal (1903–2001)
Sveaplan Girls' Grammar School, Stockholm, 1936 [436]

*Erik Ahlsén (1901–88) and Tore Ahlsén (1906–91)
Årsta Town Center, Stockholm, 1953
designs
Architectural Museum [444]

*Osvald Almqvist (1884–1950)
Forshuvudfors Power Station, 1921 [406]

Osvald Almqvist
The Mining Settlement in Borlänge, 1915–20 [407]

Osvald Almqvist
Kitchen Studies, 1934
designs
Architectural Museum [433]

†Osvald Almqvist
Hammarforsen Power Plant, 1928

*Gunnar Asplund (1885–1940)
Stockholm City Library, 1928
Architectural Museum [411]

*Gunnar Asplund
Stockholm Exhibition, 1930
designs
Architectural Museum [414]

*Gunnar Asplund/Sigurd Lewerentz
The Forest Cemetery, 1916–40 [440]

*Hans Asplund (1921–94)
Eslöv Civic Center, 1958 [450]

*Sven Backström (1903–92) and Leif Reinius (1907–95)
Gröndal Housing Project, 1946–52 [442]

*Sven Backström and Leif Reinius
Vällingby Center, Stockholm, 1954
designs
Architectural Museum [446]

Anders Beckman (1907–67)
Poster for the H55 Exhibition, Helsingborg 1955
Moderna Museet [341]

*Carl Bergsten (1879–1935)
Norrköping Exhibition, 1906, model
Architectural Museum [400]

*Carl Bergsten
Liljevalchs Konsthall, Stockholm, 1916
Architectural Museum [404]

*Sven Brolid and Jan Wallinder
Södra Guldheden, Gothenburg, 1953 [445]

Peter Celsing (1920–74)
St Thomas's Church, Vällingby, 1959
Architectural Museum [467]

*Per Ekholm and Sidney White
Baronbackarna Housing Project, Örebro, 1951 [443]

*ELLT:s architects' office
Gävle crematorium, 1960 [452]

*Ralph Erskine (b. 1914)
Luleå Shopping, 1955 [449]

*Arvid Fougstedt (1888–1949)
One Day The Earth Shall Be Ours. The Co-operative Society Architects' Office entry for a 'cheap housing' competition, Stockholm, 1932, gouaches
Architectural Museum [430]

*Léonie and Charles Eduard Geisendorf (b. 1914)
St Göran's High School, Stockholm, 1960 [468]

*Gregor Paulsson, Sven Markelius, Gunnar Asplund, Wolter Gahn, Eskil Sundahl and Uno Åhrén
acceptera (accept), 1931
Architectural Museum [455]

Ernst Grönwall (1906–96)
Draken Cinema, Stockholm, 1938 [439]

*Erik Hahr (1869–1944)
Asea's Mimer factory in Västerås, 1912 and 1915 [403]

*Paul Hedqvist (1895–1977)
Terraced House, Ålsten, 1932
designs
Architectural Museum [432]

*Paul Hedqvist
Bromma Airport, 1936 [437]

*Paul Hedqvist
Public Baths in Eskilstuna, 1932 [458]

†David Helldén and Sven Markelius
Maquette for the Hötorg Buildings, Stockholm
Plaster, 28 x 52 x 34
Private collection

*David Helldén, Sven Markelius et al
Hötorgscity in Stockholm, 1955–65 [454]

*Sigurd Lewerentz (1885–1975)
Chapel of the Resurrection, Forest Cemetery, Stockholm, 1925
designs
Architectural Museum [410]

*Sigurd Lewerentz
Stockholm Exhibition, domestic interiors with armchair, 1930
gouache, etc.
Architectural Museum [421]

*Sigurd Lewerentz
Stockholm Exhibition, poster, 1930
Chalk study
Architectural Museum [422]

*Sigurd Lewerentz
Stockholm Exhibition, 1930
Architectural Museum [423]

*Sigurd Lewerentz
Markuskyrka, Stockholm, 1960 [453]

*Sigurd Lewerentz
Furniture sketches, Stockholm Exhibition, 1930
gouache
Architectural Museum [459]

*Sigurd Lewerentz
Bus, Stockholm Exhibition, 1930
gouaches
Architectural Museum [460]

*Sigurd Lewerentz
Floating dance floor, Stockholm
Exhibition, 1930
gouache
Architectural Museum [461]

*Sune Lindström (1906–89)
Karlskoga Town Hall and Hotel, 1940
[441]

*Sune Lindström
Täby Storstuga, model, 1955
Architectural Museum [466]

Sven Markelius (1889–1972)
Door Types of the Standardization
Commission, 1920
designs
Architectural Museum [405]

*Sven Markelius
Helsingborg Concert Hall, 1930
Perspective in Spray Technique
Architectural Museum [431]

*Sven Markelius
The Apartment Hotel (Service Flat
Block) on John Ericssongatan,
Stockholm, 1935 [435]

*Sven Markelius
Proposal for Bromma Airport, 1934
gouache
Architectural Museum [457]

Sven Markelius
Proposal for Gärdet housing project,
1928 [469]

†Sven Markelius
Swedish Pavilion, New York World's
Fair, 1939

†Sven Markelius
ECO-SOC Chamber, UN Building New
York, 1952

Georg A. Nilsson (1871–1949)
Regeringsgatan 88, Stockholm, 1906
[401]

*Rudolf Persson (1899–1975)
Stockholm Exhibition, Restaurant, 1928
gouache
Architectural Museum [417]

*Rudolf Persson
Stockholm Exhibition, Entrance, 1928
gouache
Architectural Museum [418]

*Rudolf Persson
Stockholm Exhibition, Festival Square,
1929, gouache
Architectural Museum [419]

*Hans Quiding (1901–76)
Proposal for a Museum of Technology at
Hötorget, Stockholm.
Project for the Art Academy's student
examination, 1928, gouache
Architectural Museum [412]

*C. G. Rosenberg (1883–1957)
Photographs from the Stockholm
Exhibition, 1930
Architectural Museum [465]

Ernst Stenhammar (1859–1927)
Myrstedt & Stern's business property,
Stockholm, 1910
designs
Architectural Museum [402]

*The H 55 Exhibition, Helsingborg, 1955
Organizer: Swedish Society of Crafts
and Design [448]

*The Leisure Exhibition, Ystad, 1936
Organizer: Swedish Society of Crafts
and Design
Architectural Museum [462]

*Max Söderholm (b. 1908)
Stockholm Exhibition, 1929–30
gouache
Architectural Museum [415, 416, 420]

Olof Thunström (1896–1962)
Co-op terraced houses on Kvarnholmen,
1930 [427]

Sven Wallander (1890–1968)
Kungstornen Towers, Stockholm, 1923
[408]

*Ture Wennerholm (1892–1957)
L. M. Ericsson's factory, Stockholm,
1938 [438]

*Artur von Schmalensee (1900–72)
Co-op silo and oatmeal mill on
Kvarnholmen, 1928
design
Architectural Museum [413]

*Artur von Schmalensee
Co-op Luma Factory, Stockholm, 1930
[426]

Artur von Schmalensee
Borohus Housing Catalogue, 1930
Architectural Museum [428]

†Helge Zimdal and Nils Ahrbom
The Sveaplan Grammar school for Girls
1936
Maquette, c. 10 x 95 x 30
SISAB, Stockholm AB

Gösta Åbergh (b. 1919)
Professional Art College
(Konstfackskolan), Stockholm, 1959
[451]

Uno Åhrén (1897–1977)
Entry for an International Theatre
Building Competition, Kharkov, USSR,
1930, designs
Architectural Museum [424]

*Uno Åhrén
Flamman Cinema, Stockholm, 1930
[425]

*Uno Åhrén
Ford Motor Company's Factory at
Frihamnen, Stockholm, 1931 [429]

Uno Åhrén
Scenery for the play Sällsamt mellanspel
by Eugene O'Neill, 1928
Royal Dramatic Theater Stockholm

Presentation of a new building technique
with prefabricated elements, Grimsta,
Stockholm, 1955 [447]

The journal 'Arkitektur och samhälle'
(Architecture and Society), 1933
Architectural Museum [456]

PHOTOGRAPHY

*Moisé Benkow (1892–1952)
Torso, 1932
silver gelatin print, 27.8 x 22.5
Moderna Museet [541]

Kerstin Bernhard (b. 1914)
Meniscus, Stockholm, 1939
silver gelatin print, 28.6 x 23
Moderna Museet [586]

Helmer Bäckström (1891–1964)
St Hubert's Chapel, Munich, 1921/3
silver gelatin print, 21.3 x 20
Moderna Museet [507]

Erik Collin (1918–80)
Sokol Festival in Prague, 1948
silver gelatin print, 23.5 x 29.5
Moderna Museet [600]

†Henry Buergel Goodwin
Greta Garbo, 1926
silver gelatin print
Moderna Museet

Erik Collin
Harrison Dillard wins the 100 meters,
London Olympic Games, 1948
silver gelatin print, 23.5 x 29.5
Moderna Museet [602]

Gustaf W:son Cronquist (1878–1967)
The First Snow. Berlin December, 1931
silver gelatin print
Moderna Museet

Gustaf W:son Cronquist
Tramlines. Stockholm, 1933
silver gelatin print, 39 x 29
Moderna Museet [547]

Gustaf W:son Cronquist
Lines and Curves, c. 1945
silver gelatin print, 29 x 23
Moderna Museet [597]

†Harry Dittmer
Granada, Spain ,1952/1978
silver gelatin print, 28.6 x 38.5
Moderna Museet

Ture E:son (1903–79)
Portrait of the Actress Signe Hasso.
Stockholm, c. 1935
silver gelatin print, 35.3 x 26.7
Moderna Museet [560]

*Ture E:son
Prime Male / A-person, c. 1939
silver gelatin print, 12.8 x 14.7
Moderna Museet [583]

*Tore Ekholm (b. 1925)
Canoe Race Kungsholmen around
S:t Eriksbron Bridge, 1949
silver gelatin print, 40 x 30
Moderna Museet [603]

*Bertil Ekholtz (b. 1915)
Seal Hunter, c. 1939
silver gelatin print, 29 x 36
Moderna Museet [584]

*Sture Ekstrand
Three dancers, c. 1925
silver gelatin print, 16.9 x 23.2
Moderna Museet [510]

Sture Ekstrand
Portrait of the airman, Captain Albin
Ahrenberg, Stockholm, c. 1930
silver gelatin print, 39.5 x 29
Moderna Museet [520]

†Thure Eson Erikson
Portrait of Ingrid Bergman, 1936
silver gelatin print, 23 x 19.9
Moderna Museet

Andreas Feininger (1906–99)
Apartment House on Kvarnholmen, c.
1934
silver gelatin print
Moderna Museet [549]

Andreas Feininger
Apartment House on Kungsklippan
silver gelatin print, 16.6 x 22.5
Moderna Museet [559]

Andreas Feininger
South Municipal Middle School,
Stockholm, c. 1939
silver gelatin print, 17.4 x 23.3
Moderna Museet [577]

Andreas Feininger
HSB Building on Södermalm, c. 1939
silver gelatin print, 16.4 x 23
Moderna Museet [561]

Pär Flacke (b. 1906)
Lulle Ellboj Quartet with the Violinst
Leopold Becker, Stockholm, 1933
silver gelatin print, montage, 22.7 x 17.2
Moderna Museet [544]

Erik G:son Friberg (1901–71)
Two Young People, Arholma, c. 1939
silver gelatin print, 26.3 x 23.5
Moderna Museet [585]

*Henry Buergel Goodwin (1878–1931)
The Dancer Jenny Hasselqvist, 1916
Hand-printed photogravure, 20 x 15
Moderna Museet [504]

Henry Buergel Goodwin
Portrait of Ida Goodwin, 1918
color print, 30 x 22.7
Moderna Museet [505]

*Henry Buergel Goodwin
Full-length Portrait of a Woman, 1919
color print, 30 x 20.5
Moderna Museet [506]

Henry Buergel Goodwin
Luzula Silvatica, 1930
silver gelatin print
Moderna Museet [530]

*Henry Buergel Goodwin
Saxifrage Cushion in Flower, c. 1930
silver gelatin print, 30 x 20.5
Moderna Museet [636]

Gustaf Grahm (1901–71)
After the Rain, 1936
silver gelatin print, 21.3 x 16.4
Moderna Museet [566]

Gustaf Grahm
Shadows, Enskede, 1937
silver gelatin print
Moderna Museet [574]

*Karl Werner Gullers
The Winter Road, c. 1943
silver gelatin print, 35 x 29.5
Moderna Museet [582]

*Curt Götlin (1900–93)
Out for a Walk, 1928
silver bromide print, 26 x 22.5
Moderna Museet [513]

*Oscar Halldin (1883–1980)
*Photograph taken directly over
Vasastaden, Stockholm, looking down,*
1898, silver gelatin print, 18 x 23.8
Moderna Museet [500]

*Hans Hammarskiöld (b. 1925)
Staircase in Snow, c. 1950
silver gelatin print
Moderna Museet [608]

Hans Hammarskiöld
Park Benches. Stockholm, c. 1950
silver gelatin print, 16 x 29
Moderna Museet [610]

*Hans Hammarskiöld
Section of Tree
silver gelatin print, 34.3 x 28.6
Moderna Museet [625]

*Agnes Hansson (1888–1961)
Poppy, c. 1945
silver gelatin print, 25 x 22.6
Moderna Museet [580]

Emil Heilborn (b. 1900)
Dog Show, Stockholm, 1934
silver gelatin print, 17 x 23
Moderna Museet [552]

Emil Heilborn
Advertisement for *Läkerol*, 1934
silver gelatin print, 29.7 x 40
Moderna Museet [554]

Emil Heilborn
Photomontage for *Konsumentbladet*,
1936
silver gelatin print
Moderna Museet [568]

*Emil Heilborn
The Sun-Smoker, Yxlan, c. 1938
silver gelatin print, 28.5 x 21
Moderna Museet [576]

*Emil Heilborn
Milk Container, 1946
silver gelatin print, 38 x 29.8
Moderna Museet [599]

†Emil Heilborn
Västerbron Bridge under construction,
1934
silver gelatin print, 38 x 29
Moderna Museet

Inge Holm
Rivets on Västerbro Bridge, c. 1938
silver gelatin print, 30 x 23.5
Moderna Museet [577]

*Inge Holm
Operation, c. 1940
silver gelatin print, 29.7 x 23.7
Moderna Museet [592]

*Tore Johnson
Rue de Rivoli, Paris, c. 1951
silver gelatin print, 23.5 x 20.5
Moderna Museet [605]

Tore Johnson
Beside Canal St Martin, Paris, c. 1951
silver gelatin print, 24.2 x 17
Moderna Museet [609]

Tore Johnson
Paris, c. 1950
silver gelatin print
Moderna Museet [635]

*Harry Jonasson (1906–87)
From South Kungstornet Tower, c. 1938
Silver gelatine print, 29 x 23
Moderna Museet [581]

Harry Jonasson
Splicing of 16mm film
silver gelatin print, 23 x 17
Moderna Museet [590]

*Sune Jonsson (b. 1930)
*Elsa Bygdell, b. 1927 in Bergland,
Dikanäs and Evert Bygdell, b. 1925
in Stensele*, 1983
silver gelatin print, 31.5 x 21
Moderna Museet [629]

Sune Jonsson
Märta Olofsson, 8, playing with dolls,
1961/1983–6
silver gelatin print, 30 x 20.5
Moderna Museet [630]

Sune Jonsson
Set Ramstedt, b. 1885 in Hekigfjäll,
1961/1983–6
silver gelatin print, 21 x 31.5
Moderna Museet [631]

*Sune Jonsson
*Lineman's Widow Severina Nyberg
(1898-1977)*, 1961/1983–6
silver gelatin print, 31.5 x 31
Moderna Museet [632]

*Sven Järlås (1913–70)
Ostrich, c. 1930
silver gelatin print
Moderna Museet [526]

*Sven Järlås
Under Skurubron Bridge, c. 1933
silver gelatin print, 22.3 x 21
Moderna Museet [546]

Sven Järlås
Advertisement for *Albyl*, c. 1937
silver gelatin print, 28.5 x 22.5
Moderna Museet [567]

Sven Järlås
Solarisation, 1936
silver gelatin print, 38.4 x 28.4
Moderna Museet [570]

Sven Järlås
Advertisement for face cream, c. 1938
silver gelatin print, 21.2 x 17
Moderna Museet [579]

Sven Järlås
Staircase, Stockholm, c. 1940
silver gelatin print
Moderna Museet [587]

Sven Järlås
House Roofs, c. 1950
silver gelatin print
Moderna Museet [612]

Sven Järlås
*Marik Vos at Dramaten designing
costumes*
silver gelatin print, 30 x 23.2
Moderna Museet [633]

†Sven Järlås
*Peace in Europe, Kungsgatan,
Stockholm*, 1945
silver gelantin print, 20.1 x 16.1
Moderna Museet

Bertil Lindskog (b. 1906)
Sweden's Haifa, Lidingö, c. 1950
silver gelatin print
Moderna Museet [606]

*Gunnar Lundh (1898–1960)
Norrmalmstorg Square, Stockholm, May
1933
silver gelatin print, 9 x 14.5
Moderna Museet [543]

Gunnar Lundh
Skate Sailing, c. 1936
silver gelatin print, 23.6 x 17
Moderna Museet [626]

*Gunnar Lundh
The First Semester, 1938
Nordiska Museet [637]

*Harald Lönnqvist
Still Life, 1928
silver gelatin print
Moderna Museet [516]

*Gunnar Malmberg (1824–95)
My first attempt at gum printing.
Stockholm February 26, 1899
silver gelatin print, 16 x 20.5
Moderna Museet [501]

Jan de Meyere
Kraka. Stockholm, 1937
silver gelatin print, 23.5 x 28.6
Moderna Museet [575]

Jan de Meyere
*The Actress Ester Rock Hansen.
Stockholm*, 1932
silver gelatin print, 29 x 22
Moderna Museet [542]

†Jan de Meyere
The Author Luigi Pirandello, c. 1934
silver gelatin print, 28.9 x 22.9
Moderna Museet

Peddy Moberg (1891–1961)
Truck for distribution of Föreningsbladet,
c. 1930
silver gelatin print, 16 x 22
Moderna Museet [519]

*Theodor Modin (1882–1959)
Battery of Cameras in the Firing-Line, c.
1925
silver gelatin print, 11.5 x 17.3
Moderna Museet [509]

*Artur Nilsson
Reflex, c. 1951
silver gelatin print
Moderna Museet [613]

Lennart Nilsson (b. 1923)
After Hitler Europe Lies in Ruins, 1946
silver gelatin print, 24.8 x 29.6
Moderna Museet [598]

†George Oddner
The Kabuki Actor, 1956
silver gelatin print, 22.9 x 29.7
Moderna Museet

Lennart Olson (b. 1925)
The Sluice, 1952/1980
silver gelatin print, 27 x 36
Moderna Museet [611]

†Lennart Olson
Station Termini III, 1953
silver gelatin print, 24.8 x 39.8
Moderna Museet

Lennart af Petersens (b. 1913)
*Autumn in Klara during the demolition;
an apocalyptic storm. Stockholm*, 1955
silver gelatin print, 16.6 x 23
Moderna Museet [614]

Lennart af Petersens
*Worm-eaten Façade,
Malmskillnadsgatan 34, Stockholm*,
1955
silver gelatin print, 22 x 17.5
Moderna Museet [615]

Lennart af Petersens
Vällingby II, 1955
silver gelatin print, 36.5 x 29
Moderna Museet [616]

*Lennart af Petersens
*The House's Evil Eye and the Three
Norns, Stockholm*, 1955
silver gelatin print, 23.6 x 15
Moderna Museet [617]

Lennart af Petersens
*Subway Construction under
Drottninggatan – Klarabergsgatan,
Stockholm*, 1956
silver gelatin print, 23 x 16
Moderna Museet [620]

*Anna Riwkin
*The Writer Harry Martinsson,
Stockholm*, 1932
silver gelatin print, 30 x 22.5
Moderna Museet [538]

Anna Riwkin
The Writer Artur Lundkvist, 1933
silver gelatin print, 29.6 x 22.5
Moderna Museet [545]

Anna Riwkin
*The Dancer Alexander van Swaine.
Stockholm*, 1936
silver gelatin print
Moderna Museet [569]

*Anna Riwkin
Portrait of Karin Boye, 1939
silver gelatin print, 38.5 x 28.3
Moderna Museet [628]

Anna Riwkin
The Composer Karl Birger Blomdahl,
1960
silver gelatin print, 39 x 28.7
Moderna Museet [622]

†Anna Riwkin
The choreographer Birgit Åkesson, 1950
silver gelatin print, 37.9 x 28.4
Moderna Museet

Carl Gustaf Rosenberg (1883–1954)
Wheat Harvest on a Large Estate, Skåne, 1932
silver gelatin print, 33.5 x 44
Moderna Museet [537]

†Carl Gustaf Rosenberg
Horses in Söderslätt, 1934
silver gelatin print, 17 x 23
Moderna Museet

†Carl Gustaf Rosenberg
Bulltofta airport, Malmö, 1934
silver gelatin print
Moderna Museet

Karl Sandels (1906–86)
Crown Prince Leopold of Belgium Arrives in Stockholm, 1926
Moderna Museet [512]

*Karl Sandels
The Airship Italia Passes Stockholm on its Way to the North Pole, 1928
silver gelatin print, 29.5 x 39
Moderna Museet [514]

*Karl Sandels
Speed, c. 1928
positive collage, silver gelatin print, 33.4 x 28.7
Moderna Museet [515]

*Karl Sandels
From 9 to 5. Stockholm Report in pictures without words for Stockholms Dagblad Sunday Supplement, 1930
silver gelatin print, 42.5 x 29.7
Moderna Museet [527]

Karl Sandels
Fireworks over the Stockholm Exhibition, 1930
silver gelatin print, 39 x 29
Moderna Museet [528]

Karl Sandels
The Pole Vaulter Henry Lindblad, Stockholm Stadium, 1931
silver gelatin print, 23.4 x 28.5
Moderna Museet [534]

*Karl Sandels
The Internationale, Stockholm, 1931
silver gelatin print, 38.3 x 29.5
Moderna Museet [536]

Karl Sandels
The Arrival of the Changing of the Guard, Stockholm, 1932
silver gelatin print, 29.4 x 39.4
Moderna Museet [540]

*Karl Sandels
Moreau, USA, Stockholm Stadium, 1934
silver gelatin print, 20.7 x 23.3
Moderna Museet [553]

*Karl Sandels
Archery, 1934
silver gelatin print
Moderna Museet [555]

Karl Sandels
Maneuvers at Västervik, 1934
silver gelatin print, 16.7 x 23
Moderna Museet [557]

Karl Sandels
Swedish Flag Day at the Stadium, June 1936
silver gelatin print
Moderna Museet [571]

*Karl Sandels
Press Photographers at Work – When Per Albin Resigned, 1936
silver gelatin print, 16.8 x 23
Moderna Museet [573]

†Karl Sandels
110 meters Hurdle Race at the Stockholm Stadium, 1931
silver gelatin print, 39.4 x 29.4
Moderna Museet

*Ture Sellman (1888–1969)
Norrbro, Stockholm, c. 1920
silver gelatin print, 16.7 x 23
Moderna Museet [637]

Ture Sellman
Riddarholmen, Stockholm, 1926
silver bromide print
Moderna Museet [638]

Arne Wahlberg (1905–87)
At Sea, c. 1930
silver gelatin print, 38 x 27
Moderna Museet [524]

*Arne Wahlberg
The City Library, Stockholm, 1930
silver gelatin print, 22 x 28
Moderna Museet [525]

Arne Wahlberg
Glass Study. Stockholm, 1931
silver gelatin print, 16.6 x 23
Moderna Museet [531]

Arne Wahlberg
Fabric Sample, 1931
silver gelatin print
Moderna Museet [533]

Arne Wahlberg
Tennis Racket with Balls, 1932
silver gelatin print, 29.5 x 39
Moderna Museet [539]

Arne Wahlberg
Silver Jug, Stockholm, 1934
silver gelatin print, 10 x 8
Moderna Museet [556]

Arne Wahlberg
Fabric Sample, 1934
silver gelatin print, 29 x 23
Moderna Museet [558]

Arne Wahlberg
The Apartment House, Stockholm, 1950
silver gelatin print, 30.5 x 22
Moderna Museet [607]

Arne Wahlberg
Street Life, c. 1960
silver gelatin print, 23.7 x 30
Moderna Museet [621]

†Arne Wahlberg
Glass and Carafe, c. 1955
silver gelatin print, 16.6 x 22.9
Moderna Museet

Erik Walldow
The Converter is Upturned, c. 1934
silver gelatin print, 26.5 x 22
Moderna Museet [551]

Edvard Welinder (1901–59)
Fashions for NK. Stockholm, 1924
silver gelatin print, 22.7 x 17.2
Moderna Museet [508]

*Rolf Winqvist (1910–68)
Broken nitraphot, Stockholm, 1948
silver gelatin print, 43.5 x 35.5
Moderna Museet [601]

Rolf Winqvist
Girl in Rain, Stockholm, 1956
silver gelatin print, 29.5 x 17.5
Moderna Museet [619]

Gunnar Wåhlin
8 degrees cold and clear. Stockholm, c. 1940, silver gelatin print, 24 x 26
Moderna Museet [591]

Nils Örke (1901–79)
Danish Resistance Men. Copenhagen May 1945
silver gelatin print, 23.5 x 16.7
Moderna Museet [594]

Nils Örke
German Troops Leave Copenhagen May 1945
silver gelatin print
Moderna Museet [595]

Nils Örke
Denmark Free Again. Copenhagen May, 1945
silver gelatin print, 28 x 26.4
Moderna Museet [596]

*Anonymous
Modern press photographers, c. 1930
silver gelatin print
Moderna Museet [529]

†Anonymous
A group of Lapps
Race Biological Album D 16:9850
Gelatin silver print, 55 x 65 x 3
University Library, Uppsala

† Anonymous
Woman Gymnasts from the Front and from Behind
Race Biological Album I 5:9280; 9281
Gelatin silver print, 55 x 65 x 3
University Library, Uppsala

† Anonymous
Clergyman
Race Biological Album J 2:3486; 3487
Gelatin silver print, 55 x 65 x 3
University Library, Uppsala

† Anonymous
Five Boys, Jukkasjärvi
Race Biological Album M 9:902, 903; 904
Gelatin silver print, 55 x 65 x 3
University Library, Uppsala

† Anonymous
Four Girls, Jockmock
Race Biological Album M 10:875; 876; 877 1932
Gelatin silver print, 55 x 65 x 3
Universitetsbiblioteket, Uppsala

INDEX

Numbers in italic refer to illustrations